Correggio and Parmigianino

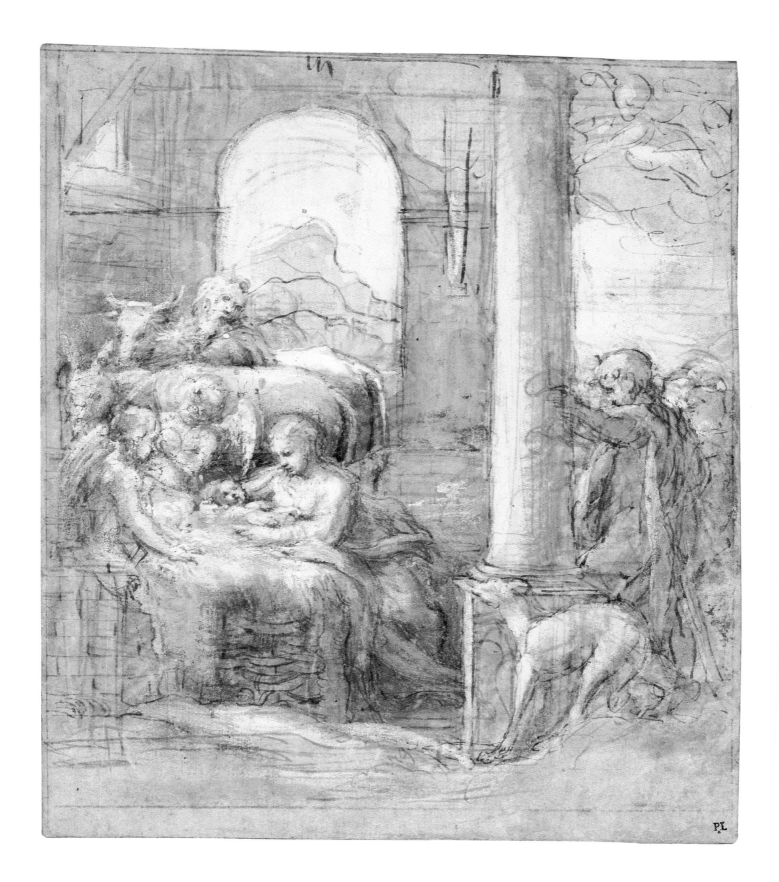

Correggio and Parmigianino

MASTER DRAUGHTSMEN OF THE RENAISSANCE

Carmen C. Bambach

Hugo Chapman

Martin Clayton

George R. Goldner

Published for The Trustees of

The British Museum by

BRITISH MUSEUM ⚎ PRESS

This catalogue is published to accompany an exhibition held at The British
Museum from 6 October 2000 to 7 January 2001 and at The Metropolitan
Museum of Art, New York, from 5 February to 6 May 2001.

The exhibition in New York is made possible in part by Parmalat.

Frontispiece: Correggio, *The Adoration of the Shepherds, c.* 1522.
Fitzwilliam Museum, Cambridge (cat. 22).

© 2000 The Trustees of the British Museum
Published by British Museum Press
A division of The British Museum Company Ltd
46 Bloomsbury Street, London WCIB 3QQ

First published 2000

A catalogue record for this book is available from the British Library

ISBN 0-7141-2628-4

Designed and typeset in Photina by Andrew Shoolbred
Printed in Spain by Grafos SA, Barcelona

Contents

Directors' foreword

This exhibition is devoted to the drawings of the two leading Parmese artists of the Renaissance, Correggio and Parmigianino. Their work has been admired throughout the centuries, not least by the many distinguished collectors who sought out their paintings and drawings. It is, therefore, all the more surprising that no major exhibition has ever been dedicated to these artists. It was against this background that our two institutions began to plan exhibitions of their drawings. When we discovered that we had similar intentions, it made good sense for us to make this a joint project.

In bringing together the finest drawings by Correggio and Parmigianino in England and America we have become keenly aware of the achievement of collectors, private and public, in amassing so many fine sheets that the current exhibition can represent only a selection. The painterly subtleties of Correggio's drawings and the mannered refinements of Parmigianino's sheets continue to attract the same enthusiasm today as they have over previous centuries. The present selection is the result of a determined effort to offer the full range of their varied activity in drawing. It is clear testimony to the greatness of our joint holdings that this could be accomplished through recourse to collections in our two countries alone.

We are very grateful to Her Majesty Queen Elizabeth II, the Duke of Devonshire and the Trustees of the Chatsworth Settlement, the several anonymous private collectors, and to the public institutions who have generously agreed to part with their drawings for an extended period. The Metropolitan Museum extends its gratitude to Parmalat for its support of the exhibition in New York. The exhibition is curated by Hugo Chapman, Assistant Keeper in the Department of Prints and Drawings at the British Museum, Martin Clayton, Assistant Curator at the Royal Library, Windsor, and George R. Goldner, Drue Heinz Chairman, and Carmen C. Bambach, Associate Curator, of the Department of Drawings and Prints at the Metropolitan Museum of Art.

ROBERT ANDERSON,
DIRECTOR
THE BRITISH MUSEUM

PHILIPPE DE MONTEBELLO,
DIRECTOR
THE METROPOLITAN MUSEUM OF ART

Authors' acknowledgements

The present exhibition was initially planned as an updated and slightly enlarged version of A.E. Popham's pioneering exhibition of Emilian sixteenth-century drawings held in 1951 at the British Museum. Our wish to pay tribute to Popham's extraordinary contribution to this field led us to narrow the focus to Correggio and Parmigianino, the leading figures of the School of Parma, whose corpus of drawings he had established in his peerless monographs: *Correggio's Drawings* (1957) and *The Drawings of Parmigianino* (1971). Although British collections have fine holdings of their drawings, the opportunity to combine them with superlative examples from North America added a new dimension to the exhibition which allowed the diversity and range of both artists to be shown to even greater effect. Inevitably the material assembled by Popham has since been enriched through the discoveries of scholars such as the late Richard Harprath, Mario Di Giampaolo, David Ekserdjian and Konrad Oberhuber, and the present exhibition includes a number of drawings that have only emerged in the last thirty years. Although compared with Popham's laconic cataloguing style the following entries may appear prolix, our common wish to have a catalogue that can be read without recourse to heavy lifting equipment has meant that we have confined the bibliography to substantive publications post-dating Muzzi and Di Giampaolo's 1989 monograph on Correggio's drawings and that devoted to Parmigianino's drawn corpus by Popham published in 1971. In general we discuss versos of drawings and works not in the exhibition only when they add significantly to the understanding of the recto.

An exhibition of this nature is dependent on the generosity and goodwill of a large number of people and we should like to pay thanks to the following: Richard Bagley, Christopher Baker, Andrea Bayer, Lisa Baylis, Fabio Benzi, Suzanne Boorsch, Alan Borg, Ada Bortoluzzi, Helen Braham, William C. Breazedale, Christopher Brown, Andrew Burnett, Peter Day, Diane De Grazia, Cara Denison, Mario Di Giampaolo, David Ekserdjian, Peter Ellis, Oliver Everett, Anne Fahy, Teresa Francis, Andrea Gates, Achim Gnann, Margaret Morgan Grasselli, William M. Griswold, Gerhard Gruitrooy, Jeremy Harding, Lee Hendrix, David Jaffé, Neil MacGregor, Gillian Malpass, Theresa-Mary Morton, Jane Munro, John Murdoch, Charles Noble, Brian Owen, Nicholas Penny, Charles E. Pierce Jr, Michiel Plomp, Catherine Pütz, Janice Reading, Duncan Robinson, The Hon. Mrs Roberts, William Robinson, Andrew Robison, Martin Royalton-Kisch, Francis Russell, Richard Rutherford, David Scrase, Maurizio Seracini, Marjorie Shelley, Kate Stewart, Julien and Simon Stock, Jennifer Tonkovich, Julian Treuherz, Jonathan Williams, Timothy Wilson, Catherine Whistler, Linda Wolk-Simon and David Wright, and to all the private collectors who have so kindly agreed to lend their drawings to the exhibition. We should also like to acknowledge our debt to Rachel McGarry and Emily Seidel, whose work as exhibition assistants at the Metropolitan Museum of Art was essential to the completion of this project.

Chronology: Correggio

1480	*c.* 1489 Antonio Allegri born in Correggio (east of Parma)		
1490			
1500			
1510	*c.* 1510 Frescoes in S. Andrea, Mantua 1514 Commission to paint organ shutters for abbey of S. Benedetto Po, near Mantua (one surviving canvas: private collection, Turin)	1514–15 First surviving documented altarpiece, *Madonna of St Francis* (Dresden) for S. Francesco, Correggio	1518–19 Probable journey to Rome; move to Parma; frescoes in Camera di S. Paolo
1520	1520 Begins work in S. Giovanni Evangelista, Parma, probably with the dome	1522 Working in apse of S. Giovanni Evangelista; receives commissions for nave of S. Giovanni Evangelista, for dome, apse and choir vault of Parma cathedral, and for *Adoration of the Shepherds* (Dresden)	1523 Probably working on *Madonna of St Sebastian* (Dresden) and *Madonna della Scodella* (Parma) 1524 Final payment for frescoes in nave of S. Giovanni Evangelista; begins work in cathedral 1528 *Madonna of St Jerome* installed in S. Antonio, Parma
1530	1530 Completes dome of Parma cathedral; receives no further commissions in Parma. *Adoration of the Shepherds* installed in S. Prospero, Reggio Emilia; *Madonna of St George* (Dresden) finished for Confraternity of St Peter Martyr, Modena	1530–31 Probably begins work on the *Loves of Jupiter* series (Vienna, Rome, Berlin)	1534 (5 March) Dies in Correggio
1540			

Chronology: Parmigianino

1480			
1490			
1500	1503 (11 January) Girolamo Francesco Maria Mazzola born in Parma		
1510			
	1519 *Baptism of Christ* (Berlin)		
1520	1521 Leaves Parma for Viadana; *Mystic Marriage of St Catherine* (Bardi) 1522 Returns to Parma; begins work in S. Giovanni Evangelista; commission for transept of cathedral (unexecuted)	*c.* 1523 Assisting Correggio in S. Giovanni Evangelista; organ shutters for S. Maria della Steccata 1523–4 Work for Galeazzo Sanvitale, including frescoes in the Rocca Sanvitale (Fontanellato)	1524 Leaves Parma for Rome 1526 *Madonna of St Jerome* (London, NG) commissioned for S. Salvatore in Lauro, Rome 1527 Sack of Rome; flight to Bologna 1527–30 In Bologna; *St Roch and Donor* for S. Petronio (in situ); *Madonna of St Margaret* for S. Margherita (now Pinacoteca)
1530	1530 Return to Parma; commission for two altarpieces for S. Maria della Steccata (unexecuted)	1531 Commission for decoration of S. Maria della Steccata 1534 *Madonna of the Long Neck* (Florence, Uffizi) commissioned for S. Maria dei Servi, Parma (installed 1542) 1535 Revised contract for S. Maria della Steccata	1539 Arrest and imprisonment; release and flight to Casalmaggiore 1539–40 *Madonna of St Stephen* (Dresden); *Lucretia* (lost)
1540	1540 (24 August) Dies in Casalmaggiore		

Correggio as a draughtsman

Antonio Allegri is universally known by the name of the small town of Correggio outside Parma where he was born around 1490. His father was a small businessman, and the young artist grew up in decent circumstances. There is no concrete evidence as to his teacher, but it may well have been his uncle Lorenzo, a modest provincial figure. More important for his artistic beginnings are the influences of Mantegna – whose son he knew – and Leonardo, both of whom had a profound impact on his early artistic development. Correggio spent virtually all of his professional career in Correggio and Parma, where he worked for a quite sophisticated local patronage, which included laymen of substantial humanist learning, and for the Benedictine Order. He may well have visited Rome toward the end of the second decade of the sixteenth century, and by the 1520s had gained a new monumentality of figure style and boldness of spatial invention that may have resulted from the impact of this trip. By the end of the 1520s he was producing mythological and allegorical pictures for Isabella d'Este and Federico Gonzaga in Mantua. He appears to have been a well-respected figure in Parma, and was married with several children. Vasari tells that he was a modest and rather self-effacing man.

The high position that Correggio has maintained in the pantheon of Italian Renaissance artists has largely been the result of his achievements as a painter rather than as a draughtsman. In his *Vita* of Correggio (Vasari-Milanesi IV), Vasari set the tone for nearly all later criticism when he wrote that the artist would not have been so highly regarded for his drawings alone had they not yielded the resultant frescoes and individual paintings. To someone imbued with the drawings of Michelangelo and Raphael, Correggio must have lacked structural design sensibility, although he was among the most original and brilliant pictorial draughtsmen of the sixteenth century.

It is not easy to assess the sum of Correggio's graphic output, but there are hints of its extent amongst the roughly one hundred surviving sheets. For example, there are seven extant studies for the pendentive with Saints Matthew and Jerome in San Giovanni Evangelista alone (cats 13–14 and 21 verso; Muzzi and Di Giampaolo 1988, nos 23–5). Furthermore, in certain cases the alterations of this grouping from one study to the next are so minor as to indicate clearly that Correggio jotted down virtually every variation as it entered his mind. This is by no means a unique instance of the proliferation of studies for one figure or grouping. Eve and her attendant figures were studied in five surviving sheets as Correggio prepared his design for the dome of the cathedral of Parma (cats 29–30; Muzzi and Di Giampaolo 1988, nos 65–7). And, here again, he makes gradual and fairly modest changes from one drawing to the next. These and similar instances suggest that he drew compulsively while in the midst of planning a painting or fresco. On the other hand, we have no studies from life, none after the work of other artists and no landscapes or portrait studies. In addition, although it is reasonably assumed that Correggio went to Rome for a visit, there are no drawings after the Antique. On the evidence of his painted work there is good reason to suppose the existence of each of these categories of drawing, and fair to assume that he produced a large quantity of drawings of which only a tiny fraction accidentally survives.

The earliest drawings by Correggio reflect the impact on him of Mantegna on the one hand and of Bolognese artists such as Francesco Francia (*c.* 1450–1517) and Amico Aspertini (1474/5–1552) on the other. A fragment of the cartoon (full-scale drawing) showing the head of Mary Magdalene, made in preparation for the frescoed tondo of the *Entombment of Christ* for the atrium of Sant'Andrea in Mantua, now in the Morgan Library (cat. 1), is a powerful example of Mantegna's influence on the young Correggio, all the more resonant in this case on account of the fresco being part of a campaign of work that included the older artist's funerary chapel. The facial type, classical monumentality and expressive force of the image are derived from Mantegna, but in this cartoon there is already a softer, more *sfumato*, manner of modelling, which may reflect some early contact with Leonardo's work. Similarly, the *Scene of sacrifice* in the Louvre (Muzzi and Di Giampaolo 1988, no. 2) suggests the variety of sources that affected the young Correggio (fig. 1). The odd proportions and eccentric classicism of figures and expression are Bolognese in origin, but the varied textural modelling and freely sketched landscape details seem to show that he was already familiar with drawings by Leonardo. Both of these drawings appear to date from around 1510–11.

There are several more drawings dating from the period before Correggio's hypothetical visit to Rome and his frescoes

Fig. 1. Correggio, *Scene of sacrifice*, red chalk, 196 × 157 mm. Musée du Louvre, Paris, inv. RF 529.

in the Camera di San Paolo, Parma (cats 6–7). They are all drawn in red chalk, sometimes with white heightening. The forms retain a generalized debt to Mantegna in many cases, but the effect is altogether different from the stridently crisp and sculptural forms he created. Outlines gradually become less defined and a great effort is made to give an atmospheric cast to compositions. In sheets such as the *Adoration of the Magi* in the Metropolitan Museum (cat. 3), Correggio also begins to explore the expressive possibilities of light and shade, with white heightening emerging as brilliant light from the darker overall tonality achieved in various reds. One could hardly be further from Mantegna, who drew like a printmaker, even when he was not designing a print. At the same time, certain eccentricities of detail are still present in Correggio's drawings. The *Apollo and Diana* in the British Museum (cat. 4) is composed of two classical forms executed in a Leonardesque *sfumato* technique and is probably the most advanced of his pre-Roman drawings. Nevertheless, Correggio still finds it difficult to set heads convincingly on torsos, so that the result is somewhat awkward. These and related sheets appear to date from around 1513–17, and all bear the broad influence of Leonardo in their emphasis on gradations of tone and atmosphere, as well as in their freedom of handling. It has been

reasonably proposed that the young Correggio visited Milan, in which case he might well have had the opportunity to see drawings by Leonardo and his Lombard followers. This contact might also account for Correggio's preference for red chalk, a medium first brought to the fore by Leonardo.

Correggio seems to have visited Rome around 1518, but the impact of this trip is not fully evident until a few years later in the frescoes of San Giovanni Evangelista. There are two drawings that may date from during or just after his Roman stay, in the Getty Museum (cat. 5) and the Rijksmuseum (Muzzi and Di Giampaolo 1988, no. 12). The relief-like presentation of the foreground group in the black chalk Getty drawing and the dependence of the principal soldier to the left on a similarly situated figure in Raphael's *Battle of Ostia* fresco in the Vatican argue for a connection to Correggio's time in Rome. Despite a continuing awkwardness in the placement of the bull-rider's head on his torso, the figure shows a greater solidity of form that may also reflect a study of Antique and High Renaissance material in Rome. Other elements in the drawing look back to earlier drawings of the second decade of the century. Similarly, the Rijksmuseum sheet shows a new-found elasticity of form and movement in the figure of Adam, which is closely related to the soldiers in the Getty drawing.

The review of Correggio's drawings of the second decade of the century concludes with two relatively minor studies for the frescoes in the Camera di San Paolo of around 1518–19 (cats 6–7) in the British Museum. The study of putti in an oval is a quick notational drawing, setting out the principal features of the composition. Although squared for transfer, it may simply have been one of a series of partially rejected ideas on the road to a satisfactory solution. The other study is more evolved in the description of form and setting, but was only used in part in the resultant fresco. Here again Correggio draws to test an idea with a summary rendering of form. It is sheets of this kind that may have been in Vasari's mind when he wrote of the superiority of the final product.

The first project for which we have a significant group of surviving sheets is the fresco decoration of San Giovanni Evangelista, painted in the period 1520–4 (cats 8–17; Muzzi and Di Giampaolo 1988, nos 13–46). In the studies for the first frescoes in the dome and pendentives, there are already indications of the impact that Rome had on Correggio in the

more graceful and monumental figural style. Even in quick sketches on a small scale, such as the study in the British Museum for an apostle (cat. 8), there is a grander and clearer vision at work, as well as the suggestion of a classical prototype. In a sheet in the Louvre for another apostle (Muzzi and Di Giampaolo 1988, no. 16), the evident reference is to Michelangelo's *Jonah* on the Sistine ceiling.

At this time Correggio's draughtsmanship becomes more varied and flexible, both in his choice and handling of the media. In several studies for this part of the decoration he begins to use pen and ink together with red chalk to clarify or rework individual passages (cats 13a and 14 verso). There are also occasions in which for the first time he uses pen and ink and wash alone. The progressively greater assurance with which he employs new techniques visibly expands from the studies of apostles for the dome to the pendentive drawings. The splendid sheet in the British Museum, with studies of Saints Matthew and Jerome on the recto and of a bound figure on the verso (cat. 14), clearly demonstrates a new exploratory freedom in the handling of red chalk, as Correggio sacrifices tidy outlines in favour of a searching and remarkably loose rendering. In later studies of the same two apostles he will go on to clarify the precise poses and forms of the figures (Muzzi and Di Giampaolo 1988, nos 23–5), at one point reversing the composition.

In the drawings for the apse with the *Coronation of the Virgin* and the frescoes of the nave these tendencies are further developed (cats 9–12, 15–16). The chalk studies of Christ and of the Virgin show a richer tonal range than before, with a corresponding blurring of the outer contours of the figure (cats 9–10; Muzzi and Di Giampaolo 1988, nos 27–9, 31, 34 recto). Where pen and ink are used over chalk underdrawing, they are handled with greater assurance and flexibility than in his first efforts with that medium only slightly earlier (Muzzi and Di Giampaolo 1988, nos 32, 34 verso, 35). Wash is sometimes added to achieve richer and more varied tonal effects, as in the fine study of putti in the Louvre (Muzzi and Di Giampaolo 1988, no. 37). Here and in the British Museum study of figures around an altar (cat. 16), Correggio's use of the pen is sometimes almost notational, as he quickly jots down an idea for a figure group. These differ from the more fully developed pen drawings – with long, flowing outlines –

which are similar to his *sinopie*, the bold, summary underdrawings on the plaster of his frescoes (Muzzi and Di Giampaolo 1988, no. 32).

The surviving drawings for the Del Bono chapel (cats 18–20; Muzzi and Di Giampaolo 1988, nos 48–9), and for the *Annunciation* fresco from San Francesco from the mid-1520s (cat. 25), reveal how far Correggio's technique of integrating diverse media has evolved. Drawing over a reddish ground, he employs varied tones of red with white heightening to develop a pictorial manner that achieves effects of light, colour and atmosphere which parallel those of painting. In some instances the white heightening is laid on thickly, as if he were applying *impasto*. A highly finished example, such as the Metropolitan Museum's *Annunciation* (cat. 25), is so complete and highly worked that one might well believe that it was used to gain a patron's final approval before proceeding to begin painting. Yet, even in cases such as this, where the sheet is squared for transfer, there remain further changes that were made in the final work.

Correggio's success at San Giovanni Evangelista was followed by a still more important commission in November 1522: the fresco of the *Assumption of the Virgin* in the dome of the cathedral of Parma. The dome rests on an octagonal drum, with each face of the octagon having an oculus. Correggio conceived of the Assumption reaching to the infinity of the heavens, with a vast multitude in an upper concentric arrangement that echoes the prophets and other figures on the drum below. The conception is entirely new and daring, requiring exacting planning not only of individual figures and groups, but of their complex interrelationships in this elaborate spatial continuum. The artist must have made hundreds of preparatory studies for this project, of which only a small number survives. They are varied in purpose and therefore provide a good indication of many of the steps he went through in designing the dome frescoes (cats 26–32; Muzzi and Di Giampaolo 1988, nos 56–81).

A double-sided sheet in the Ashmolean Museum (cat. 26) reflects two stages in Correggio's search for a solution to the iconography and design of the pedestal and area around the eight oculi. The main architectural forms are clearly set down, but the figures are quickly sketched as he attempts to give them identity and definition. The majority of studies for the apostles

Fig. 2. Correggio, *Head of an angel*, charcoal
and white chalk, 217 × 278 mm. Ecole des
Beaux-Arts, Paris, inv. 109.

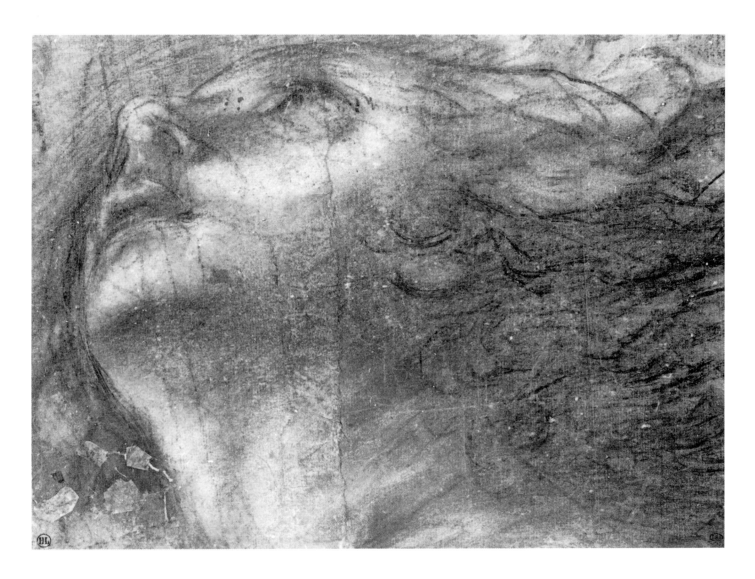

and *ephebi* (the youths tending the candles) are entirely in red
chalk, although they tend to form two groups. The double-
sided sheet in an English private collection (cat. 27) exemplifies
the rather broadly drawn studies in which light and
atmosphere are important considerations. The second category
consists of highly linear studies, with sharply defined outlines.
Although some of this latter type contain a certain amount of
shading, they appear to have been made to establish or define
poses and figural interrelationships in space. This 'linear

manner' was used for the most elaborate of the preparatory
drawings for this part of the dome frescoes (Ekserdjian 1997,
fig. 245). It is far less pleasing than those sheets with *sfumato*
effects, but more appropriate for the function of clarifying
precise individual poses and of integrated groups of figures.
Surprisingly, both groups of sheets are most often squared,
even though Correggio made changes in every case in the
resultant fresco. This implies that he recognized the need to
consider these figures in terms of the complicated spatial

Fig. 3. Correggio, *Saint Bernard Uberti*, red chalk, 228 × 245 mm. Musée du Louvre, Paris, inv. 5974.

setting into which they would be placed, even as he was determining their poses.

Among the drawings for the upper zone of the dome there are five splendid studies for the figure of Eve (cats 29–30; Muzzi and Di Giampaolo 1988, nos 65–7). Although the pose used at first for Eve was broadly based on a classical prototype, she possesses a remarkable sensuality and naturalism. At a later stage Correggio reconsiders Eve in the context of a figure to her right and decides to use the pose he originally had in mind for the latter (cat. 30). As a final step, he puts this small group of figures within the larger spatial and figural setting in a sheet in Frankfurt, in which not only the placement of each figure is considered, but the complex matter of joining two sides of the octagon is also achieved (Muzzi and Di Giampaolo 1988, no. 67).

Notable among other studies for the upper section of the fresco is the sheet of *Abraham, Isaac and Adam* at Windsor (cat. 31). This group faces Eve on the other side of the Virgin in the fresco and the rendering of Adam is almost a mirror image of the earlier studies of Eve. As was his habit, Correggio first drew spontaneously in red chalk and then went on to clarify selectively the forms in pen and ink. The result closely anticipates the painted fresco, although he continues to make changes right until the end of the process.

Lastly, there are two sheets with three studies of the Virgin, in Dresden and in the British Museum (Muzzi and Di Giampaolo 1988, no. 69; and cat. 28). The verso of the Dresden sheet – probably traced from a lost drawing – shows the Virgin in nearly full-face and turned in the opposite direction from the two other extant studies and the fresco. The recto was traced from the verso and depicts her much as she will appear in the fresco; both sides were executed first in black chalk, which was partially gone over in pen and ink in an effort to define the forms more clearly. The British Museum drawing seems to be later, as it is much more fully developed in both form and effects of light. On the other hand, the Virgin's pose – with legs far apart – is further from the fresco than is the recto of the Dresden sheet. In either case, the order of execution of these studies is somewhat anomalous, which is not surprising, given Correggio's exploratory freedom as a draughtsman.

The drawings for the four pendentives with four patron saints of Parma include a vigorous red chalk and pen and ink study of Saint John the Baptist (Muzzi and Di Giampaolo 1988,

no. 80), in which Correggio considers the pose of the saint, and a later, more tepid sheet for the pendentive with Saint Bernard Uberti, in the British Museum (cat. 32), made to establish precise poses and spatial relationships amongst the various figures in this fresco. There are also four red chalk drawings in the Louvre (Muzzi and Di Giampaolo 1988, nos 76–9), each representing one of the scenes much as they will be depicted in the frescoes (fig. 3). These date from about 1528 and are exemplary of his ability at this point to combine the definition of form and spatial setting with the subtlest suggestion of light and atmosphere. They may well have been drawings shown to the patron for approval of the final scheme, even though Correggio continued to make minor alterations. Finally, the most beautiful surviving cartoon by the artist, in the Ecole des Beaux-Arts, Paris (Muzzi and Di Giampaolo 1988, no. 70), was made in preparation for the head of one of the angels in the fresco with Saint Joseph (fig. 2). It is very fully worked up in black chalk, highlighted with white chalk in order to study tonal and atmospheric effects, and it complements the rather summary linearity of Correggio's *sinopie* (Ekserdjian 1997, fig. 253).

Correggio's drawings for altarpieces show a comparable range of media and types. The compositional study for the *Madonna of Saint Jerome* at Christ Church, Oxford, of around 1523 (cat. 23) was made at an early stage in the preparatory process and is full of creative energy, with a virtually illegible jumble of red chalk lines of underdrawing, with which Correggio seeks out the basic form of the composition of its constituent parts. This is followed by selective broad pen work defining some of the principal figures and contours. The whole

is set against a reddish preparation that enables him to see the figures against a rich middle tone.

By contrast, the recto of the Washington sheet for the *Madonna della Scodella* (cat. 21), drawn at much the same period, represents a later stage in the evolution of this type of composition. Red chalk is selectively used to assist in rendering areas of light and shadow, as well as in making the initial designs for the figures. The design process has by this time evolved to the point that Correggio defines most of the individual figures in pen and ink and wash with greater assurance. As is virtually always the case, he will go on to make myriad changes before the altarpiece is complete.

There are also much more fully worked compositional studies for altarpieces, such as the *Adoration of the Shepherds* in the Fitzwilliam Museum of around 1522 (cat. 22), arguably the most beautiful of all Correggio's surviving drawings. (See also Muzzi and Di Giampaolo 1988, nos 48, 86; and Ekserdjian 1997, fig. 204.) Executed with energetic strokes of red chalk and then reworked with pen and ink, they are given unprecedented luminosity through the liberal application of wash and white heightening. Correggio's drawings in this technique provide the best claim for his innovative genius as a draughtsman. It is noteworthy that however complex and elaborate they may be, they do not usually seem to be the final stage of design, except in the instance of the Metropolitan Museum study for the San Francesco *Annunciation* (cat. 25).

Lastly, there are a number of drawings for individual figures or groups, and, as is true of his frescoes, they consist of various types. The pen and ink and wash study for the upper section of the *Madonna of Saint George* (cat. 33), drawn in the second half of the 1520s, shows this detail almost precisely as it will appear in the altarpiece. By contrast, there are other much more exploratory studies such as the red chalk drawing of Christ in the British Museum (cat. 24), an early idea for the painting at Apsley House of the *Agony in the Garden* datable to the beginning of the 1520s. In some instances preliminary studies show the extent of overlap or re-use of motifs between two projects. A case in point is the drawing of angels in the collection of Rugby School (Muzzi and Di Giampaolo 1988, no. 87), where two of the angels were used for the *Madonna della Scodella* and the third for the *Assumption* fresco in the cathedral. Another example of this practice is the angel in cat. 32 whose pose was re-used for a figure in the painting of the *Abduction of Ganymede* (Kunsthistorisches Museum, Vienna).

Correggio's drawings for his late mythological paintings follow along similar lines. In some instances they display a lightness of touch characteristic of his later drawings. Among the most remarkable is the *Sleeping woman* at Windsor (cat. 34), a study for the *Venus, Cupid and a Satyr* in the Louvre of around 1523. This is among the most sensuous and texturally sophisticated figure studies of the Italian Renaissance. Compositional drawings range from the exploratory efforts of the pen drawings for the *Allegory of Virtue* (Muzzi and Di Giampaolo 1988, nos 96–7) to the highly developed sheet of the *Allegory of Vice* in the British Museum (cat. 36). The latter is closely comparable with the Louvre studies for the pendentives of the cathedral in both technique and handling: it displays Correggio's full-blown mastery of his favourite red chalk medium.

An effort to characterize Correggio's accomplishment as a draughtsman is made difficult by the loss of countless drawings and of entire categories. Furthermore, some of his efforts on paper had a purely utilitarian purpose, so that a notational form of handling or simple outline might have been sufficient for him. At the same time, he was among the first and greatest pictorial draughtsmen of the Renaissance, able to suggest effects of light and texture to an unprecedented extent. His most fully worked and innovative studies – such as the Fitzwilliam *Adoration* or the Metropolitan *Annunciation* – are intimate little pictures, as affecting and beautiful as his paintings, and among the finest drawings of the sixteenth century. GG

Parmigianino as a draughtsman

Emerging from the powerful legacy of Correggio, Parmigianino – his artistic heir in the Emilian tradition of design – became one of the most original, influential and technically accomplished artists of early Mannerism. His contemporaries would sum up his artistic contribution above all in terms of the aesthetic quality of *grazia* (grace) in his paintings, as expressed in a late-sixteenth-century sonnet attributed to the Bolognese artist Agostino Carracci.[1] His drawings were also famous for precisely this quality. According to Lodovico Dolce's *Dialoghi* (Venice, 1557), '[Parmigianino] gave his creations a certain loveliness which makes whoever looks at them fall in love with them. [He was] so delicate and accurate in his draughtsmanship that every drawing of his that is preserved on paper brings astonishment to the eyes of the beholder.'[2] As his early biographers also often pointed out, Parmigianino died young, at the age of thirty-seven. His likeness, both as an adolescent and as a mature man, is well recorded in his paintings and drawings (fig. 4; cats 49, 115 and 130). No sixteenth-century artist – apart from Albrecht Dürer – would portray himself as frequently as did Parmigianino.

To judge from his surviving drawings, Parmigianino seems, after Leonardo, to have been the most prolific and fluent Italian draughtsman of the sixteenth century. In comparison with the seventy or so paintings by him that are known today, 823 sheets of autograph drawings were catalogued by A.E. Popham in 1971, and since then an abundance of further discoveries has brought this number close to one thousand (Ekserdjian 1999). Yet despite the vast corpus of surviving drawings by the artist, there are also great *lacunae* in his oeuvre (as will be discussed), as some of his working methods were destructive. From such data it is nevertheless evident that Parmigianino's drawings provide an indispensable tool for an understanding of his artistic contribution and his pioneering role within Mannerism. The selection of ninety-eight drawings in the present exhibition is representative of his extant design types (executed in a greater range of media than was common among many of his contemporaries), and includes preparatory studies for all his major projects.

The chronology of Parmigianino's early work (before his trip to Rome around 1524) is especially unclear, and his complex artistic origins therefore require some comment. Girolamo Francesco Maria Mazzola, nicknamed 'Parmigia-nino' when he left his birthplace of Parma, was born on 11 January 1503, and was trained as a painter by his uncles Michele and Pier'Ilario Mazzola, following the death of his father in 1505. The young artist stayed briefly in Viadana (north-east of Parma) in 1521–2, accompanied by his older cousin, Girolamo Mazzola Bedoli (*c.*1500–69), whose own style as a painter and draughtsman was from the outset closely modelled on that of Parmigianino. Only a few paintings survive from this initial phase of Parmigianino's life, chiefly the altarpieces: the *Baptism of Christ* (Gemäldegalerie, Berlin), painted at the age of sixteen, and the *Mystic Marriage of Saint Catherine* (Santa Maria, Bardi), executed around 1521–2 for San Pietro in Viadana.

Popham identified 146 sheets of early (i.e. pre-Roman) drawings by Parmigianino, and this number has recently been increased by about twenty (Ekserdjian 1999). The handful of pen and ink studies that can be grouped stylistically around the time of the San Pietro altarpiece display animated, reinforced outlines with a sparse use of modelling in patches of wash or of somewhat stiff hatching and cross-hatching (Popham, *Parm.*, pls 1–2 and 4). In sketches, whether in pen or chalk, his distinctive, highly expressive way of abbreviating the figure seems already fully formed by 1522 (the date of his return to Parma), and would vary little until his Roman period. It consists of small oval heads (with delicate, pointy feminine features low on the circumference of the head or large, chiselled masculine ones), on somewhat awkwardly jointed, long-limbed bodies of oddly swelling musculature. Examples are cats 42–3, probably related to chapel frescoes in San Giovanni Evangelista. Often the faces of male figures border on the caricatural.

The paths of Correggio and Parmigianino seem to have crossed at two points during their work on separate projects in Parma. (As Cecil Gould commented, Parmigianino seems to have absented himself from the city precisely during the periods when Correggio's star shone most brightly.) These involved fresco cycles at San Giovanni Evangelista between July 1520 and January 1524, and at Parma cathedral around November–December 1522. Both Michelangelo Anselmi (1491/2–1554/6) and Francesco Maria Rondani (1490–1550), who likewise mined the Correggesque vocabulary in both their drawings and paintings, were also at work there. Rondani was

Fig. 4. Parmigianino, *Self-Portrait*, pen and brown ink over traces of black chalk, 109 × 118 mm. Ornamental frame and inscription (red chalk) by Giorgio Vasari, 264 × 181 mm. Graphische Sammlung Albertina, Vienna, inv. 2623.

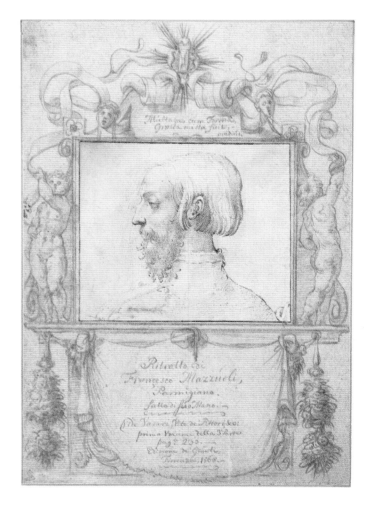

probably Correggio's assistant at Parma cathedral. Sometime in 1520–2 the young Parmigianino may have acted as Correggio's assistant as well, for, as has been proposed, a putto frescoed on the right corner of Correggio's pendentive of Saints Matthew and Jerome (fig. 10), below the dome in San Giovanni Evangelista, seems to be by Parmigianino.[3]

More evidence for Parmigianino's access to Correggio's work is found in the double-sided sheet of drawings in red chalk in the Ashmolean (cat. 37), which copies some saints and putti in Correggio's San Giovanni Evangelista dome, but from a lost drawing rather than from the frescoes. Among Parmigianino's further early Correggesque studies in red chalk are the *Diana*, inspired by the master's Camera di San Paolo fresco (cat. 38), as well as the bearded prophet with two putti (cat. 39) and the young Saint John the Evangelist (cat. 40), both of which are evocative of the apostles in the dome of San Giovanni Evangelista. Around 1522, Parmigianino's drawing technique and his figural style in more finished studies also began to reflect those of Correggio. In pen and ink sketches and studies, the young artist now sought a more sculptural definition of tone in his quick articulations of more massive anatomical forms with plump, reinforced contours (cats 39, 41 and 45). Much like Correggio, Parmigianino used natural red chalks (which can range in hue from deep brick-red to slightly orange), applying them by hatching, stumping (rubbing the chalk to blend in strokes) or graining (drawing with the side of the stick for more uniform tone and to exploit the texture of the paper).[4] He often wetted the tip of the chalk for deeper tonal accents, sometimes also adding highlights in white gouache.

Through Correggio, Parmigianino absorbed the contribution of Leonardo and his Lombard followers to the repertoire of Renaissance drawing – especially the technique of *sfumato*, the seamless blurring of tone and outlines 'in the manner of smoke'('*a uso di fumo*', as Leonardo called it in his notes). This Leonardesque-Correggesque legacy is particularly evident in Parmigianino's drawings in natural red and black chalks, and would last throughout his career, as is clear from comparisons of early chalk studies to late ones (cats 44–5, 50, 55, 57, 121 and 129).

Parmigianino's use of natural chalks combined with pastels, as in his exquisite full-scale drawing at the Albertina for the Christ Child's head in the *Madonna of Saint Jerome* (figs 5

and 36; Popham, *Parm.*, no. 610) from around 1527, is another aspect of the Leonardesque tradition in Lombardy that he may have learned from Correggio.[5] (Although no pastel drawings by Correggio are known, early written sources suggest his mastery of the medium.) Other specifically Correggesque techniques in Parmigianino's drawings are his use of a pink-tinted ground for some studies (cat. 42), and the reworking of spirited underdrawings in red chalk with pen, brown ink and wash (cats 46 recto and 77). This combination of pen and ink over red chalk was deliberately emulated by the Carracci much later in the century. In contrast to most sixteenth-century Tuscan and Roman artists, Correggio and Parmigianino also frequently relied on the medium of red chalk alone for quick sketches (as well as for refined studies), a technique that would also later be revived by Baroque draughtsmen.

Dating around 1523–4, the few compositional drawings associated with Parmigianino's most important early project, the frescoes in the Rocca Sanvitale at Fontanellato, north-west

of Parma (figs 25–6), are not complete enough as a sequence to offer an understanding of his design process at this point in his career. It is difficult to identify with certainty the initial ideas for the frescoes, or the intended placement of many motifs within the small chamber (Popham, *Parm.*, pls 29–30), and few studies for the main figures in the lunettes are extant. The sheet in the Morgan Library (cat. 46) is perhaps the most significant to be connected with the fresco cycle. Parmigianino often combined drawings for different projects on the same sheet, as in cat. 47, which includes preliminary ideas for selected motifs in the Fontanellato frescoes and for a portrait of Galeazzo Sanvitale (figs 25–7), the patron of that decoration. This tendency toward an imaginative amalgamation of unrelated projects on the same sheet would also be typical of many of his later drawings (see, for example, cat. 115).

Parmigianino's career took a crucial turn between 1524 and 1527, during his sojourn in Rome. As Giorgio Vasari's *Lives of the Most Eminent Artists* describes, the young artist probably arrived in the city in 1524, accompanied by one of his uncles, because he especially wished to see at first hand the masterpieces by Michelangelo and Raphael (cats 58–9). Michelangelo was alive (although working primarily in Florence), but Raphael had died in 1520. Parmigianino's interest in both these artists, however, had stirred for some time before his Roman trip (again probably through the influence of Correggio), as is evident in his Michelangelesque studies in cat. 43 and in his early partial copy after Marcantonio Raimondi's reproductive engraving of Raphael's *Poetry* fresco on the vault of the Stanza della Segnatura (Vatican Palace; Popham, *Parm.*, pl. 16). According to Lodovico Dolce's *Dialoghi* (Venice, 1557), Parmigianino and Raphael 'were seen to be alike in intellect and habits'. Vasari famously stated that in Rome 'it was said that the spirit of Raphael had passed into Parmigianino's body'.[6]

Although apparently productive (Vasari states that he executed many small paintings or *quadretti*), Parmigianino's Roman years are sparsely documented. The young artist met Rosso, as well as the members of Raphael's workshop – Perino del Vaga, Polidoro da Caravaggio and possibly also Giulio Romano (before his departure to Mantua in October 1524) – with whom he also shared a number of patrons. Again according to Vasari, the talented twenty-year-old artist

impressed the papal datary Matteo Giberti (a major patron of Giulio), and through him the Medici pope Clement VII, who wished to give him work in the great Sala dei Pontefici (Vatican Palace), the vault of which had already been decorated in fresco and stucco by Giovanni da Udine and Perino del Vaga. Nothing came of the project. Popham speculated that the three compositional drawings of the *Martyrdom of Saint Paul* (the most finished of which is here exhibited as cat. 75) were originally intended for a scene in the Sala dei Pontefici, but this idea has been refuted, especially on iconographic grounds.[7] The composition of Parmigianino's *Martyrdom of Saint Paul* was reproduced in somewhat different versions in an engraving by Giovanni Jacopo Caraglio (fig. 31), and later while Parmigianino was in Bologna in a woodcut by Antonio da Trento (Bartsch XII.79.28). Another composition possibly first begun as an idea for a painting is the *Betrothal of the Virgin* (cats 76–7), which was inspired by Rosso's altarpiece in the Ginori chapel at San Lorenzo, Florence, and which Caraglio also later engraved (fig. 32).

The profitable collaboration between artists and reproductive printmakers surely did not escape the notice of the young newcomer, as he looked to establish his artistic reputation in the extremely competitive art market of the eternal city (cats 75–8). Raphael, Giulio, Rosso and, to a lesser extent, Baldassare Peruzzi and Perino del Vaga had all cultivated the circle of reproductive printmakers in Rome as a means of disseminating their inventions. Parmigianino's finished drawing of the *Martyrdom of Saint Paul* (cat. 75) has stylus-incised outlines and its design is reversed, suggesting that it was the model for Caraglio's engraving (fig. 31).

The invasion of Italy by the troops of the emperor Charles V culminated in the traumatic Sack of Rome in May 1527, which put Parmigianino's life in acute danger and brought his career in the city to an abrupt end, although, as Vasari's biography notes, not before the artist saved his own skin by giving 'an infinite number of drawings in wash and pen and ink' to the German soldiers. He fled to Bologna, where he remained from 1527 to 1530, and where he continued his fruitful, if not always peaceful, association with reproductive printmakers. In Bologna, he also explored more fully the medium of etching, of which he was a pioneering practitioner in Italy (figs 29 and 34).

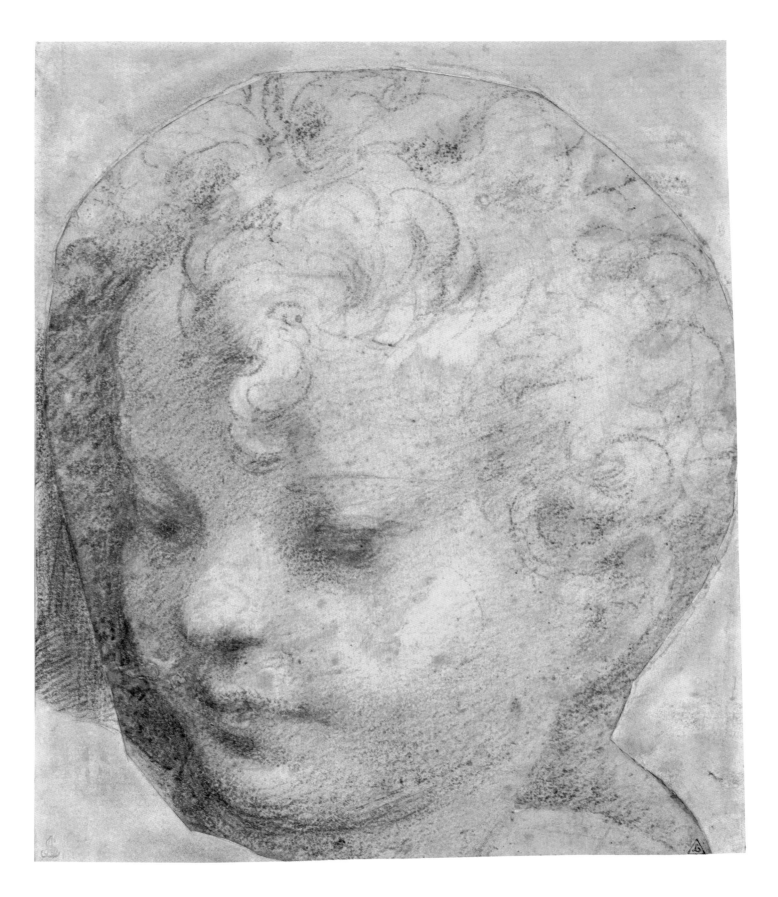

The stylistic distinction between drawings that Parmigianino produced in Rome and those he did in Bologna is not always clear (the period in question is about six years long), and it thus seems valid to discuss them broadly as a group. Among the new qualities of his work during this time are a greater monumentality in the figures, and a more sophisticated approach to narrative and to the arrangement of pictorial space (see cats 63–4, 73, 75 and 81). Parmigianino drew prolifically and with great fluency, draft after draft of each compositional idea. His preferred medium seems to have been pen and brown ink (iron gall) with washes, often highlighted with white gouache (lead white) – which he applied very thinly, in great contrast to Correggio's heightening technique – over a sparing underdrawing in black chalk, leadpoint, or charcoal.[8] Sometimes, however, he relied on the uninked pen or stylus to jot down a quick preliminary underdrawing, or improvised sketches without any under-drawing. To judge from the numbers of related drawings, a sequence of designs on a theme, along with variants of individual motifs inspired by the composition, offered seemingly inexhaustible possibilities. More than twenty sheets studying the subject of the Adoration of the Shepherds (cats 79–81) can be identified, and his copious Madonna and Child compositions recall Raphael in their facility of invention (cats 61 and 101–2).

Nearly thirty preparatory sheets can also be connected with the *Madonna of Saint Jerome* altarpiece (National Gallery, London; cats 88–93), which Maria Bufalini commissioned from him on 3 January 1526 for her deceased husband's family chapel in San Salvatore in Lauro, Rome (fig. 35). This would be Parmigianino's only major Roman painting, but it was never installed in its intended setting as the artist abandoned it in his studio when he deserted the city for Bologna in 1527. The drawings are by and large fairly rough sketches. The drafts and partial drafts of figures for the altarpiece explore diverse compositional solutions in quick succession. In their seemingly effortless inventiveness and technical virtuosity, these drawings confirm Parmigianino's place among the very greatest Italian draughtsmen of any age. Only two highly rendered studies exist, one for the figural group of the Madonna and Child and another large full-scale pastel drawing for the Christ Child's head, both in the Albertina (fig. 5; Popham, *Parm.*, pl. 100). With the *Madonna of Saint Jerome* (which pays homage to and competes with Raphael's *Sistine Madonna*, as is clearest in cat. 90), Parmigianino had emerged as much more than simply Raphael reborn.

In Rome, the compositional drawing methods of Raphael and members of his workshop, and the finished paintings themselves, probably led Parmigianino to rethink his entire approach to the preliminary design process. His practice would now more closely resemble the Central Italian model described in the introduction of Vasari's *Lives* (1550 and 1568), if with a greater range of intermediate drafts at the sketching stage. The artist derived his sketches (*schizzi*) from his imagination, tracing the forms with rapid, spidery strokes and blotches of wash, 'in order to find the manner of the poses, and the first idea for the work', as Vasari explained. (Pen and ink sketches are by far the most abundant drawing type extant by Parmigianino.) His virtuoso handling of the pen vividly evokes the sublime '*furore* of artistic inspiration' that was so prized by Vasari and other sixteenth-century art theorists. The English eighteenth-century painter Sir Joshua Reynolds would praise the sketches of Parmigianino (and Correggio) for a similar reason in his eleventh *Discourse* (London, 1797).

In composition and figure sketches Parmigianino often drew the figures nude, probably in order to gauge their overall proportions and anatomical correctness (cat. 122). But like many Mannerist artists of his generation (except Pontormo), he does not seem to have done many closely observed studies after the nude live model in preparation for his paintings. Among the life studies are cats 67–8. Other such sheets, drawn with raw expressiveness, include studies of a nude man awkwardly leaning his body's weight on a posing stick, and a nude bony woman unselfconsciously sprawled on a bed (Popham, *Parm.*, pls 285–6). By contrast, several larger-scale life studies of heads of great delicacy and beauty survive (cats 48 and 128). Rendered on prepared grey paper with white gouache highlights, the exquisite head of the young woman looking down (cat. 62) appears to be the only extant drawing in the medium of metalpoint produced by Parmigianino in Rome. His experimentation with this technique may well have been inspired by Raphael's delicate metalpoint studies of his Roman years, such as the famous example from 1513–16 now at Chatsworth, portraying a seated young woman reading with

a child standing by her side.[9] More scientific studies of the human figure by Parmigianino are also extant, but these are extremely rare: a finished Leonardesque portrayal of an upturned skull, *écorché* studies of legs, as well as measured drawings of the proportions of a standing nude man and of the human foot, the latter in a Leonardesque plan and elevation technique (Popham, *Parm.*, pls 72, 282 and 352). Parmigianino apparently relied on cast models to investigate the poses of figures (cats 38 verso and 118), much as Correggio is known to have done to design the foreshortened apostles on the dome of San Giovanni Evangelista. (Although still a relative novelty in the early 1520s, this practice would become extremely common later in the century, as Vasari's *Lives* attests.) The artist, however, may have produced relatively few *modelli* (small-scale composition drawings) with squaring grids, which served for the proportional enlargement of a design on to another working surface (Popham, *Parm.*, pls 256, 334, 340 and 349).

In Rome, Parmigianino seems to have begun to use watercolour on his more finished pen and ink drawings (cat. 60), probably stimulated in this by his contact with members of Raphael's workshop, particularly Giovanni da Udine, who employed the technique for naturalistic animal studies and playful *grotteschi* ornament. As a whole, Parmigianino's contribution to the tradition of drawing in colour has received less attention than it deserves.[10] There are, in fact, more coloured drawings by him than by any other Emilian artist, and his use of pastels and coloured natural chalks was a noteworthy innovation. He was also among the earliest sixteenth-century artists outside Venice to explore the tonal possibilities of drawing on blue paper (*carta azzurra*), a medium that is often associated with North Italian draughtsmen (particularly from Venice), and that he began to use probably shortly before going to Rome around 1524.[11] Cat. 65 is a vigorous example from the Roman period. An unusually pictorial treatment – nearly Venetian in mood – is seen in the late study, softly rendered in black chalk with white chalk highlights, for the *Madonna with Saints Stephen and John the Baptist* (cat. 129), the altarpiece painted for Santo Stefano, Parma, in 1540 (fig. 45; Gemäldegalerie, Dresden). Parmigianino had gone to Venice to buy pigments in 1530–1.

Described in detail in Vasari's *Lives*, the preparation of cartoons (*cartoni*) – drawings in the full scale of the final painting – was frequently the last step in the process of preliminary design in Central Italian sixteenth-century practice. The extent to which Parmigianino relied on cartoons, however, is not clear. This drawing type is extremely rare in his surviving oeuvre. Most of the evidence dates from the 1520s and later. Although his Steccata frescoes reveal signs of transfer, and the repetition of decorative motifs there must imply use of cartoons, the few examinations of his easel paintings with infrared reflectography yield ambiguous results regarding his underdrawing techniques because of the thickly applied pigment layer on top.[12] Cat. 65 is a cartoon for a small composition, possibly a small devotional panel painted in Rome (1524–7). The outlines of the drawing were pricked for transfer on to the working surface by rubbing charcoal dust through the holes (the technique of pouncing, or *spolvero*). Cat. 99 is a cartoon for the large-scale design of a bishop saint in prayer, from Parmigianino's years in Bologna (1527–30). Its outlines were probably incised with a stylus for transfer on to the working surface (the *calco* technique).

Parmigianino produced a number of drawing types that fall outside the scheme of preliminary design posited in the introduction to Vasari's *Lives*. Like a few artists of his day (notably Michelangelo), he made large, carefully finished drawings – in pen and ink, rather than the chalk that Michelangelo favoured for such drawings – that seem to have been an end in themselves, a type often called 'presentation drawings' by art historians. Three such late pen and ink drawings are the victorious *David holding the head of Goliath*, the Apollonian *Standard-bearer*, and the erotic *Priapus and Lotis* (cats 132–4). This group also includes life drawings of bust-length figures (cats 96 and 126). Admiration for the art of engraving may well have stimulated Parmigianino's graphic manner of meticulous pen hatching and cross-hatching. His scenes inspired by everyday life from the late 1520s to the late 1530s, many of them drawn softly in red chalk, are brilliantly innovative. Not until the Carracci in Bologna, much later in the century, would artists again succeed in evoking the mood of quiet intimacy that characterizes his genre studies. Here, examples are the seated man removing a shoe (cat. 71), the head of a girl (cat. 62), the woman nursing a child (cat. 70), the seated woman sleeping (cat. 72) and the man holding a

pregnant bitch (cat. 130). In the naturalistic tradition of Lombard art, Parmigianino also produced a sizeable number of individual animal studies throughout his career (Popham, *Parm.*, pls 36, 79, 175, 304–6, 318, 443–4 and 446). Some of his Roman figural compositions set in pastoral landscapes project the nostalgic mood of classical bucolic poetry (Popham, *Parm.*, pls 297–8, 303). There are very few extant independent landscape studies by Parmigianino as this type of drawing was not widely practised by Central Italian artists of his generation. An important early instance is cat. 53.

In 1530 Parmigianino resettled in Parma, where he was to remain until 1539. Increasingly during the 1530s, it seems, a psychological inability to focus on the task of actually painting the final work led him to produce instead a surfeit of preliminary drawings. The contract to decorate the apse and eastern barrel vault of Santa Maria della Steccata secured what appeared to be the most prestigious project of his career, but soon his relationship with his conservative patrons deteriorated into vicious disputes as Parmigianino indulged the passion for alchemy which, according to Vasari, proved his mental and financial undoing. The contract of 10 May 1531 for the Steccata frescoes obliged the artist to finish them in eighteen months, and to follow a demonstration drawing in colour for the decoration of the apse with a *Coronation of the Virgin* and for the barrel vault with gilded coffering. The drawing that was mentioned had received prior approval from the church administrators (*fabbricieri*).[13] The Chatsworth fragment in watercolour for the *canephori* or virgins (cat. 105) offers a very similar arrangement of figures to that in the final fresco, and may thus be a draft for a revised contractual drawing. Formal contractual drawings by Parmigianino, however, are a category of design that seems extremely difficult to identify.

In contrast to the paucity of extant cartoons by Parmigianino, the surfaces of his frescoes at Santa Maria della Steccata reveal extensive evidence of stylus incisions from the transfer of cartoons. The incised outlines on the frescoed figures of the *canephori*, or virgins, are relatively descriptive,[14] suggesting that the cartoons must have been detailed. These full-scale drawings, however, were presumably destroyed in the working process, for in order to transfer cartoons they were cut into manoeuvrable sections, and the tracing of the outlines

with a stylus often tore through the paper. The monochrome figures of Moses, Aaron, Adam and Eve on the soffits (undersides of the arches) of the vault were transferred by means of squaring grids, which were directly incised on to the fresco surface[15] from squared *modelli* (rather than from full-scale cartoons). Only small-scale drawings for these figures survive (cat. 114).

The vast number of extant drawings for the Steccata can hardly be an accident of survival: a little over one hundred sheets have come to light. Popham published six sheets of sketches for the *Coronation of the Virgin* fresco on the eastern apse (cats 116–17). The production of a few such scattered studies may have been all that the artist did, before that part of the project was taken away from him. When the *fabbricieri* of the Steccata lost patience with the dilatory artist, they turned to the busy Giulio Romano in nearby Mantua who in the end only managed to provide a small compositional drawing, rather than the cartoon fragments that he had been requested; they finally settled on Michelangelo Anselmi for the job, a few months before Parmigianino's death. The *Coronation of the Virgin* frescoed in 1540–7 by Anselmi bears a closer resemblance to the composition seen in Parmigianino's spirited pen and ink with wash sketch in Parma than is sometimes conceded by art historians (Popham, *Parm.*, pl. 309). The extant letters and documents on the Steccata apse frescoes offer a fascinating record of the arguments, pleas and accusations involving the *fabbricieri*, Parmigianino, Giulio Romano and Anselmi (Testi 1922).

The remaining ninety-seven sheets for the project relate to the decoration of the barrel vault. Both the steep curvature of the vault, and the fact that the moulded gilded coffering with rosettes (*rosoni*) was already in place, must have posed a daunting challenge in projecting a framework of figures. The physical constraints of the architecture thus partly explain the extensive production of drawings. A reason for their survival emerges from the legal context of the commission. Cavaliere Francesco Baiardo, who is remembered today as the principal early collector of Parmigianino's drawings, paid a considerable surety on the second contract for the Steccata project on 27 September 1535, drafted when Parmigianino failed to deliver on the original contract of 1531. On the artist's death, Baiardo and the other co-guarantor (the architect Damiano de Pleta)

were legally bound to pay for the unfinished work,[16] and as such Baiardo probably received title to Parmigianino's drawings and many of his paintings. The inventory of Baiardo's possessions, drafted at the time of his death on 30 September 1561, lists a great quantity of drawings by Parmigianino (557 sheets, according to Popham), which were inherited by Baiardo's grandson, Cavaliere Marc'Antonio Cavalca, whose collection Vasari saw in 1566 when he visited Parma.

Parmigianino's fresco cycle in the Steccata was incomplete at his death, after nearly a decade of preparatory work, for little had actually been designed and painted beyond the barrel vault. Tensions with the *fabbricieri* climaxed in 1539, with Parmigianino being thrown into prison by his disgruntled patrons. According to Vasari, the enraged artist even began to destroy a portion of the executed frescoes after his release. His illegal actions again brought the threat of imprisonment, and the artist escaped to Casalmaggiore, where he died on 24 August 1540.

While at work on the Steccata frescoes, Parmigianino also produced one of his last great sequences of studies for a painting, the *Madonna of the Long Neck* (fig. 43; Uffizi, Florence), commissioned on 23 December 1534 by Elena (Tagliaferri) Baiardo for her deceased husband's family chapel in Santa Maria dei Servi, Parma, and for which nearly fifty preparatory studies are extant (cats 119–22). The altarpiece would also remain unfinished at his death. The artist's superbly graceful figural vocabulary – which led later Italian art theorists to coin the admiring term '*imparmiginare*' to describe elegance and delicacy[17] – culminated in the *Madonna of the Long Neck* and the *canephori* on the Steccata vault, where he perfected a canon of sublimely elongated bodily proportions.

Vasari praised Parmigianino's portrayals of the human figure for their qualities of *venustà*, *dolcezza* and *leggiadria* (beauty, sweetness, and grace), and also collected some of his drawings in his *Libro de' disegni*. Parmigianino's style would inspire numerous Italian artists, including Francesco Salviati, the Campi family, Andrea Schiavone and Jacopo Bertoia. And, through the work of Niccolò dell'Abate and Francesco Primaticcio in the 1530s to 1560s, he would help to shape the refined graphic production of the School of Fontainebleau in France. The known copies and reproductive prints after his drawings suggest the extent to which his work was influential for graphic artists. By the second half of the sixteenth century his reputation had spread widely across Europe, as his paintings, drawings and prints were avidly collected in the princely and royal courts, and as his work was increasingly reproduced by Italian and foreign printmakers. In looking at Parmigianino's drawings today, we are struck by the immediacy with which they communicate his vibrant powers of invention and technical skill, and – to quote Sir Joshua Reynolds's words on the artist in 1797 – 'we are here at a loss which to admire most, the correctness of drawing, or the grandeur of the conception'.

CCB

NOTES

1 Dempsey 1977, p. 61; and Emison 1991.
2 The quotations of Dolce's *Dialoghi* that follow are from Roskill 1968, pp. 181–3.
3 Gould 1994, pp. 14, 29, fig. 14; and Ekserdjian 1996.
4 I am indebted to Marjorie Shelley, Paper Conservator at the Metropolitan Museum of Art, for her insightful technical examination of Parmigianino's red chalk drawings.
5 Popham, *Parm.*, no. 610. The medium given by Popham for the drawing is incorrect; it should read soft black chalk or charcoal, natural red and white chalk, and pastel. I am grateful to Elisabeth Thobois, Paper Conservator at the Graphische Sammlung Albertina, for confirming the medium.
6 The quotations of Vasari's *Lives* that follow are from Vasari-Milanesi V, pp. 217–38.
7 Quednau 1979, p. 638, n. 562; Wolk 1987, pp. 123–5, n. 107.
8 Based on examination with infrared reflectography and ultraviolet light conducted by Marjorie Shelley.
9 Illustrated in London 1983, no. 137.
10 A foundation is offered in McGrath 1994; McGrath 1997, pp. 22–30; Washington and Parma 1984, pp. 36–42.
11 See example published in Ekserdjian 1999, no. 18, figs 23–4.
12 Examination of paintings by Parmigianino in the Uffizi and the Pinacoteca Nazionale di Bologna was conducted by Maurizio Seracini (Editech, Florence).
13 Transcription of contract in Testi 1922, p. 265.
14 Illustrated in Adorni 1982, pp. 108–9, 114–15 and 150.
15 Illustrated in Rossi 1980, pl. LV; and Adorni 1982, pp. 110, 112.
16 Popham 1967, p. 27.
17 Shearman 1986; Vaccaro 1998.

The collecting of Correggio's and Parmigianino's drawings in Britain and America

Roughly ten times more drawings survive by Parmigianino than by Correggio. Because of their essentially utilitarian nature Correggio's drawings seem never to have been prized in quite the same way as those by Parmigianino: they may have been collected primarily as the relics of a great painter, whereas Parmigianino's have always been sought after as exemplars of fine draughtsmanship, and this must have affected their survival rate. The theft of Parmigianino's drawings and etching plates by Antonio da Trento in Bologna (see p. 116) could perhaps have befallen any artist, but the purchase in 1538 by the Venetian sculptor Alessandro Vittoria (1525?–1608) of 'un libretto disegnato di man del Parmigianino' is evidence of a wide renown as a draughtsman even within his short lifetime.

While there was no large group of drawings by Correggio recorded after his death, we have in the posthumous inventory of the Cavaliere Francesco Baiardo (d. 1561) the most detailed description of a sixteenth-century collection of drawings known to us. Baiardo was Parmigianino's protector and patron, and the 557 sheets by Parmigianino listed in this inventory are thus likely to have been autograph; the drawings may have been acquired from Parmigianino's estate as a consequence of Baiardo having stood surety for the artist in his broken contract for the Steccata (see cats 103–17). The artist and historian Giorgio Vasari (1511–74) saw Baiardo's collection in 1566 but its subsequent fate is unknown; although the drawings were described in some detail, only a handful can be identified today and the majority must have been lost.

Other references to drawings by the two artists in the sixteenth and early seventeenth centuries are less illuminating. Vasari himself owned several drawings that he believed to be by Correggio and 'molte carte' by Parmigianino, including a *Martyrdom of Saint Paul* perhaps identifiable as cat. 75. Cardinal Alessandro Farnese's Roman *studiolo* (small study room) contained in 1588 drawings by Parmigianino, Correggio and Raphael; the inclusion of Correggio and Parmigianino may be due to the close connection of the Farnese with Parma. Likewise the Este at Modena, who stamped their collector's mark probably during the seventeenth century on drawings by both Correggio and Parmigianino (most of which are now in the Louvre), may have owed their interest in the former's drawings to their avid collecting of his paintings.

By the seventeenth century the most eager collectors of Parmigianino's drawings were English, and given the nature of the present exhibition it is on England that this essay will mostly dwell. A crucial event in this development may have been the tour of Italy in 1613 by Thomas Howard, 2nd Earl of Arundel (1585–1646), in the company of the architect Inigo Jones (c. 1573–1652). Jones was fascinated by Parmigianino, copying his works and collecting his prints and modelling his drawing style partly on the Renaissance artist's example, and he seems to have been instrumental in encouraging Arundel to form his magnificent collection of drawings, in which Parmigianino figured strongly. We do not know what drawings Arundel may have acquired in person on this tour, and the drawings that came to England in succeeding decades for Arundel and for other collectors who followed his example were in general bought in Italy by agents acting on their behalf. Arundel did not stamp or inscribe the drawings in his collection to indicate his ownership, and with varying reliability this must be established either from subsequent tradition – in later sale catalogues and the inscriptions on reproductive prints made after such drawings (and it is clear that an Arundel provenance was considered valuable) – or from the existence of a drawn or etched copy by one of Arundel's protégés, Lucas Vorsterman, Wenceslaus Hollar or Hendrick van der Borcht. These copies form a fascinating episode in the history of taste in England and demonstrate that the drawings of Parmigianino, in particular, were revered almost as academies of design in themselves.

The collections of Arundel's contemporaries are harder to define. A.E. Popham (in 1957 and 1971) catalogued two drawings by Correggio and eighteen by Parmigianino marked with the star stamps supposedly of the musician and dealer Nicholas Lanier (1588–1666), who is known to have acted as an agent for King Charles I (1600–49) in the purchase of paintings. Of the drawings collection of the king himself it is difficult to say anything with certainty. A royal inventory of 1735 lists three small albums of drawings supposedly by Parmigianino as from Charles I's collection, but as this was drawn up almost a century after the king's death it cannot be taken as entirely reliable. 'Four small Pocket Books of Drawings by Parmegiano' were listed in the Royal Library around 1810 (without mention of their earlier provenance); the bindings of

three of these survive at Windsor, and the contents of all four can be identified with some confidence. Volume I contained copies by an artist (or artists) of Arundel's circle after Parmigianino's drawings, and the price-mark of the dealer William Gibson (1644/5–1702?) inscribed inside the cover. Volume II contained a series of metalpoint drawings by an unidentified Netherlandish artist of the late sixteenth century. Volume III was in the collection of Wallerant Vaillant (1623–77) in 1655 and consisted of copies after Parmigianino. Only Volume IV contained drawings by Parmigianino himself, and a number of Arundel-circle copies and etchings after these drawings indicate that they were in the 2nd Earl's collection. In sum, there is no material evidence that Charles I owned any drawings by Parmigianino, and it seems more likely that the three albums listed in 1735 entered the Royal Collection during the reign of Charles II. The fact that all four of the albums listed around 1810 were so small – the largest containing sheets of just 3 × 4 inches (76 × 102 mm) – highlights a notable aspect of Parmigianino's drawings and their subsequent treatment by collectors. While he was capable of designing on a large scale, many of his individual sketches are significantly smaller than was usual in the sixteenth century, and collectors and dealers seem routinely to have cut his sheets into fragments, each bearing a single self-contained composition on the recto. The sheet of studies for Moses and Eve in the Steccata (cat. 114) is a rare survival; more typical of the fate of Parmigianino's drawings are the fragments of similar sheets for the Steccata (cats 107–13), and the placement of Nicholas Lanier's stamp on cats 107–9 indicates that this mutilation had taken place by the mid-seventeenth century.

Arundel went into exile on the Continent in 1642 and took some of his collection with him, but large parts of this apparently remained together for many years after his death, passing through the hands of his widow (d. 1654), his son William, Viscount Stafford (d. 1680) and his grandson Henry, Earl of Stafford (d. 1719). At the subsequent sale in 1720, the Venetian artist and collector Antonio Maria Zanetti (1680–1767) claimed to have acquired around 130 drawings by Parmigianino (see cats 60, 63, 87, 89, 119 and 122), some of which he reproduced in chiaroscuro woodcuts; this was not the full extent of Arundel's holdings and some sheets must have been bought by collectors other than Zanetti or have left

the Arundel collection earlier. But with one possible exception, Arundel's drawings were not the source of the next great collection to be assembled in England, that of Sir Peter Lely (1618–80), who owned over a hundred drawings by Parmigianino and over a dozen by Correggio that can be identified today.

How Lely acquired such huge quantities of drawings is not known in detail, though he presumably benefited from the dispersals that followed the English Civil War. There must have been a good supply of drawings on the market for decades after, for although Lely's posthumous sale in 1688 released a flood of drawings back into circulation (the 8th Earl of Pembroke, for example, acquiring eight Correggios from that source, including cats 3, 6 and 22), the collection of Jonathan Richardson Sr (1665–1745) included at least sixty-seven drawings by Parmigianino and fourteen by Correggio, of which only ten and four respectively were from Lely. It is not easy to gauge how highly the drawings of Parmigianino and Correggio were esteemed relative to those of other Italian artists at this time: Parmigianino was never again the subject of the adulation that he received from Arundel, but Correggio's drawing for the *Notte* (cat. 22) was valued by the dealer Gibson at £5, a huge sum and one of the highest known estimations of any drawing that passed through his hands.

Both William, 2nd Duke of Devonshire (1665–1729), and Richardson Sr profited from the arrival in England and subsequent dispersal of the extensive collection of drawings assembled by Padre Sebastiano Resta (1635–1714), a Milanese cleric with a particular fondness for Correggio. Resta's collection was mounted in over thirty volumes which cumulatively demonstrated, with the help of accompanying critical notes inscribed on the album sheets, the development of drawing in Italy. No fewer than three of these albums were devoted to Correggio, with a further one given over to works by his predecessors and followers. The bulk of Resta's collection was acquired by agents in Italy acting for Lord Somers in two tranches in 1710 and around 1712–14, but the albums were soon broken up at Somers' posthumous sale in 1717. Resta's fallibility as a connoisseur of drawings is now well established, but even so it is surprising, given the strength of his admiration for Correggio, that only a handful of drawings unquestionably from his collection are still considered to be by the artist (Muzzi

and Di Giampaolo 1988, nos 17 and 31, and Ekserdjian 1997, fig. 245).[1] Even if a sizeable number of Resta's drawings have not survived, the paucity of autograph Correggio drawings from his collection indicates their rarity in Italy even by the second half of the seventeenth century. Partly as a consequence of this, Resta evidently found it difficult to distinguish the few genuine Correggios from the many later copies and imitations in his collection. In this he was not alone among seventeenth-century connoisseurs, and even Peter Paul Rubens (1577–1640), whose knowledge and admiration of the Parmese artist was founded on his study of paintings in the Gonzaga collection while he was court artist in Mantua, believed that a Correggesque study of a young man in his collection, now in the British Museum, by the youthful Annibale Carracci was by Correggio.[2]

The impact of the Somers sale on the connoisseurship of Correggio's drawings in England cannot have been negligible. Resta was a respected authority on drawings, and his acceptance of so many dubious Correggios must have blurred the distinction between the rarely seen genuine article (many of which had come to England in the preceding century) and the large number of later copies circulating in the market. The demand for Correggio drawings was inextricably linked to his enormously high standing as a painter in the eighteenth and early nineteenth centuries. Some idea of his exalted status can be gained from references to him in English literature of the period, his name often associated with an elevated gracefulness of movement or form.[3] (This connection is explicitly stated in the *Annual Register* of 1760: 'among us any action that is singularly graceful is termed Correggiesque'.[4]) The quantity of drawings bearing old, and fallacious, attributions to Correggio bears testament to his popularity, and it is easy to forget that our modern understanding of Correggio as a draughtsman is almost entirely dependent on A.E. Popham's magisterial monograph published in 1957. Some idea of the widespread and long-standing misconception of Correggio's style, even among the most distinguished experts and collectors, can be gained from studying the works attributed to the artist in the Christie's auction held in London in July 1936 of Henry Oppenheimer's collection of drawings, unquestionably the choicest English private collection assembled during the last century. Only three of the nine studies (lots 69–74) in

Oppenheimer's collection are now considered autograph (Muzzi and Di Giampaolo, nos 25 and 62–3), and among the works erroneously ascribed to him in the catalogue is a characteristic drawing by the seventeenth-century painter Giovanni Francesco Barbieri, il Guercino (1591–1666).[5]

As a result of Popham's systematic sifting through the accreted mass of drawings ascribed to Correggio, a number of drawings that had long been considered masterpieces by the artist were rejected from the small corpus of autograph works. Perhaps the most famous of these casualties was an *Adoration of the Shepherds*, with a glittering English provenance stretching back to Lely, which was long thought to be a study for the *Notte* painting now in Dresden (fig. 15 on p. 58).[6] The drawing, acquired by the British Museum from the Woodburn sale in 1860 for the enormous sum of £14 10 shillings (the top price for a work by Correggio in the sale, and astonishingly even more than was paid for Michelangelo's *Epifania* cartoon which now hangs opposite the door of the Prints and Drawings Department in the British Museum), is now generally, albeit not universally, accepted as a work by Giorgio Gandini del Grano (d. 1538), a little-known follower of Correggio. Similar problems of connoisseurship did not affect the collecting of Parmigianino's work to the same degree, as his drawings survived in great numbers and his inimitable style, disseminated by prints made after his studies, ensured that his hand was well known to collectors and dealers.

Although Popham's research on Correggio resulted in a greatly slimmed down vision of the artist's oeuvre, he did add a few hitherto neglected drawings to the corpus. Perhaps the most remarkable of these additions is the early Correggio cartoon in the Pierpont Morgan Library (cat. 1) which had been overlooked, because of its atypical medium and character, when in 1811 it was sold from the collection formed by the 1st Earl Spencer (1708–46). This included a small clutch of autograph drawings by Correggio (cats 9, 10 and 26), but a sizeable number of the eighteen lots attributed to him were almost certainly not by the artist, most likely including the fine early Parmigianino study in the Ashmolean (cat. 37). The Pierpont Morgan drawing (cat. 1), optimistically catalogued in the 1811 Spencer auction as by Leonardo da Vinci, was bought at the sale by William Alexander (1767–1816), the artist and first Keeper of the Department of Prints and Drawings in

the British Museum, and on his death was once again sold as a Leonardo.

The catalogues of other great eighteenth- and nineteenth-century English collections present a similar pattern, with often large numbers of drawings given to Correggio (the cabinet formed by Sir Joshua Reynolds (1723–92) included more than fifty) of which only a fraction can have been autograph. Sir Thomas Lawrence (1769–1830), for example, had a large number of so-called Correggios in his magnificent collection, many of them bearing the marks of his distinguished forebears as painter-collectors: Richardson Sr (1665–1745), Thomas Hudson (1701–79) and Reynolds. Of the selection of fifty of them exhibited in 1836 after Lawrence's death, only nine were included in Popham's monograph. On the other hand, William Young Ottley (1771–1836), one of the finest connoisseurs of the period, was evidently aware of the lack of critical rigour surrounding Correggio, and the catalogue of the 1814 auction of his collection of drawings, many of them acquired during his nine-year sojourn in Italy in the 1790s, included the following observation: 'there are few masters, whose Genuine designs are so rare as those of Correggio; as by far the greater part of those ascribed to him are either made by students from his pictures, or copied from his designs.' This was not, of course, a disinterested statement (such a quality is rarely found in auction catalogues of any age) as it inevitably goes on to claim that the twenty or so Correggio drawings in the sale were all authentic works by the artist. Although this is demonstrably not the case (lot 417, for example, is the early Annibale Carracci study of an angel playing a violin now in the British Museum), the descriptions given in the catalogue show that he did own some fine examples of Correggio's work.[7] As Ottley's drawings frequently bear no distinguishing marks, his ownership has often been overlooked, but scrutiny of the 1814 catalogues reveals that in addition to the two works noted by Popham (cats 7 and 16), he also owned two studies of the ascending Virgin for the Parma cathedral fresco (cat. 28; Muzzi and Di Giampaolo 1988, no. 69), and most probably the marvellous cartoon for the head of an angel for the same commission now in the Ecole des Beaux-Arts, Paris (fig. 2).[8]

The appetite of English eighteenth-and nineteenth-century collectors for Correggio's drawings was no less great than for those by his younger contemporary Parmigianino, but it remained far easier to obtain authentic works by the latter. The majority of the great English collectors of the period, such as the 1st Earl Spencer, the 2nd Duke of Devonshire, Richard Payne Knight (1751–1824), the banker William Esdaile (1758–1837), the painters Richardson Sr, Reynolds and Benjamin West (1738–1820), boasted fine groups of Parmigianino drawings, as the present selection makes clear. The greatest collection was unquestionably that formed by Sir Thomas Lawrence, who had the good fortune (although it was to bankrupt him) to be acquiring at a time when many European collections came on the market due to revolution and war. Lawrence's own refinement as a draughtsman might explain his predilection for Parmigianino, but what is unarguable is his almost unerring eye for quality. Seventeen of the ninety-eight Parmigianino drawings in the present selection were once owned by Lawrence, and they include some of the artist's most celebrated studies (for example, cats 103 and 114). The long tradition of English artist-collectors continued right up to the beginning of the last century when the painter and dealer Charles Fairfax Murray (1849–1919) sold his drawings collection, including a fine group of Parmigianinos (cats 46, 59, 77–8, 95, 101, 118 and 121), to the financier J. Pierpont Morgan (1837–1913) in 1910.

American collecting of Correggio drawings also began with Morgan's acquisition of the Fairfax Murray collection, as it contained the grand cartoon of the head of a woman (cat. 1), which was then considered to be the work of a Lombard master. This was followed with the acquisition at auction in July 1917 by the Metropolitan Museum of two fine examples from the collection formed by the earls of Pembroke (cats 3 and 25). Interestingly, not a single further authentic drawing by Correggio was acquired by an American institution or private collector until after the publication of Popham's book forty years later.

Since that date a further thirteen sheets have been acquired by American collectors or institutions, ranging from major drawings to fragmentary slight sketches. This has resulted from the ambitious growth of several American public and private drawings collections and also from the solid scholarship on the subject by Popham and others who have worked in this area. Several new drawings have emerged

during the last fifty years, most of which have ended up in the United States, which now ranks after England and France in terms of national holdings of the artist.

Parmigianino has also enjoyed an especial popularity with collectors of drawings in the United States. The painter Benjamin West, born in Springfield (Pennsylvania) and first active in Philadelphia, can be counted as the earliest American collector of Renaissance Parmese drawings, although he made his career as a history painter and assembled his art collection in England. West succeeded Sir Joshua Reynolds as President of the Royal Academy of Arts in London, and his acquisitions of Correggio (cat. 11) and Parmigianino (cats 47, 66, 71 and 131) more properly belong to a discussion of English collecting of the period. A sizeable portion of drawings by Correggio and Parmigianino now in the United States was once in English collections: the Pierpont Morgan Library's collection of Parmigianino drawings, the largest outside Europe, is due, for example, to the aforementioned acquisition of twenty-one works by the artist by J. Pierpont Morgan from Fairfax Murray in London in 1910. The same year, the Metropolitan Museum of Art began its collection of Parmigianino's drawings with the acquisition of two early sheets in red chalk: the *Diana* (cat. 38), once owned by the 2nd Earl of Arundel and Sir Joshua Reynolds, and the *Male nude torso* (cat. 41), which was once part of the Spencer collection. Further drawings by the artist continued to be added to the Metropolitan's collection from the 1940s to the 1970s (cats 60, 64, 114 and 124), the most significant of which is the sheet of energetic sketches for the figures of Moses and Eve at the Steccata, originally owned by the Cavaliere Francesco Baiardo (cat. 114). Recent purchases by the Museum include the cartoon for the *Bishop saint in prayer* in 1995 (cat. 99), possibly the only such monumental drawing extant by the artist, and the languid *Mercury* in 1997 (cat. 69), which have brought its holdings to a total of thirteen

sheets by the artist. The group of works acquired in the 1980s by the J. Paul Getty Museum includes studies for some of the major projects of Parmigianino's career, such as the *Madonna of Saint Jerome* (cats 92–3) and the *Madonna of the Long Neck* (cat. 120). American private collectors have also benefited from the dispersal of historic English collections in the last thirty years, most notably the Chatsworth sale in 1984 when the *Woman nursing a child* (cat. 70) and the *Bearded man seen in profile* (cat. 96) were acquired, and at the auction of the Gathorne-Hardy collection, which included two fine early drawings (cats 47 and 53). Four of the Parmigianino drawings owned by American private collectors exhibited here are very recent discoveries (cats 44, 53, 102 and 106). Although drawings by Parmigianino come on to the market regularly, the increasing rarity of the finest examples has led to fierce competition between private collectors and museums, demonstrating that the centuries-old admiration for his unique talent shows no sign of waning. CCB, HC, MC and GG

NOTES
1 For a history of the formation and dispersal of Resta's collection, see Warwick 1996 and 2000. Correggio's study for the decoration of a rib of a vault (cat. 17) and the Del Bono chapel designs (cats 18–19) at Chatsworth were probably also owned by him.
2 British Museum, 1895-9-15-739.
3 Correggio is mentioned by a number of English writers including Laurence Sterne, Thomas Carlyle and Oliver Goldsmith: *Oxford Dictionary of Quotations*, Oxford, New York and Toronto, 1985, pp. 131, 519 and 231. Interestingly, the volume gives no quotations relating to Parmigianino.
4 Taken from the *Oxford English Dictionary*.
5 The drawing, lot 71, is illustrated as pl. 18 in the catalogue.
6 British Museum, 1860-6-16-20. For the attribution to Gandini del Grano see D. De Grazia in Washington and Parma 1984, no. 30.
7 British Museum, 1895-9-15-723 (see Washington and Parma 1984, no. 34).
8 Muzzi and Di Giampaolo 1988, no. 70. Ottley believed it to be for the head of the ascending Virgin.

The Catalogue

Correggio

1 *Head of a woman* c. 1511

Charcoal, in some passages blended with white chalk, and accents in brush and black oil pigment. 322 × 224 mm (12 ⅝ × 8 ⅞ in)

The Pierpont Morgan Library, New York (IV, 30)

Provenance: N. F. Haym (L. 1970); Earls Spencer (L. 1530; sale, T. Philipe, London, 11 June 1811, lot 806, as Leonardo da Vinci, bt Alexander); W. Alexander (sale, Sotheby's, London, 12 March 1817, part of lot 894 as Leonardo da Vinci); C. Fairfax Murray; purchased by J. P. Morgan in London, 1910

Literature: Popham, *Corr.*, no. 1; Washington and Parma 1984, no. 1; Muzzi and Di Giampaolo 1988, no. 1; Ekserdjian 1997, p. 26; Romano 1998, p. 19

The discovery that this cartoon was made in preparation for the fresco of the *Lamentation* in the atrium of Sant'Andrea, Mantua, was due to Popham, who also advanced the attribution to Correggio (fig. 6). The belief that this and the other fresco in the atrium showing the *Holy Family with Saints Elizabeth and John the Baptist* were painted by Correggio goes back only to the early seventeenth century, and it is not altogether easy to connect it stylistically to Correggio's later, more secure works. Nevertheless, the position is well argued by Popham and Ekserdjian, and no plausible alternative exists.

The cartoon, in fact, provides support for the attribution of the fresco to Correggio. The broad and somewhat impressionistic use of charcoal is what one would expect of the young artist. The cartoon is achieved in a manner that suggests Mantegna seen through a Leonardesque lens, an approach fully in accord with what we know of Correggio's early paintings. Therefore, although no precise comparison with another cartoon or fresco is known, Correggio's authorship of both is secure. A date of around 1511 seems approximately correct. GG

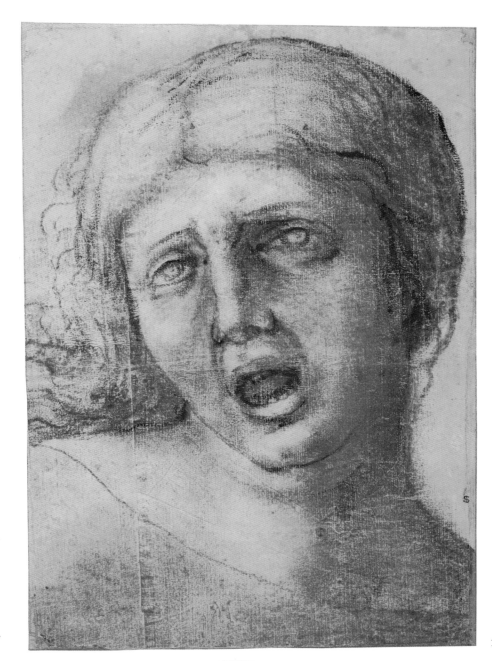

1

Fig. 6. Correggio, *Entombment of Christ*, detached fresco. Museo Diocesano, Mantua.

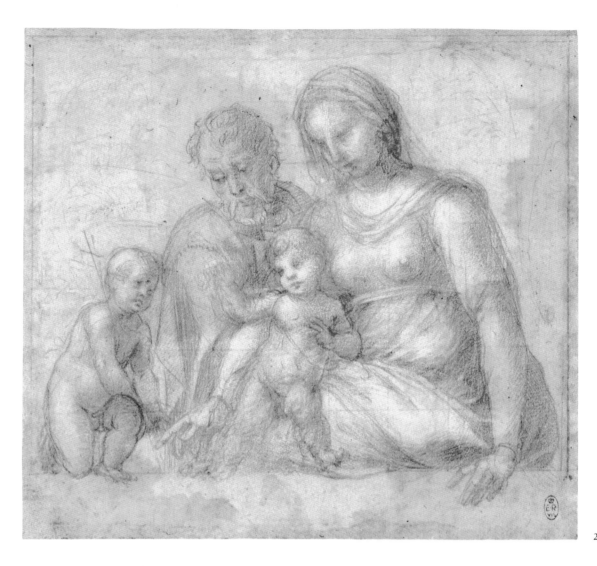

2

2 The Holy Family with the Infant Baptist c. 1515

Red and white chalks over some traced black chalk, lightly squared in black chalk. 172 × 195 mm (6 ¼ × 7 ¹¹/₁₆ in)

Royal Library, Windsor Castle (0101)

Provenance: Presumably King George III

Literature: Popham and Wilde 1949, no. 248; Popham, *Corr.*, no. 2; Muzzi and Di Giampaolo 1988, no. 3

The right arm of the Christ Child is drawn in two positions, both across his body and raised to bless the Infant Baptist. The Baptist and the Madonna appear to be gesturing, and Joseph looking, towards the same point at the Baptist's feet, although nothing is drawn there. In the background are rudimentary indications of a landscape which might identify the subject more precisely as the Rest on the Flight into Egypt, for although the presence of the Baptist is apocryphal in this scene, he was occasionally included.

The drawing was traditionally attributed to Sodoma, and while there is something in the rather flat handling of the chalk that is reminiscent of that artist, the figure and facial types – especially the hamster-cheeked Child – are those of the young Correggio, as Antal was the first to recognize (recorded in Popham and Wilde 1949). De Grazia (in Washington and Parma 1984, p. 66) rejected the attribution and thought the drawing to be 'nearer Gandini'; all other authors have accepted the drawing as by Correggio. Many of the artist's early paintings are small devotional works of this character, and the squaring and border lines, probably ruled by the artist himself, suggest that the drawing was a study for a now lost panel. The subject and some of the gestures are found in a painting by the artist at Orléans (Ekserdjian 1997, pl. 65); Muzzi and Di Giampaolo associated the drawing with a small painting of the same subject in the Los Angeles County Museum of Art (Washington and Bologna 1986, no. 28) in which the figure types and use of a parapet are the same. An absolute chronology of Correggio's small devotional works before 1520 is unattainable and, in the absence of any strict association with a datable painting, we can probably do no better than to date the drawing to around the middle of the preceding decade. MC

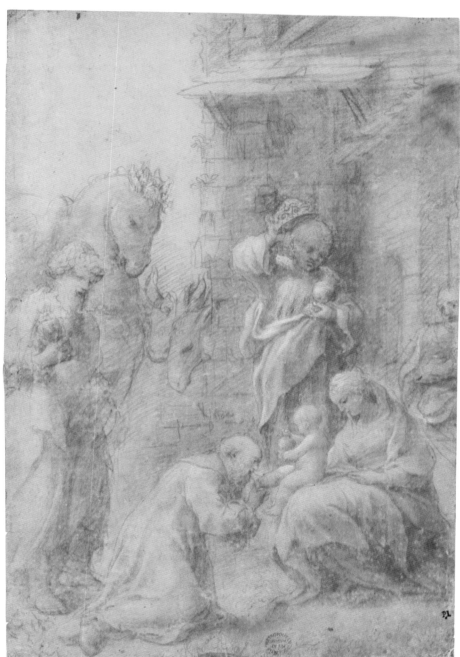

3

3 *Adoration of the Magi* c. 1517

Red chalk, white heightening. 291 × 197 mm
(11 ⅛ × 6 ¼ in)

The Metropolitan Museum of Art, New York
(19.76.10; Hewitt Fund, 1917)

Provenance: Sir P. Lely (L. 2092); Earls of
Pembroke (sale, Sotheby's, London, 10 July
1917, lot 464)

Literature: Popham, *Corr.*, no. 5; Washington
and Parma 1984, no. 5; Muzzi and Di
Giampaolo 1988, no. 5; Ekserdjian 1997, p. 59

There have been occasional doubts about
the attribution of this sheet to Correggio,
but it is in every sense characteristic of
his drawings before his trip to Rome and
his frescoes in the Camera di San Paolo.
The facial types, the handling of the combi-
nation of red chalk and white gouache to
achieve a rich *sfumato*, and even the slightly
quirky references to earlier North Italian
paintings in the depiction of the horse, are
all typical of his work of this period. One
may add that the drapery style of the Magus
standing at the right behind the Virgin and
Child clearly anticipates the manner used
later for figures such as the Saint Flavia in
the *Martyrdom of Four Saints* in the Galleria
Nazionale, Parma.

Popham suggested a connection
between this drawing and a painting of the
same subject in the Brera, Milan, executed
around 1517, according to Ekserdjian.
Despite their many differences in format and
detail, this possibility cannot be excluded,
but Ekserdjian is probably correct in seeing
the drawing as slightly later. A date of about
1517 would seem right for it, as well as for
the quite similar drawing in Dresden of
A woman driving a carriage with two horses
(Muzzi and Di Giampaolo 1988, no. 6). GG

4 *A god and goddess (Apollo and Diana ?)* c. 1517–19

Red chalk. 147 × 103 mm (5 ¹³/₁₆ × 4 ¹/₁₆ in)

British Museum, London (1957-12-14-1)

Provenance: S. Woodburn (sale, Christie's, London, 12 June 1860, part of lot 1196); P. & D. Colnaghi; presented by the National Art Collections Fund in 1957

Literature: Popham, *Corr.*, no. 4*; Popham, *BM*, no. 2; Washington and Parma 1984, no. 6; Muzzi and Di Giampaolo 1988, no. 10; Ekserdjian 1997, pp. 266–8

The drawing was described in the 1860 Woodburn sale catalogue as 'Cupid and Psyche', but Popham suggested that the two figures might be Apollo and Diana, who are paired together in engravings by Dürer and Jacopo de'Barbari. It is unclear what the seated woman is pointing at because the sheet has been trimmed, but if she is the goddess Diana, it may have been a reclining deer as in Dürer's print. The drawing has the appearance of being rapidly executed with the head of the goddess studied in three different positions, and the feet of the standing figure left unfinished. The soft, rounded forms and the crumbly texture of the chalk are most closely matched in the drawing of *Three putti in an oval* (cat. 6) related to the Camera di San Paolo of 1518–19. Further support for this dating is provided by Ekserdjian's observation that the pose of the seated soldier in the middle ground of Correggio's *Adoration of the Magi* (Brera, Milan) of around 1517 is close to that of the goddess in the drawing. HC

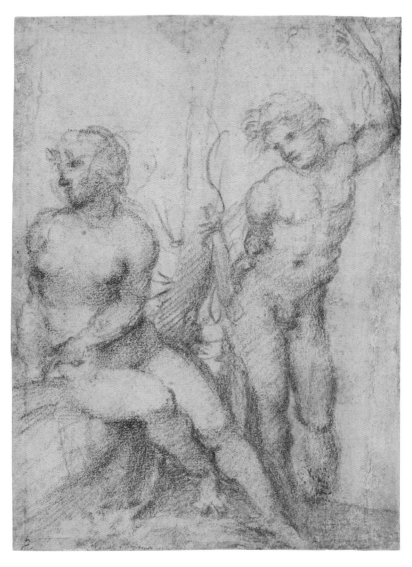

4

5 *A man riding a bull, and other figures* c. 1518

Black chalk and pale brown ink wash.
218 × 177 mm (8 ⅝ × 6 ¹⁵/₁₆ in)

The J. Paul Getty Museum, Los Angeles
(83.GB.344)

Provenance: P. Pouncey

Literature: Washington and Parma 1984,
no. 4; De Grazia 1986, pp. 199–200; Muzzi
and Di Giampaolo 1988, no. 11

The attribution of this complex drawing
to Correggio was first advanced by Philip
Pouncey, who acquired it sometime after
the publication of Popham's monograph
of 1957. It has since been accepted with
hesitation in the literature on the artist.
De Grazia pointed to connections to Lotto,
which are pursued by Muzzi and Di
Giampaolo, who even raise the hypothetical
possibility of his authorship of the
drawing, although they maintain the
attribution to Correggio. There are generic
similarities between it and some Lotto
drawings, but the use of the black chalk
medium is entirely unlike anything in the
latter's work. The breadth of handling
of details such as the trees finds close
correspondence in contemporary sheets,
such as *Adam picking the forbidden apple* in
the Rijksmuseum, Amsterdam (Muzzi and
Di Giampaolo 1998, no. 12). Similarly, the
principal soldier at the left has much in
common with the figure of Adam in the
Rijksmuseum sheet, in overall pose and
in the structure and uneasy placement
of the head. Lastly, the bull-rider can be
compared with the nude male figure in
another early drawing in the British
Museum (cat. 4) in anatomy, in facial
features and in the oddly awkward setting
of the head in relationship to the body.

The handling of the black chalk
medium is fully Correggesque. The firm
outlines and soft modelling of the forms
are hallmarks of his draughtsmanship.
There is still a somewhat Mantegnesque
quality to the rider, but the *sfumato*

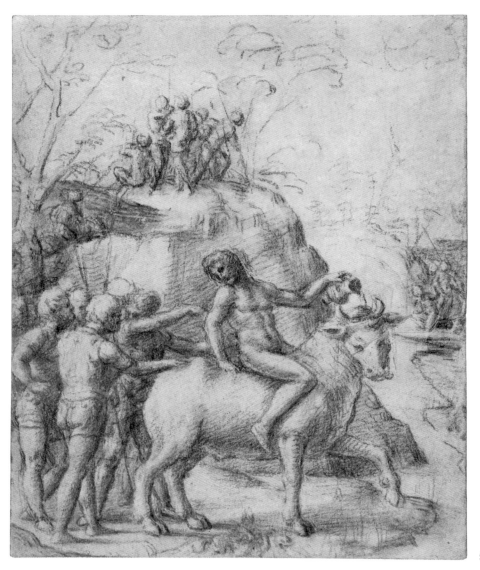

5

technique is owed to Leonardo. It should
be noted that Correggio used black chalk
as the principal medium again as late
as the Dresden study of the *Virgin of the
Assumption* (Muzzi and Di Giampaolo 1988,
no. 69). The drawing was probably made
during or shortly after Correggio's Roman
trip of about 1518, as it has rightly been
pointed out that the soldier at the left derives
from a similarly placed figure in Raphael's
Battle of Ostia fresco in the Vatican. Further-
more, the frieze-like arrangement of the
foreground group adds to the classicizing
character of the composition. The subject
appears to be mythological, but its meaning
has yet to be determined. GG

The Camera di San Paolo, Parma (cats 6 and 7)

The following two drawings are the only known preliminary studies for Correggio's decorations in the Camera di San Paolo, a small room in the private apartments of the Benedictine convent of San Paolo in the centre of Parma. It is not known exactly when the frescoes were painted, but they are usually dated to the period 1518–19 when the artist seems to have been absent from Correggio. They are the painter's first works in Parma, and it has been suggested that he was recommended to the aristocratic abbess of the convent, Giovanna da Piacenza, by her brother-in-law Scipione Montino della Rosa who was on friendly terms with the ruling family in the artist's birthplace. The decoration of the Camera consists of sixteen lunettes, with simulated antique sculptures set in concave niches, above an illusionistic painted cornice. The vault is painted with a fictive pergola, like that in the background of Mantegna's *Madonna of Victory* (Louvre, Paris), broken by sixteen ovals through which can be seen playful putti silhouetted against a brilliant azure sky. Not long after their completion, Correggio's decorations became inaccessible because the nuns of San Paolo became a closed order in 1524; the convent was only opened up at the end of the eighteenth century.

The Camera di San Paolo is generally regarded as being the first work executed after an undocumented visit to Rome by the artist. Correggio's sophisticated use of antique models in the lunette frescoes and his impressive command of form, seen most clearly in the bold movements of the muscular putti, are often taken as signs of his first-hand study of classical art and the work of Michelangelo and Raphael in Rome. By contrast, the two surviving studies for the Camera di San Paolo show that if he did make such a journey at this time his style of drawing appears to have been little affected by the experience.

HC

6 *Three putti in an oval*
c. 1518–19

Red chalk, unevenly squared in red chalk. 109 × 94 mm (4 ⅛ × 3 ¹¹/₁₆ in)

British Museum, London (1922-2-9-93)

Provenance: N. Lanier (L. 2886); Sir P. Lely (L. 2092); Earls of Pembroke (their inscription *Cor:* and *from Vol 2ⁿᵈ No: 7* on the old mount; sale, Sotheby's, London, 10 July 1917, lot 462); L.C.G. Clarke, by whom presented

Literature: Popham, *Corr.*, no. 8; Popham, *BM*, no. 4; Washington and Parma 1984, no. 8; Muzzi and Di Giampaolo 1988, no. 8; Ekserdjian 1997, p. 88

This is a preliminary idea for one of the ovals in the vault of the Camera di San Paolo. Although it does not correspond to any of the painted scenes, one of the ovals on the east wall does include a putto holding a similar shield decorated with a gorgon's head (fig. 7). The changes made to the position of the central putto's legs and to the contours of his back, and the general hesitancy of the line, suggest that this study was made at a fairly early stage in the genesis of the vault decorations. Although squaring was often added by artists to the final drawing to allow the design to be enlarged for the preparation of a full-size cartoon or to copy it on to the

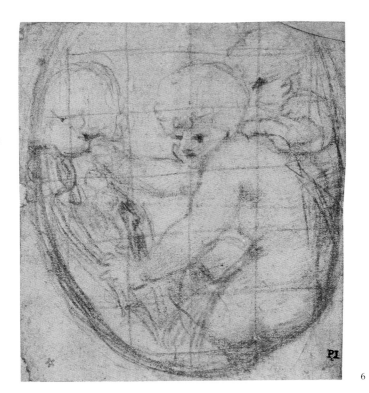

6

final painting surface, this is clearly not the case with the present study as it is so unlike the finished work. This sheet, like the drawing of Christ from the Courtauld Institute (cat. 9), is one of a number of intermediate studies that Correggio squared up in order to allow him to copy the composition on to another sheet so that he could continue to refine the design.

HC

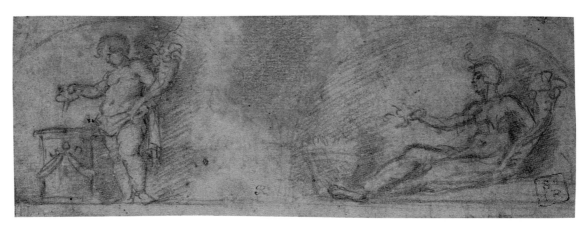

7

7 *A Genius pouring a libation at an altar and a woman (Africa) with a cornucopia*

c. 1518–19

Red chalk. 59 × 158 mm (2 ⁵⁄₁₆ × 6 ¼ in)

British Museum, London (1895-9-15-740)

Provenance: J. Richardson Sr (L. 2184); Sir J. Reynolds (L. 2364); W.Y. Ottley (sale, T. Philipe, London, 21 June 1814, part of lot 1544); Sir T. Lawrence (L. 2445); J. Malcolm

Literature: Popham, *Corr.*, no. 9; Popham, *BM*, no. 5; Washington and Parma 1984, no. 7; Muzzi and Di Giampaolo 1988, no. 9; Ekserdjian 1997, p. 88

This is related to adjoining lunettes on the east wall of the Camera di San Paolo. The frescoed lunettes are decorated respectively with a Genius (a kind of classical guardian angel) before an altar, and the reclining figure of the earth goddess Tellus (fig. 7). As Affò in his 1794 monograph on the Camera

Fig. 7. Correggio, detail of east wall of the Camera di San Paolo, fresco. San Paolo, Parma.

first noted, many of the figures in the lunettes are based on Roman coins, and this is demonstrable in the present drawing. The left-hand figure was inspired by a coin, originating from the period of the emperor Nero (54–68) or Titus (79–81), of a young man holding a cornucopia and pouring oil over a flaming altar. This figure in the drawing is transformed into a putto, but in the finished work Correggio returned to the form of the original, perhaps, as Ekserdjian observed, because it might have looked odd to have a baby on the same scale as fully grown figures in the other lunettes. The source for the reclining figure on the right of the drawing was a coin from the reign of the emperor Hadrian (117–38) showing an allegorical figure of Africa (for illustrations of the coins, see Ricci 1930, pl. 2). Correggio adapted the cramped, upright pose of the figure in the coin to a more languorous and elegant posture. Both the drawing and the fresco also differ from the coin in that Correggio's figure has a serpent rather than an elephant head-dress, but whether this is a deliberate alteration is uncertain as the trunk could easily be read as a rearing snake (particularly if the artist was copying from a worn impression of the coin). The figure in the fresco corresponds closely to the drawing, except for the addition of a mound of earth that clarifies her identification as Tellus. HC

San Giovanni Evangelista, Parma *(cats 8–17)*

In 1520 Correggio was commissioned to fresco the dome, apse, choir and the frieze above the nave of the newly constructed Benedictine church of San Giovanni Evangelista in Parma. The artist worked on the project for the next four years with the final payment recorded in January 1524. The subject of the dome fresco is the Vision of Saint John the Evangelist with the saint at the base of the dome below eleven apostles seated on clouds, and at the centre the figure of Christ bathed in a golden glow of light and surrounded by cherubim. The fresco was carefully designed for the different viewpoints of the congregation and the Benedictine monks, as the area directly below the dome was filled by the choir, a walled structure enclosing the high altar and sixty choir stalls, which would not have been accessible to the laity (see Shearman 1992, pp. 181–6; and Ekserdjian 1997, p. 100). The principal viewpoint is that of a viewer standing under the western arch of the crossing, as from this angle the figure of Christ is isolated in all his majesty. The monks seated below the dome would have had a better view of the apostles encircling Christ, and only from their vantage point could the figure of the monastery's titular saint, John the Evangelist, be seen. There has been considerable scholarly debate as to the chronology of Correggio's work in the church, but the traditional view that the dome fresco was executed before the *Coronation of the Virgin* in the apse is supported by the few brief descriptions of the progress of the work supplied by payments to the artist, and also by the stylistic development of Correggio's preparatory drawings for the various constituent parts of the decorations. The pendentives below the dome frescoed with paired evangelists and doctors appear, on stylistic grounds, to have been painted last. HC

8 *A nude man seated with a putto at his feet; fragment of a ground-plan* c. 1520

Red chalk with some black chalk, the plan in pen and brown ink over stylus ruling. 110 × 93 mm (4 ⁵⁄₁₆ × 3 ¹¹⁄₁₆ in)

British Museum, London (Pp.2-103)

Provenance: Sir P. Lely (L. 2092); Sir J. Reynolds (L. 2364); R. Payne Knight Bequest, 1824

Literature: Popham, *Corr.*, no. 15; Popham, *BM*, no. 7; Muzzi and Di Giampaolo 1988, no. 18

The present drawing does not correspond to any of the apostles in the dome, although the position of the figure's right arm and leg recall, albeit in reverse, the pose of the so-called Saint Philip. The action of the swooping putto with his awkwardly extended right arm is difficult to interpret, but he appears to be helping the apostle to gather together his billowing drapery. The style of the drawing supports the view that Correggio began his work in the church with the dome fresco, as the feathery and rather tentative chalk contours are like those of the two Camera di San Paolo studies of *c.* 1518–19 (cats 6 and 7). The purpose of the fragmentary plan of a circular building drawn in ink over the figure is obscure, but a small number of surviving studies testify to Correggio's involvement in architectural projects. HC

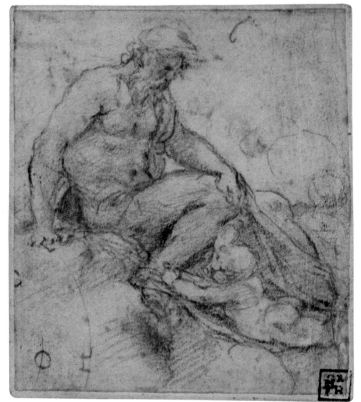

8

The Apse of San Giovanni Evangelista (cats 9–12)

Correggio's fresco of the *Coronation of the Virgin* in the apse of San Giovanni Evangelista, Parma, probably followed his completion of the *Vision of Saint John* in the dome of the same church; work was ongoing in the summer of 1522, when the artist received payments for work in the apse (Gould 1976, p. 181). As well as Christ and the Virgin and their attendant angels, Correggio painted four saints, symmetrically placed on either side of the central group. They were Saints John the Evangelist (the titular saint of the church) and John the Baptist (who was, along with the Virgin, the patron saint of Parma), together with Saint Benedict, the founder of the church's order, and probably another Saint John, the first abbot of the monastery.

Correggio's fresco was destroyed in 1587 when the choir of the church was extended, although a replica was executed in the new apse (by Cesare Aretusi; fig. 8). The central part of the fresco showing Christ and the Virgin in half length, as well as the underlying *sinopia*, were preserved (Galleria Nazionale, Parma). These active measures to record and preserve an original work were very unusual for the period and betray a devotion to a painting of an earlier generation that may often have been felt, but was rarely acted upon, when building works necessitated that painting's destruction. Smaller fragments of the fresco with the heads of angels are in the National Gallery, London (see cat. 12) and elsewhere.

MC

9 Christ *c. 1522*

Red chalk over traced black chalk, squared in red chalk. 160 × 133 mm (6 5/16 × 5 ¼ in)

Courtauld Institute, London (D.1972.PG.352)

Provenance: J. Richardson Sr (L. 2183, and his mount with the inscription *Coreggio*); Earls Spencer (L. 1531); Lord D. Cecil (sale, Sotheby's, London, 1 July 1965, lot 154); Count A. Seilern

Literature: Muzzi and Di Giampaolo 1988, no. 33

Exhibited in London only

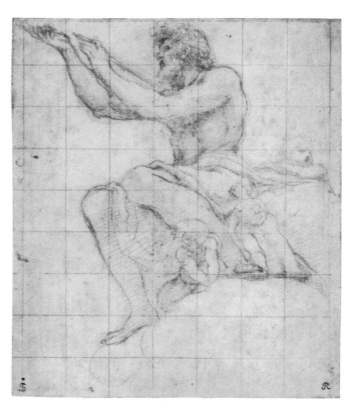

9

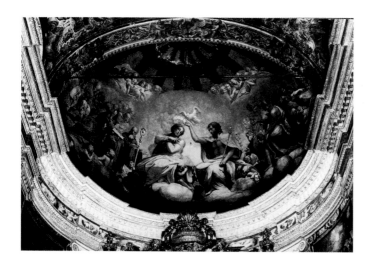

Fig. 8. Cesare Aretusi after Correggio, *Coronation of the Virgin*, fresco. San Giovanni Evangelista, Parma.

10 *Christ* c. 1522

Red chalk. 239 × 180 mm (9 ⁷⁄₁₆ × 7 ¹⁄₁₆ in)

Ashmolean Museum, Oxford (P. II 204)

Provenance: Earls Spencer (L. 1530);
bequeathed by F. Douce in 1834, and
transferred from the Bodleian Library in 1863

Literature: Parker 1956, no. 204; Popham
Corr., no. 24; Muzzi and Di Giampaolo 1988,
no. 30

Seven studies survive for the figure of Christ
in the *Coronation of the Virgin*, more than for
any other figure in Correggio's oeuvre.
Taken together they demonstrate his
method of working towards a harmonious
solution to a pictorial problem in a series of
drawings of roughly the same scale and
degree of finish, and it is reasonable to
suppose that a comparable series of studies
would have been executed for each major
figure in Correggio's frescoes.

In cat. 9 Christ is seated almost in profile
with both hands raised to crown the Virgin.
In his left hand he also holds a sceptre, an
encumbrance that must have been required
as part of the iconography of the fresco, for
it is included in all seven studies and much
of Correggio's attention was devoted to
arranging a pose in which Christ could hold
both crown and sceptre without splitting the
focus of the figure.

The drawing is a development of a study
for both Christ and the Virgin in Rotterdam
(Muzzi and Di Giampaolo 1988, no. 35), the
earliest known study for Christ but also the
last of three surviving studies for the Virgin.
The figure of Christ in cat. 9 is the same size
as that on the Rotterdam sheet, and the
smooth, even black chalk underdrawing of
cat. 9 suggests strongly that it was traced
from the Rotterdam sheet by placing some
black-chalk- or charcoal-rubbed paper
between the two and going over the outlines
of the Rotterdam sheet with a broad stylus.
In turn, cat. 9 is squared to transfer the
design to the next sheet, a drawing at
Poitiers (Muzzi and Di Giampaolo 1988,
no. 32) that is also squared; there the

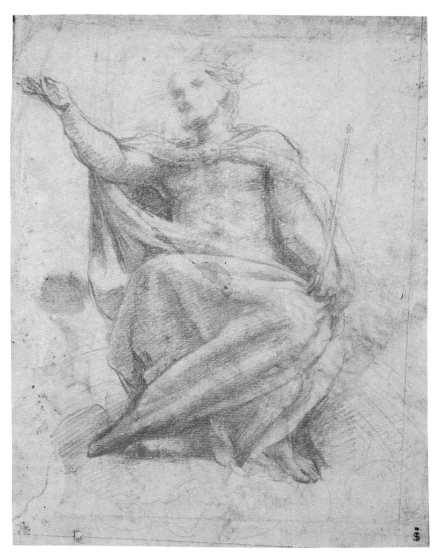

10

placing of Christ's head and torso within
the grid is the same as in cat. 9, but the
right hand stretches out further, the thighs
are much longer and the arrangement of
the drapery is quite different.

In the Poitiers study the cloak clasped
across Christ's shoulders appears for the first
time, a motif that was to be compositionally
vital thereafter. The Oxford study (cat. 10) is
dominated by the soft, voluminous drapery,
although as this is the only study in which
Christ is shown almost frontally it is not
immediately obvious that it follows the
Poitiers sheet. The hand holding the sceptre
now rests on Christ's left knee, and the
lower half of his body is a remarkably bold
'X' of drapery that obscures the position of
the legs.

The last three surviving studies, in the
Louvre and at Budapest (Muzzi and Di
Giampaolo 1988, nos 31, 34 recto and
verso), retain the placing of the left hand
seen in cat. 10, but twist the body back in
the direction of the first studies – not as far
as their near-profile, but to a three-quarters
pose. A single compositional line now runs
up the drapery of Christ's legs, through his
left arm and across his shoulders to the focal
point of the composition, the crown of stars
and the dove of the Holy Spirit. This overall
structure renders the gesture of the figure
immediately obvious from the floor of the
church and emphasizes that it is the act of
crowning, the moment of glorification of
the Virgin, that is the essential subject of
the fresco. MC

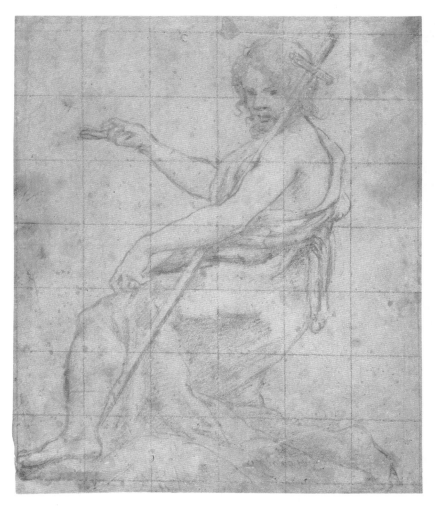

11

11 *Saint John the Baptist*
c. 1522

Red chalk, squared in red chalk, on pink-washed paper. 190 × 156 mm (7 ½ × 6 ⅛ in)

Walker Art Gallery, Liverpool (1995.325)

Provenance: B. West (L. 419); C.R. Blundell

Literature: Popham, *Corr.*, no. 27; Muzzi and Di Giampaolo 1988, no. 36; Brooke 1998, no. 21

Exhibited in London only

The drawing is a final squared study for the figure of the Baptist to the right of the *Coronation of the Virgin*. The only significant differences are the position of the reed cross, which in the fresco passes behind rather than in front of the Baptist's left leg, and the form of the lambskin tied behind his waist. MC

12 *The head of an angel*
c. 1522

Black chalk on discoloured paper, retouched with black chalk and brush. 303 × 215 mm (11 ¹⁵⁄₁₆ × 8 ⁷⁄₁₆ in)

Christ Church, Oxford (1784)

Provenance: J. Richardson Sr (his mount with the inscription *Coreggio*); General J. Guise

Ref: Byam Shaw 1976, no. 1066; Ekserdjian 1997, p. 113

The traditional attribution to Correggio, tentatively maintained by Byam Shaw, was rejected by Popham and (*ex silentio*) Muzzi and Di Giampaolo. David Ekserdjian observed, however, that it corresponds with the head of an angel now in the National Gallery, London, a fragment of Correggio's destroyed fresco of the *Coronation of the*

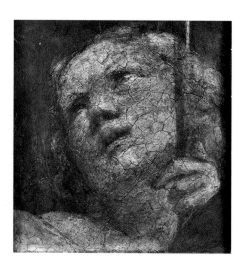

Fig. 9. Correggio, *Head of a putto*, detached fresco, 36.9 × 33 cm. National Gallery, London.

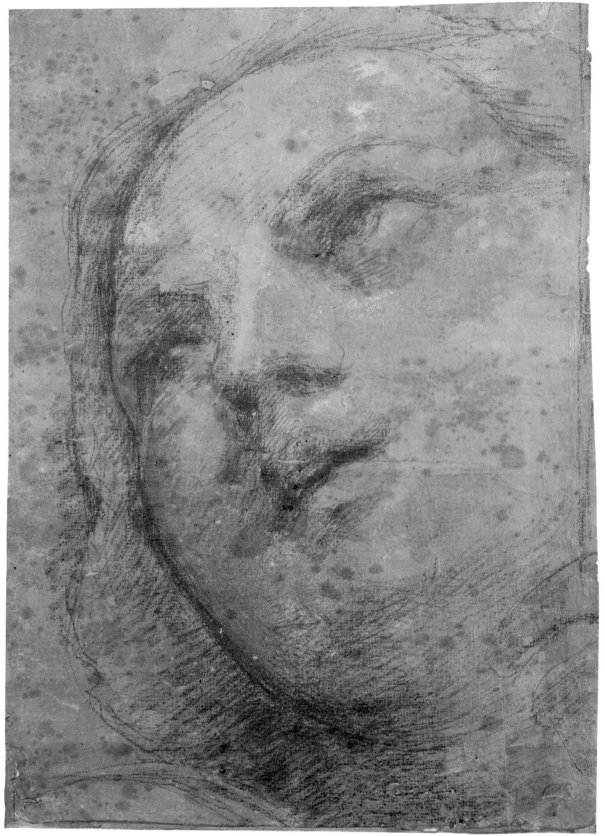

12

Virgin (fig. 9). A tracing of the drawing has recently been placed over the fresco fragment, and the outlines match exactly. This allows several possibilities: the drawing may be a portion of the original cartoon, a copy of the lost cartoon, a portion of the traced cartoon that Aretusi presumably made from the extant fresco to allow him to execute his replica, or a tracing from the preserved fragment of the fresco after its destruction in 1587 (the fact that the sheet corresponds with one of these few fragments might arouse suspicion).

Correggio's method of transfer in the fresco was to go over the contours of a cartoon with a pointed implement, pressing the outlines into the wet plaster; although there is no sign of incision on the sheet, the damping and pressing that it has clearly suffered over the centuries could have flattened out such indentations. Despite its compromised condition, badly damaged and reworked around the right eye and cheek, the drawing retains great power: it does not have the precise outlines and finicky concern for detail typical of a copy and is more impressive at a distance

than close to, for its effect is dependent not on careful working but on its broad conception, on what is essential to capture the form, angle and expression of the face. The only securely attributable cartoon fragment of Correggio's maturity (fig. 2), a head of an angel for a squinch of the cathedral (Ecole des Beaux-Arts, Paris; Muzzi and Di Giampaolo 1988, no. 70), is in a different technique with softly blended charcoal and white chalk, but the overall conception of that drawing is not sufficiently dissimilar to discount Correggio as the author of the present sheet. MC

The pendentives of San Giovanni Evangelista (cats 13–14)

The following three drawings are all related to the fresco of *Saints Matthew and Jerome* on the south-east pendentive or squinch of San Giovanni Evangelista (fig. 10). The survival of the artist's studies for the four pendentives beneath the crossing is extremely uneven, with seven designs (on six sheets) for *Saints Matthew and Jerome* and only one study for the remaining three, the pen and ink design of *Saints Mark and Gregory* in the Louvre (Muzzi and Di Giampaolo 1988, no. 26). Each pendentive shows an Evangelist in discourse with

an appropriate Doctor of the Church – in the present case, for example, Jerome is paired with Matthew because of his celebrated commentary on the latter's gospel. In contrast to the apparently silent gathering of semi-nude apostles in the dome above, the actions and behaviour of the colourfully dressed saints in the pendentives are distinctly more earthbound, with the figures shown either vigorously debating the meaning of the gospels, or studiously concentrating on the texts themselves. HC

13 *Saint Matthew* c. 1522–3

Red chalk. 120 × 110 mm (4 ¼ × 4 ⁵⁄₁₆ in)

The J. Paul Getty Museum, Los Angeles
(91.GB.4)

Provenance: Sir P. Lely (L. 2092); W. Gibson
(his price mark 2.3., verso); S. Schwarz (sale,
Sotheby's, New York, 16 January 1986, lot
41); J.R. Gaines; S. Abate; art market, Boston

Literature: De Grazia 1990, p. 83; Turner,
Hendrix and Plazzotta 1997, no. 13

This spirited sheet was already considered
to be the work of Correggio by Oberhuber
nearly twenty years ago (oral communi-
cation to this writer *c.* 1982). It was related
to the pendentives at San Giovanni
Evangelista in the Sotheby's sale catalogue
of 1986, and finally proposed as a study for
the fresco of Saint Matthew by De Grazia.
It is close in handling to the drawing for the
same pendentive in the British Museum
(cat. 14) in the thick chalk contours and
angularity of line. This drawing must fall
very early in the sequence of studies for
this pendentive, probably even before that
in Washington (cat. 13a). The absence of
Saint Jerome, the placement of the angel at
the left, and the fact that the saint's foot
rests on a block of stone, rather than on the
clouds, all indicate that Correggio was very
far from the solution that evolves in all the
other surviving sheets made for this
pendentive. GG

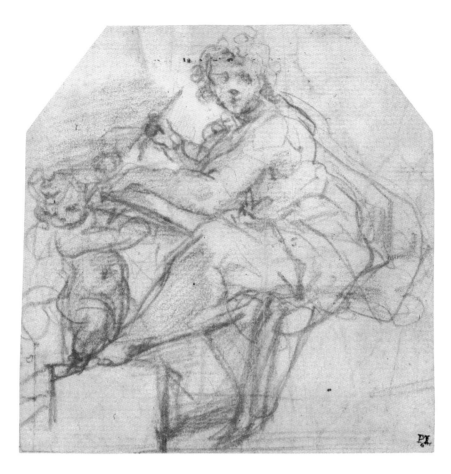

13

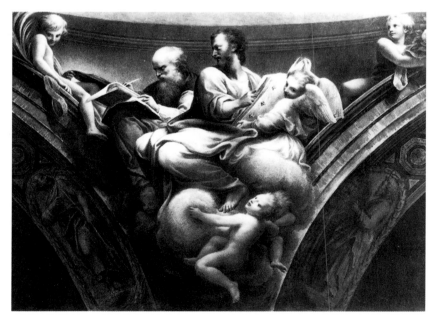

Fig. 10. Correggio, pendentive with Saints Matthew and
Jerome, fresco. San Giovanni Evangelista, Parma.

13a *Saints Matthew and Jerome* (verso of cat. 21)

c. 1522–3

Red chalk, pen and brown ink, brown wash.
207 × 140 mm (8 ⅛ × 5 ½ in)

National Gallery of Art, Washington D.C.
(1991.217.6 b, The Armand Hammer
Collection)

For provenance and literature, see cat. 21

This is among the earliest in the sequence of
preparatory studies for the pendentive with
Saints Matthew and Jerome in San Giovanni
Evangelista (fig. 10). Over some very free
passages of red chalk, Correggio searches
for and gradually establishes many features
of the solution that will be modified some-
what in the other drawings and in the fresco
itself (cat. 14; Muzzi and Di Giampaolo
1988, nos 23–5). The forms are rapidly set
down in pen and ink and then developed
and altered in brush and wash. The child
angel is moved downward at the right and
there are several attempts at rendering the
head of Saint Matthew. The entire ensemble
is depicted with great energy and creative
verve. One may note that there are lightly
indicated lines setting down the outer limits
of the pendentive at the top and to the right.
The sheet was clearly cut down at the left,
possibly when Correggio made the drawing
on the recto. GG

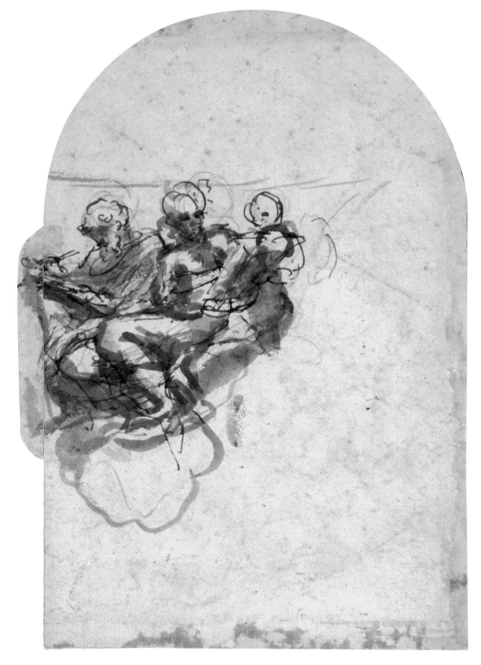

13a

14 *Saints Matthew and Jerome* (recto); *Cupid bound to a tree* (verso) *c.* 1522–3

Red chalk (recto); red chalk, pen and brown ink (verso). 197 × 154 mm (7 ¼ × 6 ¹⁄₁₆ in)

British Museum, London (1953-12-12-1)

Provenance: E. Bouverie (L. 325; sale, Christie's, London, 20 July 1859, lot 291); Earl of Gainsborough (according to Russell sale catalogue); A.G.B. Russell (L. 2770a; sale, Sotheby's, London, 9 May 1929, lot 14); H.S. Reitlinger (sale, Sotheby's, London, 9 December 1953, lot 38); P. & D. Colnaghi; presented by the National Art Collections Fund in 1953

Literature: Popham, *Corr.*, no. 18; Popham, *BM*, no. 6; Muzzi and Di Giampaolo 1988, no. 22; Ekserdjian 1997, pp. 150, 274

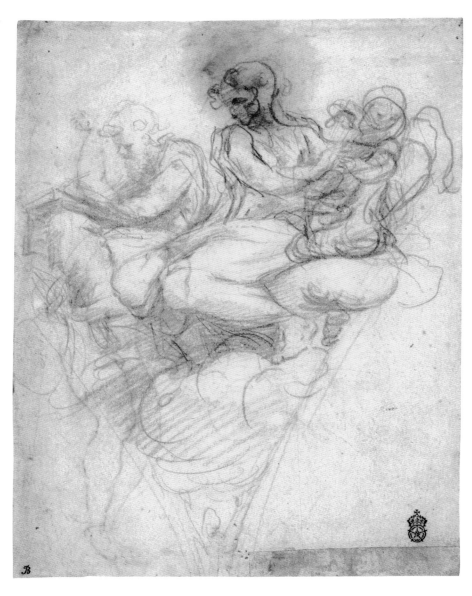

14r

The drawing on the recto follows on closely from the Washington study on the verso of cat. 21 (cat. 13a). The figure of Jerome in the London study is almost identical to his counterpart in the earlier drawing, and he is little changed in the fresco except that his knees are brought up nearer to his head to fit into the restricted space of the pendentive. Jerome has been drawn with barely any changes, except for some minor adjustments to the contours of his left shoulder, in vivid contrast to the flurry of chalk lines outlining Saint Matthew. Correggio began by drawing the latter's head in profile, but then went over his earlier effort, making the turn of the saint's head more emphatic so that the figure is more evidently looking down over his shoulder at his companion's scroll. The drawing demonstrates that Correggio was also undecided as to the placement of the attendant putto, and, as in the Washington study, he began by drawing him holding the book behind Matthew and looking down at the text. He then changed his mind and quickly sketched in the figure seated on a cloud beside the evangelist, supporting the volume with his arms outstretched. As a result of this alteration to the position of the putto, Correggio slightly lowered the

position of the saint's right hand in order that it should not be too close to the putto's hand.

The two studies of *Cupid bound to a tree* on the verso of the drawing are not related to any painted composition, although Ekserdjian plausibly suggests that the subject would have been a suitable pendant to his painting of the *School of Love* (National Gallery, London). As Popham first noted (1957, p. 153), the attitude of the right-hand figure resembles, in reverse, that of Saint Sebastian in the background of Correggio's painting of the *Mystic Marriage of Saint Catherine* in the Louvre. The picture probably post-dates Correggio's work in San Giovanni Evangelista by a few years, which

would mean that the artist adapted the present study for the figure of Saint Sebastian tied to a tree (for a similar case of his recycling of a figure study for another context, see cat. 32). Correggio began the drawing with the left-hand Cupid, who is markedly more infant-like in the rounded contours of his face and limbs, and then continued to develop the pose in the study on the right. As in some of the red chalk studies for the *Coronation of the Virgin* from the same period (Muzzi and Di Giampaolo 1988, nos 32, 34–5), Correggio fixed the final pose by drawing over the red chalk with a pen, adding a few details such as the cord securing his ankles and some luxuriant curls to Cupid's hair.

HC

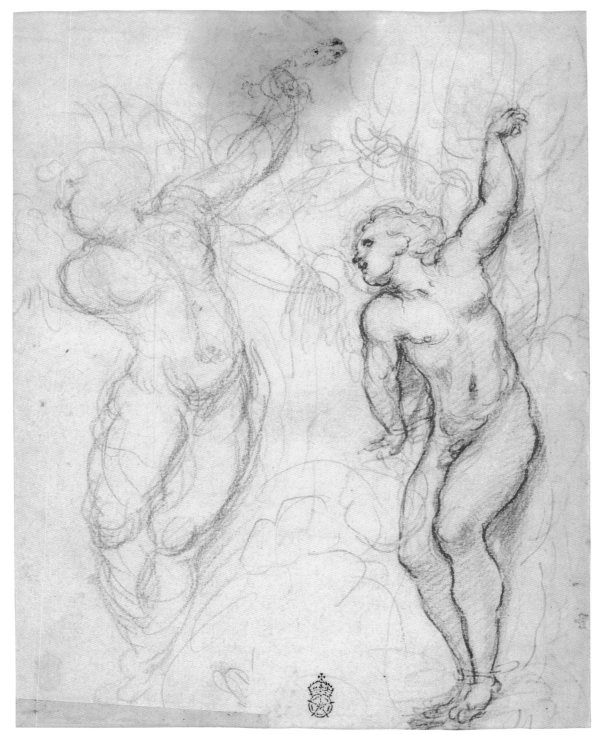

14v

15 *Two figures before an altar, and a sibyl holding a tablet* c. 1522–3

Red chalk, the lower study with pen and brown ink, brown wash, white heightening, on pink washed paper. 108 × 112 mm (4 ¼ × 4 ⁷⁄₁₆ in)

British Museum, London (1902-6-17-2)

Provenance: Sir J. Reynolds (L. 2364); P. & D. Colnaghi

Literature: Popham, *Corr.*, no. 31; Popham, *BM*, no. 9; Muzzi and Di Giampaolo 1988, no. 40

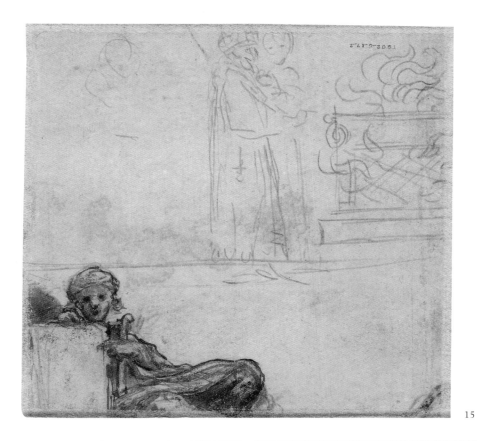

15

Fig. 11. Workshop of Correggio, detail of nave frieze, fresco. San Giovanni Evangelista, Parma.

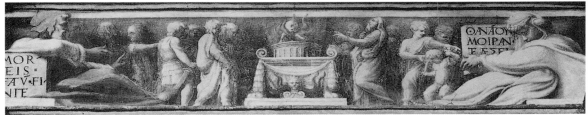

16 *Figures around an altar*

c. 1522–3

Red chalk, the lower study with pen and brown ink, on pink-washed paper.
97 × 151 mm (3 ⅞ × 5 ¹⁵⁄₁₆ in)

British Museum, London (1895-9-15-741)

Provenance: J. Richardson Sr (L. 2184; sale, Cock's, London, 30 January 1747, part of lot 46); W.Y. Ottley (sale, T. Philipe, London, 21 June 1814, part of lot 1544); Sir T. Lawrence (L. 2445); J. Malcolm

Literature: Popham, *Corr.*, no. 30; Popham, *BM*, no. 8; Muzzi and Di Giampaolo 1988, no. 39

Cats 15–16 are both studies for the nave frieze in San Giovanni Evangelista, commissioned in November 1522 and probably painted the following year. The work consists of thirteen sections of frieze painted in grisaille (six on each side of the nave and one on the entrance wall at the west end), with alternating representations of an Old Testament sacrifice – a lamb being burned on an altar – and a pagan sacrifice represented by figures gathered round an altar inscribed DEO IGNOTO, an allusion to the altar of the Unknown God encountered by Saint Paul on the Acropolis in Athens. These repeated scenes are flanked by a prophet at one end and a sibyl on the other, who each hold tablets with inscriptions from the Bible and from ancient texts. Preliminary drawings for the friezes and the flanking figures establish that Correggio was responsible for the design of the frescoes, but there is some doubt as to how much he intervened directly in their execution.

The schematic red chalk drawing on the upper part of cat. 15 is a summary sketch of figures around an altar for the Old Testament sacrifice frieze (fig. 11). The seated woman below is an unused idea for one of the sibyls in the frieze. The chalk study on the upper part of the second sheet (cat. 16) is related to the frescoed frieze in the easternmost bay on the south side of the nave (Gould 1976, pl. 62a). A detailed and presumably later study by Correggio for the left-hand prophet is in the Städelsches Kunstinstitut, Frankfurt (Muzzi and Di Giampaolo 1988, no. 45). The lower part of the sheet is taken up by a more detailed drawing of the central sacrificial scene, with the figures cursorily drawn in pen over a slight underdrawing in red chalk.

HC

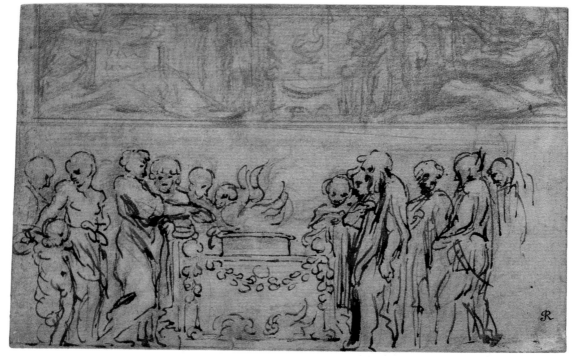

16

17 *Grotesque decoration for the rib of a vault* c.1522–3

Red chalk, over stylus and black chalk.
307 × 88 mm (12 ¹⁄₁₆ × 3 ⁷⁄₁₆ in)

Chatsworth, Devonshire Collections (413)

Provenance: S. Resta (?); 2nd Duke of Devonshire (L. 718)

Literature: Brown 1975, pp. 136–9; Washington and Parma 1984, no. 16; Muzzi and Di Giampaolo 1988, no. 47; Jaffé 1994, no. 650; Warwick 1996, p. 244

The drawing was traditionally listed as Agostino Carracci at Chatsworth, and it was David Alan Brown who first published it as a study by Correggio for the upper section of the grisaille decorations on the ribs of the choir vault in San Giovanni Evangelista (fig. 12). This work, which was only uncovered during restoration in the 1960s, has been linked by some scholars to a payment to

Correggio of a small sum in October 1525 for a 'pictura intorno al chora di foro', but this is more likely a reference to some kind of painted decoration for the stone structure, now destroyed, that contained the wooden choir stalls beneath the dome. The choir vault decorations (the putti in the centre were painted by Innocenzo Martini in 1588) may date from around the same time as the frescoed frieze in the nave. Like the latter works, the rather pedestrian quality of the frescoed ribs suggests that they were largely executed by assistants following Correggio's design. The decorations depend on a single cartoon cut into three sections, with variety introduced, as in the friezes in the nave, by reversing parts of the design so that adjacent ribs are not identical. The differences between the finished work and this drawing are fairly minor. These include the enlargement of the shield at the top, while the satyr above it stands straight and not with his head inclined. HC

Fig. 12. Workshop of Correggio, frescoed choir vault. San Giovanni Evangelista, Parma.

17

The Del Bono chapel *(cats 18–20)*

The Del Bono chapel is the fifth on the right in the church of San Giovanni Evangelista, Parma. Correggio painted two canvases for the side walls, the *Martyrdom of Saint Placidus and his siblings* and the *Lamentation over the Dead Christ*; for some reason he never began work on the altarpiece, although an elaborate frame was executed and still survives (all now Galleria Nazionale, Parma). Frescoed on the underside of the broad arch between the chapel and the body of the church are two scenes involving the titular saints of the chapel and the church: the *Conversion of Saint Paul* to the left, with Christ appearing to the saint from a fictive oculus in the centre of the underarch (fig. 13), and *Saints Peter and John healing a cripple at the Beautiful Gate* on the right. Pairs of putti appear to shoulder Christ's oculus, and on the underside of a narrower, outer arch of the chapel more putti support shields with the Del Bono arms, against a gold ground. The patron Placido del Bono was the principal lay figure responsible with the monks of San Giovanni for the programme of decoration of the church (see Ekserdjian 1988, p. 447), which might explain why he alone was able to commission Correggio to decorate his family chapel. The actual frescoes of the underside of the arch were apparently carried out not by Correggio himself but by his assistants to the master's designs.

No documents survive regarding Correggio's work in the Del Bono chapel, and its date can only be inferred from external evidence. The likely derivation by Pordenone (1483/4–1539) in his *Conversion of Saint Paul* (cathedral, Spilimbergo) from Correggio's treatment of the same subject on the underarch of the chapel – and not vice versa – would suggest that at least the design of the Del Bono chapel had been worked out by early 1524, when Pordenone would have passed through Parma on his return from Cremona to Friuli. In January 1524 Correggio made a declaration that he had received a final payment for his work in San Giovanni (Gould 1976, p. 181), but this must refer only to the work for the church authorities in the body of the building and did not include private, separately commissioned projects for the side chapels; indeed it is inherently probable that Correggio did not turn his attention to the Del Bono chapel until the main decorative scheme was complete. A date of around 1523–4 would accord well with the style of the two canvases, and a stone in the floor of the chapel incised ANTIQUISS.FAM.DEL.BONO [...] REFECIT MDCXXIII may well record a centenary restoration.

MC

Fig. 13. Workshop of Correggio, soffit (*sottarco*) of Del Bono chapel, fresco. San Giovanni Evangelista, Parma.

18 *Two putti supporting a medallion with a figure of Christ* c. 1524

Red chalk, pen and ink, brown wash, extensive white heightening (partly discoloured), squared in red chalk, on pink-washed paper. 191 × 140 mm (7 ½ × 5 ½ in), losses at lower right

Chatsworth, Devonshire Collections (763)

Provenance: S. Resta (?); Dukes of Devonshire

Literature: Popham, *Corr.*, no. 46; Washington and Parma 1984, no. 17; Muzzi and Di Giampaolo 1988, no. 53; Jaffé 1994, no. 648; Warwick 1996, p. 254

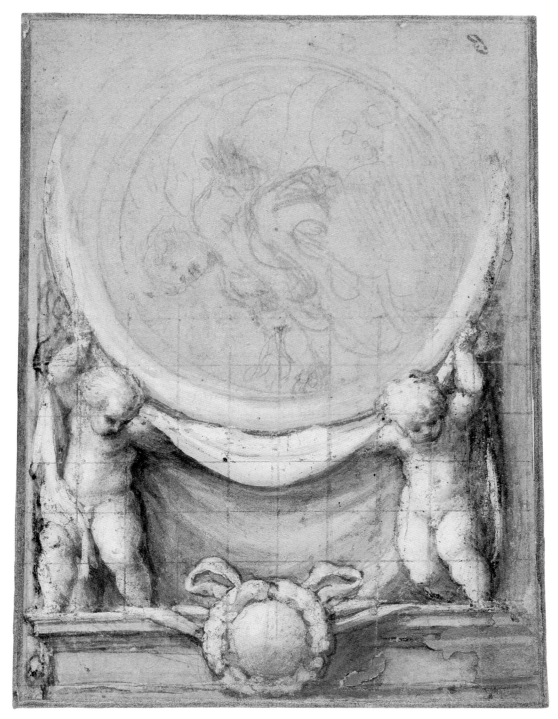

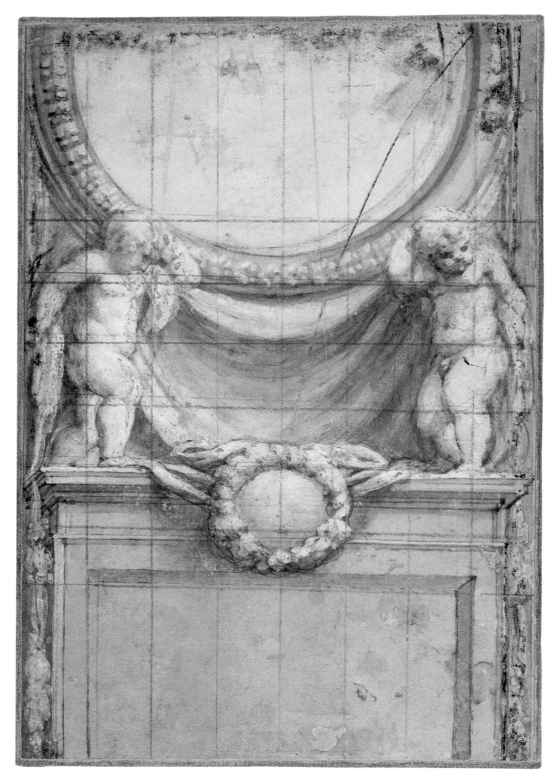

19

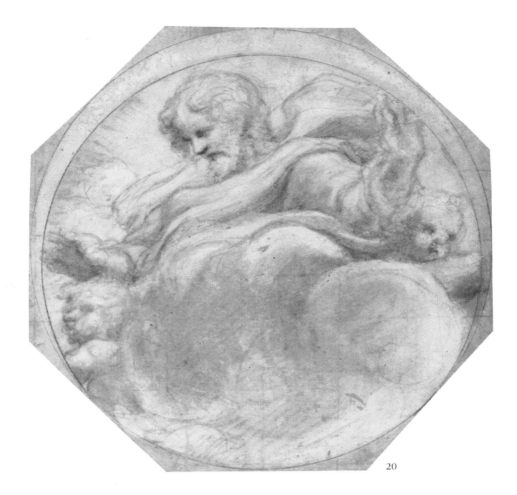

20

19 *Two putti supporting a medallion* c.1524

Red chalk, pen and ink, brown wash, extensive white heightening (partly discoloured), squared in red chalk, on pink-washed paper. 206 × 138 mm (8 ⅛ × 5 ⁷⁄₁₆ in)

Chatsworth, Devonshire Collections (762)

Provenance: S. Resta (?); Dukes of Devonshire

Literature: Popham, *Corr.*, no. 45; Muzzi and Di Giampaolo 1988, no. 52; Jaffé 1994, no. 649; Warwick 1996, p. 254

20 *Christ in Glory* c.1524

Red chalk, brown and grey washes, extensive white heightening, squared in red chalk, on pink-washed paper. 145 × 146 mm (5 ¹¹⁄₁₆ × 5 ¼ in), cut to an octagon

J. Paul Getty Museum, Los Angeles (87.GB.90)

Provenance: Dukes of Devonshire (sale, Christie's, London, 6 July 1987, lot 5)

Literature: Popham, *Corr.*, no. 44; Muzzi and Di Giampaolo 1988, no. 51; Goldner and Hendrix 1992, no. 15; Jaffé 1994, no. 647

The figures correspond in all essentials (modelling as well as outline) with those painted on the underside of the arch of the Del Bono chapel, and the drawings were presumably squared for transfer to the cartoon or wall surface (fig. 13). As seen by a spectator standing in the body of the church, looking into the chapel – the intended viewpoint for the canvases painted for the lateral walls – the putti of cat. 18 are those to the right of the oculus and those of cat. 19 to the left; the light falls on them as if from the altar wall, and the right embrasure and left end of the entablature in cat. 19 are seen correctly in perspective. However, such effects can be difficult to work out on paper,

and the figure of Christ sketched in cat. 18 would be the wrong way up as seen by the spectator and would be gesturing down to the *Healing* rather than the *Conversion*. Correggio therefore inverted the Christ in cat. 20 for the fresco, but neglected to maintain the position of the visible inner rim of the oculus; in the studies for the putti this was seen in its correct perspective, but the rim was frescoed in on the nave side of the oculus and thus incorrectly for the intended viewer. This error must have been realized by Correggio after the fresco had been executed, for the rim was painted out *a secco* and replaced by another on the opposite, correct, side of the oculus, as seen in old photographs (Popham, *Corr.*, pl. LIb). Sadly, when the frescoes were cleaned in the 1960s, this *secco* work was removed, and the wrongly positioned fresco rim revealed.

This beautifully homogeneous trio of drawings had presumably been together from Correggio's lifetime until 1987, when cat. 20 was sold. MC

21 *The Rest on the Flight into Egypt* (recto); *Saints Matthew and Jerome* (verso)

c. 1522–3

Red chalk, pen and brown ink, brown wash.
202 × 129 mm (7 ¹⁵/₁₆ × 5 ¹/₁₆ in)

Inscribed on mount: *Correggio*

National Gallery of Art, Washington D.C.
(1991.217.6 b; The Armand Hammer
Collection)

Provenance: Sir P. Lely (L. 2092); P. & D.
Colnaghi; M. Hirst; purchased by the Armand
Hammer Collection, 1970

Literature: Washington and Parma 1984,
no. 19; Muzzi and Di Giampaolo 1988, no. 85;
Ekserdjian 1997, p. 105

For the verso, see cat. 13a

This is one of three surviving drawings by
Correggio made in preparation for the
altarpiece known as the *Madonna della
Scodella* (fig. 14). The painting, now in the
Galleria Nazionale, Parma, was painted for
the chapel of the Society of Saint Joseph in
the church of San Sepolcro in Parma. It was
begun around 1522 and completed in 1530,
a lengthy delay not out of keeping with the
artist's habits.

This drawing depicting the Rest on the
Flight into Egypt was made very early in the
preparatory process. The composition was
first sketched loosely in red chalk, then
gradually defined with searching pen
strokes. Finally, it was given further tonal
resonance in red chalk and wash, although
Correggio still made a few rapid changes
of form with the brush. The rich flow
of movement leads from the dynamic, twisting
Saint Joseph down to the Virgin and Christ
Child, and then back to the left where an
angel takes away the ass. A second angel is
suggested in wash between the Christ Child
and Joseph. As has been thoroughly
analysed by Ekserdjian, the subject and form
of the composition change in the study in
the Uffizi (Muzzi and Di Giampaolo 1988, no.
86). Among other things, the subject

becomes the Return from Egypt, with a now
older Christ Child, and the figure of Joseph
adopts a pose close to that found in the final
painting. A third drawing in the Bloxham
Collection, Rugby School, consists of three
studies for the angels above (Muzzi and Di
Giampaolo 1988, no. 87) and, like the Uffizi
drawing, comes late in the evolution of
the project.

The style of the Washington drawing
is in full accord with the evidence of the
verso (see p. 46), a study for the pendentive

of San Giovanni Evangelista, showing Saints
Matthew and Jerome. The technique here is
very similar to that of the *Studies of putti*
(Louvre; Muzzi and Di Giampaolo 1988, no.
37) for the apse fresco of the same church,
while the figural and facial type of the
Virgin closely parallels the form of Saint
Matthew in the study in the J. Paul Getty
Museum (cat. 13). All of these stylistic
points argue for a date of around 1522–3
for the Washington sheet. GG

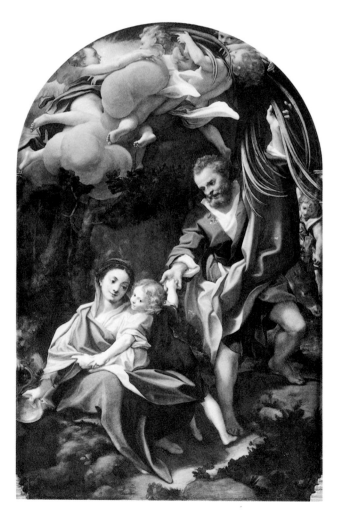

Fig. 14. Correggio, *Madonna
della Scodella*, oil on panel,
218 × 137 cm. Galleria
Nazionale, Parma.

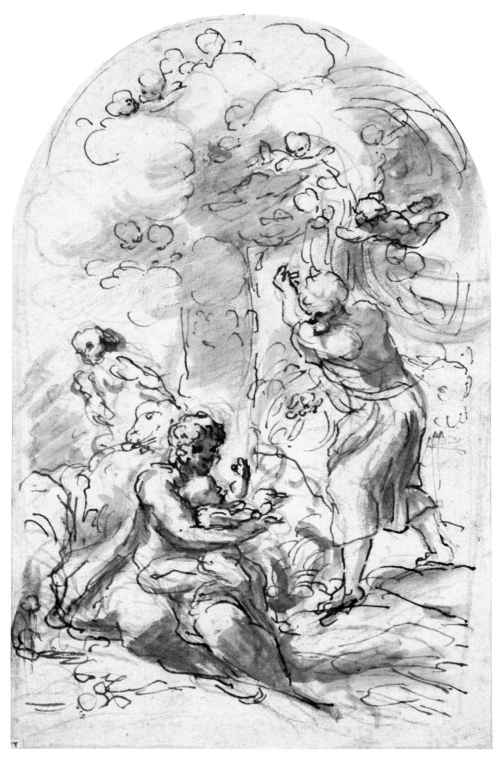

21

22 The Adoration of the Shepherds c. 1522

Red chalk, pen and brown ink, brown wash, extensive white heightening. 230 × 184 mm (9 ⁷⁄₁₆ × 7 ¼ in)

Fitzwilliam Museum, Cambridge (PD.119-1961)

Provenance: Sir P. Lely (L. 2092); W. Gibson (his price mark *Coreggio. 20.3.*, verso); Earls of Pembroke (their inscription *Cor: from vol. 2nd: No. 6.* on a fragment of an old mount; sale, Sotheby's, London, 10 July 1917, lot 490, bt C.B.O. Clarke); bequeathed by L.C.G. Clarke in 1960

Literature: Popham, *Corr.*, no. 72; Muzzi and Di Giampaolo 1988, no. 82; Ekserdjian 1997, p. 208

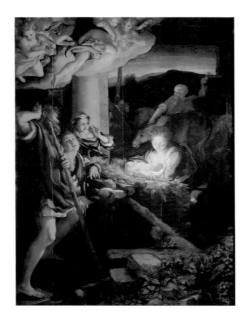

Fig. 15. Correggio, *Adoration of the Shepherds (La Notte)*, oil on panel, 256.5 × 188 cm. Gemäldegalerie, Dresden.

This is perhaps Correggio's most beautiful drawing and among his most elaborate, in which the artist obtained a highly colouristic effect by working the white gouache into the red chalk and brown wash, such that the principal group is essentially a painting. The sheet is generally accepted to be a study for the *Adoration of the Shepherds* in Dresden (fig. 15), commonly known as *La Notte*, with which it shares many elements, though completely rearranged – the same number of figures (the two angels standing beside Christ here are relegated to the background of the painting), the knot of shepherds along one edge, the group of flying angels in one corner, the column, and so on.

The painting was apparently installed in the Pratoneri chapel of the church of San Prospero, Reggio, in 1530. The contract between Correggio and Alberto Pratoneri was signed eight years before, on 24 October 1522, probably in fulfilment of the will of Alberto's father Gerolamo, and refers to a drawing by Correggio that he was to follow in the painting. It is implausible that Correggio could have devised the composition of the executed *Notte* as early as 1522, for its style and sophistication are much more compatible with his works of the late 1520s: there must have been

substantial revision of the composition after the contract of 1522 had been signed, most probably by informal agreement between patron and painter.

The present drawing may thus reflect to some degree Correggio's initial design for the painting, but it is unlikely that it is the drawing referred to in the contract (or a design that was to be transcribed in a 'fair copy' for that purpose) as there are fundamental compositional problems that Correggio had yet to resolve. The column here divides the composition in two and, with a hound and a patch of ground in the foreground, has the effect of pushing the main figure group further back in space. The drawing shows the experimentation with light sources that is the single most striking aspect of the painting: the composition is not tight enough, however, for the light from the Christ Child to illuminate

the entire picture field, and the shepherds merge with a landscape lit by a bright sky in gouache.

All of the figures at ground level are underdrawn with rapid red chalk in which many minor *pentimenti* are visible. Before beginning the drawing Correggio must have worked out the basic arrangement of these figures without fixing their precise poses, but the angels at upper right are drawn in pen and ink only, suggesting that their inclusion was not planned from the outset and that they were introduced at this stage to balance the group around the Christ Child. Despite the sharp chalk lines drawn with a ruler that delimit the composition and might indicate some degree of definitude, this must be an exploratory drawing dating from before the signing of the 1522 contract. MC

23 *The Madonna and Child with saints* *c.1523*

Red chalk, brush and brown ink, on pink-washed paper. 207 × 152 mm (8 ⅛ × 6 in)

Inscribed twice on mount: *Tiziano*

Christ Church, Oxford (0387)

Provenance: F. Baldinucci (his mount); General J. Guise

Literature: Popham, *Corr.*, no. 75; Byam Shaw 1976, no. 1065; Washington and Parma 1984, no. 20; Muzzi and Di Giampaolo 1988, no. 84; Ekserdjian 1997, pp. 197–8

Correggio's most frenetically worked drawing is the only surviving study for the *Madonna of Saint Jerome* (fig. 16) in the Galleria Nazionale, Parma (sometimes called *Il Giorno*, by analogy with *La Notte*, cat. 22). The relevant documents are lost but earlier writers stated that it was commissioned in 1523 by a Donna Briseide Colla for a chapel dedicated to Saint Jerome in the church of Sant'Antonio in Parma (where it was recorded by Vasari), and installed there in 1528, the year of the patron's death, and there seems no reason to disbelieve this basic information. The style of the painting suggests, as might be expected, that Correggio worked on it towards the end of the intervening period.

The iconography and form of the drawing (so far as can be discerned) are related to those of the painting but differ in many respects. In the painting Saint Mary Magdalene rests her head as if to kiss the Christ Child's foot, a reference to her anointing of the adult Christ's feet,

and thus behind the Magdalene is a child with her ointment jar. Saint Jerome stands to the left holding a Hebrew scroll and, with an angel, offers his translation of the Bible to Christ. These details allow most features of the drawing to be read. Here it is Saint Jerome who rests his cheek against Christ's head; the saint holds, and the Child reaches for, what is probably the scroll seen in the painting. A childlike figure, the angel of the painting, stands before the Madonna

Fig. 16. Correggio, *Madonna of Saint Jerome (Il Giorno)*, oil on panel. 205 × 141 cm. Galleria Nazionale, Parma.

supporting the Bible at which she looks (the pose of this figure was later recycled by Correggio for the Baptist in the *Madonna of Saint George*: fig. 21 on p. 74). To the right stands another male figure in a pose mirroring that of Saint Jerome in the painting: it is not entirely clear whether this is a second saint or, as seems more likely, a standing Saint Jerome superseding the half-crouching pose. Several other swirls of red chalk and brush strokes to the upper right must represent ancillary figures considered at some point in the study's evolution, but there is no indication of the Magdalene.

The central motif of a figure resting his or her head against the Christ Child was first used by Correggio in a lost *Holy Family of the Cradle* of *c.*1520 (see Ekserdjian 1997, pl. 156, for a copy), but that was a much smaller painting, and for an altarpiece Correggio had to find some way of expanding both the composition and its iconographic interest. In the absence of further studies, it is impossible to establish whether the introduction of the Magdalene was prompted primarily by formal or iconographic considerations, but by enclosing the Virgin and Child between two saints, one kneeling by the couple and one standing a little way off, Correggio was able to fill the height of the altarpiece and at the same time to maintain a sense of intimacy.

Byam Shaw mentioned a drawing in the Accademia, Venice, that he believed also to be by Correggio for the project, but De Grazia correctly assigned that sheet (in Washington and Parma 1984, no. 29) to Giorgio Gandini. Muzzi (in Muzzi and Di Giampaolo 1988) held out the possibility that cat. 23 might also be by Gandini, but all aspects of its style and conception speak of the hand of Correggio. MC

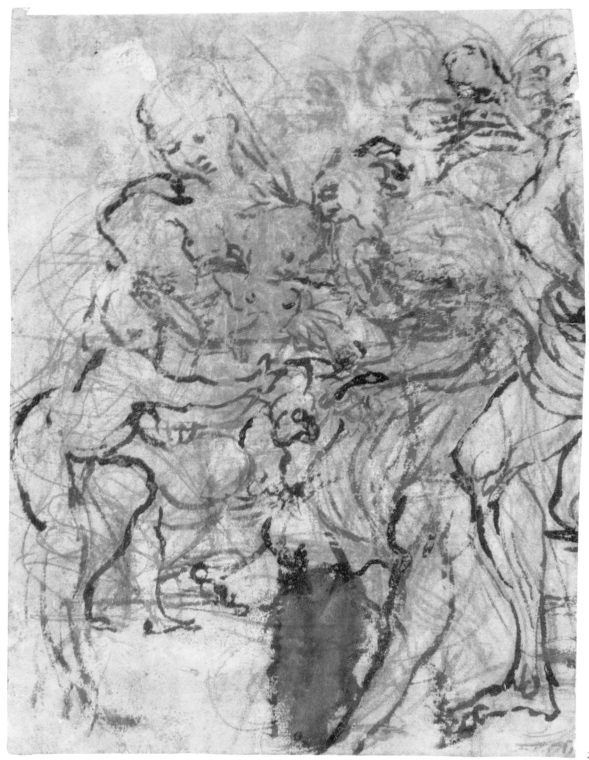

23

24 *Christ kneeling* *c. 1522–4*

Red chalk. 235 × 175 mm (9 ¼ × 6 ⅞ in)

Inscribed: *2* and *Coreggio*

British Museum, London (1862-10-11-200)

Provenance: S. Woodburn (sale, Christie's, London, 12 June 1860, part of lot 1187); W.B. Tiffin

Literature: Popham, *Corr.*, no. 79; Popham, *BM*, no. 16; Muzzi and Di Giampaolo 1988, no. 88; Ekserdjian 1997, p. 160

This is a study for the figure of the kneeling Christ in the *Agony in the Garden* (Apsley House, London), a picture which, from its intimate scale and high finish, must have been intended as a private devotional work (fig. 17). The painting is generally assigned to the period 1522–4, and this dating is consistent with the style of this drawing as the treatment of the figure is similar to that of Christ in the Chatsworth study for the Del Bono chapel

commission of the mid-1520s (cat. 18). The present drawing appears from the lively spontaneity of handling to be an early idea for the figure. Comparison with the finished work shows that the artist made a number of changes – adding a thick blue cloak over Christ's white shift (the colours delicately echoing the dawn landscape in the background); and, more significantly, the figure is shown more frontally so that his open-palmed gesture of acceptance of his impending suffering is directed outwards towards the viewer. As Ekserdjian perceptively observed, Christ's isolation is made even more poignant in the painting because he is shown gazing upwards to the right, seemingly unaware of the comforting presence of the angel arriving to the left. On the verso of the sheet there is a study for the figure of Cupid related to Correggio's painting of the *Education of Cupid* (National Gallery, London), which suggests that the latter work was executed at about the same period as the Apsley House panel. HC

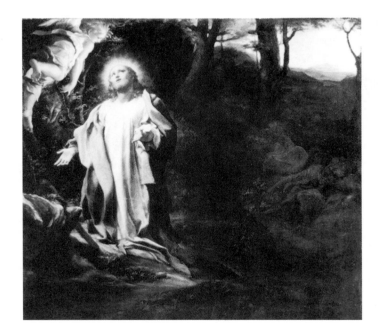

Fig. 17. Correggio, *Agony in the Garden*, oil on panel, 37 × 40 cm. Apsley House, London.

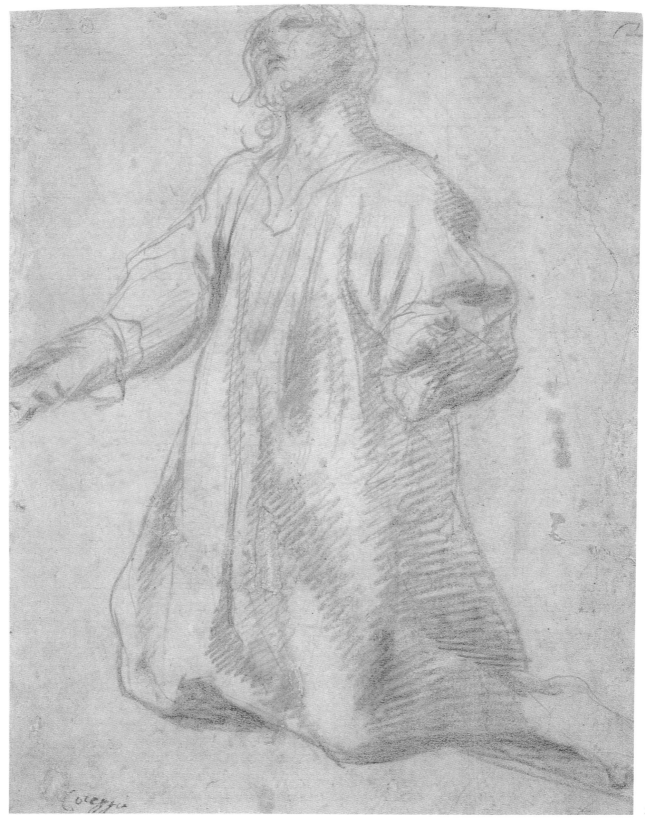

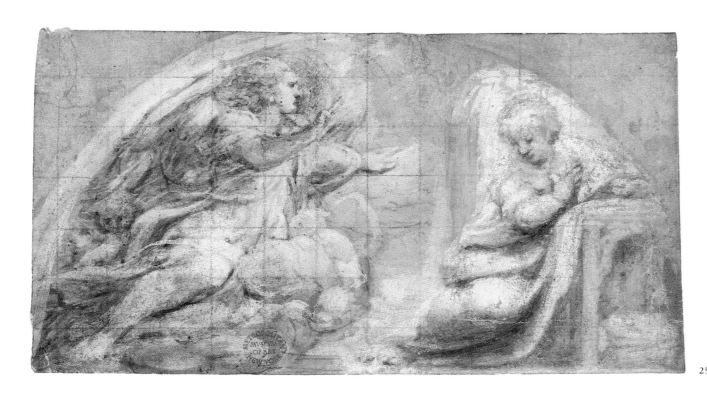

25 *The Annunciation* *c. 1522–5*

Pen and black ink, grey wash, extensive white heightening, squared in red chalk, on pink-washed paper. 95 × 172 mm (3 ¾ × 6 ¼ in)

The Metropolitan Museum of Art, New York (19.76.9; Hewitt Fund, 1917)

Provenance: Earls of Pembroke (detached from mount with their inscription *from vol 2ⁿᵈ No II*; sale, Sotheby's, London, 10 July 1917, lot. 465)

Literature: Popham, *Corr.*, no. 49; Washington and Parma 1984, no. 18; Muzzi and Di Giampaolo 1998, no. 54; Ekserdjian 1997, p. 144

This exquisite small sheet is a preparatory study for the badly damaged fresco now in the Galleria Nazionale, Parma, originally painted for the Frati Zoccoli of San Francesco, Parma (fig. 18). The drawing is highly worked up in a richly orchestrated mixture of media, with the topmost layer in thick white gouache. The highly sophisticated tonal and colouristic effects anticipate the brilliant lighting and colour of the fresco. The sheet is squared and must have been the final *modello*, in which the painter (and his patrons?) would have been able to visualize much of the final result on the wall. This and other sheets by Correggio in the same technique are perhaps the most painterly drawings made in Italy during his period.

Correggio made a few changes between the drawing and the fresco. The number of angels is brought up to four and the burst of light behind the Virgin is still more extensive. Both fresco and drawing have generally been dated to 1522–5, which surely seems to be accurate. GG

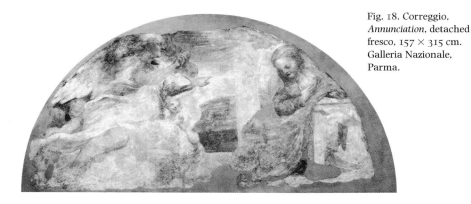

Fig. 18. Correggio, *Annunciation*, detached fresco, 157 × 315 cm. Galleria Nazionale, Parma.

Parma cathedral (cats 26–32)

Doubtless on the strength of his success in San Giovanni Evangelista, Correggio was commissioned in November 1522 by the administrators of the cathedral in Parma to paint its dome, pendentives, apse, choir and choir vault. He almost certainly did not begin work in the cathedral before 1524, when his work in San Giovanni Evangelista was concluded. In the event, the only part of the vast undertaking in the cathedral that Correggio completed was the dome and pendentives, which must have been finished by November 1530 when the artist received final payment for his work in the church. The subject of the dome fresco is not specified in the contract, but it was almost certainly intended from the beginning that Correggio should represent the Assumption of the Virgin as she was patron saint of the city of Parma, and the cathedral itself was dedicated to this episode.

The cathedral dome is much larger and higher than that of San Giovanni Evangelista, and Correggio's composition is correspondingly far grander and bolder than his earlier fresco, with a multitude of radically foreshortened figures. Quite apart from the daunting scale of the surface to be painted, Correggio also had to contend with the uneven form of the dome – rounded at the top and octagonal at the base – and he had, in addition, to work around the eight circular windows at the centre of each of the sides of the drum. As in his previous dome fresco, the primary viewpoint is that of a viewer at the foot of the steps leading to the crossing: from here the rising figure of the Virgin is most clearly visible, surrounded by a soaring mass of exultant angels. At the base of the drum, steeply foreshortened apostles witness the Virgin's ascension, while the level above is taken up by angels, some of whom tend candelabra. The sequence of surviving drawings for Eve (cats 29–30) demonstrates that Correggio was keenly aware of how hard it would be to distinguish any of the foreshortened figures high up in the dome. He was not, however, entirely successful in resolving the problem of legibility, to the extent that the all-important figure of the Virgin in the finished work is not immediately discernible among the mass of angels that follow her. There is anecdotal evidence to suggest that the daring illusionism of Correggio's work, which was so admired and influential in the seventeenth century, may not have been so well received by the cathedral canons; certainly after 1530 the painter received no further commissions in Parma.

HC

26 Studies for the base of the dome (recto and verso)
c. 1524–5

Red chalk over stylus. 197 × 167 mm (7 ¾ × 6 ⁹⁄₁₆ in)

Inscribed, verso: *Del Correggio*

Ashmolean Museum, Oxford (P. II 203)

Provenance: Sir P. Lely (L. 2092); J. Richardson Sr (L. 2183); Earls Spencer (L. 1531; sale, T. Philipe, London, 11 June 1811, lot 195, bt Thane); C. Hall gift, 1855 (L. 551)

Literature: Parker 1956, no. 203; Popham, *Corr.*, no. 50; Washington and Parma 1984, no. 21; Muzzi and Di Giampaolo 1988, no. 55; Ekserdjian 1997, pp. 242–3

The Ashmolean drawing is one of only two known studies from the early stages of Correggio's preparation for the decoration of the dome (the other is in the Teylers Museum, Haarlem; Muzzi and Di Giampaolo 1988, no. 65 verso). Drawn on both sides of the paper, the Oxford sheet shows a single bay of the lower part of the octagonal dome with the circular window at the centre. Correggio started the drawing on what is now regarded as the verso of the sheet and continued to develop the composition with increasing fluency of touch on the recto. It is likely that the artist himself cut the paper into its present curved form, as it corresponds to the shape of one of the sections of the dome; the division of such a large project into more manageable (and potentially repeatable) units is entirely in keeping with Correggio's very logical method of working.

The artist began on the verso by defining the architectural elements (guided by preliminary stylus indications), with the circular window, as in the finished work, set into a recessed panel. On either side of this are figures, most probably prophets, seated on high-sided thrones placed behind winged sphinxes. Correggio may have had in mind Michelangelo's brooding seated prophets in the Sistine Chapel ceiling, but unconventionally one of the figures on the verso and both of those on the recto appear to be sleeping. Behind the right-hand prophet the artist has roughly indicated a massive curved half-column which terminates, rather unsatisfactorily, below the level of the parapet, and a similar form can be dimly made out on the left. This architectural feature is repeated on the verso, and the idea of fictive columns punctuating the curved surface of the drum is developed further in the Haarlem drawing. On the parapet above the prophets are candelabra, beside which are seated angels whose draperies trail over the edge of the cornice. The space between these figures is blank, but the artist must always have intended it to be filled, as the subject of the Assumption of the Virgin demanded the inclusion of the apostles witnessing the event.

The architecture on the recto follows on closely from the earlier study (and is probably traced through from the verso), except that the moulding for the frame of the window is simpler apart from a section in the upper right where the foliate wreath decoration used on the verso is repeated.

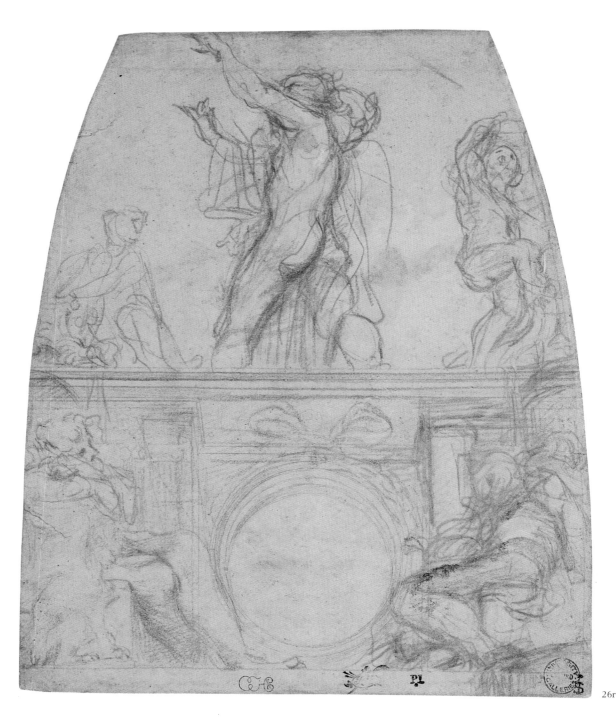

26r

Correreggio was similarly undecided as to the form of the flanking pilasters and he tried out, as he had on the verso, two different orders, but with the added variation that the right-hand one is taller. The two prophets on the recto are more clearly conceived as pendants than the ill-matched pair on the verso, but to ensure the visibility from below of the right-hand figure the artist eliminated the sphinx and the side of the throne. The bold manner in which the right-hand prophet is studied contrasts with the generally hesitant and probing touch of the verso, and this new-found dynamism is also found in the rapidly sketched figures standing on the parapet, in particular the striding figure of the partly draped apostle with his head drawn in two different positions.

The Oxford drawing demonstrates that Correggio originally had in mind an

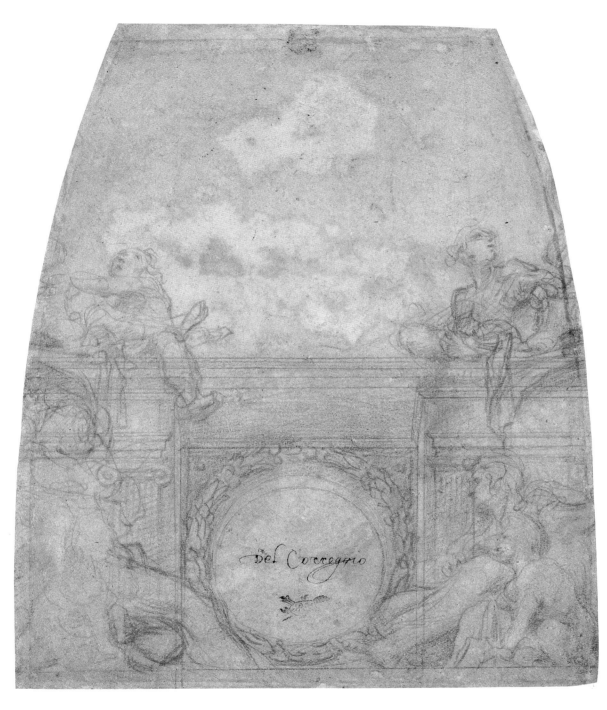

arrangement similar to that of the dome of San Giovanni Evangelista, with the apostles encircling the central scene. This would have seriously interrupted the space available to show the Virgin ascending into paradise, and it would also have resulted in the apostles and the figures tending the candelabra being packed closely together. Correggio's elegantly simple solution was to place the apostles in the unadorned space between the windows, and as a consequence their scale could be increased without impinging on the scene above. Unfortunately, no drawings survive to document the revision of the design, and the remaining studies for this part of the fresco all post-date this change. HC

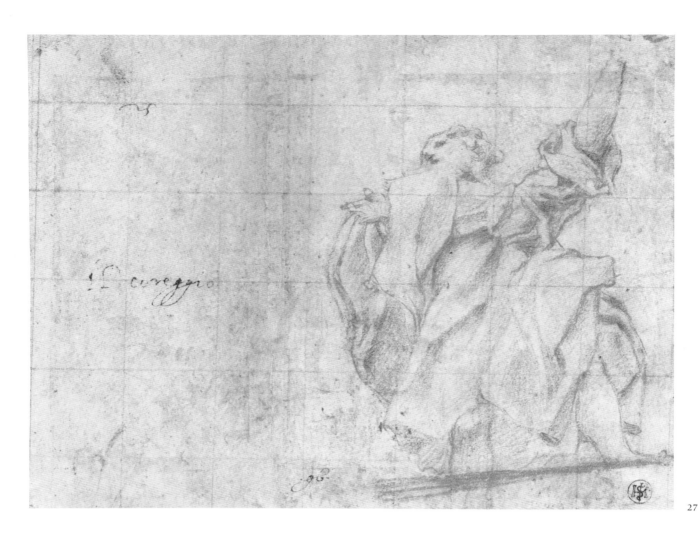

27 An apostle *c. 1523–5*

Red chalk, squared in red chalk.
138 × 179 mm (5 ⁷⁄₁₆ × 7 ¹⁄₁₆ in)

Inscribed: *il coreggio* and *gb*

Private collection, London

Provenance: P. Sylvester (L. 2108);
J. Richardson Sr (L. 2184); an unidentified
collector's mark, HK (Dr H. Koch ?); anon.
sale, Sotheby's, New York, 3 June 1980, lot 90

Literature: Muzzi and Di Giampaolo 1988,
no. 74

This double-sided drawing is one of five
surviving full-length studies for the
foreshortened apostles at the base of the
dome (Muzzi and Di Giampaolo 1988, nos
71–5). The study on the recto is a squared
and, most likely, final, design for the apostle
gesturing skywards above the pendentive
of Saint Bernard (Gould 1976, pl. 135).
Correggio evidently continued to refine the
pose of the figure, as the position of the left
arm is slightly altered in the fresco and the
apostle's right leg is moved further forward.
The broad simplification of the drapery and
the unnatural articulation of the limbs,
which make the drawn figure look so
awkward, are not apparent in the corre-
sponding figure in the fresco when viewed
from below; indeed they are vital to the
powerfully affecting impression of the saint
in the finished work, who gestures upwards
but averts his eyes, as though unable to bear
the burst of heavenly light shining on him
from above. The study gives some insight
into the formidable difficulties that
Correggio had to confront in planning such
steeply foreshortened figures, and the extent
to which he was willing to manipulate the
forms of the apostles for expressive effect. HC

28 *The Virgin ascending*

c. 1523–5

Red chalk, traces of white heightening.
278 × 238 mm (10 ¹⁵/₁₆ × 9 ⅛ in)

Inscribed: *Coregio 76*

British Museum, London (1895-9-15-720)

Provenance: J. Richardson Sr (L. 2184); T.
Hudson (L. 2432); Sir J. Reynolds (L. 2364);
W.Y. Ottley (sale, T. Philipe, London, 23 June
1814, lot 1733); Sir T. Lawrence (L. 2445);
King William II of Holland (according to
Robinson); G. Leembruggen (sale,
Amsterdam, 5 March 1866, lot 868);
J. Malcolm

Literature: Popham, *Corr.*, no. 57; Popham,
BM, no. 13; Washington and Parma 1984,
no. 22; Muzzi and Di Giampaolo 1988, no. 68

This and the following three drawings (cats
29–31) are preparatory studies for figures in
the fresco of the *Assumption of the Virgin* in
the dome of Parma cathedral. They relate
specifically to the ascending figure of the
Virgin and the surrounding group of
biblical characters divided by gender (men
to the left of her and women to the right)
who welcome her into paradise (fig. 19).
The majority of the elect in paradise are
anonymous, but a few key figures around
the Virgin are recognizable through familiar
attributes, such as the apple held by Eve.

 The present study is, along with a
double-sided study in Dresden (Muzzi and
Di Giampaolo 1988, no. 69), related to the
figure of the ascending Virgin. It is not
easy to determine the relative order of the
two drawings, as the Dresden drawing
looks from the freedom of execution to be
earlier, although it is closer to the form of
the finished figure. The main difference
between the two studies is the dynamic, if
indecorous, pose of the Virgin here, which
was not adopted in the final work. The
vitality of the drawing owes much to the
sharply etched quality of the line, and to the
incisive alterations made to the position of

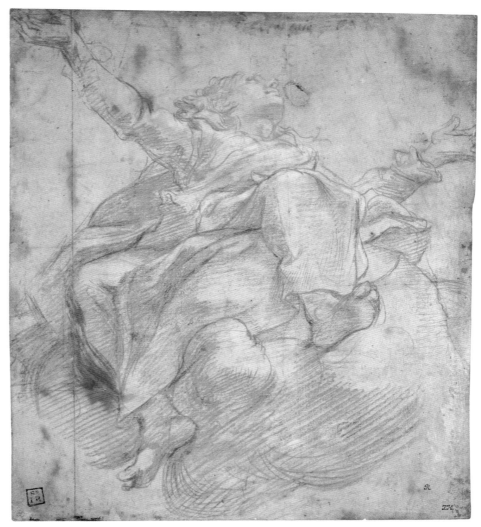

28

the Virgin's hands and drapery folds.
Correggio's range as a draughtsman is
readily apparent from the very different
effects he achieved using the same red chalk
medium in this drawing and the near-
contemporary study of Eve (cat. 29). HC

Fig. 19. Correggio, detail from the *Assumption of
the Virgin*, fresco. Parma cathedral.

29 *Eve, with a putto holding the apple* c. 1523–5

Red chalk. 183 × 130 mm (7 ³/₁₆ × 5 ⅛ in)

British Museum, London (1895-9-15-738)

Provenance: Sir P. Lely (L. 2092); Earls of Cholmondeley (L. 1149); Sir J. Reynolds (L. 2364); R. Ford (L. 2209); J.H. Hawkins (according to Robinson); J. Malcolm

Literature: Popham, *Corr.*, no. 51; Popham, *BM*, no. 12; Muzzi and Di Giampaolo 1988, no. 64

Three other studies for the figure of Eve are known (Muzzi and Di Giampaolo 1988, nos 65–6, and cat. 30 below), the earliest of which is the red chalk and pen and ink drawing in the Teylers Museum, Haarlem (Muzzi and Di Giampaolo 1988, no. 65). The outlines of the figures of Eve and the putto in the British Museum drawing were traced from the Haarlem study, as was recently demonstrated when a tracing of the latter was placed over the present sheet. The only major difference between the two drawings is the addition in the London study of the grinning woman to the left of Eve – a figure not found in the finished work. Unlike in the Haarlem drawing, there are relatively few alterations to the contours, except for the adjustments made to the position of the apple held by the putto. Correggio's main focus in the present sheet appears to have been to study the play of light over Eve's seductively rounded form. The artist also kept in mind the relative position of the figure within the composition, as in cat. 31, by means of the curved line at the upper left, roughly marking the boundary between the heavenly company and the burst of light in the centre. In the fresco Eve's right-handed gesture of supplication is retained, although it is obscured by her left arm, which is extended to offer the apple to Adam on the other side of the Virgin. HC

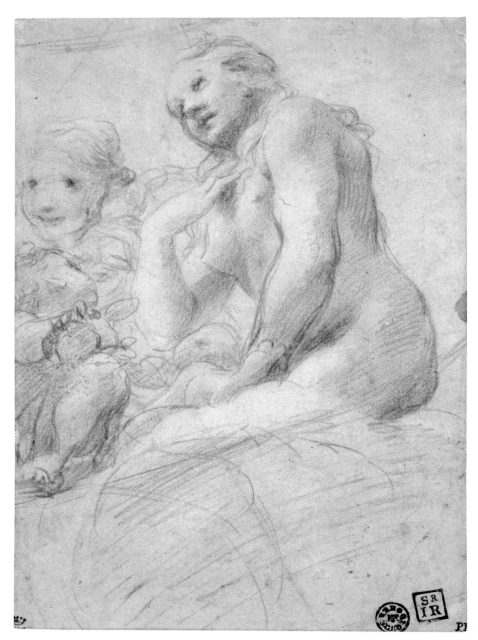

P1 29

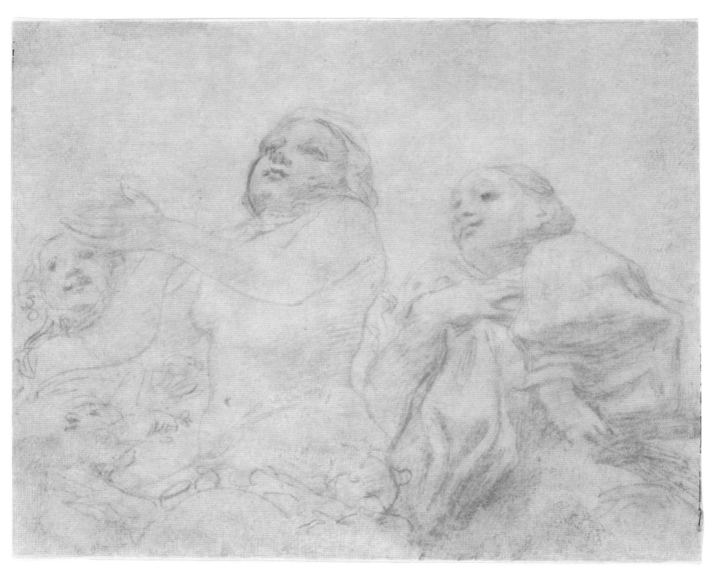

30 *Eve and other figures*
c. 1523–5

Red chalk. 171 × 200 mm (6 ¼ × 7 ⅞ in)

Private collection, USA

Provenance: European private collection

Literature: Ekserdjian 1997, p. 247

This recently discovered sheet was made late in the design process for the group of Eve with several attendant figures. Unlike in the British Museum study (cat. 29), Eve is here shown with her left arm extended, offering the apple to Adam. This pose is already used in a study in the Louvre of Eve alone (Muzzi and Di Giampaolo 1988, no. 16) and was adopted with minor adjustments in the fresco. Here Correggio also considers the poses of those around Eve, giving the female figure to her right the gesture of Eve's right hand found in earlier studies. She will also appear in similar form in the final painted version. He also adds quick notational sketches of several of the angels nearby. Lastly, he reinforces the contour along one side of Eve's face and on the drapery of her companion to clarify these important details in the overall design.　　　GG

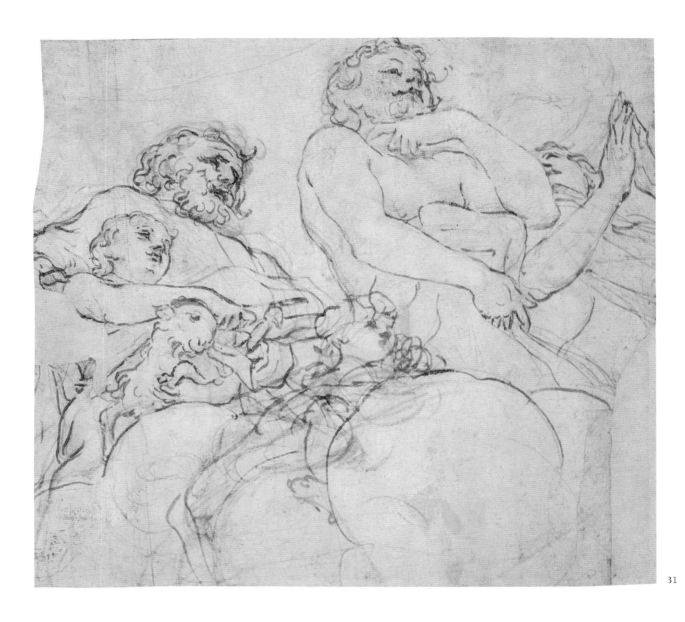

31

31 *Abraham, Isaac and Adam* c. 1523–5

Red chalk, pen and brown ink.
206 × 235 mm (8 ⅛ × 9 ¼ in)

Royal Library, Windsor Castle (0597)

Provenance: King George III

Literature: Popham and Wilde 1949, no. 247;
Popham, *Corr.*, no. 55; Muzzi and Di
Giampaolo 1988, no. 61

The drawing shows on the left the Old
Testament patriarch Abraham and his son
Isaac holding a lamb, and on the right

Adam, musing on Eve's offer of the apple,
with John the Baptist at his side (the latter
figure is identifiable in the fresco, but not
here, by a reed cross). Cat. 31 corresponds
closely to the form of the finished work,
apart from the omission of the Virgin's
outstretched arm (fig. 19). Doubtless guided
by previous studies, Correggio first drew the
outlines of the composition in red chalk,
roughly indicating by the curved line in the
top left corner where the figures would be in
relation to the central circle of light. Only in
the figure of the putto is the chalk under-
drawing ignored and the pose studied
afresh; the figure of John the Baptist was
initially drawn higher up the page and then

studied again slightly lower down. The artist
then went over the chalk with the pen,
fixing the contours and adding a few details.
The primary function of the Windsor
drawing appears to have been to establish
the relative position of the figures, and it
must have been preceded by detailed figure
studies such as cats 29–30. Correggio's use
of very thin paper for the present work is
characteristically practical, as it would have
allowed him to trace the outlines of pre-
existing studies simply by placing the almost
transparent sheet on top of them. HC

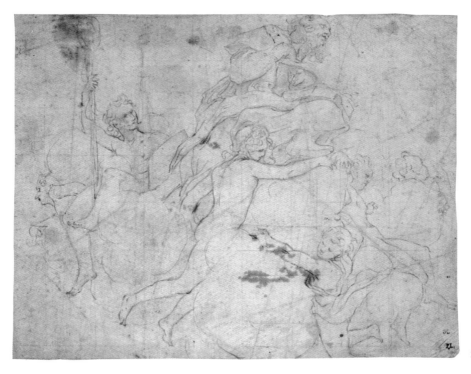

32

32 *Saint Bernard Uberti*
c. 1527–8

Red chalk, the outlines partly gone over in
pen and brown ink, squared in red chalk.
203 × 252 mm (8 × 9 ¹⁵⁄₁₆ in)

British Museum, London (5210-24)

Provenance: Sir P. Lely (L. 2092); J.
Richardson Sr (L. 2184); W. Fawkener
Bequest, 1769

Literature: Popham, *Corr.*, no. 70; Popham,
BM, no. 14; Muzzi and Di Giampaolo 1988,
no. 81

Fig. 20. Correggio, pendentive with Saint
Bernard Uberti, fresco. Parma cathedral.

After completing the cathedral dome
Correggio frescoed the pendentives of the
crossing with four patron saints of Parma:
Hilary, Joseph, Bernard Uberti and John the
Baptist. As Ekserdjian first pointed out,
Correggio's paintings can be dated with
some precision to a two-year period between
the adoption of Saint Joseph as one of the
patrons of the city in March 1528, and
November 1530 when the painter received
his final payment for his work in the
cathedral (Ekserdjian 1997, p. 258). The
present drawing relates to the north-west
pendentive with Bernard Uberti, the twelfth-
century Florentine saint who had served
as Bishop of Parma (fig. 20). In the fresco

he gazes upwards, his right hand on his
breast in an attitude of supplication to the
assembled company of heaven above him,
while with his other hand directing their
attention to the congregation in the
cathedral below. The drawing corresponds
closely with the painting except that here
the angel on the left holds the crozier in his
right rather than his left hand. As Popham
observed, the artist made this change
because in its original position the crozier
would have impinged on the border of the
shell niche surrounding the figures. The
even, unmodulated quality of the line shows
that Correggio began by tracing the outlines
from an earlier, and now lost, study. He then
made a number of small adjustments to the
figures in ink, most notably to the position
of the head of the angel directly below the
saint. Although the drawing is squared –
twice over in the case of the figures on the
right – it is probably not the final design
as there is a red chalk study in the Louvre
that corresponds even more closely to the
frescoed pendentive (fig. 3; Muzzi and Di
Giampaolo 1998, no. 79). As has often been
noted, the pose of the angel clinging to the
cloud was re-used in a slightly modified
form for the figure of the youthful shepherd
in the painting of the *Abduction of Ganymede*,
commissioned in around 1530 by Federico
Gonzaga and now in Vienna. HC

33 *Study for the upper part of the 'Madonna of Saint George'* c. 1524–9

Traces of red chalk, pen and brown ink, brown wash. 163 × 232 mm (6 ⁷/₁₆ × 9 ⅛ in)

British Museum, London (1860-6-16-21)

Provenance: Count Bianconi (according to Lawrence Gallery); Sir T. Lawrence (L. 2445); S. Woodburn (sale, Christie's, London, 5 June 1860, lot 287)

Literature: Popham, *Corr.*, no. 74; Popham, *BM*, no. 15; Muzzi and Di Giampaolo 1988, no. 83; Shearman 1992, p. 154; Ekserdjian 1997, p. 188

A study for the arch and angels in the upper section of the *Madonna of Saint George* (Gemäldegalerie, Dresden) painted for the confraternity of Saint Peter Martyr in Modena (fig. 21). The date of the altarpiece is unknown, but a feeble adaptation of the composition in a grisaille painting in the City Art Gallery in York by the Modenese painter Girolamo Comi dated 1530 (Ekserdjian 1997, fig. 203) proves that Correggio's work was in place by this date. One other drawing for the project survives, a splendid study, executed in brush and brown wash with white heightening, for the entire composition and the frame (Dresden; Popham, *Corr.*, no. 73; a drawing surprisingly excluded from Muzzi and Di Giampaolo's corpus). The Dresden study differs in a number of respects from the finished work and must date from quite an early stage in the evolution of the design. The present drawing is, by contrast, so close to the altarpiece that Popham

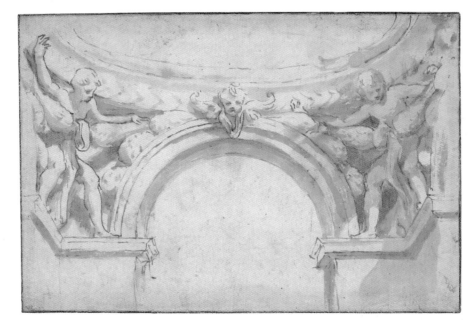

33

convincingly reasoned that it was executed while Correggio was in the process of painting the picture in order to help him finalize the effect of light coming through the openwork dome at the top right of the composition. The figures and the architectural elements, outlined in pen over a minimal red chalk underdrawing, are boldly simplified, enabling Correggio to study, through delicate modulations of the wash and the use of the blank paper as a highlight, the chiaroscuro lighting that plays over their surfaces. The final composition is close to that studied in this drawing, except that the arches at the sides are no longer visible.

HC

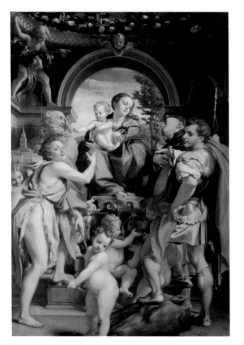

Fig. 21. Correggio, *Madonna of Saint George*, oil on panel, 285 × 190 cm. Gemäldegalerie, Dresden.

34 *Venus asleep* c. 1523

Red chalk, some white heightening, on pink-washed paper. 168 × 110 mm (6 ⅝ × 4 ⁵⁄₁₆ in)

Inscribed: *Del Coreggio*

Royal Library, Windsor Castle (0594)

Provenance: King George III

Literature: Popham and Wilde 1949, no. 246; Popham, *Corr.*, no. 81; Muzzi and Di Giampaolo 1988, no. 91

The drawing is a study for the painting in the Louvre of *Venus and Cupid with a satyr* (fig. 22). This was perhaps painted as a pendant to the National Gallery *Venus with Mercury and Cupid*, although the marked difference in size and figure scale would argue against this; regardless, they were both probably executed for the collector Nicola Maffei in Mantua, later passing into the Gonzaga collections and thus to King Charles I in 1627–8. On stylistic grounds it seems that the London painting was executed around 1523 and the Paris picture a little later. As Freedberg pointed out (1950, p. 71), the pose of Venus may have inspired Parmigianino's Saint Jerome in his *Madonna of Saint Jerome* (see cats 88–93), which would imply that the composition was known to the younger artist before his departure for Rome in 1524. It is therefore plausible that the two pictures for Maffei were designed concurrently around 1523.

The rough chalk lines surrounding Venus here were presumably intended as drapery, for there is no indication of Cupid or of the satyr. Her pose is close to that in the painting, but there she is placed in a more relaxed attitude; this seems to be a real development by Correggio and not merely a reorientation of this sheet by a later collector's scissors, for it was unusual for an artist to draw skew to his sheet and

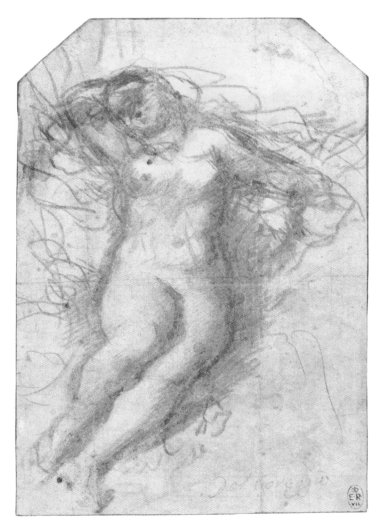

34

here the edges of the sheet follow the laid lines of the paper. By laying Venus at a shallower angle Correggio was able to draw the spectator into a curved space, seeing the goddess's body as if from above – our viewpoint is in essence the same as that of the satyr, and this sense of voyeurism is one of the painting's most striking qualities.

A drawing in the Louvre of a *Satyr and a sleeping nymph* was thought by Popham (1957, no. 80; Muzzi and Di Giampaolo 1988, no. 90) to be possibly an earlier study for the picture, although the composition is completely different and there seems to be no relation between the two beyond the general subject matter. MC

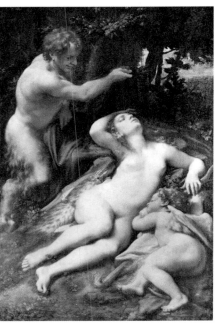

Fig. 22. Correggio, *Venus and Cupid with a satyr*, oil on canvas, 188.5 × 125.5 cm. Musée du Louvre, Paris.

35

35 *Female figure with a torch*
c. 1530

Red chalk. 78 × 59 mm (3 1/16 × 2 5/16 in)

Inscribed, verso: *Del Coregio*

The Woodner Collections, on deposit at the National Gallery of Art, Washington, D.C.

Provenance: J. Richardson Sr (L. 2183, verso); E. Bouverie (L. 325); Rev. Dr H. Wellesley (L. 1384, verso; sale, Christie's, London, 26 June 1866, probably part of lot 360); R. Johnson (L. 2216, verso); H. Oppenheimer (L. 1351, verso; sale, Christie's, London, 10 July 1936, lot 74A); F. Strolin, Lausanne

Literature: Popham, *Corr.*, no. 87; Washington and Parma 1984, no. 26; Muzzi and Di Giampaolo, no. 95; New York 1990, no. 21

This fine fragmentary drawing is related in subject and pose to two studies on the verso of a sheet in the Musée Bonnat, Bayonne (Muzzi and Di Giampaolo 1988, no. 94). Popham identified the figure as Venus, and suggested that these studies were made in preparation for an unexecuted painting for Isabella d'Este of the *Battle between Chastity and Lust*, which would hypothetically have replaced the one completed for her in 1505 by Perugino. There is no documentary evidence to support this proposal, which would place the Bayonne and Woodner sheets in the 1530s, when Correggio was employed on several mythological paintings for Isabella. This dating has been generally rejected, in part on account of the supposed relationship between the Woodner drawing and two still smaller fragmentary studies for Correggio's frescoes in the dome of the cathedral (Muzzi and Di Giampaolo 1988, nos 62–3). It is claimed that since these three fragments share a common eighteenth-century provenance and are similar in style, they were all from the same sheet and drawn at the same time. This would imply a date of around 1525 for the Bayonne and Woodner drawings of *Female figure with a torch*. There is, in fact, nothing to support this hypothesis, and the style of the Bayonne sheet accords much more fully with studies of the 1530s. For example, the sketch of the figure which is gone over in pen and ink on the verso of the Bayonne sheet finds close parallels to the drawing of *Four saints* in the Uffizi (Muzzi and Di Giampaolo 1988, no. 89), while the Woodner study is very similar to the *Putto riding a goat* in the Galleria Estense, Modena (Muzzi and Di Giampaolo 1988, no. 93). The latter was probably also made in connection with the artist's work for Isabella. Therefore, a date of around 1530 for the Woodner drawing appears likely. GG

36 *Allegory of Vice* *c. 1530–1*

Red chalk. 274 × 194 mm (10 13/16 × 7 5/8 in)

British Museum, London (1895-9-15-736)

Provenance: J. Richardson Sr (L. 2184); E. Bouverie (L. 325; sale, Christie's, London, 20 July 1859, lot 26); Sir J.C. Robinson; J. Malcolm

Literature: Richardson 1722, p. 15; Popham, *Corr.*, no. 91; Popham, *BM*, no. 17; London 1981–2, no. 115; Muzzi and Di Giampaolo 1988, no. 98

This is a study for the *Allegory of Vice*, one of a pair of allegorical paintings by Correggio commissioned by Isabella d'Este for her *studiolo* in the Palazzo Ducale in Mantua (fig. 23). The painter Jonathan Richardson Jr saw Correggio's painting in Paris and noted in print for the first time its relationship to the present drawing, which

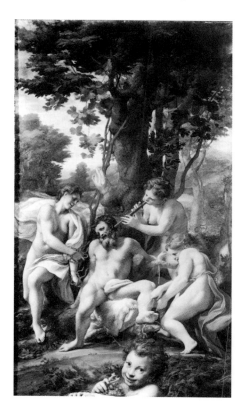

Fig. 23. Correggio, *Allegory of Vice*, tempera on canvas, 149 × 88 cm. Musée du Louvre, Paris.

was then in his father's collection, in his account of his Italian tour published in 1722. The *Allegory of Vice* and its pendant, the *Allegory of Virtue*, both of which are now in the Louvre, were painted in tempera to accord with the allegorical works by Mantegna, Perugino and Costa already hanging in the room. The correspondence between the drawing and the finished work is close, the only significant difference being the addition of a head of a grinning boy holding a bunch of grapes in the foreground of the painting. This highly finished but unsquared study may have been drawn specifically to show the intended composition to the notoriously fussy patron in order to win her approval.

The recondite subject matter of Correggio's picture is typical of the works commissioned by Isabella d'Este for her *studiolo*, and still defies precise interpretation. This confusion can be traced back to an early date, for in Isabella's posthumous inventory of 1542 it was wrongly described as an *Apollo and Marsyas*, an identification that overlooks the fact that the snake-haired tormentors are all clearly female. No precise literary source for the work has been discovered, but the prominence of the vine is, as Ekserdjian pointed out (in London 1981–2), the most likely iconographic clue. The vine is also found in Mantegna's *Samson and Delilah* (National Gallery, London) and in both works it embodies the notion of man as a prisoner of his desires. HC

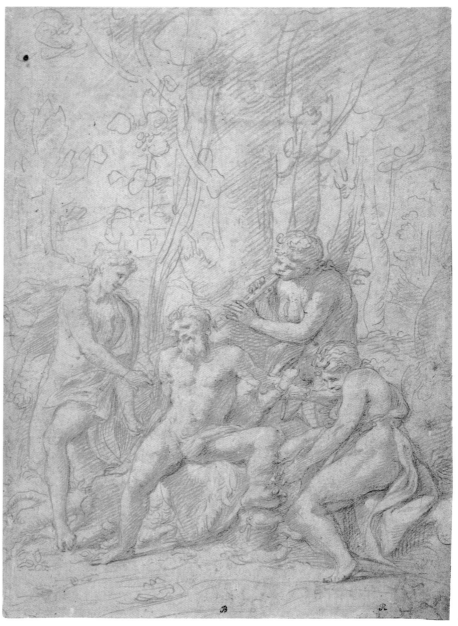

36

Parmigianino

Parmigianino's early years in Parma (cats 37–56)

Parmigianino (Girolamo Francesco Maria Mazzola) was born on 11 January 1503 in Parma to a family of artists. His father Filippo and uncles Pier'Ilario and Michele Mazzola were all painters, and much of their hard style can be seen in Parmigianino's first securely datable painting, the Berlin *Baptism* of 1519 (though this has not been accepted by all scholars as by Parmigianino). In 1521 he left Parma for Viadana, twelve miles north-east of Parma on the Po, to escape a resurgence of the long struggle between papal and French forces for control of the city. There he painted a *Mystic Marriage of Saint Catherine* (Santa Maria, Bardi) and a lost *Saints Francis and Clare*. The final resolution of the conflict in favour of the Papacy led to a boom in artistic patronage in Parma, and on Parmigianino's return he became involved in the decoration of San Giovanni Evangelista. He frescoed parts of at least two chapels in the church between 1522 and 1524 (cat. 42) and assisted Correggio in his pendentives below the dome; he must at this time have had ready access to Correggio's drawings (cat. 37). In November 1522, still not twenty years old, Parmigianino was also one of the artists commissioned to fresco parts of Parma cathedral, although his allocation in the north transept was never carried out (cats 39–40). While Correggio was the leading painter in the city there was a dynamic *équipe* of younger artists, including Parmigianino, Michelangelo Anselmi and Francesco Maria Rondani, who probably exchanged ideas in loose collaboration on such large-scale projects.

Beyond these ecclesiastical commissions Parmigianino was in demand among private patrons, especially Galeazzo Sanvitale, whose portrait he painted in 1524 (Capodimonte, Naples) and for whom he executed the beautiful fresco cycle of *Diana and Actaeon* at Fontanellato (cats 46–7). There was thus no shortage of prestigious work in Parma, but Pope Clement VII, elected in November 1523, soon began to revive the dynamic patronage of his cousin Leo X (d. 1521) and Rome once again became the focus of artistic progress in Italy. Like many other young artists Parmigianino set out for the city, probably travelling via Florence and arriving in Rome in late 1524.

MC

37 *Studies of Saint John the Evangelist, a putto and a leg (recto); Two heads of a woman, an arm, the head of a bearded man, a seated male nude and a heraldic device (verso)* c.1522

Red chalk and a little pen and pale brown ink (recto); red chalk and charcoal or black chalk (verso). 183 × 205 mm (7 3/16 × 8 1/16 in)

Inscribed, recto: *Coregio*

Ashmolean Museum, Oxford (P. II 435)

Provenance: J. Richardson Sr (L. 2183); Earls Spencer (L. 1531; perhaps sale, T. Philipe, London, 11 June 1811, lot 187, bt Coxe); C. Hall gift, 1855 (L. 551)

Literature: Parker 1956, no. 435; Popham, *Parm.*, no. 330; Washington and Parma 1984, no. 27; Ekserdjian 1997, pp. 103–4

The bearded head and male nude on the verso, and the leg on the recto, correspond with the figure of Saint Peter painted by Correggio in the dome of San Giovanni Evangelista, Parma. Parmigianino's model was not the fresco, but Correggio's drawing now in the Louvre (Muzzi and Di Giampaolo 1988, no. 13), for the putto drawn twice on the recto of the present sheet reproduces one below Saint Peter in the Louvre sheet who does not appear in the fresco. Similarly the Saint John (identified by his eagle) studied three times on the recto does not agree with that figure in the dome, and it seems inherently likely that he was also copied from a drawing by Correggio, now lost; another drawing by Parmigianino in the National Gallery of Ireland (Popham, *Parm.*, no. 64, pl. 9) also appears to reproduce lost studies by Correggio, for the figure generally identified as Saint Matthias in the same fresco and for the frieze running around the base of the dome. The source of the woman's head drawn twice on the verso here has not been identified: there are no women depicted in the dome.

Parmigianino was not attempting to make a facsimile of Correggio's drawings, for he selected and rearranged motifs that caught his attention and the character of his sheet is thus quite different from that of Correggio. Both Parmigianino and Correggio were active in San Giovanni Evangelista for much of the period between 1522 and 1524, Parmigianino even working as one of Correggio's assistants for a time (a putto in one of the squinches of the dome is now generally accepted as painted by the younger artist; Ekserdjian 1997, pl. 91), and there would have been ample opportunity for him to copy the master's drawings. The slightly hesitant style would place this sheet earlier rather than later in that period.

Traversing the upper left corner of the verso is a saw-like heraldic device, a bend sinister raguly, drawn in black chalk or charcoal. This must have been drawn first, for the red chalk studies on the verso are laid out to avoid this feature. It has not proved possible to associate this device with any relevant family arms.

MC

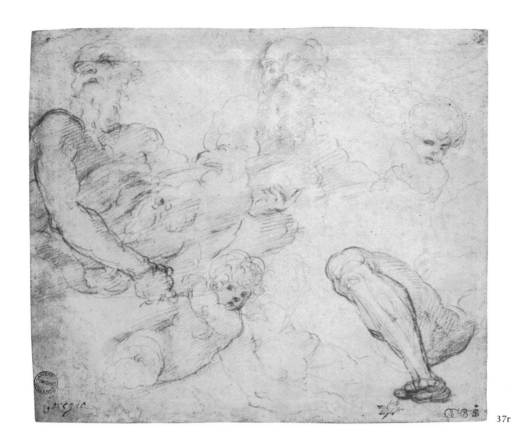

37r

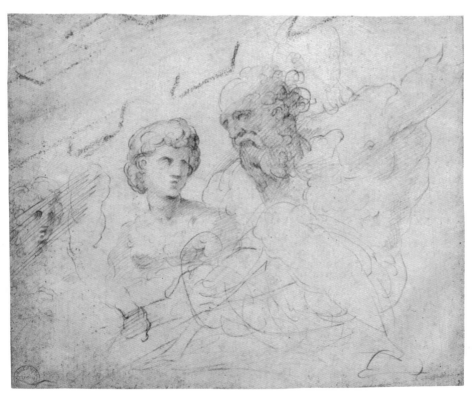

37v

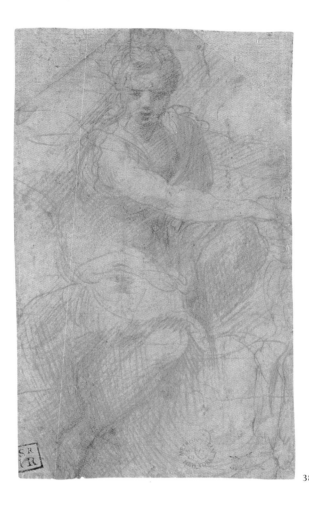

38r

38v

38 *Seated goddess Diana (recto); Studies of a nude male torso seen from the rear, and of a leg (verso)* *c.1522*

Red chalk. 148 × 87 mm (5 ¹³/₁₆ × 3 ⁷/₁₆ in), upper corners cropped and made up

The Metropolitan Museum of Art, New York (10.45.4; Rogers Fund, 1910)

Provenance: 2nd Earl of Arundel; Sir J. Reynolds (L. 2364); J. Richardson Sr (L. 2183); J. Barnard (L. 1419 and 1420); purchased in London, 1910

Literature: Popham, *Parm.*, no. 295; Rossi 1980, pp. 5, 84; Bean 1982, no. 158; Washington and Parma 1984, no. 28

Exhibited in New York only

The softly rendered drawing on the recto of this early sheet was clearly inspired by Correggio's *Diana*, frescoed around 1518–19 above the fireplace in the Camera di San Paolo in Parma. The drawing technique is palpably Correggesque, with reinforced contours full of movement and a *sfumato* effect of tone despite the use of hatching. The present study has been described as a 'copy from memory' after Correggio, but it reveals such fundamental differences of conception with respect to Correggio's fresco (the goddess exhibits more compact bodily proportions, and is seated in a languid, entirely restful pose) that it seems an independent work. It may well be that the challenge of designing a Diana fresco cycle of his own in the small room at the Rocca Sanvitale in Fontanellato stimulated Parmigianino in this iconographic exercise.

The proportions of the torso on the verso of the sheet seem closer to the hefty anatomy of some of the putti in Correggio's Camera di San Paolo oculi frescoes, or of his semi-nude apostles in the dome frescoes at San Giovanni Evangelista than to the original of the famous Belvedere *Torso*, as has been suggested. (This Hellenistic marble sculpture now in the Vatican Museums was at the Palazzo Colonna in Rome in the early sixteenth century.) Rather, the artist probably drew the torso after a wax model, a practice also used by Correggio to design the San Giovanni Evangelista frescoes. Parmigianino's studies of two putti in the Louvre (Popham, *Parm.*, no. 405, pl. 15) of *c.*1522 offer an exact analogy to the present sheet in terms of technique and practice. The recto was most probably produced soon after Correggio completed the Camera di San Paolo frescoes. The style and technique of the drawing suggest that it dates from around 1522, reflecting the moment when Parmigianino and Correggio were both working in San Giovanni Evangelista.

CCB

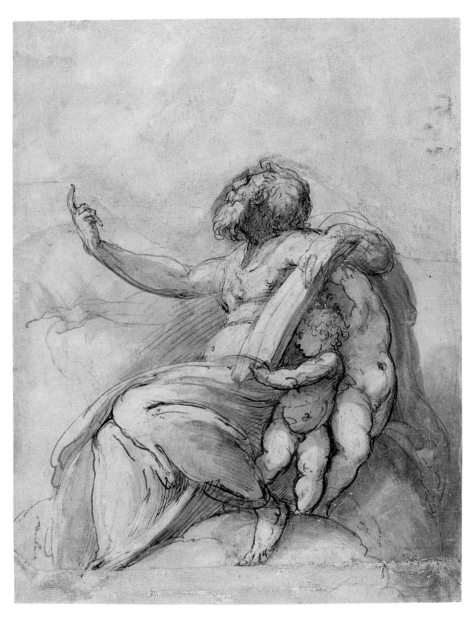

39

39 *A bearded prophet or evangelist with two putti*

c. 1522–3

Pen and brown ink, brown wash.
266 × 197 mm (10 ½ × 7 ¾ in), made up at
the top and bottom

British Museum, London (1874-8-8-2267)

Provenance: H. Howard; Charles, 5th Earl of
Wicklow

Literature: Popham, *BM*, no. 64; Popham,
Parm., no. 166

Parmigianino was commissioned in
November 1522 to decorate the cross-
vaulted ceiling of the north transept of
Parma cathedral with 'four figures'. This
was, as far as we know, never even begun
before Parmigianino's departure for
Rome in 1524, but Popham plausibly
suggested that the artist intended to
paint the four evangelists and associated
cat. 39, along with two studies of Saint
John the Evangelist enclosed within a
triangular vault in the Louvre and in the
Kupferstichkabinett, Berlin (Popham,
Parm., nos 401 and 14, pls 56 and 84),
with this commission. The inspiration for

Parmigianino's cloud-borne figure in the
present study is unmistakably Correggio's
apostles in the dome of San Giovanni
Evangelista. HC

40 *Saint John the Evangelist*

c. 1522–3

Red chalk. 241 × 203 mm (9 ½ × 8 in), top corners cut

British Museum, London (1895-9-15-730)

Provenance: J. Richardson Sr (L. 2183); Sir J. Reynolds (L. 2364); Sir T. Lawrence (L. 2445); W. Coningham (L. 476, verso); J. Malcolm

Literature: Popham, *BM*, no. 63; Popham, *Parm.*, no. 165

The traditional attribution was to Correggio, as a study for one of the apostles in the dome of San Giovanni Evangelista, Parma (see cat. 8). Popham first observed that it is rather by Parmigianino at the start of his career, for the tapering forms and sharp accents are unmistakably those of the younger artist.

Although the figure lacks the attribute of the eagle, his physical type and the action of writing in a book probably identify him as Saint John the Evangelist. His pose is in no way derived from any of the three representations of the saint frescoed by Correggio in San Giovanni Evangelista (in the dome, squinch and overdoor lunette), but the character of the figure is strongly reminiscent of the apostles surrounding Christ in Glory in the dome, and more particularly of the studies by Correggio for these saints. We know that Parmigianino had access to such studies (cat. 37) and it seems very likely that, if not a copy by Parmigianino after Correggio, this is an exercise consciously in his manner.

The probable identification of the youth as John the Evangelist may connect the study with a commission to paint 'four figures' in the north transept of Parma cathedral, given to Parmigianino in November 1522 but apparently never begun (see cat. 39). The four evangelists were a standard subject for such cross-vaults, the crouching figure would fit well into a curved triangular field and the putti

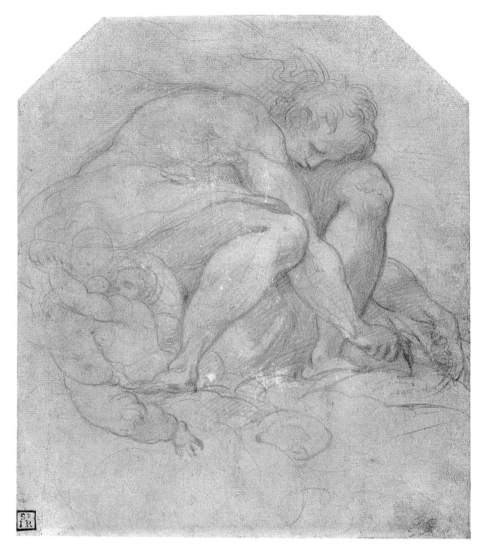

40

and clouds are of course appropriate for vaulting. Although the pose is quite unlike that in a drawing in the Louvre (Popham, *Parm.*, no. 401, pl. 56), which has a stronger claim to be a study of John the Evangelist for this project, the present drawing may have been an earlier sketch for the same figure. MC

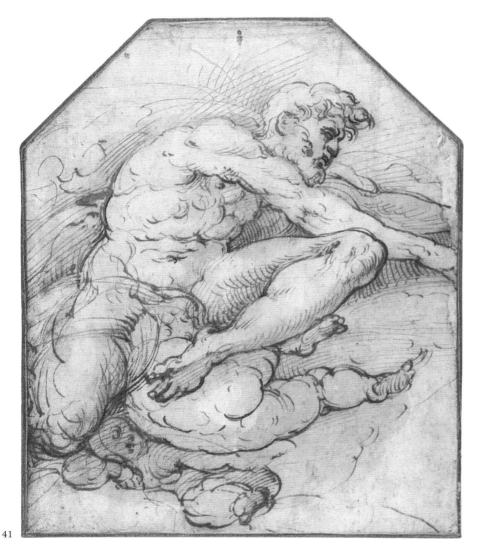

41

41 *A nude man supported by putti* c. 1522–3

Pen and brown ink (two shades), grey-brown wash. 183 × 150 mm (7 ³/₁₆ × 5 ⅞ in), top corners cut

Chatsworth, Devonshire Collections (444)

Provenance: Probably 2nd Duke of Devonshire

Literature: Popham, *Parm.*, no. 697; Jaffé 1994, no. 668; Ekserdjian 1997, p. 250

Like cats 39–40, the drawing is in the manner of the apostles frescoed by Correggio in the dome of San Giovanni Evangelista. The principal putto seems to be based on a three-dimensional model, probably of wax, used (and presumably made) by Correggio for his work in the dome; it is found, seen from the front, in a drawing for Saints Peter and John in the Louvre (Muzzi and Di Giampaolo 1988, no. 13) and was copied four times by Parmigianino on two drawings also in the Louvre (Popham, *Parm.*, nos 396 verso, 405, pl. 15). The unseemly placing of the putto's head between the figure's thighs does suggest a motif borrowed with little consideration for appropriateness.

The hands of the figure have been trimmed off by an earlier owner of the drawing, and thus we cannot interpret the gesture of the outstretched arms. It is conceivable that he was reaching towards an open book, and given the presence of putti and clouds the drawing should be considered in the context of the artist's commission for the north transept of the cathedral (see cat. 39). MC

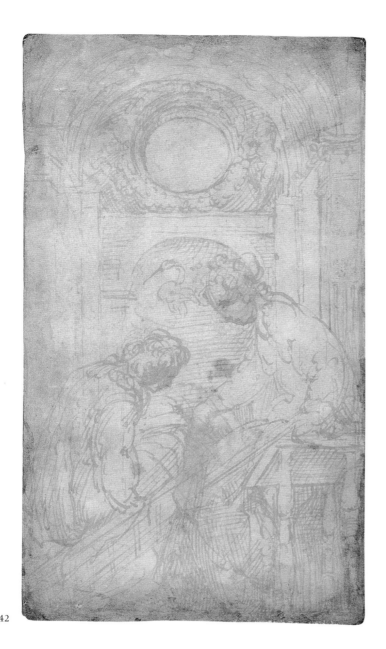

42

42 Saints Lawrence and Stephen in an architectural setting *c. 1522–4*

Pen and brown ink, on unevenly pink-washed paper. 201 × 113 mm (7 ¹⁵/₁₆ × 4 ⁷/₁₆ in)

British Museum, London (1948-10-9-126)

Provenance: W.F. Watson; D. Gordon

Literature: Popham, *BM*, no. 59; Popham, *Parm.*, no. 161

43 A seated woman supported by two putti *c. 1522–4*

Pen and brown ink, on accidentally (?) pink-tinted paper. 217 × 105 mm (8 ⁹/₁₆ × 4 ⅛ in)

British Museum, London (1880-10-9-32)

Provenance: J. Richardson Jr (L. 2170); Sir W. Worsley, Bt

Literature: Popham, *BM*, no. 60; Quintavalle 1968, p. 68; Popham, *Parm.*, no. 162

Vasari's claim in the second edition of the *Lives* (1568) that Parmigianino decorated seven chapels in San Giovanni Evangelista has long been discounted, and it is now generally agreed that he was responsible for frescoing the underside of the entrance arches of the first two chapels on the left and, less certainly, the fourth on the same side. The arrangement of the frescoes in these chapels is basically the same, with the narrow outer arch painted with decorative motifs and the broader inner one with niches filled by a single saint at one end and a pair of saints at the other. Cat. 42 is an

early, and unfortunately much faded, study for the niche in the second chapel showing two studious young deacons, who, thanks to David Ekserdjian's discovery of the dedication of the chapel (1988, p. 444), can be securely identified as Saints Stephen and Lawrence (fig. 24). In the drawing both saints are identifiable by the attributes alluding to their martyrdoms: Saint Lawrence by his gridiron, and Saint Stephen by the stones adhering to his head. The two figures in the drawing are squeezed into the narrow space of the niche, and there is no sense of any dialogue between them. In a solution that owes much to Correggio's frescoed pendentives in the same church, Parmigianino links the two figures in the painting by showing them both studying the same volume, with the seated saint leaning towards his standing companion so that he can read the page. Correggio's influence is also discernible in smaller details, such as the illusionism of having the seated saint's leg apparently dangling over the edge of the niche into the space of the chapel, and in the general mood of quiet intimacy that unites the two figures.

It was suggested by Augusta Quintavalle that cat. 43 was a study for Saint Agatha in the first chapel. This seems unlikely as the pose of the saint in the painting is completely different, although the drawing would appear to be from the same period since the relationship between the figure and the architectural background is similar. Although Correggio was the strongest influence on the young Parmigianino, the pronounced torsion of the latter's figures shows an awareness of Michelangelo's Sistine Chapel ceiling (the pose of Saint Agatha in San Giovanni Evangelista is, for example, inspired by that of Eve in the *Temptation*), which he must have known through drawn copies. HC

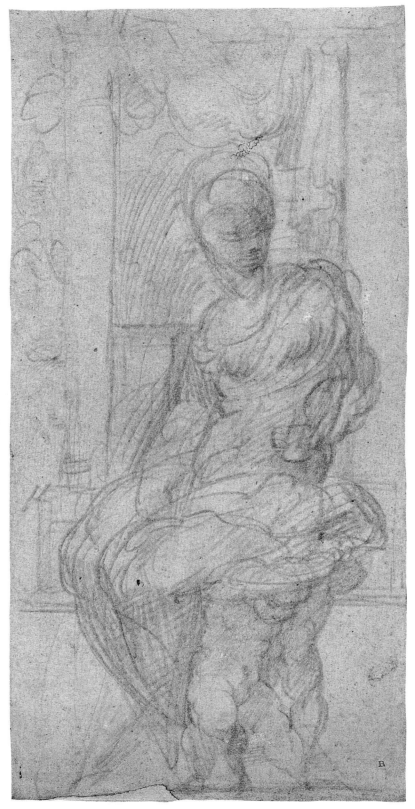

43

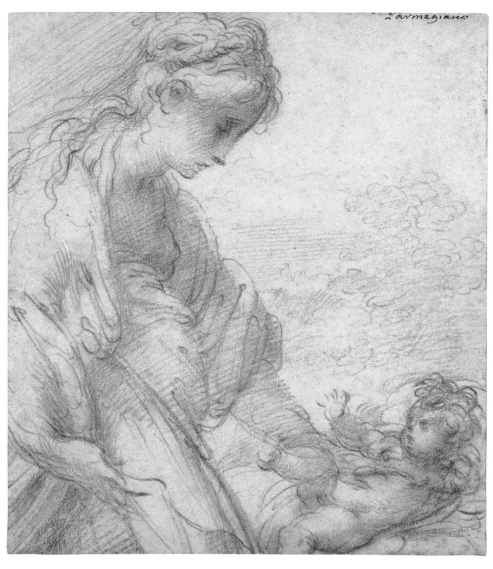

44

44 *Virgin and Child* *c. 1522–3*

Red chalk. 175 × 149 mm (6 ⅞ × 5 ⅞ in)

Inscribed, upper right corner: *Parmegiano*

The Woodner Collections, on deposit at National Gallery of Art, Washington, D.C.

Provenance: Hanley

Literature: Malibu, Forth Worth and Washington 1983, no. 14; New York 1990, no. 27

This is among the artist's most affecting depictions of the theme of the Virgin and Child, with a moving interplay between the devoted contemplation of the Virgin and the lively child she restrains with her left hand.

As De Grazia notes in New York 1990, the effect is heightened by the technique and handling, which add to the tenderness of the scene.

The avoidance of clearly outlined contours and the *sfumato* modelling argue forcefully for an early date, when Parmigianino was most strongly influenced by Correggio. The figural proportions of the Virgin and the rendering of her drapery are comparable with several figures in the frescoes at Fontanellato and in the painting of the *Rest on the Flight* in the Courtauld Institute Galleries, London, and to several preparatory studies for the former (Popham, *Parm.*, nos 435 and 501 recto, pls 24, 27–8). De Grazia has suggested a connection with the Courtauld painting. Given the closeness

in date, style and emotional content between the Woodner drawing and this painting, there is every reason to link them together. On the verso there is a study of a man, which was crossed out by the artist. He is similar to several figures in works of the Parma period, such as the Saint John the Baptist at the right side of the *Madonna and Child with Saints*, in the church of Santa Maria, Bardi, of 1522. The evidence favours a date of 1522–3 for the sheet.　　GG

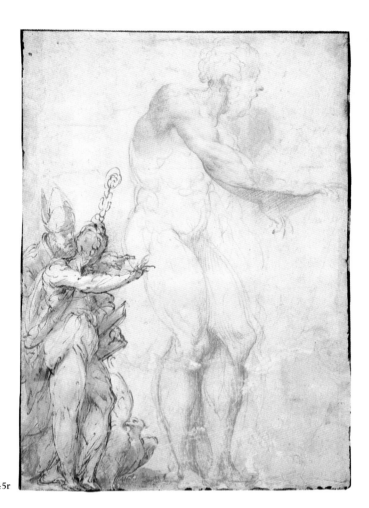

45r

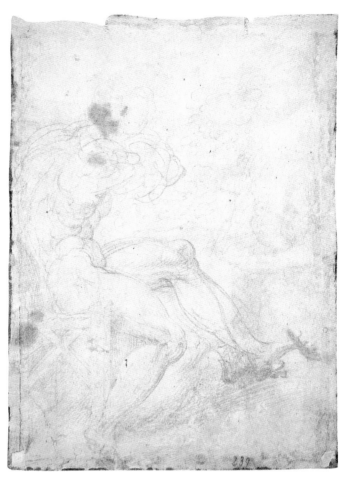

45v

45 *Standing male nude, Saint John the Evangelist with a bishop or abbot saint (recto); Seated male nude in a landscape (verso)* *1522–3*

Nude study in red chalk, small sketch in lower left in pen and brown ink, brown wash (recto); red chalk (verso); scattered paint stains and verso lined with Japan paper.
287 × 202 mm (11 ⁵⁄₁₆ × 7 ⅞ in)

Inscribed, verso: *parmigiano, LS/* and *239*

Fogg Art Museum Cambridge, MA (1969.32; Austin Avery Mitchell Bequest)

Literature: Freedberg 1970, p. 3; Popham, *Parm.*, no. 823; Goldfarb 1979, no. 13; Mongan, Oberhuber and Bober 1988, no. 30

This sheet with figures executed in very different scales and media offers a telling synthesis of Parmigianino's pre-Roman drawing style. The general bodily proportions recall those of Saint John the Baptist in the altarpiece of the *Mystic Marriage of Saint Catherine* (Santa Maria, Bardi) from 1522. On the recto of the Fogg sheet, the artist rendered the large caricature-like male nude, a study after a live model, with hatching that he then rubbed smoothly to blend in tone, much as in the verso of cat. 38. It appears that Parmigianino drew this red chalk study first, and then used it as a basis for the pose of Saint John the Evangelist (identified by his attribute of the eagle) in the small group sketch on the lower left of the sheet; John's right arm is shown raised in a manner similar to the reworked right arm of the male nude in the large red chalk study. On the lower left, the identity of the bishop or abbot saint behind John is not clear. As a whole, the recto of the Fogg sheet is typical of Parmigianino's style of preliminary drawings for works commissioned around 1522–4 in Parma: the frescoes in the side chapels of San Giovanni Evangelista and on the cross-vaulted ceiling of the north transept of the cathedral, as well as the panels for the organ shutters of Santa Maria della Steccata.

Both Freedberg and Popham agreed on a date around 1522–3 for the Fogg sheet, based on its similarity to the frescoes at San Giovanni Evangelista and the specific connection of the seated male nude study on the verso with the figure of Saint Joseph in the Louvre *Holy Family* (Popham, *Parm.*, no. 426, pl. 66). The pose of the latter male nude, who sits unceremoniously on a wooden stool amidst foliage, evokes that of at least two of Michelangelo's heroic *ignudi* (athletic youths) on the Sistine ceiling, frescoed in 1508–12. Even before his trip to Rome around 1524, Parmigianino seems to have borrowed a number of motifs from Michelangelo's works, presumably through reproductive drawings and prints, as well as through Correggio's Michelangelesque evocations (see Popham, *Parm.*, nos 15 verso, 328 recto and verso, pls 12–13). CCB

46 *Three putti, two in spandrels* (recto); *Diana and Actaeon in a spandrel* (verso)

1523–4

Pen and brown ink, brown wash, the figure in the centre over red chalk, the figure on the left over black chalk and ruled with horizontal parallel lines at intervals of 18 mm (¹¹⁄₁₆ in) (recto); charcoal or soft black chalk, touches of red chalk on the figure on the upper left (verso). 156 × 156 mm (6 ¹⁄₁₆ × 6 ¹⁄₁₆ in)

The Pierpont Morgan Library, New York (I, 49)

Provenance: 2nd Earl of Arundel; N.F. Haym (L. 1970); Earls Spencer (L. 1530; sale, T. Philipe, London, 14 June 1811, lot 535, bt Coxe); C. Fairfax Murray; purchased by J.P. Morgan in London, 1910

Literature: New York 1965, no. 88; Popham, *Parm.*, no. 313; Rossi 1980, pp. 89–92; Denison, Mules and Shoaf 1981, no. 20

Exhibited in New York only

The studies on both sides of this square sheet are preparatory for the illusionistic frescoed vault in the small room at the Rocca Sanvitale in Fontanellato, dating around 1523–4 and cleaned in 1998. On the recto, the pose of the putto in the centre is almost exactly that in the final fresco, as is the device of the background trellis of foliage; only his two hares are omitted (fig. 25). The putto on the left is also similar to the solution in the fresco. The running infant on the right would eventually be discarded in favour of figures in greater repose.

The main challenge for the young Parmigianino in composing the vault of the Fontanellato fresco cycle was the adaptation of the figures on to the pronounced curvature of the spandrels in the actual architecture. For example, on the recto of the sheet the densely modelled study of the putto on the left is not squared for enlargement (as has been stated), but is ruled with a series of horizontal parallel lines plotted at regular intervals. The artist relied on these horizontals in order to relate the putto's foreshortened body to the curvature of the spandrel. On the lower right of the recto, and next to the main spandrel, the groined underside of the vault has polygonal coffering in steep foreshortening. This area is also scored with parallels, but here the lines are drawn freehand in red chalk and as a series of diagonals, for the polygonal coffers are seen at an angle rather than straight on. Clearly the frescoing of a fictive ceiling design densely packed with Antique-style coffering – seen in difficult and varying perspectival projections – would have presented a nightmarish and laborious problem for the artist. Parmigianino greatly pared down his design for the spandrel parts of the groin vault in the final fresco. He used the much simpler and possibly more effective illusionistic device of a main foreshortened oculus, flanked with twirling ribbons.

The composition sketch on the verso, drawn in a soft impressionistic technique, portrays the cropped figure of the goddess Diana and her nymphs splashing water on the still human and courtly figure of Actaeon. In the fresco the youth appears transformed into a stag and wears a classical tunic (fig. 26). The study on the verso suggests that Parmigianino originally intended to fresco at least some of the figural scenes also on the spandrels, rather than all on the lunettes below, as he finally did. Here too, the artist used loosely drawn parallels (at uneven intervals) at the base of the spandrel as a reference for the curvature of the painting surface. CCB

Fig. 25. Parmigianino, detail from *Diana and Actaeon* (nymph pursued by huntsman), fresco. Rocca Sanvitale, Fontanellato (near Parma).

Fig. 26. Parmigianino, detail from *Diana and Actaeon* (Actaeon transformed into a stag), fresco. Rocca Sanvitale, Fontanellato (near Parma).

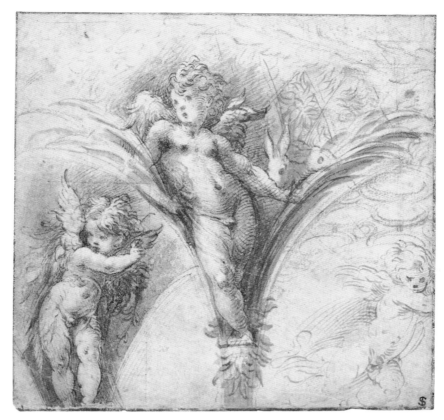

46r

46v

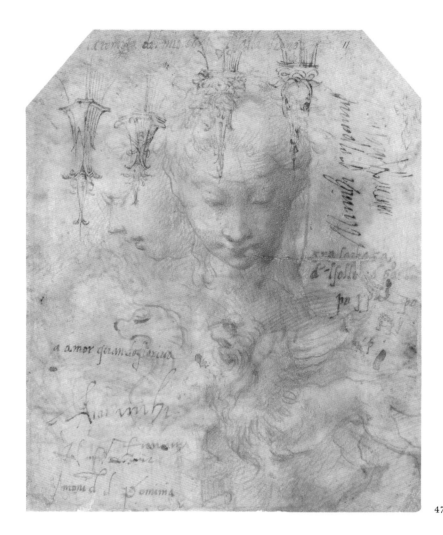

47r

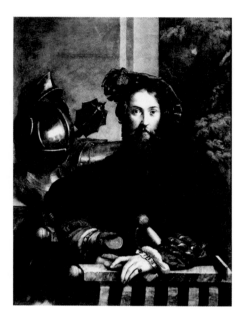

Fig. 27. Parmigianino, *Portrait of Galeazzo Sanvitale*, oil on panel, 109 × 81 cm. Gallerie Nazionali di Capodimonte, Naples

47 *Studies of a female head, a winged lion and finials (recto); A man and a woman with foliage (verso)* 1523–4

Red chalk, pen and brown ink (recto); pen and brown ink (verso). 185 × 145 mm (7 ¼ × 5 ¾ in)

Inscribed by the artist: *amor quando fioriva* and *Fran[cesco]*

Private collection, New York

Provenance: Sir P. Lely (L. 2092); J. Richardson Sr (L. 2184); T. Hudson (L. 2432); B. West (L. 419); J. Malcolm and by descent to The Hon. R. Gathorne-Hardy (sale, Sotheby's, London, 28 April 1976, lot 20); British Rail Pension Fund; European private collection

Literature: Popham, *Parm.*, no. 748; London and New York 1991, no. 5

Popham proposed that the two beautiful drawings on the recto were made as studies for the terracotta heads at the bottom of the pendentives in the Rocca of Fontanellato frescoed by Parmigianino in 1523–4. The juxtaposition of full-face and profile views of the head supports this hypothesis, even though this exquisitely modelled type recurs in a number of paintings and drawings of the Parmese period, including the frescoes at Fontanellato. The pen studies are surely related to the finials at the angles of the same room, lending further reinforcement to the connection to the project at Fontanellato. Lastly, the winged lion does not appear anywhere else in Parmigianino's work, but may represent some discarded idea for part of the decoration of the room. As Ekserdjian pointed out (London and New York 1991), a similar lion appears on the drum of Correggio's dome in San Giovanni Evangelista.

The verso shows a male figure, correctly identified by Popham as Galeazzo Sanvitale, the patron of the Fontanellato commission, turning back to speak with a young woman, who may be his wife Paola Gonzaga. The wonderfully spontaneous nature of both gesture and execution makes it evident that this is a study from life, one of a group of life studies that Popham proposed were made at Fontanellato, but some of which may be from a year or so later (see cats 70–2). The light and rather feathery rendering of foliage is again typical for this early period. It is possible that the verso is a preparatory study for the *Portrait of Galeazzo Sanvitale* in Naples, but it is far removed from the much less spontaneous and more formal painting (fig. 27). Perhaps this is simply a life study, of which there is a partial reminiscence in the finished work.

GG

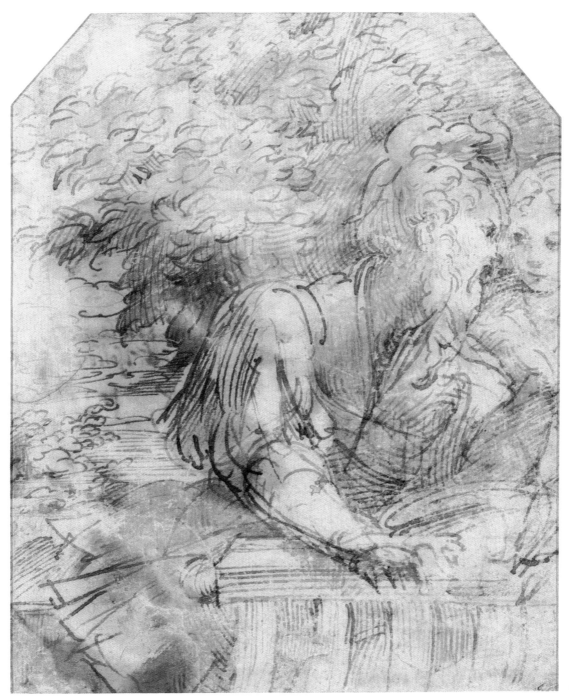

47v

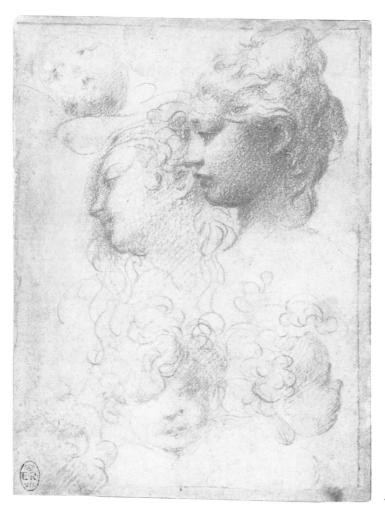

48

48 *Two women's heads in profile, and heads of children*
c.1524

Red chalk. 135 × 93 mm (5 ⁵⁄₁₆ × 3 ¹¹⁄₁₆ in)

Royal Library, Windsor Castle (0345)

Provenance: King George III

Literature: Popham and Wilde 1949, no. 582;
Popham, *Parm.*, no. 650

Popham considered the sheet to be
preparatory for the *Madonna of Saint
Margaret* (Pinacoteca, Bologna), but it is
difficult to reconcile the style of the sheet
with the drawings of Parmigianino's
Bolognese period (1527–30). The looping
modelling seen in the heads in the lower
half of the sheet, and even more strongly
in further sketches of putti on the verso, is
inconsistent with the sinuous lines of the
late 1520s and much more typical of the
artist's early drawings: the delicately
blended chalk in the two main heads is
found in several pre-Roman sheets (such
as Popham, *Parm.*, nos 424–5, pls 90 and
80, and Ekserdjian 1999, no. 8, fig. 11). The
resemblance between the inclined profile
here and the head of the Saint Margaret in
the Bolognese painting is not particularly
close. The figure here wears her hair down
and is presumably the Magdalene, and given
her attitude it is tempting to think that
Parmigianino might have known that saint
in the design for Correggio's *Madonna of
Saint Jerome*, a painting supposedly
commissioned in 1523 (see cat. 23). In the
absence of any related compositional
drawings it cannot be known whether
this beautiful sheet was a study towards
a painting or an independent exercise. MC

49 *A self-portrait* c. 1524

Red chalk over a little stylus. 107 × 76 mm
(4 ³/₁₆ × 3 in)

Royal Library, Windsor Castle (0529)

Provenance: King George III

Literature: Popham and Wilde 1949, no. 566;
Popham, *Parm.*, no. 635; Quintavalle 1971,
no. LXXVI

Popham's supposition that this is a self-
portrait has not been challenged, for the
freshness and immediacy of the likeness
and the frontal pose are typical of such
drawings. The study was made with a
minimum of preparation: the artist simply
sketched in the line of the jaw and the brim
of the soft hat with the stylus, then worked
up the shadows with gentle close hatching
before fixing a few accents with the point
of the chalk.

The resemblance between the drawing
and the painted *Self-portrait in a convex
mirror* (Kunsthistorisches Museum, Vienna)
is not close, although the two representa-
tions are very different in character (and
neither resembles the disputed *Self-portrait*
in the Louvre; Di Giampaolo 1991, no. IA).
Here the private nature of a small drawing
permitted an air of gentle caricature,
whereas the Vienna painting was a show-
piece of refinement and accomplishment.
That was a work of 1524, one of the three
paintings presented to Pope Clement VII by
Parmigianino on his arrival in Rome. The
artist looks younger in the painting than in
the drawing, and indeed younger than his
twenty-one years, but the shadow cast by
the soft hat and the larger and more
emphatic eyes and mouth here might
explain the difference in apparent age of the
two likenesses. On grounds of style there is
no reason to suppose that the painting was
executed much before his departure from
Parma, nor that the drawing is significantly
different in date. MC

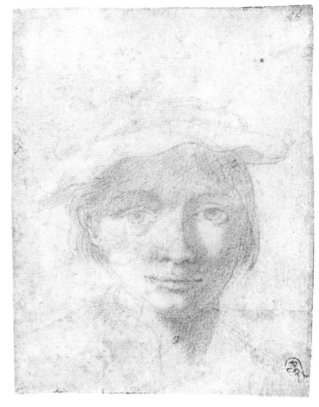

49

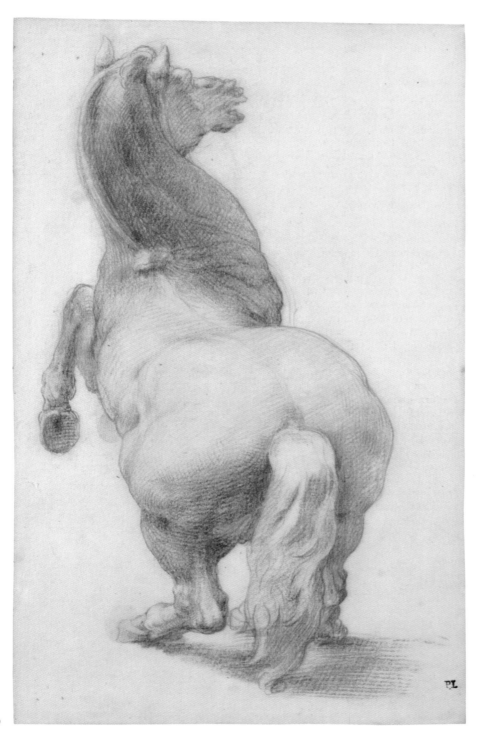

50 *A rearing horse, seen from behind* *c.* 1524

Red chalk; the paper locally bleached.
232 × 144 mm (9 ⅛ × 5 ¹¹⁄₁₆ in)

Courtauld Institute, London (D.1952.RW.4526)

Provenance: N. Lanier (?) (inscribed *Fr. Parmegeano* on a slip formerly attached to the mount, in the hand associated with Lanier); Sir P. Lely (L. 2092); Sir R. Witt

Literature: Popham, *Parm.*, no. 265; McTavish 1980, p. 187; London 1987, no. 5

The drawing was traditionally identified as by Parmigianino; Popham's initial doubts (in a letter to its former owner Sir Robert Witt he suggested that it might date from later in the sixteenth century) may have been induced by a modern bleaching of the paper beyond the chalk that has silhouetted the horse and makes the drawing appear rather artificial. The

Fig. 28. Parmigianino, *Saint Vitalis*, fresco. San Giovanni Evangelista, Parma.

50

tightly controlled chalk modelling would place the sheet in the artist's pre-Roman years, and the difficult but confident foreshortening indicates that it is copied from some three-dimensional piece. That Parmigianino drew from such models early in his career is demonstrated by four studies of a figure of a putto from different viewpoints (Louvre; Popham, *Parm.*, nos 396 verso and 405, pl.15), perhaps a putto modelled by Correggio for his work in the dome of *San Giovanni Evangelista* (see Popham, *Corr.*, p. 9).

The old Courtauld hand-list described the present drawing as copied from a small bronze horse and rider in Budapest sometimes attributed to Leonardo da Vinci (see Agghàzy 1989). While there are significant differences from that statuette – the tail is different, the rear legs are closer together here, and the Budapest horse bends its neck further over to the right – the two are undoubtedly connected, both depicting a heavy, barrel-chested horse squatting low in a manner quite unlike the antique ideal typified by the Dioscuri group in Rome. The existence of early variants of the Leonardesque statuette (Agghàzy 1989, pls 45–6) suggests that the invention was known outside Leonardo's immediate circle, and Parmigianino must have known a version of the statuette in Parma. It seems likely that the drawing, perhaps one of several made from different viewpoints, was a record of an object to which Parmigianino would not have had permanent access. A study from a different angle of the same statuette (or a version of it) was, as Michael Hirst noted, utilized by Pellegrino Tibaldi in his ceiling fresco of the *Fall of Phaethon* in the Palazzo Poggi, Bologna (see McTavish 1980, p. 187).

Popham thought that the drawing might be associated with the horse rearing behind Saint Vitalis in the second chapel on the left in San Giovanni Evangelista, Parma (fig. 28). The relationship is, however, only general, for in the fresco the horse is much more lithe and, seen from the front, stretches out as if leaping. MC

51 *Male nude torso with raised arms* c. 1522–4

Red chalk. 103 × 55 mm (4 ¹/₁₆ × 2 ⅛ in)

The Metropolitan Museum of Art, New York (10.45.3; Rogers Fund, 1910)

Provenance: Earls Spencer (L. 1530; sale, T. Philipe, London, 14 June 1811, lot 512); purchased in London, 1910

Literature: Popham, *Parm.*, no. 294; Bean 1982, no. 159

Exhibited in New York only

Popham considered this small, delicately executed study a pre-Roman drawing by the artist, copied probably from an antique statue of the Flaying of Marsyas. However, the pose of the shoulders and armpit here does not seem to correspond to the tight compression of the shoulders and disjointed raising of the arms, with wrists bound above the head, that is typical of Marsyas figures (see Bober and Rubinstein 1986, pls 32–4). The figure's pose in Parmigianino's study, with a gently distended torso and raised arms, seems more appropriate for a portrayal of the crucified Christ. The stumps indicating the arms may suggest that the drawing is based on a wax sketch model. The artist concentrated on the rendering of the torso, blending the strokes seamlessly by means of stumping and inflecting the contours with small points of shadow. To provide a contrast, he left much of the parallel hatching in the background evident. CCB

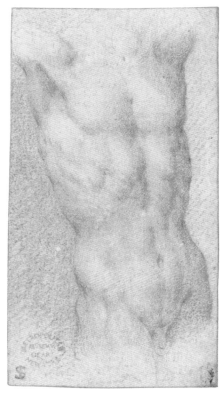

51

52 *Studies of an antique torso* c. 1524

Pen and brown ink on blue paper. 257 × 203 mm (10 ⅛ × 8 in)

Inscribed by the artist: [i]n amore / p[er]ch[e] dan / facto ormai / si certo qual nia ni[n]fa sta cer / tanta ne puo sara / tontar san pena [chon parole esc deleted] / con parole escolto disscer co; and by a later hand: *Angelo*

National Gallery of Art, Washington D.C. (Andrew W. Mellon Purchase Fund, 1978.52.1)

Provenance: H. Calmann; D. Daniels (sale, Sotheby's, London, 25 April 1978, lot 16, as Florentine School, sixteenth century)

Literature: New Haven 1974, no. 10

This bold study was attributed to Cellini in 1974 but appears rather to be by Parmigianino, of his pre-Roman period. A combination of flowing outlines and vigorous hatching and cross-hatching occurs in many drawings of the earlier 1520s, and the rapid, even aggressive use of a calligraphic pen on blue paper is found for instance in a pair of early drawings in the Louvre (Popham, *Parm.*, no. 419 verso, pl. 61) and at Würzburg (Ekserdjian 1999, no. 18, figs 23–4). Conclusively, the writing towards the bottom of the sheet seems to be in the distinctive hand of Parmigianino's younger, less tidy years (cf. cat. 47).

Parmigianino's interest in the Antique pre-dates his journey to Rome, for studies of torsos from the back (Uffizi; Popham, *Parm.*, no. 76 verso, pl. 2) and from the front (cat. 51), of the Belvedere *Torso* (cat. 38 verso) and the *Spinario* (Chatsworth; Popham, *Parm.*, no. 710, pl. 211) all seem to date from no later than 1524. It was not necessary to work from the originals, for casts, drawings and reduced modern statuettes circulated freely throughout Italy. Any attempt to identify Parmigianino's model here would seem to be thwarted by the lack of defining attributes and the freedom with which he drew the outline (completely rethought at the left) and the breaks at neck, shoulder and thigh.

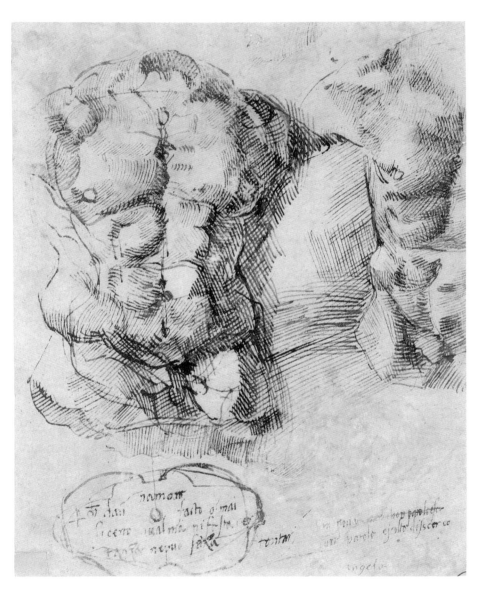

52

The inscriptions by the artist in the lower part of the sheet do not seem to be related to the torso and are probably transcribed from elsewhere: the use of Italian rather than Latin would suggest an informal source. I am grateful to David Ekserdjian for his help in elucidating Parmigianino's handwriting. MC

53 *Trees on a bluff* 1522–4

Black chalk. 280 × 215 mm (11 ¹/₁₆ × 8 ½ in)

Private collection, USA

Provenance: Anon. sale, Sotheby's, London,
18 November 1982, lot 7

Literature: New York 1993, no. 8

Throughout his career Parmigianino would
often include landscapes of great poetry
and magical effects of light in his paintings,
yet extremely few autonomous landscape
drawings by him are extant (eight at
present count), and still fewer can be firmly
connected to finished works. This expressive
early landscape study was only discovered
in 1982, when it was auctioned with the
correct attribution to Parmigianino. It
probably dates from the first half of the
1520s, to judge from the graphic handling
of the black chalk, with emphatic, curved,
parallel hatching that often changes
direction from passage to passage with
charming rhythms and little blending of
individual strokes. The artist selectively
inflected outlines and small areas of shadow
with a sharper-point black chalk for denser
shadows.

The manner of hatching is reminiscent
of Parmigianino's pen and ink study
connected with the portrait of Galeazzo
Sanvitale from 1524 (cat. 47 verso). In the
present landscape drawing, the foliage of
the trees is stylized to achieve comple-
mentary, decorative forms of great
movement, and the light falls in effulgent,
if slightly disjointed patches. A similar
stylization of trees and lighting is also seen
in the frescoed lunettes (especially in those
at the corners of the room) in the Rocca
Sanvitale at Fontanellato from around
1523–4. It may well be that Parmigianino
undertook the present study, and presu-
mably other landscape drawings as well,
with the idea of adapting various motifs for
the backgrounds in that project. Traces of
stitch holes along the left border of the sheet
suggest that it was a fragment of a page in a
sketchbook. Between the end of the fifteenth
century and the beginning of the sixteenth,

53

artists such as Leonardo and Fra
Bartolomeo dedicated large parts of their
sketchbooks solely to the investigation of
landscape. It seems quite probable that
Parmigianino also followed this practice,
considering the prominence of delicately
described landscape features in his
paintings. CCB

54 *Male figures (shepherds for an Adoration?)* (recto); *Two seated putti amidst foliage* (verso) *c.* 1523–5

Pen and brown ink, brown wash, with some corrections in white heightening (recto); pen and brown ink, brown wash, over charcoal or soft black chalk, touches of red chalk (verso). 157 × 203 mm (6 ⁵⁄₁₆ × 8 in)

Inscribed by the artist on the recto with letters and musical notations

Private collection, USA

Provenance: N. Lanier (L. 2886); 2nd (?) Earl of Arundel (according to the 1902 Gathorne-Hardy catalogue); J. Richardson Sr (L. 2184); Sir J.C. Robinson (L. 1433); J. Malcolm and by descent to The Hon. R. Gathorne-Hardy (sale, Sotheby's, London, 24 November 1976, lot 18); British Rail Pension Fund (sale, Sotheby's, London, 2 July 1990, lot 71); Trinity Fine Art Ltd

Literature: Popham, *Parm.*, no. 747; London and Oxford 1971, no. 25; Sotheby's, London, 2 July 1990, sale catalogue, lot 71; Trinity Fine Art Ltd., May 1994 catalogue, no. 3

The previously unremarked 'IHS' watermark (close to Briquet 9462; Casalmaggiore around 1526, very similar to that of cat. 77) suggests a Parmese origin for the paper, and thus throws some light on the complex question of dating, for to judge on stylistic grounds alone this double-sided sheet must have been produced at the latest in 1524–5, around the time of Parmigianino's departure for Rome. The still abundant use of a pronounced curved cross-hatching in some of the studies on the sheet is a typical pre-Roman feature. On the recto, one of the seated male figures in the group on the left holds a shepherd's staff. This seated group relates in a general way to the verso of the British Museum *Adoration of the Shepherds* (cat. 80). But, contrary to what has sometimes been stated, the arrangements of the shepherds – both seated and standing – on the recto of the present sheet have much less in common with those in the *Adoration*

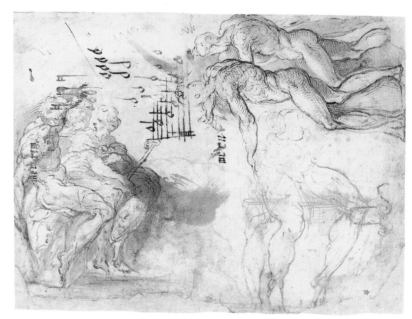

54r

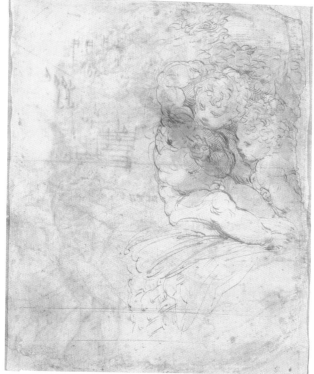

54v

of the Shepherds composition as engraved by Giovanni Jacopo Caraglio (Bartsch.xv.4.68) around 1526, on the basis of Parmigianino's drawing in Weimar (Popham, *Parm.*, no. 631, pl. 144). In Caraglio's print, the poses of the supporting figures are decorously subdued, and the motifs of the seated

shepherds are virtually displaced by a foreground group of onlookers around the Madonna and Child.

Popham thought the musical notes and the fragments of writing toward the centre on the recto were not by Parmigianino, but, as David Ekserdjian first pointed out in the

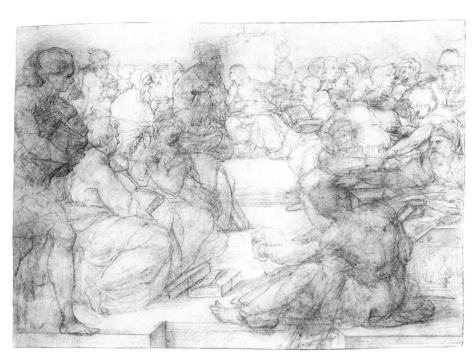

55

1990 Sotheby's auction catalogue, the handwriting is consistent with that on a number of other sheets by the artist. The words and musical notes in the present sheet, though too slight for meaningful interpretation, are in the same ink as the thick outlines in the figures on the upper right. Moreover, the fascinating account of Parmigianino's personality provided at the end of Vasari's biography of the artist states that he delighted in playing the lute (Vasari-Milanesi V, p. 234).

The drawings on the verso of the sheet may well be slightly earlier than those on the recto. For instance, the arrangement of the two putti seated on a draped basket amidst foliage is similar to that on the upper right quadrant of the *Saint Catherine of Alexandria* (Städelsches Kunstinstitut, Frankfurt), an oil painting dated by Cecil Gould to 1523–4. CCB

55 *The Dispute in the Temple*
1524–5

Soft black chalk or charcoal, the left figure and the ruled architectural lines in the foreground over red chalk, the outlines incised (?). 312 × 421 mm (12 ¼ × 16 ⁹⁄₁₆ in)

Fogg Art Museum, Cambridge, MA (1986.362; Anonymous Gift)

Provenance: R. Wien (according to Schab catalogue); William H. Schab Gallery, New York

Literature: New York 1975; Mongan, Oberhuber and Bober 1988, no. 31; Béguin 1999, pp. 35–40 (as Nosadella)

This little-known drawing by Parmigianino is executed with a Correggesque sense of plasticity and atmosphere. It was correctly identified as the work of the young artist by Konrad Oberhuber and Jonathan Bober. The

previous attribution to Parmigianino's elder contemporary Michelangelo Anselmi (1491/2–1554/6) was probably proposed because the drawing exhibits a soft Correggesque *sfumato* chalk technique (Parmigianino was influenced by Anselmi before his own profoundly Correggesque phase in the early 1520s). The ambitious conception of the space and narrative in the Fogg sheet, however, seems to exceed Anselmi's powers. Based on the gospel of Saint Luke (2:41–51), the dramatic scene portrays the twelve-year-old Jesus, seated in the centre of the background, somewhat hidden from view, and engaged in 'dispute' or learned conversation with the Jewish scribes of the Temple of Solomon. Wearing exotic dress and holding books, the erudite elders dominate the foreground and middle ground of the composition. The Fogg sheet seems to offer an improved, more unified conception of the scene than is evident in the more detailed, albeit fragmentary, study in the Ashmolean (cat. 56). The composition of cat. 55 appears to be inspired by Lorenzo Ghiberti's bronze quatrefoil relief of the same subject on the north doors of the Baptistery in Florence. Francesco Salviati's free copy after Ghiberti, from the 1530–40s, now in Philadelphia, introduces many more onlookers into the scene in a manner that seems strikingly close to Parmigianino's Fogg drawing, and it is thus worth

considering the possibility that both drawings may derive from a lost intermediary source (Bambach Cappel 1990, pp. 197–221). In Parmigianino's Fogg sheet, the monumental conception of the figures and their unified articulation within the deep architectural space both evoke Raphael's *Dispute of the Holy Sacrament (Disputa)*, frescoed in the Stanza della Segnatura (Vatican Palace) around 1509–10. In view of these varied influences, it is possible that the Fogg sheet may date slightly later than has been thought – around 1524, on Parmigianino's arrival in Rome (via Florence). The atmospheric chalk drawing technique with *sfumato* effects is found in both late pre-Roman and Roman sheets by the artist.

The recent attribution of the Fogg sheet to Giovanni Francesco Bezzi, called il Nosadella (documented 1558–71), an eclectic artist who was influenced by Parmigianino, as well as by other painters, does not seem convincing. There are no known drawings in black chalk by Nosadella, and the use of *sfumato*, as in the Fogg sheet, seems entirely foreign to his graphic vocabulary. Moreover, cat. 56, which is obviously by Parmigianino, and the Fogg sheet portray similar almost caricature-like figures (with an ample use of the *profil perdu*) typical of the artist's early style. CCB

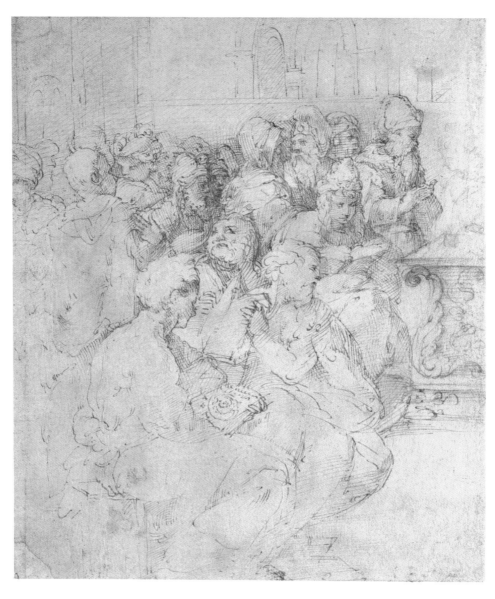

56

56 *A group of figures, some holding books (left side of the 'Dispute in the Temple')* 1524–5

Pen and brown ink, the figure of Christ and the central altar in red chalk. 220 × 180 mm (8 ¹¹⁄₁₆ × 7 ¹⁄₁₆ in)

Ashmolean Museum, Oxford (P. II 436)

Provenance: C. Turnor (sale, Sotheby's, London, 2 February 1944, part of lot 80)

Literature: Parker 1956, no. 436; Popham, *Parm.*, no. 331; Mongan, Oberhuber and Bober 1988, under no. 31; Béguin 1999, pp. 38–9

Karl Parker's supposition that this was a study for the left half of a composition of a *Dispute in the Temple* was proved to be correct when cat. 55 came to light on the New York art market in 1975. The sheet may well have been divided in half by a collector or dealer in order to create two drawings from a single study, a fate shared by a large number of the artist's studies. No painted work of this subject by Parmigianino is known, but on stylistic grounds the drawings can be dated to the mid-1520s, either at the end of his time in Parma or shortly following his arrival in Rome. The crowded background of the Oxford drawing, filled with a mass of animated Düreresque figures sporting an exotic variety of headgear, recalls paintings of the subject by contemporary Ferrarese painters, and Parmigianino may even have seen Lodovico Mazzolino's altarpiece of 1524, now in Berlin, which was painted for the church of San Francesco in Bologna. HC

Parmigianino's Roman period (cats 57–96)

In 1524 Parmigianino arrived in Rome, where he remained until the sack of the city by the troops of the Emperor Charles V in 1527. The city offered an unrivalled opportunity to study the Antique and to see at first-hand the works of Michelangelo and Raphael; and it was also where ambitious young artists went to establish their reputations. Parmigianino's arrival was doubtless linked to the election in November 1523 of the cultured Pope Clement VII (Giulio de' Medici), who it was hoped would emulate his cousin Pope Leo X as a lavish patron of the arts. According to Vasari, the twenty-one-year-old Parmigianino took with him as proof of his ability three paintings which he presented to the pope on his arrival: the *Self-portrait in a concave mirror* (Kunsthistorisches Museum, Vienna), the *Holy Family* (Prado, Madrid) and the *Circumcision* (Institute of Arts, Detroit). Clement was so impressed by Parmigianino's precocious talent that he asked him to decorate the Sala dei Pontefici in the Vatican, but the project never came to fruition. Parmigianino disappointingly executed only one major commission during his three years in Rome, the *Madonna of Saint Jerome* (National Gallery, London; see cats 88–93), although he did complete a few small-scale works and a portrait of Lorenzo Cybo, the captain of the Swiss Guard (Statens Museum for Kunst, Copenhagen).

Vasari famously commented in his biography of Parmigianino that during these years it was said, because of the graceful manners of the young artist and the beauty of his art, that the spirit of Raphael had passed into his body. Parmigianino was unquestionably profoundly affected by Raphael, and his sustained study of the latter's work is readily apparent from the National Gallery painting and from many drawings of the Roman period. Parmigianino's rapid development during these years was also spurred on by the presence in the city of two of the most innovative painters of his generation, Perino del Vaga (1501–47), who had worked in Raphael's studio, and his fellow Florentine Rosso Fiorentino (1494–1540). Parmigianino's involvement with printmaking began in Rome through his collaboration with the engraver Giovanni Jacopo Caraglio (cats 75–7), who also had worked with both Rosso and Perino del Vaga.

Parmigianino left the shattered city of Rome soon after its invasion, and made his way to Bologna. Vasari recounts that Parmigianino's work on the *Madonna of Saint Jerome* was interrupted by Imperial troops who stormed into his studio, and that he won his freedom by handing over a quantity of drawings to the soldiers. HC

57 A bearded man looking up (Laocoön) c. 1524–5

Red chalk. 119 × 110 mm (4 ¹¹⁄₁₆ × 4 ⁵⁄₁₆ in)

Inscribed: *Parmiggiano*

Chatsworth, Devonshire Collections (347B)

Provenance: Sir P. Lely (L. 2092); probably 2nd Duke of Devonshire

Literature: Popham, *Parm.*, no. 694; Jaffé 1994, no. 691

The drawing is copied from the head of Laocoön in the celebrated antique marble group, then as now in the Belvedere courtyard in the Vatican. The dramatic representation of the Trojan priest Laocoön and his two sons in the coils of serpents was, from its discovery in 1506 in a Roman vineyard, one of the most admired and copied classical works in Rome. Parmigianino's study differs slightly from the

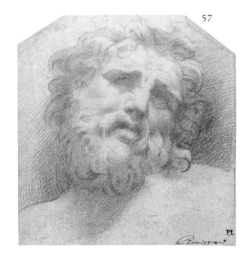

57

sculpture, with the head drawn in a more upright position; the left shoulder lowered; and the expression of terror made less apparent by slightly closing the mouth. The

observation of light is particularly refined, with the form and texture of the sculpted head, as well as the reflective brilliance of its marble surface, rendered through delicate modulations of the hatching and by highlights composed of untouched areas of white paper. A pen and ink study of the head of Laocoön's son on the right-hand side of the group is in the Uffizi, Florence (Popham, *Parm.*, no. 71, pl. 212). Parmigianino's interest in classical models pre-dates his arrival in Rome (see cats 38 verso and 52), and Vasari's description of his study of antique art once in the city is confirmed by other copies after classical sculptures. These include a drawing of a marble *Apollo*, which in the sixteenth century was in the courtyard of the Palazzo Sassi in Rome (Popham, *Parm.*, no. 518, pl. 210), and a polished red chalk study of an acanthus scroll which David Ekserdjian identified as a copy after a Roman first-century pilaster strip now in the Villa Medici in Rome (Ekserdjian 1999, no. 42, fig. 57). HC

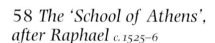

58

58 *The 'School of Athens', after Raphael* c. 1525–6

Pen and brown ink, brown wash, over black chalk. 223 × 414 mm (8 ¼ × 16 ⁵⁄₁₆ in)

Royal Library, Windsor Castle (0533)

Provenance: Probably Bonfiglioli family, Bologna (and thus Z. Sagredo; Consul J. Smith); King George III

Literature: Parker 1939/40, p. 41; Popham and Wilde 1949, no. 598; Popham, *Parm.*, no. 666; Gould 1994, p. 58; Mantua and Vienna 1999, no. 272

The so-called *School of Athens* in the Stanza della Segnatura of the Vatican Palace was probably Raphael's second great work in Rome, painted immediately after the *Disputa* around 1509–10. The drawing is not a copy of the fresco itself: it lacks the figure of Heraclitus, seated on the steps to the left and added by Raphael as an afterthought, although in all other respects the drawing (so far as it goes) agrees with the essentials of the composition. Nor can it be a copy of the cartoon (Biblioteca Ambrosiana, Milan), which would have been impracticably huge for freehand copying and was almost certainly not displayed at this time.

There was no early print after the whole of Raphael's composition, and Parmigianino's source must have been a *modello* for the fresco or a copy of such a *modello*. This means that there is no obligation to date the drawing to Parmigianino's Roman years, for copies after Raphael's designs circulated rapidly throughout Italy; the compelling comparison with the *Presentation* (cat. 87), both in drawing style and compositional principles, must place it around the mid-1520s, though the lines are perhaps unusually sharp for this period. MC

59 *The Virgin holding the dead Christ on her lap* c. 1524–5

Pen and brown ink, grey-brown wash, over traces of black chalk, red chalk. 291 × 215 mm (11 ⁷/₁₆ × 8 ⁷/₁₆ in)

Inscribed, lower right: *107*

The Pierpont Morgan Library, New York (I, 47)

Provenance: Baron F. Alziari de Malaussena (L. 1887); C. Fairfax Murray; purchased by J.P. Morgan in London, 1910

Literature: Popham, *Parm.*, no. 311

Popham thought that the passages in red chalk, most evident on the figure of Christ (but present in other parts as well), were added by a later hand. This entire layer, however, lies demonstrably under the ink and washes. It bears emphasizing that the drawing's condition detracts from an appreciation of its obviously accomplished draughtsmanship and monumentality of expression. The relatively thickly applied washes have sunk somewhat into the paper, and the surface is abraded throughout, with the result that the underdrawing in black chalk and the undermodelling in red chalk have all but disappeared. At least some of the erasing of the chalk was probably done by the artist himself in order to clean up the draft of the composition. This is the main reason why the overall modelling now seems sparse.

Revealing the typically broad wash modelling of Parmigianino's early Roman period (1524–5), this large drawing was inspired by Michelangelo's most famous marble sculpture, the *Pietà* (Saint Peter's, Vatican), carved in 1498–9 and much copied during the sixteenth century. Parmigianino would have seen the *Pietà* installed in the Secretarium or Cappella della Vergine Maria della Febbre (to where it had been moved, shortly before 1519), which was a small space at the south-east corner of the old Saint Peter's basilica (see Weil-Garris Brandt 1995, pp. 217–60). In vivid contrast to Michelangelo's sculpture, Parmigianino's

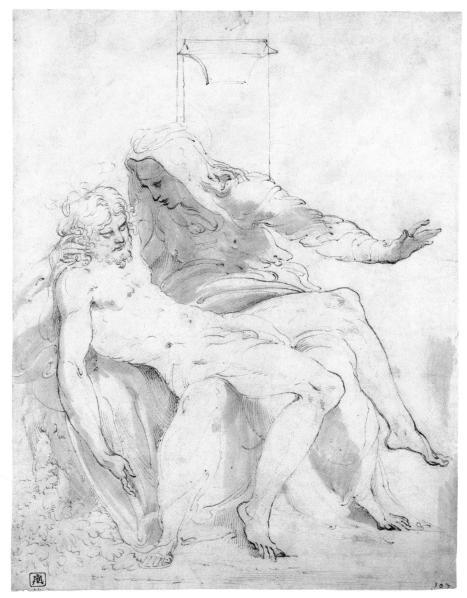

59

drawing transforms the mood of passive acceptance of the Virgin Mary in the marble into passionate and very physical grieving, with Mary staring intently at her son's head which she tenderly holds up to her own, while at the same time throwing out her arm in anguish at her loss. Of no less consequence for Parmigianino's imaginative recasting of Michelangelo's sculpture was also Perino del Vaga's closely contemporary fresco of the *Deposition from the Cross* (Santo Stefano del Cacco, Rome), which dates from around 1520–3 and which the present drawing generally evokes in the elegance of the figural types. CCB

60 *Design for the tomb of a youth* c.1524–7

Pen and brown ink, brown and yellow wash, over leadpoint and stylus-ruling, the paper rubbed with charcoal. 269 × 208 mm (10 9/16 × 8 1/16 in)

Inscribed by the artist on the tablet at the tomb's base: *D[eo] O[ptimo] M[aximo]* and in a later hand, lower right: *Permeg*

The Metropolitan Museum of Art, New York (1970.238; Rogers Fund, 1970)

Provenance: 2nd Earl of Arundel (?); A.M. Zanetti; G.A. Armano; Rev. Dr H. Wellesley (L. 1384; sale, Sotheby's, London, 3 July 1866, lot 1414); Prof. E. Perman; purchased in Stockholm, 1970

Literature: Popham, *Parm.*, no. 794; Bean 1982, no. 161; New York 1993, no. 7; Ekserdjian 1994, pp. 202–3; Marinelli and Mazza 1999, pp. 273–7

This expressive composition in colour is one of four extant drawings of funerary monuments done by Parmigianino in his Roman period (1524–7). The overall treatment of this design – presumably for a wall tomb – is the most pictorial of the small group of such drawings, and omits (as the drawing does not appear to have been cut at the top) the pedimented architectural framing elements that are typical of early sixteenth-century Roman tomb sculpture in the antique-revival style. Moreover, Parmigianino's design shows little concern for the three-dimensional nature of the sculpted structure, and it is not at all clear, for example, just how the garland-framed oval containing the vision of the Virgin and Child in the clouds would have been constructed with respect to both the flanking angels and the effigy of the deceased. This pictorial conception, together with the use of colour, perhaps suggest that cat. 60 was intended for a painted ephemeral monument. The small angel on the left extinguishes the flame on a long torch in allusion to death. Still a young man, the deceased is portrayed as if asleep, reclining on a simple bier. He holds

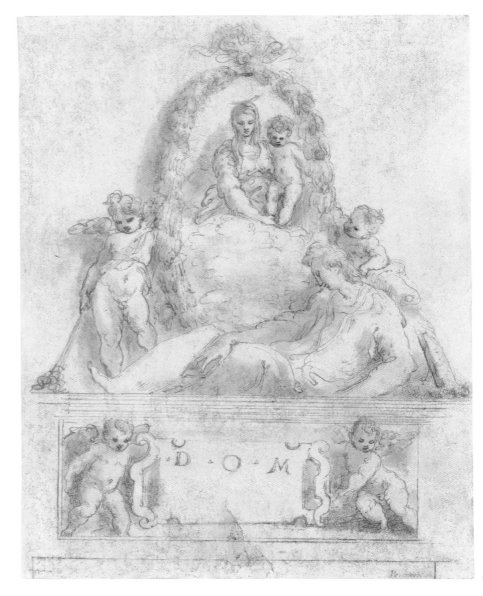

60

a small book, and another book rests to his right, but his identity remains a mystery, for there is neither a family coat-of-arms nor any other type of heraldic decoration to provide a clue, and the design for the area of the epitaph on the bier is incomplete. While the young man's identity is not known, the books may refer to his scholarly career cut short by death.

Cat. 60 is closely related in size and design to a sheet by Parmigianino in the Louvre (Popham, *Parm.*, no. 378, pl. 214), drawn with a somewhat bolder handling of the pen and without colour. There, the deceased wears a bishop's mitre and vestments, and reclines in the opposite direction. The visual evidence, although frustratingly fragmentary, suggests that the Louvre drawing may have been intended as a competing design for the tomb of a member of the Armellini family at Santa Maria in Trastevere in Rome, carved by Michelangelo Senese after Baldassare Peruzzi's design (see Wolk-Simon in New York 1994, nos 7, 93; Ekserdjian 1994). Whether the Metropolitan Museum and Louvre drawings were intended for the same project, however, is open to question. Be that as it may, the design of cat. 60, without the inscription D·O·M, was reproduced, in reverse, in an etching by Angelo Falconetto (Bartsch XX.104.6.13). Falconetto's print shows that Parmigianino's design originally included a further oblong plinth with a scene of a pagan sacrifice below the epitaph. The drawing technique with delicate touches of brown and yellow wash seems to be inspired by his contact with the young artists trained in Raphael's workshop, especially Giovanni da Udine. Curiously, the Falconetto print after the Metropolitan Museum tomb design is portrayed in the upper right of an early seventeenth-century painting of an imaginary collection by Frans Francken I in the collection of the Duke of Northumberland at Alnwick Castle (Van Regteren Altena 1956, p. 20, fig. 2). CCB

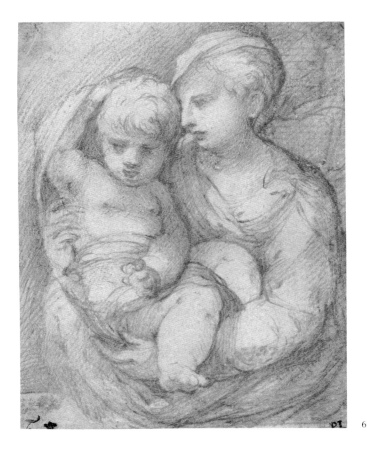

61

61 *The Virgin and Child*
c. 1524–5

Red chalk, over stylus. 112 × 88 mm (4 ⁷⁄₁₆ × 3 ⁷⁄₁₆ in)

Chatsworth, Devonshire Collections (781)

Provenance: Sir P. Lely (L. 2092); N.A. Flinck (L. 959); 2nd Duke of Devonshire (L. 718)

Literature: Popham, *Parm.*, no. 708; Jaffé 1994, no. 669

As Popham noted, Parmigianino originally conceived of this as a Holy Family group, as the head of Saint Joseph seen in profile is faintly visible to the right. The soft, rounded forms and the tender intimacy of the scene are distinctly Correggesque, and Popham was inclined to date the drawing to the pre-Roman period, but it may be slightly later. Parmigianino's composition, with the figures tightly enclosed within a circle formed by the sweep of the Virgin's mantle, is an imaginative reworking of Raphael's celebrated tondo, the *Madonna della Sedia* (Palazzo Pitti, Florence). HC

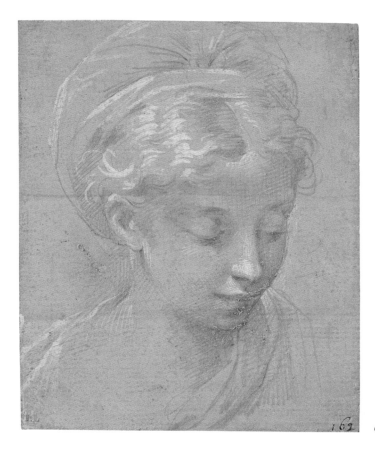

62

62 *The head of a girl* c.1524–5

Metalpoint on pale brown prepared paper, touches of brush and ink, white heightening. 113 × 90 mm (4 ⁷⁄₁₆ × 3 ⁹⁄₁₆ in)

Inscribed: *16*[*2 in a different hand*]

Fitzwilliam Museum, Cambridge (3078)

Provenance: Dukes of Modena (?); W.Y. Ottley (sale, T. Philipe, London, 6 June 1814, lot 808 ?); Sir T. Lawrence (L. 2445); bequeathed by C.B. Marlay in 1912

Literature: Fröhlich-Bum 1962, p. 694; Popham, *Parm.*, no. 46

Metalpoint is a technique of drawing with a stylus, usually of silver, on paper prepared with a coating composed of ground calcined bone, lead white, a binding medium and, often, a pigment. This pigment gave a background tone to the drawing, also providing a more dramatic contrast for highlights to be brushed in with lead white, as here. Along with pen and ink it was the dominant drawing medium of the fifteenth century, but from around 1500 it was rapidly supplanted by chalk, and Raphael was among the last major artists in Italy to use metalpoint extensively. The medium was used occasionally by draughtsmen in Rome in the 1520s, such as Perino del Vaga,

and it is likely that Parmigianino was motivated to use metalpoint here by his contact with Raphael's former assistant after his arrival in the city.

This sensitive study appears to be from the life, although there is always an element of idealization in Parmigianino's heads of young women. It was first connected by Fröhlich-Bum with the head of the Madonna in the Prado *Holy Family*, and while there is a clear resemblance in the angle of the head and the hairstyle, the facial type here is quite unlike that of the rather Slavic Madonna in the Madrid picture.

MC

63 *The worship of Jupiter*

c. 1524–5

Pen and brown ink, brown wash, white heightening. 205 × 262 mm
(8 ⅟₁₆ × 10 ⅞₁₆ in)

British Museum, London (1853-10-8-2)

Provenance: 2nd Earl of Arundel (?); A.M. Zanetti; Baron D. Vivant-Denon (L. 779; sale, Paris, 1 May 1826, lot 386); W.B. Tiffin

Literature: Popham, *BM*, no. 91; Popham, *Parm.*, no. 193; Paris 1999–2000, no. 554

The main theme of the composition is the worship of Jupiter, identified by the thunderbolts and the two eagles standing on the dais. Popham suggested that the group in the background on the right are apostles healing a sick man, and proposed that the drawing might show Saint Paul curing the cripple at Lystra with the people mistakenly worshipping Barnabas as Jupiter (Acts 14: 8–12). It seems most unlikely that the artist would have depicted Barnabas holding a bundle of thunderbolts, and the drawing may simply show a scene of pagan worship. The drawing most likely dates from the Roman period and, like the *Martyrdom of Saint Paul* (cat. 75), it is strongly influenced by Raphael's tapestry designs. HC

64 *An apparition of Christ*

c. 1524–7

Pen and brown ink, grey-brown wash, over traces of leadpoint and some stylus ruling. 146 × 126 mm (5 ¼ × 5 in)

The Metropolitan Museum of Art, New York (65.112.2; Rogers Fund, 1965)

Provenance: W. Gibson (his inscription and price mark *Fr:ᶜᵒ Parmigiano. /8.1*, on the verso of the mount); J. Richardson Sr (L. 2184; his inscription on the mount: *Parmeggiano*); Major E.W.J. Bagelaar; Dr P.O. van der Chys, Leiden (both according to inscriptions on the mount); H. van Leeuwen (L. 2799a); purchased in London, 1965

Literature: Popham, *Parm.*, no. 302; Bean 1982, no. 154

The subject of this small and vibrant composition sketch from Parmigianino's Roman period has eluded precise explanation. David Ekserdjian has proposed the Descent of Christ into Limbo (letter of 9 September 1983), recounted in the apocryphal gospel of Nicodemus, but the scene also shares some iconographic affinities with representations of both Christ healing the sick (Matthew 4: 23–4) and the Pool of Bethesda (John 5:1–25). The drawing's composition generally evokes the grandeur of Raphael's designs for the Sistine Chapel tapestry of *Saint Paul preaching in Athens*, prepared in 1514–16 and which Parmigianino also copied faithfully in a drawing in Frankfurt after Marcantonio's reproductive engraving (Popham, *Parm.*, no. 144, pl. 207). In style and technique, the Metropolitan Museum sheet fits with a number of compositional drawings from the Roman period that exhibit a similarly elusive religious subject matter and an expansive, Raphaelesque narrative construction (cat. 63; Popham, *Parm.*, nos 5, 98 recto, 374–5).

The triumphant male figure mounting the stairs on the upper left seems to be Christ in glory, who is approached by a barely sketched-out supplicant figure on the right. At the lower left, a reclining man

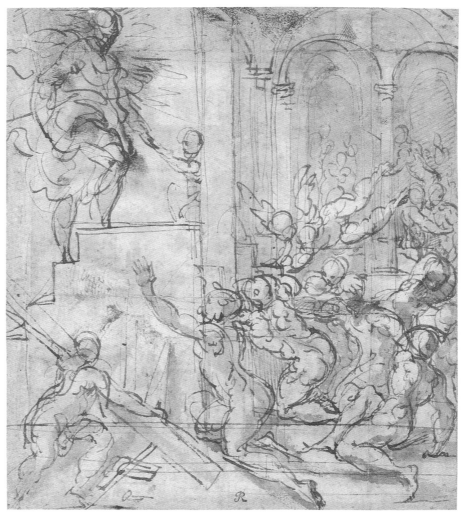

64

turns toward the Christ-like figure, holding what may be a wooden cross or pallet, while a group of beseeching figures on the right emanates from the spacious portico of an antique-style building. Hovering low amidst the crowd in the right foreground is the winged figure of an angel or a demon, but it is unclear precisely what he is doing.

Numerous figures populate the distant background of the building.

The verso of the sheet bears an impression of a small background detail in the upper right corner of Caraglio's engraving after Parmigianino's *Martyrdom of Saint Paul* (fig. 31). CCB

65 *The Nativity with the Virgin in Glory and Saint Anthony of Padua* c. 1525–6

Pen and brown ink, grey-brown wash, white heightening, the outlines pricked, on blue paper. 385 × 320 mm (15 ¹/₁₆ × 12 ⅝ in)

Ashmolean Museum, Oxford (P. II 443)

Provenance: T. Hudson (L. 2432); A. Schmid (L. 2330b); presented by the National Art Collections Fund in 1953

Literature: Parker 1956, no. 443; Popham, *Parm.*, no. 337

In a most unusual treatment of the Nativity, Parmigianino has depicted the Virgin borne in glory on a cloud of cherubim, gazed upon by Saint Anthony of Padua. Parker suggested that this may have been dependent upon the special veneration accorded to the Virgin in Franciscan circles. More specifically it seems to be based on Saint Anthony's sermon *In Nativitate Domini* which has two main themes: the contrast between the humility and poverty of the Christ Child and the glory of the Virgin, *princeps et regina nostra*; and the angelic annunciation to the shepherds, that their sign will be the Child in swaddling clothes laid in a manger. The bearded men kneeling to the left may thus both be shepherds rather than Joseph and a shepherd as hitherto stated (*S. Antonii Patavani Sermones Dominicales et Festivi*, Padua, 1979, III, pp. 1–15).

The sheet is much larger than Parmigianino's usual compositional drawings, and the outlines are pricked for transfer. It was therefore presumably the cartoon for a small devotional panel, the only such cartoon by Parmigianino to survive. No corresponding panel is known, although small private works (and their contractual documents) were much more vulnerable to loss over the years than major institutional works. The bold sweeping pen-strokes suggest that the drawing is a work of the artist's Roman years. MC

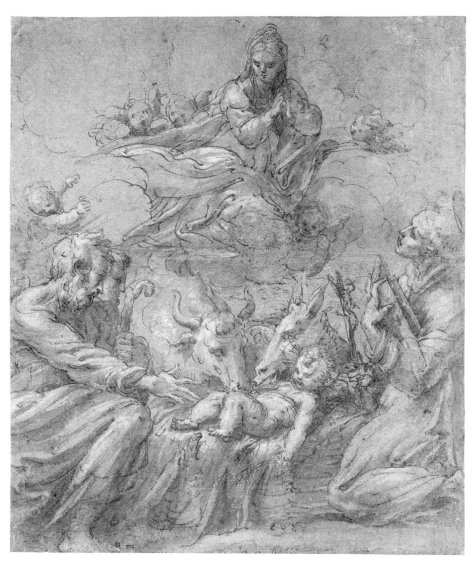

65

66 Seven gods and three goddesses c.1524–7

Pen and brown ink. 85 × 119 mm
(3 ⅛ × 4 ¹¹/₁₆ in)

British Museum, London (1861-8-10-3)

Provenance: Sir P. Lely (L. 2092); W. Gibson (?); J. Barnard (L. 1420 and 1421, verso); B. West (L. 419); Sir T. Lawrence (L. 2445, verso); J.H. Hawkins (sale, Sotheby's, London, 4 May 1850, lot 848); P. & D. Colnaghi

Literature: Popham, *BM*, no. 112; Popham, *Parm.*, no. 215

67 Two studies of a nude man c.1524–7

Pen and brown ink. 64 × 48 mm
(2 ½ × 1 ⅞ in)

British Museum, London (1905-11-10-19)

Provenance: Sir P. Lely (L. 2092); W. Esdaile, and by descent to the Rev. W. Esdaile-Richardson

Literature: Popham, *BM*, no. 113; Popham, *Parm.*, no. 216

68 Three nude men c.1524–7

Pen and brown ink, brown wash, made up upper corners. 125 × 114 mm (4 ⅞ × 4 ½ in)

British Museum, London (1905-11-10-20 and 22)

Provenance: as cat. 67

Literature: Popham, *BM*, no. 114; Popham, *Parm.*, no. 217

Cats 66–8 all share a common theme of the male nude, but it is difficult to determine the extent to which they are life drawings or else derived from the artist's imagination (some of them may even be a combination of the two). Only cat. 68 appears unquestionably to be a life study, as Parmigianino shows the models using a staff and a rope to help them sustain their poses – studio props found in countless academic nude studies including one by Parmigianino in the Victoria and Albert Museum, London (Popham, *Parm.*, no. 271, pl. 285). The complex attitude of the figure furthest to the left with his raised right arm, his head twisted to one side and his left leg thrust forward, is reminiscent of the pose of the model in a recently published academy study by Parmigianino (Ekserdjian 1999, no. 20, fig. 26). Cats 66–8 are dated by Popham to the Roman period, and although it is difficult to date them with any precision the spirited penwork is comparable with other drawings from these years.

Some of the figures in cat. 66, particularly the male nudes, could almost be taken from the life, but the composition as a whole is entirely fantastical. The artist began by drawing the three male nudes in the foreground (the central one inspired by Michelangelo's *Jonah* fresco in the Sistine ceiling), and then in an impromptu manner he proceeded to fill the background with an engagingly confused crowd of figures. The free-flowing nature of the work is shown by the artist's sudden change of mind with little thought for the overall logic of the composition – exemplified by the disembodied arm holding a lightning bolt in the centre of the sheet, presumably from an abandoned figure of Jupiter.

As Popham noted, the cursorily drawn figure of a slumped man (cat. 67) is related to the invalid being taken off a horse in a drawing of *Christ healing the sick* in Angers (Popham, *Parm.*, no. 5, pl. 189). The pose is so particular that it seems likely that it is directly related to the Angers drawing, and indeed it may be a fragment of a larger sheet of studies for the composition. HC

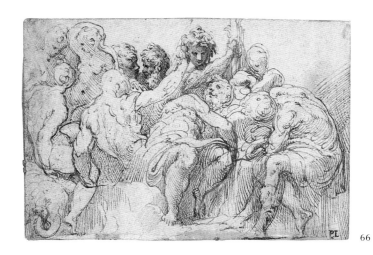

66

67

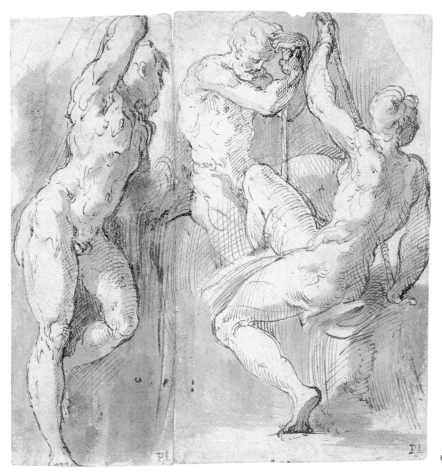

68

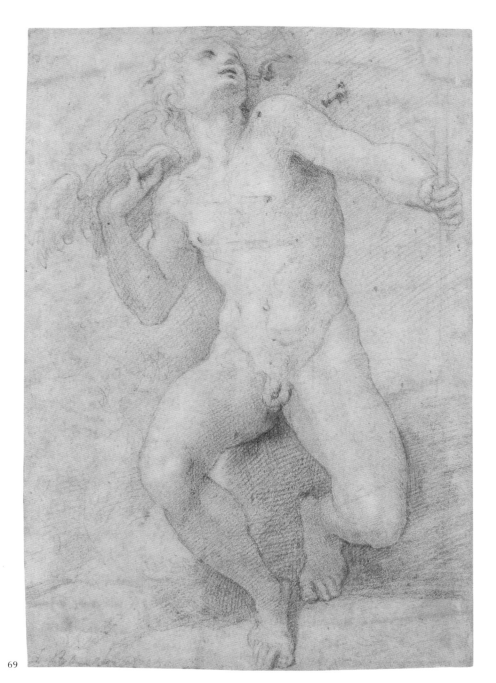

69

69 *Mercury* c.1524–6

Black chalk. 305 × 206 mm (12 × 8 ⅛ in)

Inscribed, lower left: *F. Boucher*

The Metropolitan Museum of Art, New York (1997.154; Florence B. Selden Bequest, Jessie Price Gift and Harry G. Sperling Fund)

Provenance: H. Calmann; Lerux; G. Kopelman

Literature: Washington and Parma 1984, no. 42

The attribution of this drawing to Parmigianino was first advanced by Oberhuber (oral communication to the previous owner) and has been universally accepted. De Grazia hypothesized that it may have been made as a preparatory study for a lost painting of Mercury by Parmigianino listed in the 1561 inventory of works belonging to his patron, the Cavaliere Francesco Baiardo. Whether or not this is true, it is clear that the drawing was made in connection with a finished work, on account both of the specificity of its composition and the existence of a small earlier sketch of the same figure in the National Gallery of Art, Washington (Washington and Parma 1984, fig. 42a). The pose of Mercury, with elongated torso and sharply foreshortened legs, indicates that the painting or fresco was to be viewed from below.

The style of the drawing, and its obvious partial dependence on Michelangelo's fresco of Jonah on the Sistine ceiling (see also cat. 68), indicate a date shortly after the artist's arrival in Rome in 1524. The *sfumato* modelling is still Correggesque, but the impact of Michelangelo and ancient Roman sculpture on Parmigianino are manifest here. Perhaps most comparable among his drawings in both form and technique is the study in the Louvre of a man seated on the ground (Popham, *Parm.*, no. 504, pl. 112).

GG

70 *A woman seated on the ground nursing a child* c. 1524–5

Red chalk, white heightening. 244 × 175 mm
(9 ⅝ × 6 ⅞ in)

Private collection, USA

Provenance: Dukes of Devonshire, by descent
(sale, Christie's, London, 3 July 1984, lot 31);
J.R. Gaines (sale, Sotheby's, New York, 17
November 1986, lot 9)

Literature: Popham, *Parm.*, no. 691; New
York 1994, no. 5; Jaffé 1994, no. 666

This is one of several sheets with studies
from life in various media grouped together
by Popham on account of their similarities
of style and subject (Popham, *Parm.*, under
no. 60), to which may be added the drawing
in the Ashmolean Museum Oxford (cat. 71).
Closest to the present drawing are the
Courtauld Institute study (cat. 72) and those
in Naples and in the Fondation Custodia,
Paris (Popham, *Parm.*, nos 288 and 792,
pls 39 and 42), which combine a varied, rich
use of chalk with luminous white gouache
heightening. This is among the most
moving early drawings by Parmigianino,
with a naturalism of expression and form
that is seldom present in his later, more
mannered work. It calls to mind some of
the tender renderings of the Virgin and
Child by Raphael. Popham, who dates this
and related drawings to around 1524, noted
that a chair similar to the one in this
drawing appears in the *Portrait of Galeazzo
Sanvitale* in Capodimonte, Naples, painted
in 1524 (fig. 27 on p. 90). It is hard to date
these genre studies with any precision, but
the Raphaelesque qualities of the drawings
might suggest that they post-date
Parmigianino's arrival in Rome. GG

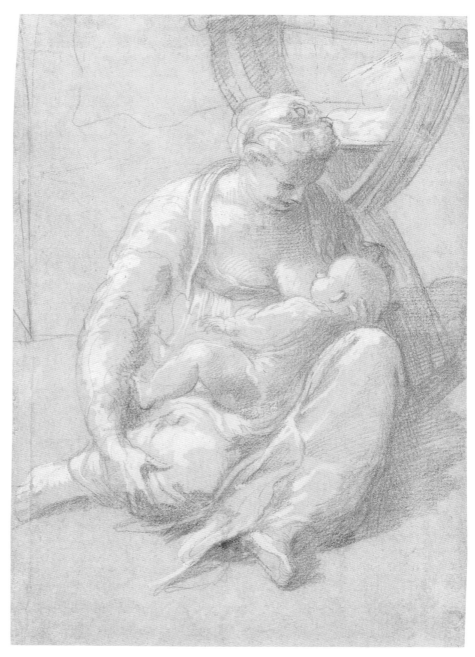

70

71 *A seated pilgrim removing his shoes* c. 1525

Red chalk. 165 × 152 mm (6 ½ × 6 in)

Ashmolean Museum, Oxford (P. II 437)

Provenance: Cavaliere F. Baiardo (?) (see below); B. West (L. 419); Sir T. Lawrence (L. 2445); G. Richmond

Literature: Parker 1956, no. 437; Popham, *Parm.*, no. 332

Popham thought that the subject of this drawing might be Moses before the Burning Bush, commanded by God to 'put off thy shoes from thy feet, for the place where thou standest is holy ground' (Exodus 3: 5), but the figure is too youthful and introspective. Further, he wears a cockleshell on his cloak and has a staff (not a shepherd's crook) by his side, identifying him as a pilgrim. This would warrant the connection of the sheet with that listed in the Baiardo inventory as 'Un' disegno di san Rocca che si calza scarpe di lapis rosse finito dil Parmesanino alto o. 4', although the physical type here is inappropriate for the usually bearded Saint Roch.

The drawing was placed by Popham as one of a group of genre studies executed in Fontanellato in 1524, but the style of the drawing seems later, probably in Parmigianino's Roman period. It was presumably drawn from the life, and no attempt is made to define the position of the torso – all we see are the shoulders and arms reaching down to the lower legs, with a mass of unobserved shadow in between. It is doubtful that the drawing was made with any further purpose in mind. MC

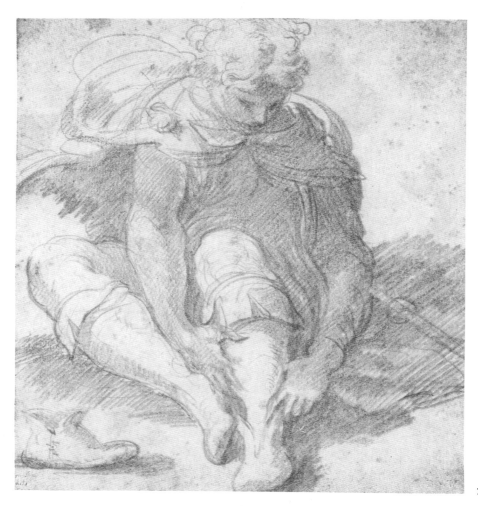

71

72 A seated woman, asleep

c. 1525

Black chalk and white heightening, on pale brown paper. 231 × 175 mm (9 ⅛ in × 6 ⅞ in)

Inscribed in two different hands: *Permegiano* and *No 29/d* (?)

Courtauld Institute, London (D.1972.PG.96)

Provenance: C.D. Ginsburg (L. 1145; sale, Sotheby's, London, 20 July 1915, lot 26 ?); H.S. Reitlinger (sale, Sotheby's, London, 9 December 1953, lot 73); Count A. Seilern

Literature: Popham, *Parm.*, no. 764; London 1987, no. 10; Landau and Parshall 1994, p. 267

Exhibited in London only

The drawing was used by Parmigianino, reduced and in reverse, as the basis for his etching traditionally held to depict the penitent Egpytian prostitute *Saint Thais* (Bartsch XVI.12.10; fig. 29). That title has no early sanction and both print and drawing are probably no more than genre studies of a sleeping woman: this would be supported by a study in the same media on the verso of the sheet, of a woman with a distaff, unconnected with any other work.

Landau and Parshall proposed that the etching was Parmigianino's first and that the drawing, made without the intention of reproducing the image, was taken by the artist from his portfolio as a suitable model. Recto and verso were thought by Popham to be among a group of studies produced during Parmigianino's stay at Fontanellato or just before his departure for Rome, but these genre studies cannot all be dated together for no better reason than their related subject matter. Many other drawings demonstrate that this was a mode that interested Parmigianino all his life, and the morphology and style of the present study place it better in the artist's Roman period.

MC

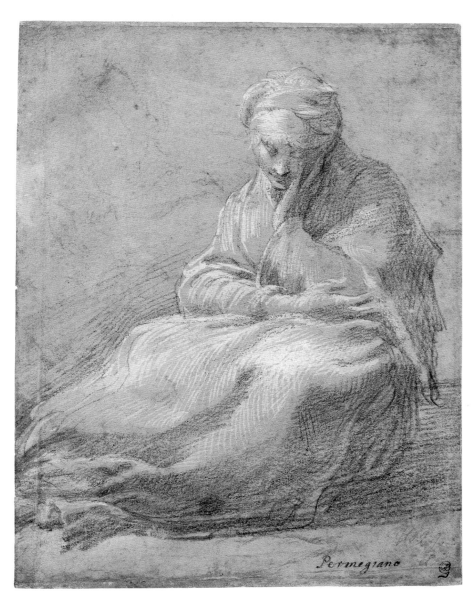

72

Fig. 29. Parmigianino, *Seated woman*, etching, 130 × 112 mm. British Museum, London (Bartsch XVI.12.10).

Parmigianino and printmaking (cats 73–8)

Parmigianino's early awareness of prints is shown by his drawn copy from the first Parmese period after Marcantonio's engraving after Raphael's figure of Poetry from the Stanza della Segnatura in the Vatican (Popham, *Parm.*, no. 168 verso, pl. 16). Parmigianino may well have been attracted to printmaking on his arrival in Rome precisely because of its association with Raphael, who had worked closely with printmakers on the production of engravings after his designs. Raphael's death in 1520 left the market open for younger artists to supply the printmakers in Rome with drawings, and Rosso Fiorentino, in particular, formed a close and productive association with the engraver Giovanni Jacopo Caraglio. Parmigianino's first documented collaboration with a printmaker was, surely not coincidentally, also with Caraglio, who engraved after his design an *Adoration of the Shepherds* in 1526. Caraglio also made three further engravings after Parmigianino designs (cats 75–6) before their collaboration was abruptly terminated by the Sack of Rome in 1527. Before his departure to Bologna Parmigianino also supplied the design for Ugo da Carpi's celebrated chiaroscuro woodcut of Diogenes, from which Caraglio made an engraved version (for the order of these, see Landau and Parshall 1994, p. 154).

During Parmigianino's stay in Bologna he worked closely with the printmaker Antonio da Trento, with whom he shared a house, in the production of chiaroscuro woodcuts. Their collaboration ended badly, with Antonio da Trento stealing from Parmigianino a quantity of woodblocks and copperplates along with a large number of drawings. The circumstances surrounding the production of Niccolò Vicentino's superb chiaroscuro woodcut after Parmigianino's drawing of *Christ healing the lepers* (cat. 73) is not known; although it is possible that Niccolò took over from Antonio da

Trento as Parmigianino's collaborator in the production of chiaroscuro prints. While in Bologna Parmigianino may well have employed an unknown printmaker, known as the 'Master F.P.' after the initials on the prints, to make etchings after his drawings. During the second half of the 1520s Parmigianino also turned his hand to etching, and one of his earliest experiments in the medium was made after his earlier drawing of a *Seated woman* (cat. 72). His experimentation in the field continued with more elaborate compositions such as the *Adoration of the Shepherds* (cat. 79), culminating in his magnificent etching of the *Entombment*, known in two versions.

Parmigianino's period of printmaking appears to have ended on his departure from Bologna in 1530, but his contribution to the development of etching during this brief period was enormous. He was the first artist to explore the spontaneous sketch-like potential of the technique which makes his etchings so similar in their immediacy to his spirited pen studies: this drawing-like manner of using the medium established a tradition that was followed by nearly all the great Italian printmakers, from Castiglione and della Bella in the seventeenth century to Canaletto and Tiepolo in the eighteenth. Parmigianino's achievements as the first Italian painter-etcher (previously the medium had only been used by specialist printmakers) also encouraged other sixteenth-century artists to take up the practice, such as Andrea Schiavone (*c.* 1510–63) and Federico Barocci (*c.* 1535–1612). Parmigianino's involvement with printmaking also had wider implications because his own prints, and those made after his designs, were widely disseminated so that his style and compositions, like those of his idol Raphael, were disseminated throughout Europe.

HC

73 Christ healing the lepers
c. 1525

Pen and brown ink, brown wash, white heightening. 271 × 420 mm (10 ¹¹/₁₆ × 16 ⁹/₁₆ in)

Chatsworth, Devonshire Collections (335)

Provenance: Sir P. Lely (L. 2092); P.H. Lankrink (L. 2090); 2nd Duke of Devonshire (L. 718)

Literature: Popham, *Parm.*, no. 690; Quintavalle 1971, no. XXVIII; Jaffé 1994, no. 673; Landau and Parshall 1994, p. 159; Mantua and Vienna 1999, no. 282

74 Christ healing the lepers
c. 1530–35

Pen and brown ink, brown wash, white heightening. 300 × 445 mm (11 ¹³/₁₆ × 17 ½ in)

Chatsworth, Devonshire Collections (334)

Provenance: 2nd Duke of Devonshire (L. 718)

Literature: Jaffé 1994, no. 434

Cat. 73 is a drawing of Parmigianino's early Roman period, self-consciously grand in emulation of the compositional manner of Raphael's Sistine tapestry designs. The

figures are much larger than normal in Parmigianino's oeuvre and it seems inherently likely that the composition was intended for same-scale transfer to some other medium. It was indeed followed faithfully, on the same scale and in the same direction, by Niccolò Vicentino in a chiaroscuro woodcut (Bartsch XII.39.15; fig. 30), but that woodcut must date from some years later and cannot itself have been Parmigianino's purpose in making the drawing. We know almost nothing about Niccolò Vicentino: Vasari stated (in his wide-ranging life of Marcantonio Raimondi) that Niccolò reproduced Parmigianino's designs after the artist's death, but all other

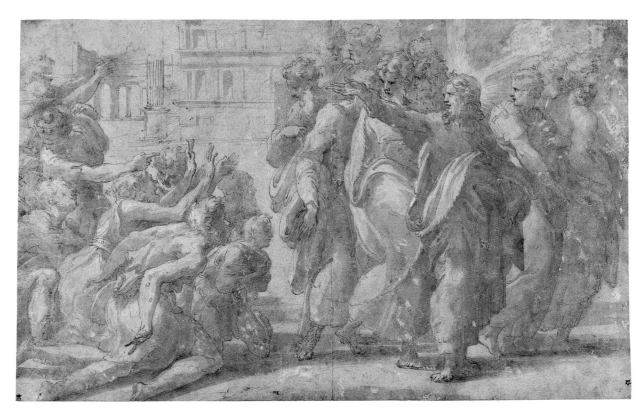

73

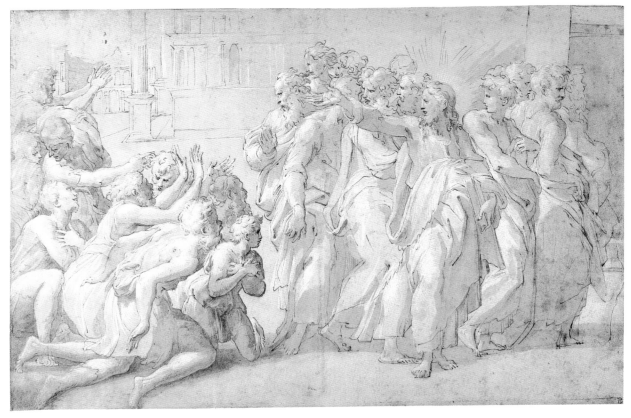

74

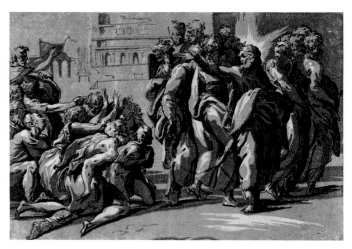

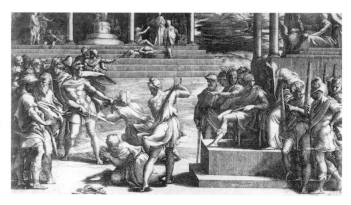

Fig. 31. Giovanni Jacopo Caraglio after Parmigianino, *Martyrdom of Saint Paul*, engraving, 256 × 444 mm. British Museum, London (Bartsch XV.71.8).

Fig. 30. Niccolò Vicentino after Parmigianino, *Christ healing the lepers*, chiaroscuro woodcut, 303 × 419 mm. British Museum, London (Bartsch XII.39.15).

information must be gleaned from the prints themselves. Niccolò was not solely parasitic of other artist's inventions, for he apparently collaborated with Pordenone in the 1530s, and the conspicuously high quality of the woodcut of *Christ healing the lepers* led Landau and Parshall to speculate that Parmigianino may have had a say in its creation.

In favour of this hypothesis is the existence of cat. 74, a version of the same composition on exactly the same scale and thus traced somehow from cat. 73 (or conceivably from some intermediate tracing or even from the woodcut). It was once held to be the original, but Popham established that cat. 73 was the model for the woodcut and thereafter cat. 74 has been regarded as a mere copy (Jaffé 1994 suggested that it might be by Niccolò dell'Abate). However, there are several substantial changes of detail, such as the gesture of the apostle furthest to the left, the head and garb of the apostle immediately to the right of Christ, the addition of an apostle at far right, and so on, and in these differences cat. 74 is if anything more attractive and more Parmigianinesque than cat. 73. The

sharper style of cat. 74 is exactly that of Parmigianino's second Parmese period; it seems to be a replica with 'improvements' by the artist himself of his own earlier drawing.

Parmigianino's motives for making such a replica cannot be known with certainty, but the most common reason for an artist to copy his own drawing is to retain one version for his portfolio when parting with the other. It is therefore possible that he gave cat. 73 to Niccolò Vicentino to reproduce, but before doing so made a copy (cat. 74). Niccolò's use of the earlier (and, considering the changes in cat. 74, implicitly less perfect) composition rather than the 'up-to-date' version would tend to argue against this hypothesis. Landau and Parshall also raised the alternative possibility that cat. 73 was among those stolen by Antonio da Trento from Parmigianino in Bologna, and that Niccolò thereafter acquired the drawing in order to make his woodcut; but this would still require an explanation of how and why Parmigianino made a near-replica of his earlier drawing during the first years of the 1530s. MC

75 *The martyrdom of Saint Paul* c. 1524–7

Pen and brown ink, brown wash, white heightening, on light brown washed paper, the outlines indented for transfer. 254 × 453 mm (10 × 17 ¹³⁄₁₆ in)

Inscribed: *Fran.ᵘˢ Parm. F. 1527*

British Museum, London (1904-12-1-2)

Provenance: G. Vasari (?) (see below); Pamphilj family; Mr Peachey; G.W. Reid (sale, Sotheby's, London, 29 February 1890, lot 614); M. Rosenheim, by whom presented through the National Art Collections Fund

Literature: Popham, *BM*, no. 88; Popham, *Parm.*, no. 190; Mantua and Vienna 1999, no. 255

This corresponds exactly, in reverse and on the same scale, with the engraving by Caraglio (Bartsch XV.71.8; fig. 31). The drawing is probably the one used by the printmaker, as the outlines have been incised, thereby allowing the design to be transferred on to the plate. Seven related studies are known (two from facsimile prints), including two drawings of the entire composition in the Louvre (Popham, *Parm.*, nos 379–80, pls 136–7). The subject of Parmigianino's drawing relates to the legend that Saints Peter and Paul were executed in Rome by the order of Emperor Nero on the same day, but not in the same place, nor by the same method. In the foreground the kneeling Paul awaits the executioner's sword, while behind him Peter is roughly dragged away by his beard to be crucified. Popham suggested that the drawings could be linked to an unexecuted project to decorate the Sala dei Pontefici in

the Vatican, a commission that is said by Vasari to have been promised to Parmigianino by Clement VII. Although the subject would certainly have been a suitable one for the decoration of the room, there is no firm evidence to corroborate Vasari's account. In Bologna Parmigianino collaborated with Antonio da Trento on a chiaroscuro woodcut of the composition (Bartsch XII.79.28), which differs in a number of respects from Caraglio's engraving. Vasari mentions in his life of Parmigianino that he owned a drawing of this subject by the artist, but it is impossible to determine whether this was the present sheet or one of the aforementioned studies in the Louvre.

The clarity and coherence of Parmigianino's composition testify to his close study of Raphael, and in particular his *Martyrdom of Saint Cecilia* engraved by Marcantonio Raimondi (Bartsch XIV.104.17). HC

76 *The Betrothal of the Virgin* c. 1524–7

Pen and brown ink, brown wash, white heightening. 453 × 232 mm (17 $^{13}/_{16}$ × 9 $^{1}/_{8}$ in), arched

Chatsworth, Devonshire Collections (339)

Provenance: Sir P. Lely (L. 2092); N.A. Flinck (L. 959); 2nd Duke of Devonshire (L. 718)

Literature: Popham, *Parm.*, pp. 9–11, no. 692; Quintavalle 1971, no. XIX; Gould 1994, p. 66; Jaffé 1994, no. 677; Landau and Parshall 1994, p. 154; Gnann 1996; Mantua and Vienna 1999, no. 266

The Apocrypha related that Joseph was chosen from among the competing suitors for the hand of the Virgin when his rod flowered miraculously in the Temple. Here the dove of the Holy Spirit alights on Joseph's rod; the aged woman seated with a book in the right foreground is probably a sibyl, as is presumably her pendant to the left with an exotic head-dress. The supposed prophecies of the antique sibyls were interpreted in the Renaissance as pagan counterparts to the Old Testament prophecies, alluding to the Virgin Birth and the coming of Christ, and thus the two men seated beyond are possibly prophets (although they lack any attribute such as a scroll and may simply be the sort of gesticulating spectator common in temple scenes).

The drawing was reproduced in the same direction and on the same scale in an engraving by Giovanni Jacopo Caraglio around 1526 (Bartsch XV.66.1; fig. 32). The penwork here is more systematic than was usual in Parmigianino's drawings: even other large and ostensibly finished sheets such as the *Christ healing the lepers* (cat. 73) display much more verve in the lines. The shadows are built up with areas of regular cross-hatching before being washed over, and the white is carefully hatched rather than brushed on in a painterly manner. Parmigianino clearly drew the sheet as an explicit model for Caraglio, and before the ink faded through damping and abrasion

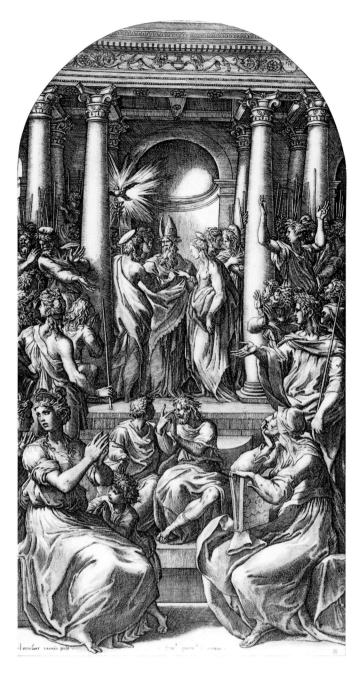

Fig. 32. Giovanni Jacopo Caraglio after Parmigianino, *Bethrothal of the Virgin*, engraving, 474 × 246 mm. British Museum, London (Bartsch XV.66.1).

the drawing would have displayed the strong contrasts still seen in good impressions of the engraving.

Because of the narrow arched field it was often suggested that the composition might have originated as an earlier design for the San Salvatore in Lauro altarpiece of the *Madonna of Saint Jerome* (see cats 88–93), but the recent discovery of the contract for the painting has dispelled that suspicion. Gnann, however, continues to

associate the drawing with the blank field at the centre of cat. 86, also formerly related to San Salvatore, proposing that both are studies for the Cesi chapel in Santa Maria della Pace and that the subject of the present drawing forms part of a general Marian programme for that chapel (for a discussion of this proposal see cat. 86). That the composition was devised for a painting is supported by a reliable copy of a lost earlier study (private collection; Gnann

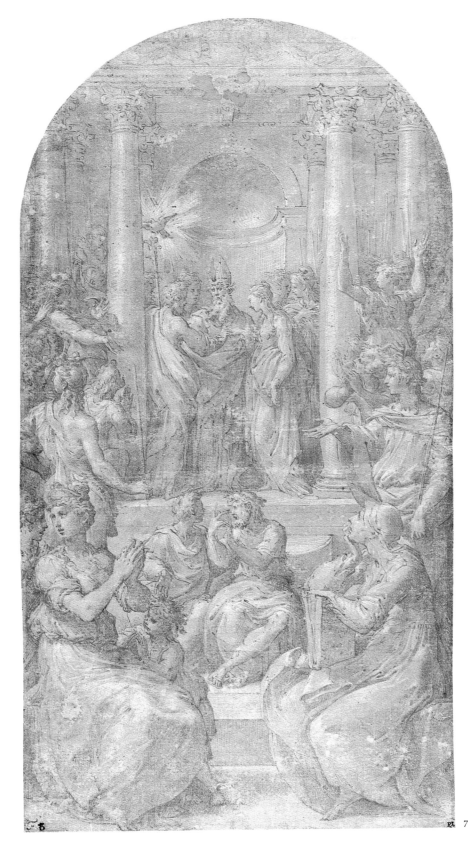

1996, p. 364, fig. 4) which displays essentially the same structure in depth but with the central event displaced to the right side of the field. This copy has an arched format of nearly the same proportions, implying a compliance with externally imposed conditions that would not be necessary for a print. It should be noted that the composition as engraved is unsuitable for an altarpiece, its spatially deep arrangement allowing the foreground sibyls to dwarf the holy couple, and if painted for the Cesi chapel the figures of Joseph and the Virgin would have been barely thirty centimetres high. It may be that the design began life as a project for an abortive commission, and that rather than waste his efforts Parmigianino subsequently developed this model for the engraver.

The dependence of the composition on Rosso Fiorentino's 1523 altarpiece of the subject for San Lorenzo in Florence has often been noted. Parmigianino could have seen this during his journey from Parma to Rome, but it is at least as likely that he would have known Rosso personally in Rome and thereby had access to studies for that painting. MC

76

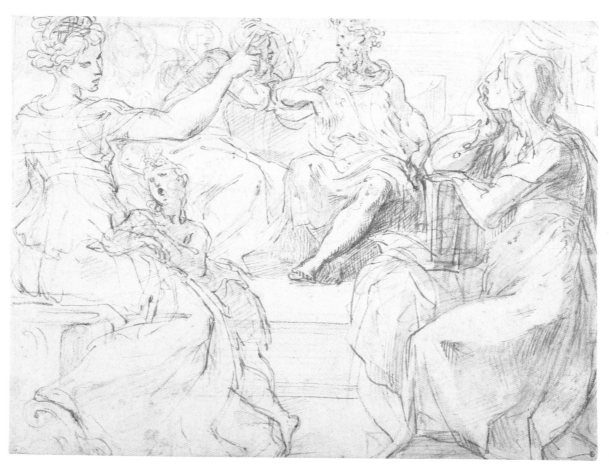

77 Seated figures of onlookers in the foreground of the 'Betrothal of the Virgin'

c.1524–7

Pen and brown ink, brown wash, over red chalk. 179 × 232 mm (7 ¹/₁₆ × 9 ⅛ in)

The Pierpont Morgan Library, New York (I, 48)

Provenance: Baron D. Vivant-Denon (L. 780); C. Fairfax Murray; purchased by J.P. Morgan in London, 1910

Literature: New York 1965, no. 92; Popham, *Parm.*, no. 312; Rossi 1980, p. 84

This drawing explores the arrangement of the figures seen in the foreground and middle ground of cat. 76. The device of the two monumental foreground female figures was among the most innovative aspects of Rosso's altarpiece in the Ginori chapel in San Lorenzo, Florence.

The 'IHS' watermark (close to Briquet 9462; Casalmaggiore around 1526) suggests a Parmese origin for the paper used for cat. 77, and it is therefore worth considering that Parmigianino produced the drawings for the *Betrothal of the Virgin* not long after his arrival in Rome in 1524 (when he might still have had paper brought from Parma with him). In great contrast to Rosso, Parmigianino's *Betrothal of the Virgin* composition is filled from front to back with figures, and in the animated Morgan Library study, the elegantly conversing figural groups are in a much more continuous, unified scale than in either the Chatsworth drawing (cat. 76) or Caraglio's print (fig. 32). The extensive underdrawing in ochre-red chalk flickers with movement, and the rendering with wash is light and airy. At the upper left, there are at least two further seated figures in indistinct poses sketched in chalk only. The sheet primarily explores the juxtaposition of type and gesture in the two monumental women seated in the foreground: young, active and beautiful on the left and older, pensive and modest on the right. They may well embody the 'active life' and 'contemplative life' according to humanist tradition, but their identity is by no means clear, and they have also been called sibyls. (In Rosso's altarpiece, the contrasting young and old female types are identifiable as Saints Apollonia and Anne.) Parmigianino greatly reworked the pose of the young woman seen on the left of the Morgan Library sheet in another intermediate study in Naples (Popham, *Parm.*, no. 290, pl. 143), before settling on the final composition shown in cat. 76.

CCB

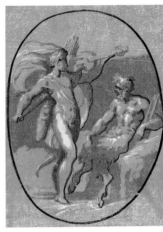

Fig. 33. Ugo da Carpi (?) after Parmigianino, *Apollo and Marsyas*, chiaroscuro woodcut, 217 × 154 mm. British Museum, London (Bartsch XII.123.24).

78 *The contest of Apollo and Marsyas* c. 1524–7

Pen and brown ink, brown wash, white heightening, over traces of black chalk. 207 × 146 mm (8 ⅛ × 5 ¼ in)

The Pierpont Morgan Library, New York (IV, 44)

Provenance: 2nd Earl of Arundel (?); A.M. Zanetti (?); Baron D. Vivant-Denon (L. 780); I. Walraven (1686–1765) (sale, De Winter & Yver, Amsterdam, 14 October 1765, portfolio E, lot 275); A. Rutgers (1695–1778) (sale, De Winter & Yver, Amsterdam, 1 December 1778, portfolio G, lot 435); J. McGouan (sale, T. Philipe, London, 30 January 1804, lot 445); Sir C. Greville (L. 549); 4th Earl of Warwick (L. 2600; sale Christie's, London, 20 May 1896, lot 260); C. Fairfax Murray; purchased by J.P. Morgan in London, 1910

Literature: Popham, *Parm.*, no. 319; Saslow 1986, p. 111; Denison, Mules and Shoaf 1981, no. 21; Wyss 1996, pp. 100–7, 149; Paris 1999–2000, no. 558

Exhibited in New York only

The oval composition in this famous Morgan Library drawing served as a *modello* for an unsigned chiaroscuro woodcut that is usually attributed to Ugo da Carpi (Bartsch XII.123.24; fig. 33). Apollo stands on the left, playing a viola, rather than a lyre, the latter his more usual instrument according to the various conflated classical myths. His pose is loosely based on the famous Hellenistic marble sculpture of the *Apollo Belvedere* (Vatican Museums), installed in 1503 in the Belvedere courtyard of the Vatican Palace. On the right, the seated satyr who holds a syrinx or pan-pipes is in all likelihood Marsyas, although he has also been called Pan. According to legend, the unlucky Marsyas dared to compete with Apollo in the playing of music, and on losing was flayed alive.

Cat. 78 is one of six drawings of closely related subject and technique by Parmigianino that reinterpret episodes from the legend of Marsyas, as told by Hyginus (a Roman scholar and friend of Ovid). According to a convincing recent reconstruction by Edith Wyss, the Morgan Library sheet would be the last scene among the extant finished drawings in a narrative sequence based around the mythical creation of the syrinx: Mercury making the pipes (Popham, *Parm.*, no. 394, pl. 132), Mercury offering them to Minerva (ibid., no. 395, pl. 132), Minerva playing them (ibid., no. 390, pl. 130), Minerva casting them away (ibid., no. 391, pl. 130) and Marsyas finding them (ibid., no. 392, pl. 131). Further fragmentary studies for this cycle exist, and it seems that there would have been a total of eight scenes, including the flaying of Marsyas. Part of a project that must have at least been begun in Rome, Parmigianino's scenes exhibit a preternatural Raphaelesque grace, and their upright oval compositions, with sinuously proportioned figures and elegantly billowing draperies, recall the format of a refined series of drawings in red chalk on the legend of Apollo by Perino del Vaga (illustrated in Paris 1984, nos 87–9), who was among Parmigianino's close acquaintances in Rome. An especially accomplished large finished drawing by Andrea Schiavone from the 1560s or 1570s adapts Parmigianino's famous composition to a square format (Pierpont Morgan Library, New York). The reproductive prints after Parmigianino's composition include an etching from around 1545 by Antonio Fantuzzi in reverse orientation, which vividly illustrates Parmigianino's influence among artists of the Fontainebleau school. The new research on the Dutch provenance of this famous drawing is due to Michiel Plomp (January 2000). CCB

79 *The Adoration of the Shepherds* *c. 1526–7*

Black chalk. 247 × 198 mm (9 ¾ × 7 ¹³⁄₁₆ in)

Royal Library, Windsor Castle (0535)

Provenance: 2nd Earl of Arundel (?); A.M. Zanetti (?); G.A. Armano (?); King George III

Literature: Popham and Wilde 1949, no. 576; Popham, *Parm.*, no. 644; Washington and Parma 1984, no. 47; Gnann 1996, p. 370; Mantua and Vienna 1999, p. 381

The upper centre part of the drawing corresponds generally with an etching by Parmigianino (Bartsch XVI.7.3; fig. 34) in the same direction and on the same scale, although there are some differences in the background architecture and in the poses of the individual figures. The etching terminates below the right sleeve of the woman in the foreground, and the three horizontal folds in the paper of cat. 79 were probably made by the artist himself as he attempted to find a satisfactory crop for the

Fig. 34. Parmigianino, *Adoration of the Shepherds*, etching, 120 × 78 mm. British Museum, London (Bartsch XVI.7.3).

composition. The lateral edges of the etched composition, running down the back of the standing figure furthest to the left and through the hair of the second foreground woman, are also indicated by two lines ruled on the drawing in stylus or hard black chalk, barely visible in reproduction.

This cropping is found in three other drawings that correspond with the dimensions of the etching and are in reverse with respect both to the etching and to the present sheet, in the British Museum (Popham, *Parm.*, no. o.c. 6, pl. 153, a copy after a lost original) and at Stuttgart and Chatsworth (Popham, *Parm.*, nos 593 and 728, pl. 153, the latter of which may in fact be a copy of the former). Although some of the figures in these three drawings are closer to those in the etching than are the equivalent figures in cat. 79, others are less similar – for example, the foreground figures in those drawings are bearded men, whereas here and in the etching they are women. The etching therefore combines features from several of the preliminary sheets.

Preceding cat. 79 in Parmigianino's development of the composition were a recently rediscovered chalk and wash drawing now on loan to the Snite Museum of Art, Notre Dame, Indiana (Ekserdjian 1999, no. 23, fig. 30), and a closely related lost sheet known from an eighteenth-century reproductive print (Popham, *Parm.*, no. o.R. 5, pl. 153). All three are conceptually similar to the contemporary *Betrothal of the Virgin* (cat. 76), in which the principal event takes place on a platform beyond a number of larger foreground figures. The subsequent cropping of the composition here stranded a half-length figure in the lower part of the composition; though disconcerting, this may have been to Parmigianino's liking for he deployed similar *repoussoir* figures in the painting of the *Mystic Marriage of Saint Catherine* (National Gallery, London) and the *Presentation of Christ in the Temple*, cut in chiaroscuro by Andrea Andreani (Bartsch XII.31.6). MC

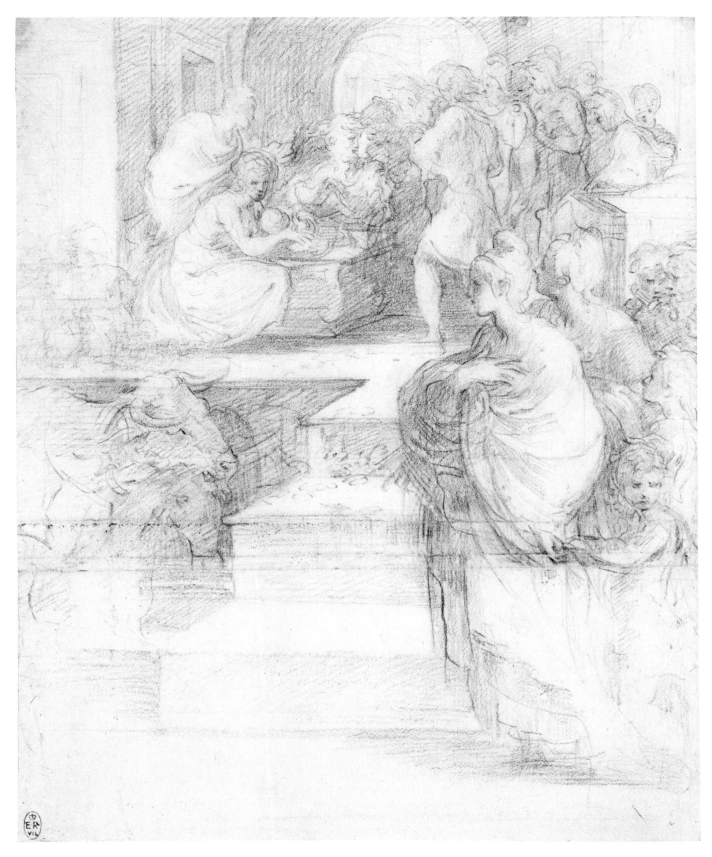

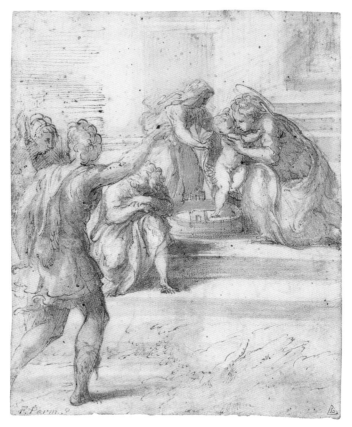

80r

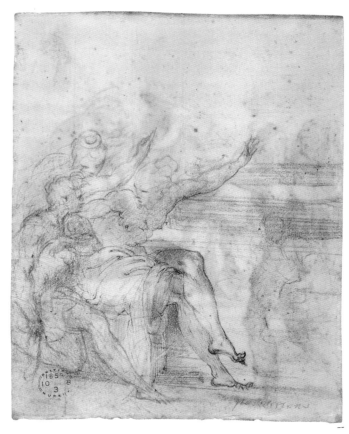

80v

80 *The Adoration of the Shepherds with the Infant Christ being bathed* (recto); *Kneeling man holding a lamb, and two seated women* (verso) *c.1524–6*

Pen and brown ink, brown wash, over red chalk (recto); pen and brown ink, and red chalk (verso). 185 × 145 mm (7 ¼ × 5 ¹¹⁄₁₆ in)

British Museum, London (1853-10-8-3)

Provenance: Marquis de Lagoy (L. 1710); T. Dimsdale (according to Louis Fagan's manuscript catalogue); W.B. Tiffin

Literature: Popham, *BM*, no. 86; Popham, *Parm.*, no. 188

This airy composition drawing is one of a number of surviving studies of the *Adoration of the Shepherds* (see cats 54 and 81). Also extant from the artist's Roman sojourn are an etching of this subject (fig. 34 on p. 124), a small painted panel (Galleria Doria Pamphilj, Rome), and Caraglio's engraving dated 1526 (Bartsch XV.68.4) after Parmigianino's highly finished drawing in Weimar (Popham, *Parm.*, no. 631, pl. 144). To complicate matters, however, Parmigianino's surviving drawings of the *Adoration of the Shepherds* (except for that in Weimar) bear few compositional similarities to the surviving prints and painting of the subject. All of the drawings reveal such marked differences with respect to each other that it is extremely difficult to establish precisely how they relate, and how they were finally used. A further and otherwise diverse group among these drawings clearly shares the specific iconographic motif of the Virgin bathing the Christ Child incorporated into the scene of the Adoration of the Shepherds. Except for the sheet of sketches in the British Museum which is ambiguous (Popham, *Parm.*, no. 189 recto), all five

drawings with 'the bath' are, like the present study and cat. 81, vertical in format (Popham, *Parm.*, nos 189 recto, 453, 522, pls 146–7). This nucleus of drawings seems to have been preparatory for a single work, possibly a small lost devotional painting for a private patron. (The *Adoration of the Shepherds* in the Doria Pamphilj Gallery, Rome, dated by Gould to around 1524–5, exemplifies one such small Roman devotional panel by Parmigianino in a vertical format.)

The composition in the present drawing is based on the earlier sheet, also in the British Museum, with a sequence of rapid sketches in pen and brown ink exploring the main group of the Virgin bathing the Christ Child (Popham, *Parm.*, no. 189 recto). As that sheet of quick sketches makes clear, Parmigianino fluently shifted the orientation of his designs back and forth – left to right and right to left – in studying the figural solutions. The small sketch on the lower left of the British Museum sheet offers the exact pose that would be adopted here: the Virgin kneeling toward the left, as she hugs the standing infant, who is turned in a three-quarter view to the right. CCB

81 *The Adoration of the Shepherds with the Infant Christ being bathed* c. 1524–6

Pen and brown ink, brown wash, traces of white heightening, over black and traces of red chalk, on brownish paper. 217 × 151 mm (8 ⁹⁄₁₆ × 5 ¹⁵⁄₁₆ in)

The Metropolitan Museum of Art, New York (46.80.3; Rogers Fund, 1946)

Provenance: C.M. Metz; Paignon-Dijonval, by descent to his grandson Vicomte Morel de Vindé; Sir T. Lawrence (L. 2445); S. Woodburn; W. Coningham (L. 476); J.H. Hawkins (according to Sotheby's catalogue); H.G. Hewlett (sale, Sotheby's, London, 28 November 1922, lot 14); Dr F. Haussman, Switzerland

Literature: New York 1965, no. 91; Popham, *Parm.*, no. 297; Collobi Ragghianti 1972, p. 48; Bean 1982, no. 152; Malibu, Fort Worth and Washington 1983, under no. 14; Di Giampaolo 1989, p. 120, under no. 54

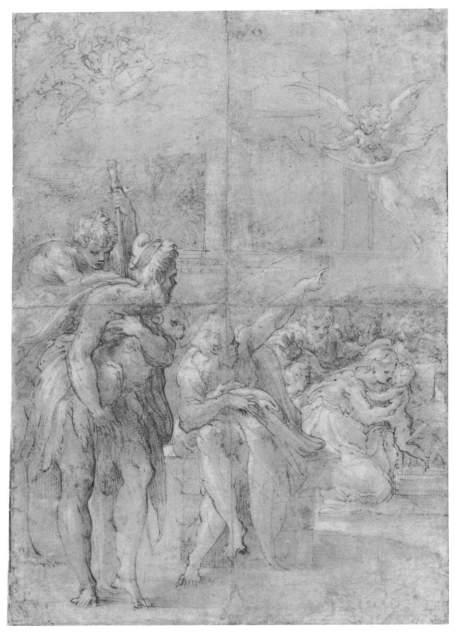

81

This fairly detailed composition shows, in comparison with cat. 80, the kneeling Virgin now facing to the right rather than to the left, and the agitated poses of the shepherds now tamed into classical balance and restraint. The Metropolitan Museum sheet also offers evidence for a dating of the *Adoration of the Shepherds* drawings early rather than late in Parmigianino's Roman years, because the pose of the large standing nude man drawn in red chalk on the recto of cat. 45 is echoed in the shepherd standing here on the left, and the general idea for the seated shepherds seen on the left in the recto of cat. 54, bearing a Parmese watermark on its paper, is also taken up here. The finished drawing by Parmigianino in Weimar (Popham, *Parm.*, no. 631, pl. 144) for Caraglio's engraving of 1526 is horizontal rather than vertical in format. The Christ Child there is held up by an onlooker from a pillow-covered manger. In spite of such differences, the poses of a few figures around the Infant Christ resemble those in the Metropolitan Museum sheet. The Uffizi drawing of the *Adoration*

of the Shepherds (Popham, *Parm.*, no. 72, pl. 145), also in a horizontal format and no longer showing the Virgin clearly bathing the Christ Child, seems to represent an intermediate stage of planning, when the composition went from the vertical format (as in cats 80–1) to the horizontal format of the Weimar drawing. The paper of cat. 81 has darkened due to light exposure, thus diminishing the original airiness of its pen and ink with wash technique. A separate study for the figure of the shepherd seen

carrying a lamb on the left is at Chatsworth (Popham, *Parm.*, no. 717, pl. 149). A drawing of good quality by a sixteenth-century copyist in the Fondazione Horne closely imitates the Metropolitan Museum composition (Collobi Ragghianti 1972, pp. 44–9, fig. 14, incorrectly attributed to Pellegrino Tibaldi). The differences in detail in that sheet, however, suggest that the copyist probably worked from a lost variant of cat. 81. CCB

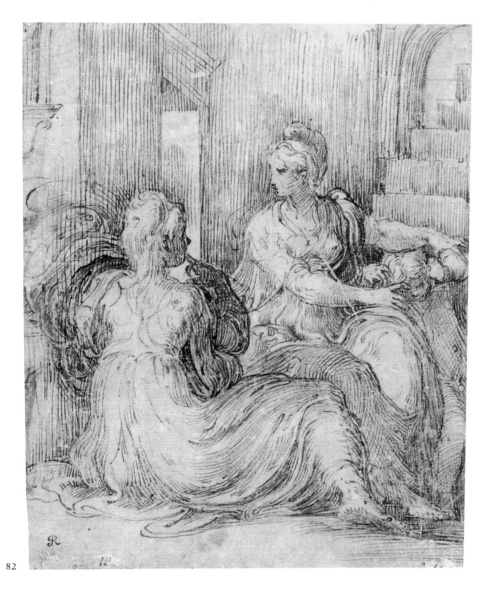

82

82 *Two women and a child in an interior* c. 1526–8

Pen and brown ink. 154 × 119 mm.
(6 ¹/₁₆ × 4 ¹¹/₁₆ in)

British Museum, London (Ff. 1-88)

Provenance: J. Richardson Sr (L. 2184);
J. Barnard (L. 1419); Rev. C.M. Cracherode
Bequest, 1799

Literature: Popham, *BM*, no. 74; Popham,
Parm., no. 176

Popham tentatively advanced the idea that
this might be an unexecuted design for a
print because of the finished nature of the
study and the engraver-like quality of the
line. In style it is close to a pen drawing of
the *Entombment* in the Louvre (Popham,
Parm., no. 466, pl. 161), and both drawings
can broadly be dated to the Roman or
Bolognese periods. Although at first glance
the composition shows little sign of revision,
the pose and drapery of the woman seen
from behind were quite substantially
altered, most significantly in the position
of her right arm. The identity of the figures
has not been satisfactorily explained.
Popham's suggestion that they might be the
Virgin and Child with Saint Anne seems
unlikely as the rustic Phrygian cap on the
head of a woman with a child is worn by
shepherds in Parmigianino's etching and
drawing of the *Adoration of the Shepherds*
(cat. 79 and fig. 34). The child in the
drawing also looks from his raised arms to
be in the middle of a tantrum, making his
identification with the Christ Child most
improbable. The drawing's spatial setting is
decidedly irrational, with the figures on a
much larger scale than the surrounding
architecture (cf. cat 83), and the perspectival
recession of the wall distorted so that it
curves around to enclose the group. HC

83 *The Adoration of the Shepherds* c. 1526–7

Pen and ink, brown wash. 256 × 216 mm
(10 ¹/₁₆ × 8 ½ in)

Chatsworth, Devonshire Collections (804)

Provenance: Dukes of Devonshire

Literature: Popham, *Parm.*, no. 732;
Quintavalle 1971, no. XXXI; Jaffé 1994, no. 701

The composition was carelessly considered
by Parmigianino and has several spatial
infelicities, most notably the placing of
the small and implicitly distant central
shepherds before a stable wall that would
otherwise be read as close to the foreground
group. The grouping of the figures into
disconnected pairs gives a restless feel to the
composition, and the perfunctory nature of
the background suggests that Parmigianino
hastily completed a sheet about which he
had no great enthusiasm. The style of the
drawing places it in the artist's Roman
period: this is supported by the existence of
a copy of the figure of Joseph on a sheet of
sketches by Perino del Vaga (Royal Library,
Windsor; Clayton 1999, no. 47 verso), who
presumably knew the composition when
he too was in Rome before the Sack.

Parmigianino himself did nothing
further with the composition, one of many
studies of Nativities and Adorations in Rome
that cannot be related to other works and
may have been begun with printmaking in
mind. The present drawing was reproduced
in a contemporary unsigned engraving (not
in Bartsch; repr. Fröhlich-Bum 1921, p. 94,
pl. 115), but the drawing does not have
the appearance of being finished for the
engraver and the engraving is certainly not
by Caraglio, Parmigianino's collaborator in
Rome. The print was thus probably made
outside the artist's control after the drawing
had left his hands. MC

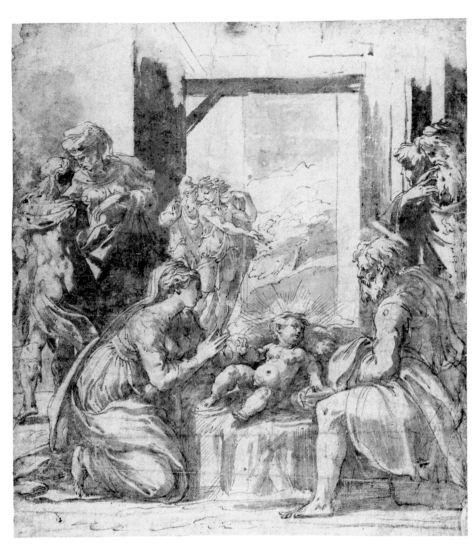

83

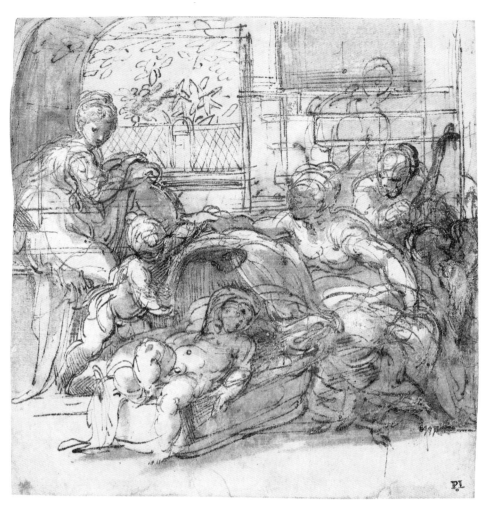

84

84 *The Holy Family with the Infant Baptist* c.1526–7

Pen and brown ink, brown wash, white heightening. 153 × 146 mm (6 × 5 ¼ in)

Fitzwilliam Museum, Cambridge (PD.123-1961)

Provenance: Sir P. Lely (L. 2092); Earls of Pembroke (their inscription *Parmegianino from Vol 2nd No 50* on a fragment of an old mount; sale, Sotheby's, London, 10 July 1917, lot 432, bt C.B.O. Clarke); bequeathed by L.C.G. Clarke in 1960

Literature: Popham, *Parm.*, no. 49

The Christ Child lies in a cradle with his right arm thrown back over his head, the antique signifier of sleep used in one standard type of *Cupid asleep* (see cat. 85) and probably adopted by Michelangelo for his early, now lost, sculpture of that subject. He is approached by the Infant Baptist who pulls a drape back from the crib, an unveiling that refers to the Baptist's role as the herald of the Saviour. Seated behind the Baptist is presumably his mother, Saint Elizabeth, leaning on a second cradle. To the right behind the Virgin crouches Saint Joseph, who seems to reach towards some long-necked object that may be a stringed instrument; this would however be a most unusual iconography, and in the tangle of lines at centre left a more conventional winged angel may perhaps be discerned. There are indications of another figure, perhaps a handmaiden, mounting the steps in the right background.

Stylistically the drawing is of Parmigianino's Roman years, although the composition cannot be related to any other work. On the verso of the sheet are copies of a dead baby and a pair of hands from Marcantonio's print after Raphael of the *Massacre of the Innocents*; a copy of another baby in the same print, in the British Museum (Popham, *Parm.*, no. 210, pl. 211), was used as the model for Parmigianino's etching of a sleeping Cupid (Bartsch XVI.13.11). The connection of both sides of the sheet with this subject would tend to date the drawing close to the print, probably towards the end of Parmigianino's Roman period when his interest in printmaking flourished, and it is quite conceivable that this composition of the Holy Family was itself considered for a print. MC

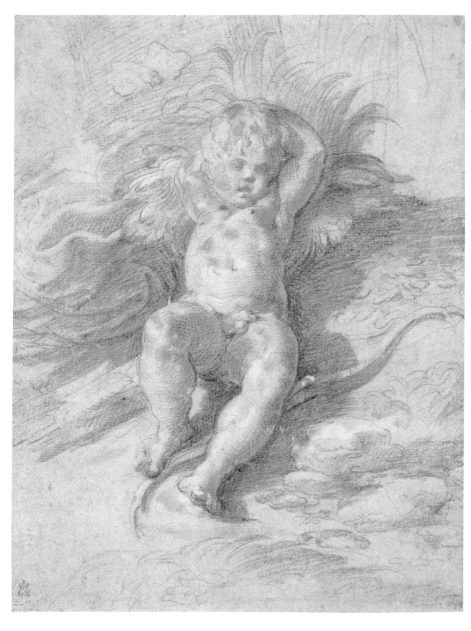

85

85 *Cupid asleep* c. 1525–30

Red and traces of white chalk, later white heightening (now discoloured) applied to mask restoration and repairs. 248 × 182 mm (9 ¾ × 7 ³/₁₆ in)

British Museum, London (1858-7-24-8)

Provenance: Paignon-Dijonval, by descent to his grandson Vicomte Morel de Vindé; Sir T. Lawrence (L. 2445); Count N. Barck (L. 1959)

Literature: Popham, *BM*, no. 111; Popham, *Parm.*, no. 214

The drawing shows Cupid, identifiable by his bow and quiver, lying asleep on a grassy bank. A number of antique sculptures of the subject were known in the Renaissance, and the young Michelangelo also made a marble, now lost, of the subject. As Popham pointed out, a Cupid in the same pose, but seen from a different angle, appears in a drawn copy after a lost painting by Lorenzino, a little-known pupil of Titian, formerly in the collection of Andrea Vendramin in Venice (see Borenius 1923, pl. 64). This would suggest that there was a common antique prototype familiar to both artists. The drawing is far from being a dry transcription of a classical model, with the figure placed in a landscape setting of verdant grasses, a trunk of a tree and what looks to be a butterfly fluttering above his head. HC

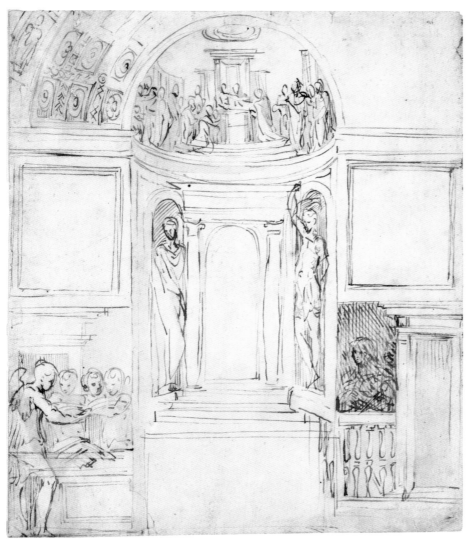

86

while a group of angels singing from a choirbook at lower left stand around a similarly inexplicable sarcophagus. The scale of the drawing is also difficult to establish: either the sculptures in the niches are well over life size (and the old woman at lower right suggests that they are not) or the altarpiece is unusually small, not a metre and a half high.

The similarity of shape of the altarpiece shown (blank) here, the Chatsworth *Betrothal* (cat. 76) and the *Madonna of Saint Jerome* (National Gallery, London; cats 88–93) has led to repeated attempts to link the three, but the recent discovery of the contract for the London painting has divorced cats 76, 86 and 87 from the San Salvatore in Lauro project. Gnann has subsequently associated the three drawings with the Cesi chapel in Santa Maria della Pace, claiming that the architectural features of cat. 86 corresponded in the 1520s with those of the side chapels of the Pace and of no other Roman church. On 26 April 1524 Rosso Fiorentino was commissioned to decorate the Cesi chapel with an altarpiece and murals in stucco and fresco, an undertaking that was apparently halted through the intervention of Antonio Sangallo the Younger when Rosso had completed only the external lunette (see Hirst 1964). Gnann therefore proposed that cats 76, 86 and 87 were Parmigianino's plans to complete the project after the commission had been taken away from Rosso: the chapel was dedicated to the Annunciation and Gnann thus read the niche figures as the Virgin and Gabriel. This theory has something to recommend it, subject to the observations that the *Betrothal* in the form known would be most unsatisfactory as an altarpiece, and that the architectural inconsistencies and character of the present drawing indicate that it was only a creative sketch and not a finished design, and would in anything like its present form have required considerable remodelling of the Cesi chapel. It must be stressed that there is no evidence beyond an interpretation of these drawings that Parmigianino was ever engaged on the chapel; if they are related to that project

86 *A design for a chapel*
*c.*1525–7

Pen and brown ink. 235 × 196 mm
(9 ¼ × 7 ¹¹/₁₆ in)

Victoria and Albert Museum, London
(E. 2693-1920)

Provenance: C.S. Bale (L. 640 on back of mount; sale, Christie's, London, 10 June 1881, lot 2393 ?)

Literature: Popham, *Parm.*, no. 273; Ward-Jackson 1979, no. 230; Gould 1994, p. 70; Gnann 1996; Mantua and Vienna 1999, p. 357

The architectural form presents some difficulties of interpretation. The central recess is clearly meant to be read as semicircular in plan, topped by a semidome, with two sculptures in niches flanking a flat aedicule which frames the altarpiece and in front of which is a stepped altar; but the walls either side of the recess are presented frontally whereas the section of coffering drawn in at upper left is apparently splayed, and the junction of these two areas at the entablature is thus contradictory. An old woman at prayer, and perhaps a second indistinctly drawn figure, inhabit a space at lower right that is not defined by the surrounding architecture,

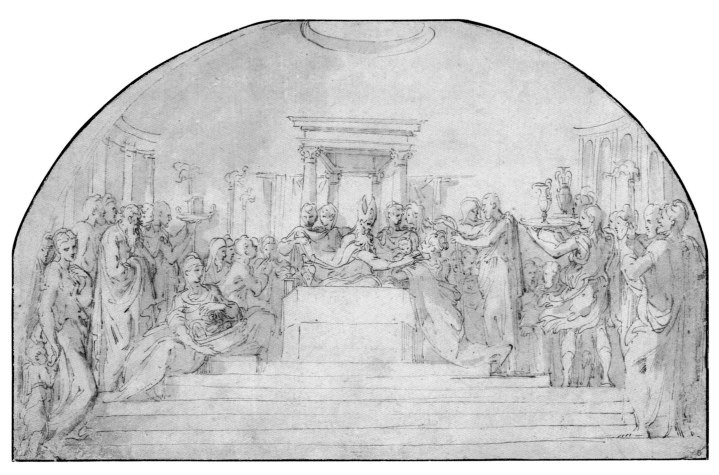

87

it may only have been as a speculative proposal and not as a direct commission.

Popham had initially thought that this might be a design for an apse of the Steccata in Parma, and the form of the coffering is indeed remarkably similar to Parmigianino's final idea for that project ten years later, minus the *canephori*: large rosettes set within square coffers, separated by decorative strips, the whole flanked by a wider band terminating in a figurated field. MC

87 *The Presentation of Christ* c. 1525–7

Pen and brown ink, brown wash. 187 × 286 mm (7 ⅜ × 11 ¼ in), cut almost to a semi-circle

British Museum, London (1910-2-12-34)

Provenance: 2nd Earl of Arundel; A.M. Zanetti; Baron D. Vivant-Denon (L. 780); Sir T. Lawrence (L. 2445); bequeathed by G. Salting in 1910

Literature: Popham, *BM*, no. 115; Popham, *Parm.*, no. 218; Gnann 1996; Paris 1999–2000, no. 553

The composition is found, lacking a number of figures, sketched in the semi-dome of cat. 86. It is inherently likely that it was devised for such an apsidal setting, for the curving figure group and architectural backdrop (plainly inspired by the Pantheon) give the whole a concave structure; however, the contrast between the highly cogitated nature of this composition and the flawed architecture of cat. 86 does make it uncertain that it was devised *ab initio* for that project.

Related to the present sheet is a contemporary study for a *Betrothal of the Virgin* (Ecole des Beaux-Arts, Paris; Popham, *Parm.*, no. 521, pl. 195), which is rectilinear in its setting but depends just as strongly on Raphael's *School of Athens*, copied by Parmigianino in a stylistically very similar drawing (cat. 58). Both follow Raphael's idea of raising the central event on a broad set of steps flanked by subsidiary figures, thus spreading an intimate event across a wide pictorial field without resorting to a monotonous frieze of figures.

The pose of the figure at the far left of cat. 87 was recycled by Parmigianino as *Adam* in the underside of the arch of the Steccata (see cats 103–15). MC

The Madonna of Saint Jerome (cats 88–93)

The following six drawings are related to Parmigianino's altarpiece in the National Gallery, London, generally but erroneously called the *Vision of Saint Jerome* (fig. 35) because of the unusual, and still unexplained, depiction of that saint asleep in the right background. The recent discovery of the contract for the painting (see Vaccaro 1993) has shown the reliability of Vasari's account of the commission given in his second edition of the *Lives* (1568). In January 1526 Parmigianino agreed to paint for Maria Bufalini an altarpiece for a chapel dedicated to the Immaculate Virgin belonging to the patron's deceased husband Antonio Caccialupi in the church of San Salvatore in Lauro, Rome. The contract states that the painting's subject was to be the seated Virgin with her son in her arms and Saints Jerome and John the Baptist below. Vasari wrote that Parmigianino was working on the altarpiece when German soldiers burst into his studio during the Sack of Rome in 1527, and that it was left unfinished when the artist fled to Bologna (recent examination of the painting casts doubt on this account as it does not appear to have been abandoned in an incomplete state). The painting remained in Rome until about 1558 when it was taken to the Bufalini chapel in Sant' Agostino, Città di Castello.

The commission for a major altarpiece destined for a church in the centre of Rome was, with the exception of the aborted Sala dei Pontefici project, by far the most significant that Parmigianino had yet received in his career, and the large number of preparatory drawings testifies to the care he lavished on the work. The intended setting for Parmigianino's painting is unknown, as San Salvatore in Lauro burned down in 1591, but the narrow proportions of the panel give some indication of the restricted space of the chapel. Unfortunately Vasari does not give the location of the chapel apart from stating that it was near the door of the church. The fact that the light in the painting comes from the right side suggests that the chapel was to the right of the nave, because in general artists devised the painted illumination of altarpieces in side chapels (excluding those that were lit from a window in the chapel itself) to accord with the actual source of light coming from the entrance wall of the church. The planned location of the painting helps to explain the reason for the slightly unbalanced composition of the lower part, dominated by the arresting figure of the Baptist on the left, for a viewer walking up the nave from the entrance of the church on the right would have first caught sight of the altarpiece not front on, but from a slightly oblique angle.

HC

88 The Virgin and Child with Saints John the Baptist and Jerome (recto and verso)
c.1526–7

Pen and brown ink, brown wash, over red chalk, touches of white heightening on the Virgin and Child (recto); red chalk (verso). 260 × 157 mm (10 ¼ × 6 ³⁄₁₆ in)

British Museum, London (1882-8-12-488)

Provenance: G. Bossi (L. 281); W. Mayor (L. 2799); Sir J.C. Robinson (L. 1433); A.W. Thibaudeau

Literature: Popham, *BM*, no. 79; Popham, *Parm.*, no. 181; Vaccaro 1993, p. 24; Mantua and Vienna 1999, no. 288a-b

This is the only surviving study for the entire composition of the *Madonna of Saint Jerome*. It most likely dates from an early stage of the preparatory process, as it differs quite considerably from the finished work. The drawing reveals that Parmigianino's original conception was a conventional one, with two saints kneeling or seated in the lower register adoring the Virgin, who, in disregard of the contract, is shown standing with the Christ Child held so that his head is almost level with hers. The Baptist, as in the finished work, is the predominant figure in the lower part of the composition, with his intercessional role as a saintly mediator between humankind and the Virgin and Child emphasized by showing him adoring and

directing attention upwards, while at the same time glancing outwards over his shoulder to the viewer. The requirement to include two saints below the Virgin posed particular problems to the artist because of the narrowness of the panel. In the drawing the figures are placed side by side, but in order to do so Parmigianino had to adopt the outmoded practice of having them on a smaller scale than the Virgin and Child.

In the red chalk drawing on the verso Parmigianino more or less repeated the Virgin and Child from the other side, but experimented with another solution to the disposition of the figures in the lower part. The figure of the Baptist is far closer to his counterpart in the finished work, with his

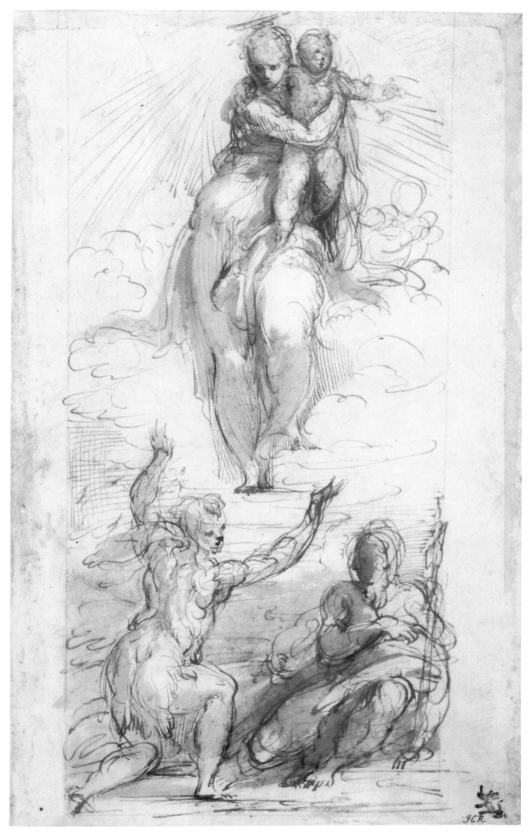

88r

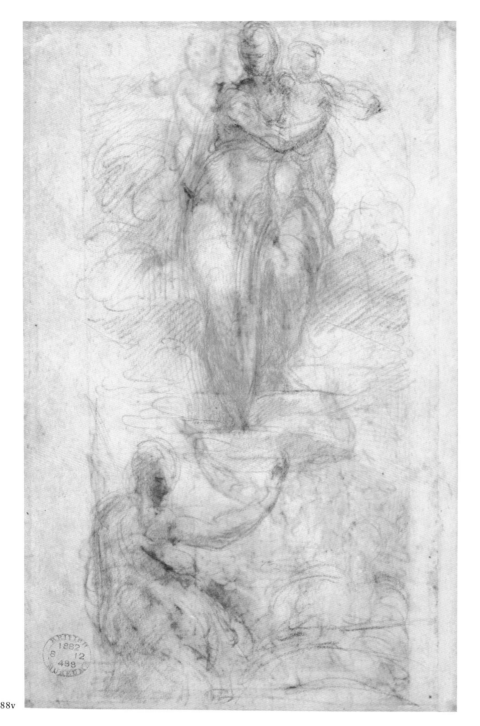

88v

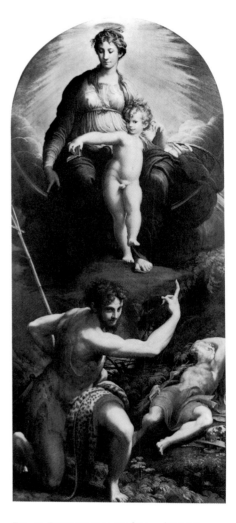

Fig. 35. Parmigianino, *Madonna of Saint Jerome*, oil on panel, 342.9 × 148.6 cm. National Gallery, London.

outstretched arm pointing upwards (a pose echoed in the figure of the Virgin) and looking down over his shoulder. Both saints are brought forward to the front of the picture plane and are on the same scale as the Virgin, but to accommodate this change the standing Baptist and the kneeling Jerome are truncated.

Unfortunately there are no known further compositional studies that illuminate the development of the finished composition, where the problem of scale in the lower register was resolved by showing Jerome asleep in the right background, and the foreground given over to the balletic figure of the Baptist.

HC

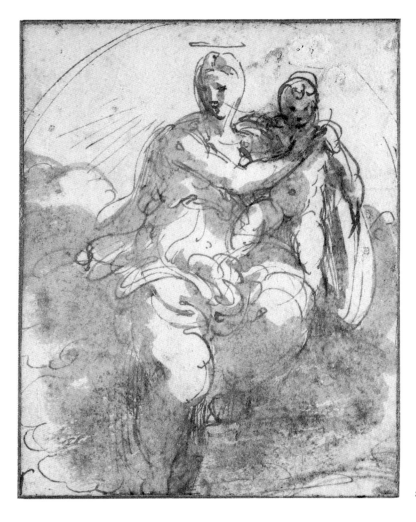

89 *The Virgin and Child*

c. 1526–7

Pen and brown ink, brown wash, some spots
of later white heightening. 130 × 100 mm
(5 ⅛ × 3 ¹⁵/₁₆ in)

Ashmolean Museum, Oxford (P. II 441)

Provenance: 2nd Earl of Arundel (?); A.M.
Zanetti; G.A. Armano; S. Rogers; R. Ford;
J. Ford (sale, Sotheby's, London, 19 March
1947, lot 76); presented in 1949 by
F.E. Maitland in memory of his wife,
Margaret Maitland

Literature: Parker 1956, no. 441; Popham,
Parm., no. 335

The Virgin in this drawing is similar to the
figure in cat. 88 except that she is shown
seated, thereby conforming to the terms
of the contract. This change of pose also
affects the Christ Child, as he is no longer
balanced in a naturalistic fashion on his
mother's hip as in the earlier study, but
stands with both legs straddling the upper
thigh of the Virgin. The drawing has
clearly been cut, and it may well be
the upper part of a study for the entire
composition which has been divided into
two and the lower section lost. HC

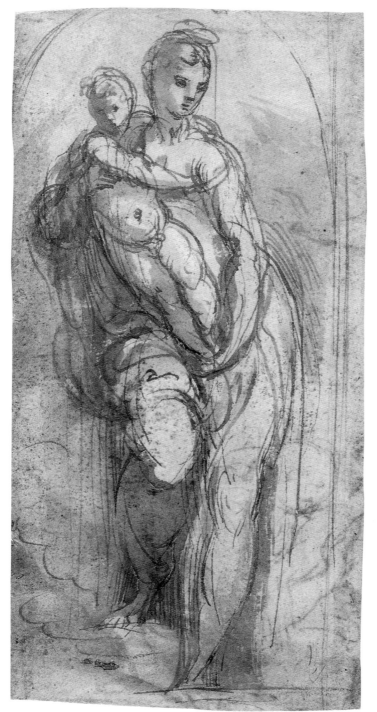

90

90 *The Virgin and Child*
c. 1526–7

Pen and brown ink, brown wash, the lines
indented. 192 × 94 mm (7 %₁₆ × 3 ¹¹⁄₁₆ in)

Chatsworth, Devonshire collection (1072)

Provenance: Dukes of Devonshire

Literature: Popham, *Parm.*, no. 741; Jaffé
1994, no. 672

Most of the surviving studies for the London
painting are related to the figures of the
Virgin and Child who occupy the upper
half of the composition. Parmigianino
experimented with a number of different
arrangements of the two figures before
settling on one inspired by Michelangelo's
marble of the Bruges *Madonna* with the
Christ Child standing between his mother's
legs. He can only have known the sculpture
through drawings, perhaps even prepara-
tory studies by Michelangelo himself, for it
had been sent north in 1506. As Shearman
observed (1992, p. 242), the final arrange-
ment of the Virgin and Child also owes
much to Raphael's *Madonna del Cardellino*
(Uffizi, Florence), which was in Florence at
the time. In the present drawing the pose
of the Virgin with the Christ Child held on
her left side is derived from an even more
celebrated painting by Raphael, the *Sistine
Madonna* (Gemäldegalerie, Dresden) then
in the church of San Sisto in Piacenza.
Although the present drawing can be fitted
into the sequence of drawings for the
London painting, the way in which the
figures are so tightly enclosed by the frame
perhaps suggests that the artist had in mind
a separate composition devoted solely to the
Virgin and Child. In a double-sided drawing
at Chantilly with figure studies related to
the London painting, Parmigianino made
another study of a Virgin and Child in an
arched frame, but with the figures seated on
a shield supported by three putti (Popham,
Parm, no. 54 recto, pl. 97). HC

91 *Drapery study for the Virgin* (recto); *Studies of a child and legs* (verso) *c. 1526–7*

Black and white chalk (recto); pen and brown ink, brown wash, white heightening, and red chalk (verso). 232 × 161 mm (9 ⅛ × 6 ⁵⁄₁₆ in)

Ashmolean Museum, Oxford (P. II 442)

Provenance: E. Joseph-Rignault (L. 2218)

Literature: Parker 1956, no. 442; Popham, *Parm.*, no. 336

The drawing on the recto, most probably studied from the life, is for the drapery of the lower half of the Virgin in the *Madonna of Saint Jerome*, much of which is obscured by the Christ Child standing between his mother's legs. The configuration of the drapery folds and the areas of highlight in the finished work broadly correspond with those in this study. The drapery style, with voluminous folds arranged into broad well-defined planes, is very much in keeping with that found in works by Parmigianino's contemporaries in Rome, such as Perino del Vaga and Polidoro da Caravaggio. The sculptural effect of the draperies in the London painting differs significantly from the inflated appearance of those in Parmigianino's pre-1524 works, underlining his rapid assimilation of a more monumental Roman manner. This stylistic transformation cannot have been effortless, and further proof of his meticulous preparation for the London painting is provided by another large-scale drapery study in the same medium, now in Windsor, for the figure of Saint Jerome (Popham, *Parm.*, no. 672, pl. III). Parmigianino probably chose black and white chalk, rather than his favoured red chalk, for these studies because the tonal range of the medium was ideally suited to studying the contrasting light effects found in the London painting, where the darkness is illuminated by the dazzling halo surrounding the Virgin and Child. Although Parmigianino's dramatic use of

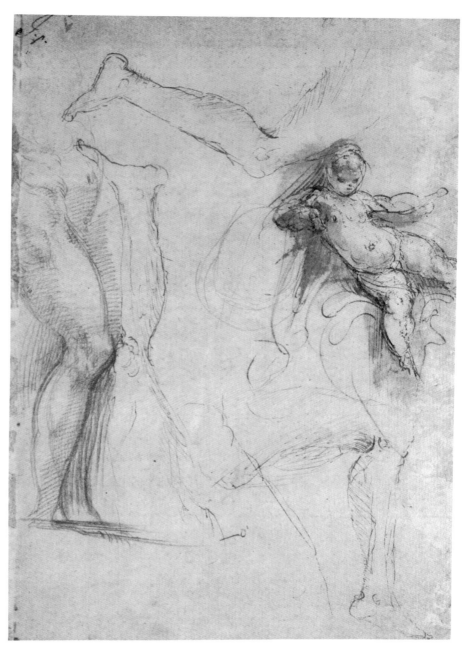

91v

light owes much to Raphael's *Transfiguration* altarpiece (Pinacoteca, Vatican), the atmospheric use of black chalk here is much closer to the tonal drawing style of Venetian artists. It seems likely that cat. 91 reflects Parmigianino's awareness of drawings by the Venetian Sebastiano del Piombo (*c.* 1485–1547) who had, with the aid of Michelangelo's powerful advocacy, established himself as one of the leading painters in Rome.

On the verso there is a pen and wash study for the Infant Christ in the National Gallery painting. The figure is shown reclining on the Virgin's lap with his left hand outstretched in benediction directed to the right, as in cat. 88. The red chalk drawing of a leg on the left appears to be unconnected with the painting. The other studies of legs are too crude to be autograph, and it is likely that they are the work of an inept copyist. HC

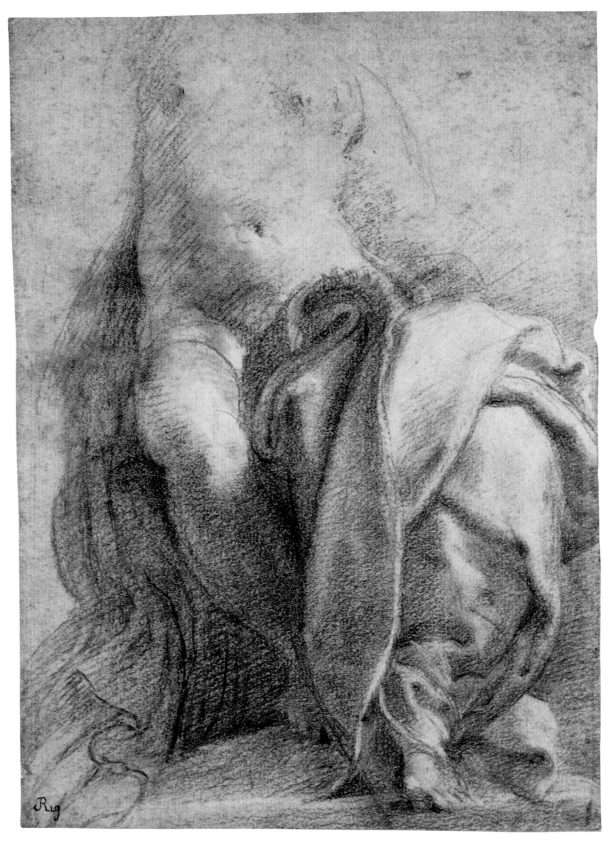

91r

140 PARMIGIANINO

92r

92v

92 Saints John the Baptist and Jerome (recto); Studies of the Christ Child, a crucifix and a dog (verso) *c. 1526–7*

Red chalk. 151 × 221 mm (5 ¹⁵/₁₆ × 8 ¹¹/₁₆ in)

The J. Paul Getty Museum, Los Angeles (87.GB.9)

Provenance: Sir T. Lawrence (L. 2445); Count N. Barck (L. 1959); N. Dhikeos; art market, New York

Literature: Goldner and Hendrix 1992, no. 28; Turner and Hendrix 1997, no. 18

The figures of Saints John the Baptist and Jerome on the recto of this sheet were made as preliminary studies for the *Madonna of Saint Jerome* in the National Gallery, London. They are shown side by side in a configuration that is comparable to the damaged study in the Städelsches Kunstinstitut, Frankfurt (Popham, *Parm.*, no. 145, pl. 110). The two saints are depicted symmetrically, although with different individual poses, in other early studies in the Musée Condé, Chantilly, and in the major compositional drawing in the British Museum (Popham, *Parm.*, no. 54 verso, pl. 97; and cat. 88). A separate study of Saint Jerome in a private collection shows him seated, but facing to

the right (Ekserdjian 1999, no. 35, fig. 46). It is only in later studies that Parmigianino arrived at the solution in the altarpiece (cat. 93).

The lightly sketched Christ Child on the verso is one of many variations of this figure in the same altarpiece, although it is not especially close to the painted one. The crucifix at the centre, like that held by Saint Jerome on the recto, is too summary to situate it at a precise point in the sequence. The surprise is the dog, which is represented in the same pose and with the same ornamented collar as in the right side of the fresco of *Diana and Actaeon* in the Rocca Sanvitale at Fontanellato (fig. 25). This spontaneously drawn rendering and the sketchier partial study below must have been made from life and in preparation for the Fontanellato fresco.

This raises the highly problematical issue of the chronology of the sheet, which contains studies that appear to be preparatory for a fresco of 1523–4 and for a Roman altarpiece painted in 1526–7. Moreover, the broad use of red chalk has a distinctly Correggesque quality that suggests an earlier date for the sheet than that of Parmigianino's Roman period. On the other hand, the only way to place the sheet in the pre-Roman period would be to hypothesize another undocumented project, in which the same pair of saints would have been

represented as they are in several of the other studies for the London altarpiece. This appears highly unlikely, all the more so since there are no other studies known to us that are relatable to this hypothetical project and not to the London painting. Furthermore, the Frankfurt study, in which the saints are shown in poses very close to the ones here, is certainly a drawing from the Roman years.

The solution may be found in re-examining the recto of the Getty sheet. It contains three still visible head studies that are unrelated to this painting and that have been drawn over entirely or in part. Their configuration is similar to that of the three-figure group in the fresco of *Diana and Actaeon* at Fontanellato, suggesting that they and the dog studies on the verso were made for that project. The sheet was then taken by the artist to Rome and drawn on again for another purpose. This may also be the case with the Christ Child on the verso, who appears to be drawn over some earlier sketches that are now unreadable. It may be added in support of this hypothesis that the Correggesque quality of the draughtsmanship on the recto is perhaps not so surprising here, and may be found in several other studies for this altarpiece (Popham, *Parm.*, nos 519, 610 and 402, pls 105–6, 110).

GG

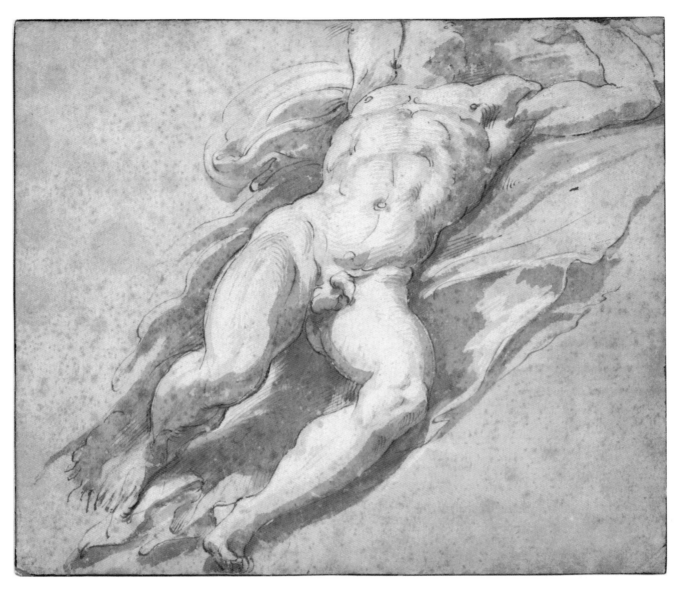

93 *Reclining male figure*

c. 1526–7

Pen and brown ink, brown wash, white
heightening. 215 × 242 mm (8 ½ × 9 ⁹/₁₆ in)

The J. Paul Getty Museum, Los Angeles
(84.GA.9)

Provenance: Sir T. Lawrence (L. 2445);
private collection, Paris; art market, Paris

Literature: Goldner 1988, no. 26

Parmigianino first intended to show the
figure of Saint Jerome seated in the
foreground, balancing the Saint John the
Baptist to the left (cat. 88). He radically
changed the pose of Saint Jerome in a pen,
ink and wash drawing in the Louvre
(Popham, *Parm.*, no. 427, pl. 110), in which
the saint is depicted lying on the ground in
a sharply foreshortened diagonal position,
moving back from the feet at the lower right
to the head at the upper left. The last stage
in the sequence consists of three studies, in
the Louvre, at Windsor, and the present
drawing (Popham, *Parm.*, nos 402 and 672
recto, pls 110–11). As in the first Louvre
drawing, they show the saint with his right
arm above and partially resting upon his
head. Moreover, he is now depicted lying on
the ground at a steep angle from the feet at
the lower left to the head at the upper right,
as in the altarpiece. Of the three sheets, the
Louvre drawing comes first, as it is a rapid
Correggesque study of the basic pose. It was
probably followed by cat. 93 in which the
form is carefully articulated in a brilliant use
of pen and ink, wash and white gouache. Its
sculptural resonance and monumentality
clearly call to mind the impact of Roman
sculpture on Parmigianino. Lastly, in the
Windsor study, the artist considers the
placement of drapery on the figure. Cat. 93
was only known to Popham through a
reproductive print (Popham, *Parm.*, no. O.R.
83, pl. 111), which shows the sheet extended
slightly further at the top. GG

94

94 *Studies of the Baptist preaching* c. 1526–30

Black chalk, pen and brown ink, the studies on the left and in the centre with brown wash and white heightening. 155 × 209 mm (6 ⅛ × 8 ³⁄₁₆ in)

British Museum, London (Pp. 2-131)

Provenance: Cavaliere F. Baiardo; M. Cavalca; J. Richardson Sr (L. 2184); N. Hone (L. 2793); Sir J. Reynolds (L. 2364); R. Payne-Knight Bequest, 1824

Literature: Popham, *BM*, no. 82; Popham, *Parm.*, no. 184; Quintavalle 1971, no. XXII

This drawing, which has studies of Saint Jerome in penitence on the verso, was included by Popham among the group of designs for the National Gallery *Madonna of Saint Jerome*, although he did not exclude the possibility that both sides might be independent compositions developing out of Parmigianino's work on the painting. A direct connection with the altarpiece seems unlikely as the recto shows the Baptist preaching to an audience, a narrative element that could never have been envisaged for the painting. The drawing and the painting are also lit from opposite directions. Even so, the drawing's close connection with Parmigianino's work on the *Madonna of Saint Jerome* is undeniable, and the kinship between the two is revealed in the strongly accented lighting of the central study, and

more directly in the similarity of the Baptist's pose to that of the standing Virgin in the double-sided compositional study for the painting (cat. 88). Parmigianino appears to have begun the drawing by lightly sketching in black chalk the figure of the Baptist holding a reed cross, a study just visible to the right of the central composition. The two pen studies show the Baptist more or less in the same pose, but in the central one he is brought nearer to the picture plane so that his movement forward, and the dramatic force of his gestures, gain an even greater immediacy. In the studies on the left a different pose for the saint is considered: he is shown with one leg behind the other rather than striding forward, and the motion concentrated instead on the twisting movement of his upper body. HC

95

95 *Prometheus animating man* c. 1524–7

Pen and brown ink, brown wash, over faint preliminary indications in black chalk. 137 × 154 mm (5 ⅜ × 6 ¹/₁₆ in)

The Pierpont Morgan Library, New York (IV, 45)

Provenance: Baron D. Vivant-Denon (L. 780); Count N. Barck (L. 1959); C. Fairfax Murray; purchased by J.P. Morgan in London, 1910

Literature: Raggio 1958, p. 58; Popham, *Parm.*, no. 320; Reed 1991, pp. 70–2; Paris, 1999–2000, no. 555

This sheet can be dated to Parmigianino's years in Rome on the basis of both style and borrowed figural vocabulary. The artist portrayed the seated figure of the Titan Prometheus (seen in the centre), who created man from clay, reaching for the life-giving spark from the chariot of the sun on the upper left to give to the seated inert nude man (to the right), whose hand he holds. The classical myth of Prometheus as the shaper and creator of mankind, refined by the prominent Latin poets of the Augustan age (Ovid, Horace, Catullus and Propertius), was recast in terms of a Christian God in Giovanni Boccaccio's *Genealogia deorum gentilium* (Venice, 1494, book IV, chap. 44). As Raggio pointed out,

this Renaissance source helps to explain a number of otherwise obscure iconographic motifs in cat. 95. Perhaps not surprisingly, Parmigianino freely quoted for the pose of Prometheus the figure of God the Father in Michelangelo's *Creation of Adam*, frescoed in 1508–12 on the Sistine ceiling. He transformed it, however, with a Raphaelesque grace that specifically recalls the drawings and paintings by the young Perino del Vaga. Similarly graceful figures of God the Father appear in the Creation scenes painted by Raphael's shop (including the young Perino) on the vault and destroyed *dado* (known from reproductive engravings) of the Raphael *Logge* in the Vatican Palace, finished in 1519. CCB

96 *Bearded man seen in profile, bust-length* *c. 1526–7*

Pen and brown ink over traces of leadpoint or soft black chalk. 167 × 123 mm (6 ⁹/₁₆ × 4 ¹³/₁₆ in)

Private collection, USA

Provenance: 2th Earl of Arundel; 2nd Duke of Devonshire (L. 718), and by descent (sale, Christie's, London, 3 July 1984, lot 32)

Literature: Popham, *Parm.*, no. 723; Jaffé 1994, no. 705

Although now for the most part evident only on the cranium of the figure, the exploratory underdrawing was originally much more extensive, and seems to have been deliberately erased, apparently by Parmigianino himself, in order to enhance the beautiful pen and ink drawing. This is typical of a number of other finished pen and ink drawings by the artist, and by such close contemporaries of Parmigianino as Giulio Romano (see Armenini 1587, p. 101). The carefully calligraphic handling of the pen, with delicate, short, curved cross-hatching in the manner of a 'presentation drawing', places this sheet at the end of Parmigianino's Roman period. The focus of attention is on the portrait-like features of the man, presumably drawn from life; the details of his costume – mantle with a wide cowl, gathered shirt neckline, and chain – are suggested with a few deft strokes. An exact reprise of the man's head, with the same intent gaze set in the distance and with his hair and beard slightly blowing in the wind, is found at the lower right of the recto of a large sheet of carefully hatched pen and ink studies, including a detailed one of a dead mouse, in Parma (Popham, *Parm.*, no. 544, pl. 98). The verso of the Parma sheet bears a securely connected study for the kneeling young Saint John the Baptist in Parmigianino's monumental *Madonna of Saint Jerome* altarpiece of 1526–7 (National Gallery, London). CCB

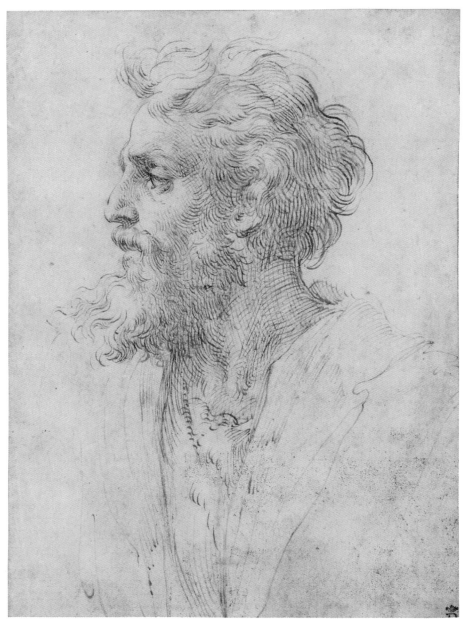

96

Parmigianino in Bologna, Parma and Casalmaggiore 1530–40 (cats 97–134)

Following his flight from the Sack of Rome in 1527, Parmigianino spent three productive years in Bologna. His reasons for not returning directly to Parma cannot be known; although Correggio was pre-eminent in the painting of large-scale fresco cycles in the city, there was no shortage of employment in Parma on the altarpieces and easel paintings that seem to have better suited Parmigianino's temperament, and it may simply have been such a succession of smaller commissions that kept the artist in Bologna. His major paintings – *Saint Roch and a donor*, still in its chapel in San Petronio, the *Conversion of Saint Paul* (Kunsthistorisches Museum, Vienna; fig. 36) and the *Madonna of Saint Margaret* (Pinacoteca Nazionale, Bologna; fig 38) and the *Madonna of the Rose* (see cat. 102) – all developed Parmigianino's interest in dramatic lighting, bold compositions and vibrant, even acid, colours. An allegorical portrait of the Holy Roman Emperor Charles V, begun at the time of his coronation in the city in 1530 (though apparently not commissioned), was not completed because the artist was dissatisfied with it, a foretaste of the problems to come in the next decade.

Parmigianino's return to Parma in 1530 may have been prompted by a commission to paint two altarpieces for Santa Maria della Steccata in April of that year; nothing survives of this project. A year later he contracted to fresco the vault and apse of the same church, a project that overshadowed the rest of his life. Very many drawings were executed in preparation for this work (cats 103–14) but the actual painting seems hardly to have been begun. In 1535 a fresh agreement was made, allowing two more years to complete the work, but in 1539 the authorities finally lost patience with Parmigianino and he was arrested and jailed. His friends put up bail for him, but on his release he fled the city to Casalmaggiore, where he died a year later, aged just thirty-seven. Vasari claimed in a vivid account that towards the end of his life Parmigianino was obsessed by alchemy and allowed his personal appearance to deteriorate until he resembled a wild man; it is not impossible that his death was due to poisoning from his alchemical experiments.

A number of easel paintings also date from the Steccata years, most famously the so-called *Madonna of the Long Neck* commissioned in 1534 (cats 119–22), and the *Cupid cutting his bow*, now in Vienna, for Baiardo. Both show the unnerving elongation of form and waxiness of surface that in many artists might indicate decadence, but the *Madonna of Saint Stephen* (cat. 129), painted in Casalmaggiore, is one of Parmigianino's strongest works and demonstrates that, despite the strains of the previous decade, his hand and mind in his last year were as incisive as ever. MC

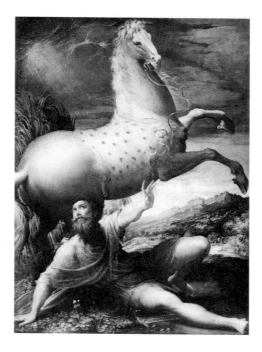

Fig. 36. Parmigianino, *Conversion of Saint Paul*, oil on canvas, 177.5 × 128.5 cm. Kunsthistorisches Museum, Vienna.

97 *The Conversion of Saint Paul* *c. 1527–8*

Pen and brown ink, brown wash, white heightening, on paper washed light brown. 237 × 330 mm (9 ⁵/₁₆ × 13 in)

Courtauld Institute, London (D.1972, PG 360 recto)

Provenance: An unidentified collector's mark, JM in a circle (L. 1493a, verso); H. Squire; Count A. Seilern

Literature: Popham, *Parm.*, no. 768 verso; London 1987, no. 23

Exhibited in London only

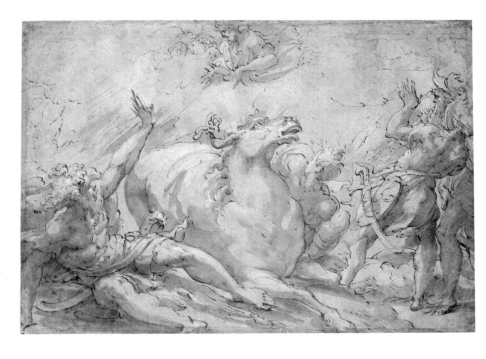

97r

This double-sided drawing is related to the painting of the *Conversion of Saint Paul* in the Kunsthistorisches Museum, Vienna, generally agreed to be the work described by Vasari as having been painted in Bologna for the Parmese doctor Giovanni Andrea Bianchi (fig. 36). This was probably painted soon after Parmigianino's arrival in Bologna in 1527, as it is similar in handling to the National Gallery *Madonna of Saint Jerome* (fig. 35). Vasari's description of the Bianchi painting as having many figures does not tally with the Vienna painting, although it is possible that he inaccurately described a painting that he had never actually seen, as is clearly the case in his muddled account of the Detroit *Circumcision*. It may also be that Vasari conflated two paintings, the Bianchi panel and another, now lost, for which the drawings on the present sheet are studies. This seems improbable in view of the relative paucity of finished works by the artist, but the Vienna painting differs fundamentally from the present drawing in its upright format and the reduction of the crowd of figures to the recumbent figure of the saint with a gigantic rearing horse behind him. (The extraordinarily elongated form of the saint's horse, which so artfully fills the upper half of the composition, led to it's being described in an early seventeenth-century inventory as a camel; Finaldi 1994.) However, a faint black chalk drawing (fig. 37) of the subject on the verso of a study corresponding closely to the Vienna picture (Courtauld Institute; Popham, *Parm.*, no. 769, pl. 221), has the horizontal format and subsidiary figures of cat. 97, providing a direct link between two apparently irreconcilable treatments of the theme. HC

Fig. 37. Parmigianino, *Conversion of Saint Paul*, black chalk, 165 × 124 mm. Courtauld Institute, London, PG 363 verso.

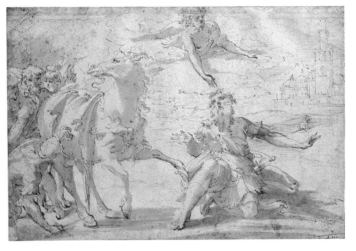

97v

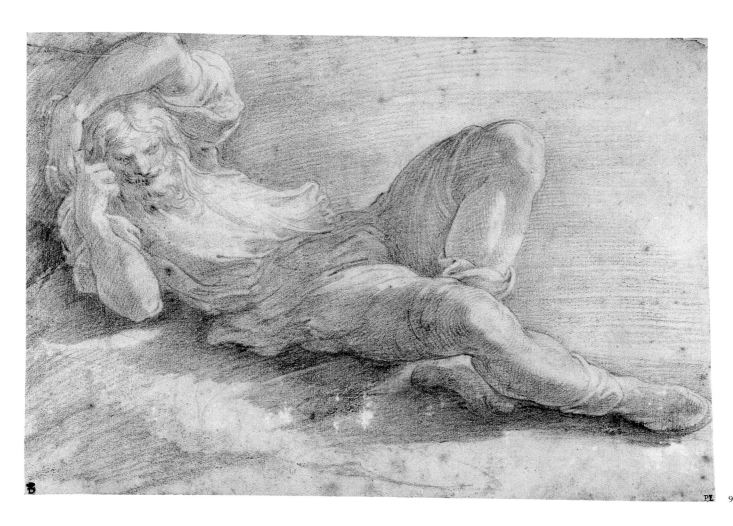

98

98 *A bearded man sleeping*
c. 1526–30

Red chalk. 191 × 273 mm (7 ½ × 10 ¼ in)

Chatsworth, Devonshire Collections (806)

Provenance: Sir P. Lely (L. 2092); 2nd Duke of Devonshire (L. 718)

Literature: Popham, *Parm.*, no. 734; Jaffé 1994, no. 681

This magnificent drawing cannot be related to any surviving work, but on stylistic grounds it can be dated to the second half of the 1520s. The sharply drawn outlines and the polished metallic brilliance of the modelling bring to mind red chalk drawings by Parmigianino's contemporaries in Rome, particularly studies by Perino del Vaga whose highly refined draughtsmanship had been shaped by his formation in Raphael's workshop. The study might have been intended for a sleeping soldier in a composition of Christ rising from the tomb, or for one of the disciples in an Agony in the Garden (the lighting of the figure suggests that Parmigianino had in mind a nocturnal scene); but no paintings of these subjects are recorded. The very detailed nature of the study, particularly in the observation of light, and the fact that the figure is in contemporary costume point to this being a life drawing. The unnatural pose, with one arm draped over the head and the legs crossed, is, however, loosely modelled on the antique sculpture of *Ariadne* in the Vatican, the most celebrated representation of a sleeping figure (Bober and Rubinstein 1986, no. 79). HC

99 *Bishop saint in prayer seen in bust-length* c. 1527–30

Brush with brown and grey-brown wash over stylus-ruled lines and charcoal, some contours stylus-incised (now flattened), on three glued sheets of paper; scattered paint stains on recto and verso. 718 × 418 mm (28 ¼ × 16 ⁷⁄₁₆ in)

The Metropolitan Museum of Art, New York (1995.306; Van Day Truex Fund, 1995)

Provenance: Anon. sale, Sotheby's, London, 3 July 1995, lot 99 as attributed to Niccolò dell'Abate

Literature: Bambach 1999, pp. 55, 59; Ekserdjian 1999, p. 41

This drawing of powerful chiaroscuro and dazzling execution with the brush was recognized as the work of Parmigianino by Mario Di Giampaolo (letter of 2 October 1995), and appears to be the only autograph cartoon (full-scale drawing) in monumental scale by Parmigianino that is extant (the Christ Church *Head of Saint Roch*, catalogued by Popham as an autograph cartoon related to the painting in San Petronio, Bologna, seems more likely a full-scale copy after the figure; *Parm.*, no. 351, pl. 217).

The artist calibrated the difficult three-quarter view of the saint's head, seen in perspective 'from below' (*di sotto in sù*), with the help of a grid of vertical and horizontal parallel lines, incised with a stylus against a ruler and now only faintly visible. These lines guided the artist in placing the saint's foreshortened facial features along the curving axes of the head. Over the charcoal underdrawing, Parmigianino applied the two colours of wash with an extraordinary rapidity of the brush, and in a manner that is very similar to that of his mature easel paintings. For example, the treatment of the bishop's hands with quick, broad brush-strokes is strikingly like that in Parmigianino's panel painting of the *Portrait of a man with a book* (Kunsthistorisches Museum, Vienna), which is also on an equivalent scale. The motif of the flame-like praying

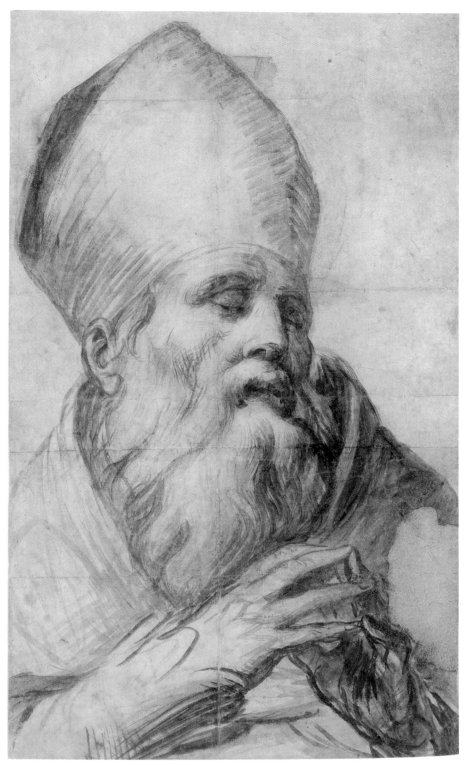

99

Fig. 38. Parmigianino, *Madonna of Saint Margaret*, oil on panel, 204 × 149 cm. Pinacoteca Nazionale, Bologna.

with charcoal seems indebted to the Renaissance tradition of cartoons for stained glass.

In design, the Metropolitan Museum cartoon is closest to the broadly painted bishop saint on the left in the so-called *Madonna of Saint Margaret* (Pinacoteca Nazionale, Bologna; fig. 38), which Parmigianino finished in 1529–30 for the nuns of the convent church of Santa Margherita, Bologna. Recent examination of the painting with infrared reflectography by Maurizio Seracini did not reveal the presence of an underdrawing in this painting, because of the great thickness of the pigment layer, but the size of the bishop saint's head in the painting and drawing correspond almost exactly (verified 1 February 2000). Early written sources describing the *Madonna of Saint Margaret* do not agree on the bishop saint's identity. Giorgio Vasari's biography of Parmigianino (Florence, 1550 and 1568) and Carlo Cesare Malvasia's *Le pitture di Bologna* (Bologna, 1681) both refer to him as Saint Petronius, the patron saint of Bologna, while a document of 8 April 1530 concerning the purchase of a house by the nuns of Santa Margherita incidentally notes him as Saint Benedict (Vasari-Milanesi V, p. 228; Malvasia, p. 88; and document in Ekserdjian 1983).

A closer version of the bishop saint's pose, with praying hands placed to the right as in the cartoon, occurs in a very rubbed red chalk drawing by Parmigianino in the Uffizi (Popham, *Parm.*, no. 79, pl. 224), a composition repeated with the addition of a landscape background in an etching by Battista Angolo del Moro (Bartsch XVI.180.7; fig. 39). The figural type of the bishop saint recurs in a number of other compositional drawings for projects that can be dated to Parmigianino's years in Bologna (1527–30). Among these are the fragile Uffizi brush and wash drawing for an altarpiece of the *Enthroned Christ with Saints*, either lost or never executed, as well as a compositional study in black chalk with wash in the Louvre of the *Virgin and Child on clouds with Saints Sebastian and Gimignano* (Popham, *Parm.*, nos 115, 464, pls 237–8). CCB

Fig. 39. Battista Angolo del Moro after Parmigianino, *The Holy Family with Saints*, etching, 277 × 204 mm. Metropolitan Museum of Art, New York (Bartsch XVI.180.7).

hands lit from below, as seen in the cartoon, is among the most distinctive of Parmigianino's stylistic devices, and it would also be often emulated by Girolamo Mazzola Bedoli, the artist's less talented older cousin.

The number of *pentimenti* in the Metropolitan Museum cartoon, particularly in the charcoal underdrawing on the right, suggests the extent of Parmigianino's reworking of the bishop saint's figure at this advanced stage of the composition. The eyes of the figure were originally open, and his gaze directed to the upper right. As is typical of such large-scale Italian Renaissance drawings, the chiaroscuro in Parmigianino's cartoon is calibrated broadly and boldly for legibility at a far viewing distance. The atypical use of a brush and wash medium

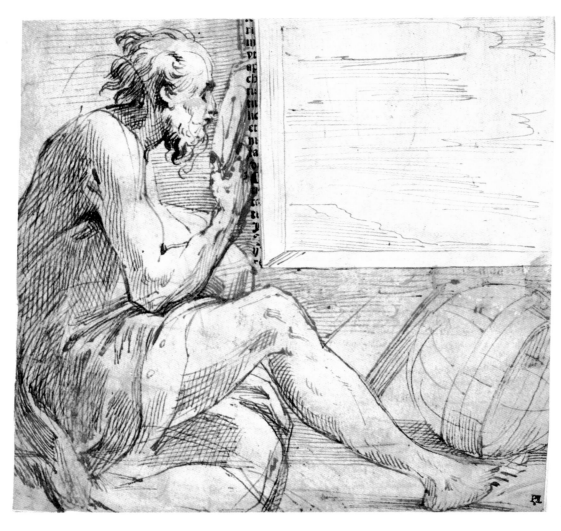

100

100 *A seated philosopher*

c.1527–30

Pen and two shades of brown ink. 167 × 175 mm (6 ⁹/₁₆ × 6 ⁷/₈ in)

British Museum, London (1952-1-21-66)

Provenance: Sir P. Lely (L. 2092); Lord J. Cavendish; Lord Chesham; L. Colling-Mudge

Literature: Popham, *BM*, no. 100; Popham, *Parm.*, no. 203

Initial letters of about twenty lines of printing to the right of the figure show that this was drawn on the lower left margin of a printed page. The printed text has been cut out and replaced by a square sheet of paper on which the frame of a window and a cloudy sky have been added. The figure is probably Archimedes, as he is shown seated by an armillary sphere, an instrument that he was reputed to have invented. Parmigianino's representation of the Greek mathemati-cian as a hermit-like figure with a straggling beard is similar to his depiction of the Greek philosopher Diogenes in an engraving by Caraglio (Bartsch XV.94.61) and a chiaroscuro woodcut by Ugo da Carpi (Bartsch XII.100.10).

HC

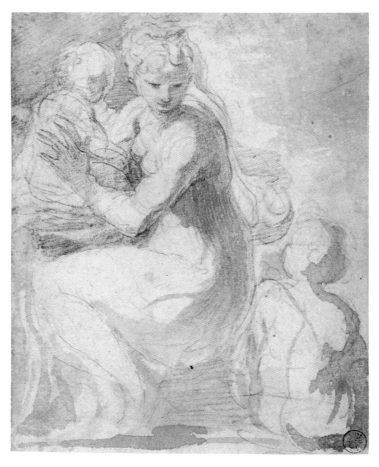

101

101 *The Virgin and Child with the Infant Saint John seated on the ground* c. 1528–30

Brush and brown wash over soft black chalk.
123 × 96 mm (4 ¹³/₁₆ × 3 ¾ in.)

The Pierpont Morgan Library, New York
(IV, 48)

Provenance: A.M. Zanetti; Sir C. Greville;
4th Earl of Warwick (L. 2600; sale, Christie's,
London, 21 May 1896, part of lot 259);
C. Fairfax Murray; purchased by J.P. Morgan
in London, 1910

Literature: Popham, *Parm.*, no. 323

Here, Parmigianino's quick, inspired handling of the extremely watery pale washes, which run on the white surface of the paper 'in the form of a stain' (to borrow Vasari's apt phrase for this type of virtuoso sketching in his *Lives of the Artists*), leads to soft, luminous and airy effects of tone. The artist relied primarily on the pale washes to define form. His main concern was to explore the pose of the Virgin's hands and upper body in holding the Christ Child, as is clear from the extensive use of chalk underdrawing in this portion of the sheet. His treatment of the Virgin's legs and of the back of Saint John is by comparison sketchily abstract. This self-confidently drawn sheet can be dated to 1528–30,

for it particularly recalls the moment of the so-called *Madonna of the Rose* (Gemäldegalerie, Dresden), the *Virgin and Child* (Kedleston Hall, Derbyshire), and the *Virgin and Child with Saints Zachariah, Mary Magdalene and the Infant John the Baptist* (Uffizi, Florence). The composition, as well as the soft manner of rendering shadows, may have been inspired by Raphael's late preparatory studies for the *Madonna of the Fish* and *Madonna di Foligno* (illustrated and catalogued in London 1983, nos 120, 136, 173). Raphael's painted tondo of the *Madonna of the Candelabra* (Walters Art Museum, Baltimore) is also echoed here.

CCB

102 The Virgin and Child ('Madonna of the Rose')

c. 1529–30

Black chalk, highlighted with white chalk, on light brown paper. 271 × 109 mm (10 ¹¹/₁₆ × 4 ¼ in)

Private collection, USA

Provenance: M. Delacre (L. 747a); Prof. W. Burgi (his mark not in Lugt); paraph Cxb, verso (similar to L. 2958); anon. sale, Sotheby's, London, 18 November 1982, lot 14; I. Duncan

Literature: Ekserdjian 1999, pp. 27–8, no. 48

This exquisitely rendered drawing was correctly identified as by Parmigianino at auction in 1982. It is an early preparatory study for Parmigianino's so-called *Madonna of the Rose* (Gemäldegalerie, Dresden), one of the most admired paintings of his Bolognese period (fig. 40). Of the eleven other known studies for the painting, this is the most dynamic in conception and also the most telling of the artist's design process. Here, Parmigianino drew the figures full-length surrounded by agitated, sweeping draperies, in order to visualize their overall aesthetic impact, before cropping the composition to the final three-quarter length of the painting. The drawing shows the composition at a very early stage of planning. The Virgin appears to be rolling up her left sleeve, as she prepares to give the Christ Child a bath (Ekserdjian 1999). Giorgio Vasari praised Parmigianino for his animated portrayals of infants (capturing especially their 'spirited sense of mischief'), a skill that is here vividly apparent. The unruly Christ Child kicks and turns on his side underneath the Virgin's elegantly crossed arms. The steep foreshortening of the moving child's body seems all the more dazzling for its lifelike pose. In great contrast, the final painting depicts the impish Christ Child quietly (if somewhat erotically) reposing on the lap of the Virgin, who sits in a pose much as she is seen in the present study. The soft, abstract drawing of the chiaroscuro – although done by hatching and graining of the chalk (shading with the side of the stick to exploit the texture of the paper), rather than by brush and wash – evokes the style of the Morgan Library *Virgin and Child* (cat. 101). In cat. 102, the artist focused his energies on the parts of the composition that would serve in the final form of the painting, which helps to explain why the upper and lower left are unfinished.

Vasari recorded that although Parmigianino originally painted the *Madonna of the Rose* for Pietro Aretino, he presented it to Pope Clement VII when he came to Bologna, and that the picture then passed to Dionigi Gianni and his son Bartolomeo, who had fifty copies made of this work – an astounding number of copies even by the standards of the Renaissance! (See Vasari-Milanesi V, pp. 227–8.) Based on Vasari's account, the painting, and consequently the related drawings, can probably be more precisely dated around the time of Pope Clement's stay in Bologna, between December 1529 and April 1530. CCB

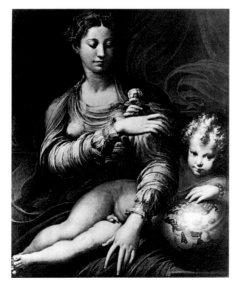

Fig. 40. Parmigianino. *Madonna of the Rose*, oil on panel, 109 × 88.5 cm. Gemäldegalerie, Dresden.

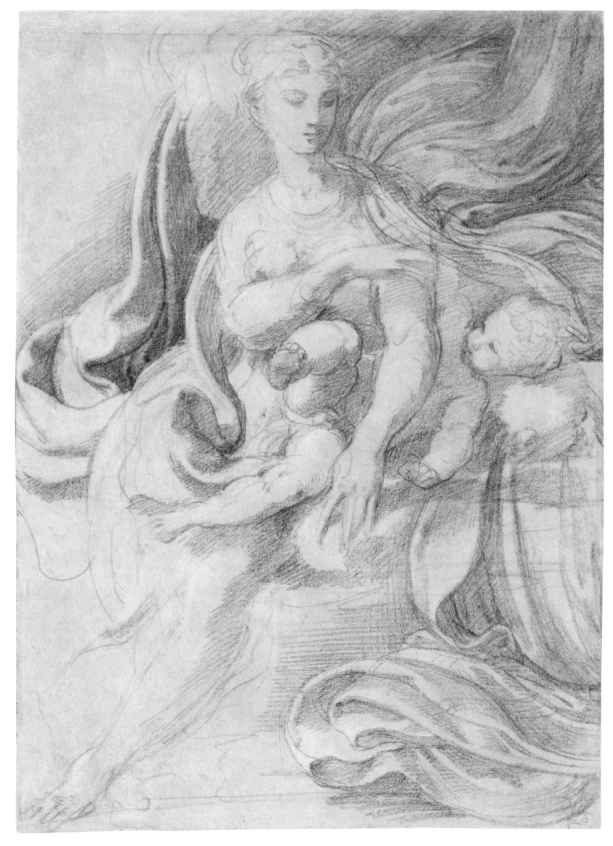

102

The Steccata decorations (cats 103–17)

In May 1531 Parmigianino signed a contract with the Confraternity of Santa Maria della Steccata to fresco the eastern apse of the newly constructed church with a Coronation of the Virgin, and to decorate the vault and underside of the arches of the area between the apse and the central dome. This colossal project, for which he was to receive 400 gold *scudi*, was originally planned to be finished in an impossibly short period of eighteen months. In the next four years little seems to have been achieved and a new contract was drawn up in September 1535, with Parmigianino agreeing to finish the decorations in two years on pain of return of the advance payment. In February 1538 the Confraternity was persuaded by Francesco Baiardo and the architect Damiano de Pleta, who stood surety for the 200 *scudi* already advanced to the artist, to put back the completion date once again, this time until August 1539. The authorities finally lost patience with the artist in December 1539, and he was arrested and jailed. Released after a short time on bail, presumably after a promise to pay back the advance, Parmigianino went to the Steccata and defaced part of his work there, and then fled to Casalmaggiore, which lay outside the jurisdiction of Parma. Most of the vault decorations had been completed prior to his flight, but the *Coronation of the Virgin* had not progressed beyond the planning stage (see cats 116–17).

Parmigianino's overall design for the vault was to a large degree determined by the fourteen square recessed coffers, divided into two rows of seven, that were already in place when he accepted the commission. There was little scope for Correggesque illusionism, and instead the artist elected to use the coffers as a frame for the boldly projecting gilt-bronze rosettes that he designed for the centre of each panel. In the finished vault, the gilded acanthus leaves of the rosettes are offset by the deep blue colour of the coffers, and by the intense red of the surrounding panels. Further gilding in the smaller rosettes at the centre and sides of the vault, and of the decorations on the lateral arches, reinforces the effect of glittering magnificence. The decorative elements are equally rich, with the frames of the coffers and the narrow strips between them painted with an eclectic and witty mixture of motifs: swags, rams' heads, shells, doves, crayfish, upturned crabs, and nude figures swinging on golden-leafed branches. At either end of the vault Parmigianino placed three gigantic, but supremely elegant maidens whose elongated forms are ingeniously fitted into the narrow space (fig. 41). Early drawings such as cats 104–5 show that he originally conceived of these figures as merely decorative, but they were later given lamps to identify them as the Wise Virgins, with lamps alight, on the south and the Foolish Virgins, with unlit lamps, on the north. The soffits of the arches on either side of the vault are largely given over to a gilded strap-work decoration, but at either end are four large grisaille figures of Adam, Eve, Moses and Aaron which appear to be placed in shallow oval niches as though sculpted. Despite the ill-fated nature of the Steccata commission, it provided Parmigianino with the only opportunity to display his decorative flair and inventive brilliance on a truly grand scale. The artist's own sense of pride at his achievements there is, perhaps, apparent from a self-portrait drawing of the period (cat. 115), which includes in the background two of the vase-bearing women from the vault.

HC

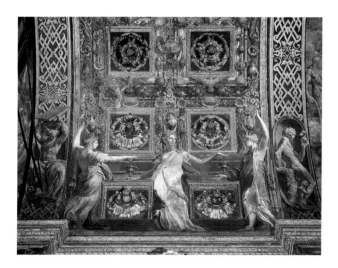

Fig. 41. Parmigianino, detail of frescoed vault of Santa Maria della Steccata, Parma.

103 *Studies for the vault of the Steccata* (recto and verso) *c.1531–3*

Pen and brown and grey ink, yellow and brown wash (recto); pen and brown ink (verso). 203 × 300 mm (8 × 11 ⅞ in)

British Museum, London (1918-6-15-3)

Provenance: 2nd Earl of Arundel (?); A.M. Zanetti (?); G.A. Armano (?); Baron D. Vivant-Denon; Sir. T. Lawrence (L. 2445); Rev. Dr H. Wellesley (sale, Sotheby's, London, 10 July 1866, lot 2402 or 2403); Sir E.J. Poynter, Bt (L. 874; sale, Sotheby's, London, 24 April 1918, lot 97); presented to the British Museum by Sir Otto Beit

Literature: Popham, *BM*, no. 125; Popham, *Parm.*, no. 228; Washington and Parma 1984, no. 50

This early study for the vault is one of the most important guides to the artist's initial conception of the design. The central study is related to the vault, and shows three rows of rather plain rosettes projecting from the square coffers, with oval medallions (the central ones slightly larger than those on the outside) held upright by nudes, some of whom are winged, at each corner. Parmigianino envisaged the central row of coffering being differentiated from the rest by larger ovals placed lengthways in the middle, and the base of the arch marked by an oval cut in two at the centre (this arrangement is repeated in the study on the verso). In the contract of 1531 he agreed to design the gilt-bronze rosettes and their surrounding frames, and the main study and that to the left include a variety of ideas for their forms. This

study must therefore pre-date 1533 when Parmigianino handed over his final designs for the rosettes to the two craftsmen responsible for their manufacture. Although his ideas for the decorations in cat. 103 generally differ greatly from the final work, it is worth noting that the crabs, which feature so memorably in one of the frame designs in the vault, already occur in the decoration on the right-hand side of the compartment at the top left. On the right-hand side of the sheet are studies for the underside of the lateral arches, and these show that the artist had already decided to place large-scale Old Testament figures at either end. At this stage he planned that the space between would be taken by feigned octagonal bosses, and in two studies for this section he experimented with various designs for the compartments framing them.

Parmigianino made further studies of the vault on the verso, drawn at right angles to an earlier study of an open arcade which appears not to be related to the Steccata. The distinction between the two designs is sometimes difficult to make out, as Parmigianino used the space between the piers of the arcade to make subsidiary studies for the decorative strips between the compartments of the vault, and he also drew over part of the arcade study. The pen drawing of the vault in the lower left corner is substantially the same as that on the verso, except that the idea of a female figure at the base of the vault, whose form is sketched in over the ovals in the centre of the first row of coffering, is introduced. From the drawing it is clear that Parmigianino intended this central figure to be matched by others on the same scale situated at the base of the lateral arches.

The seated prophet drawn at ninety degrees to the main study is related to an alternative idea for the decoration of the underside of the lateral arch, an idea developed more fully in cat. 104. HC

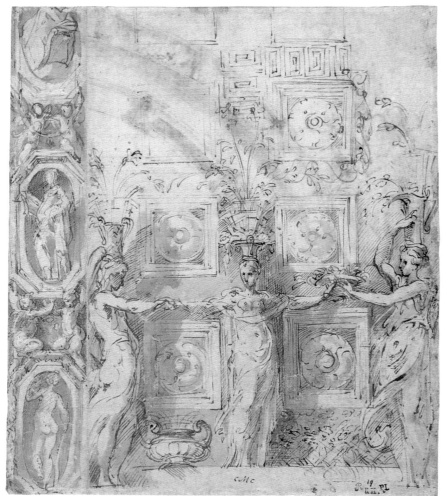

104

104 *Three* canephori, *and vaulting* c.1531–3

Pen and brown ink, brown wash, white heightening (partly discoloured).
210 × 179 mm (8 ¼ × 7 ¹/₁₆ in)

British Museum, London (Ff.1-86)

Provenance: Sir P. Lely (L. 2092);
R. Houlditch (L. 2214); J. Talman (?);
J. Richardson Sr (L. 2184); Rev. C.M.
Cracherode Bequest, 1799

Literature: Popham, *BM*, no. 126; Popham,
Parm., no. 229

In comparison with the previous drawing
the design elaborated in the present study
is far closer to the finished composition.
The *canephori* (i.e. basket- or vase-bearing
women) appear in the same position, and

in approximately the same poses as those
in the finished fresco. The central figure
in the drawing is raised above her compan-
ions by placing her on a raised dais, an idea
later rejected. The metamorphosis of these
classically inspired women into Wise and
Foolish Virgins has not yet occurred, and
here they are simply large-scale decorative
figures. The dense and predominantly
figural decoration of the vault elaborated in
cat. 103, perhaps inspired by the fashionable
antique-style painted façades of Roman
palaces initiated by Polidoro da Caravaggio
and Maturino in the early 1520s, is here
replaced with a plainer and more measured
design. Perhaps to compensate for this,
Parmigianino's design on the left-hand side
of the sheet for the underside of the lateral
arch is much busier than that studied in cat.
103, with small figures placed in oval niches
supported by twisting putti. HC

105 *Three* canephori, *and vaulting* c.1534

Black chalk underdrawing, brush and
brown ink, yellow, green and mauve washes,
red heightening, worked over with pen and
brown ink and white heightening.
233 × 170 mm (9 ³/₁₆ × 6 ¹¹/₁₆ in)

Chatsworth, Devonshire Collections (788)

Provenance: An unidentified armorial stamp
(L. 2725a, verso); Dukes of Devonshire

Literature: Popham, *Parm.*, no. 718;
Washington and Parma 1984, no. 51; Jaffé
1994, no. 710

Although much damaged, this is one of
Parmigianino's most attractive drawings,
the combination of media giving it
something of the richness of effect that he
was aiming for in the frescoes themselves.
This might normally indicates a definitive
drawing, perhaps for the approval of the
patron, but a long sequence of studies of
the individual *canephori* still closer to the
paintings as executed indicates that the
artist had yet to settle on their final form.
The motif of the *canephori* holding each
others' wrists is found on the self-portrait
sheet (cat. 115), which may date the present
sheet to around 1534. Just visible in the
lower right corner is a fragmentary head of
Moses, identified by the rays of light issuing
from his temples.

On the verso of the sheet are studies for
the painting of *Saturn and Philyra* (fig. 43)
commissioned by Francesco Baiardo (see
cat. 123). MC

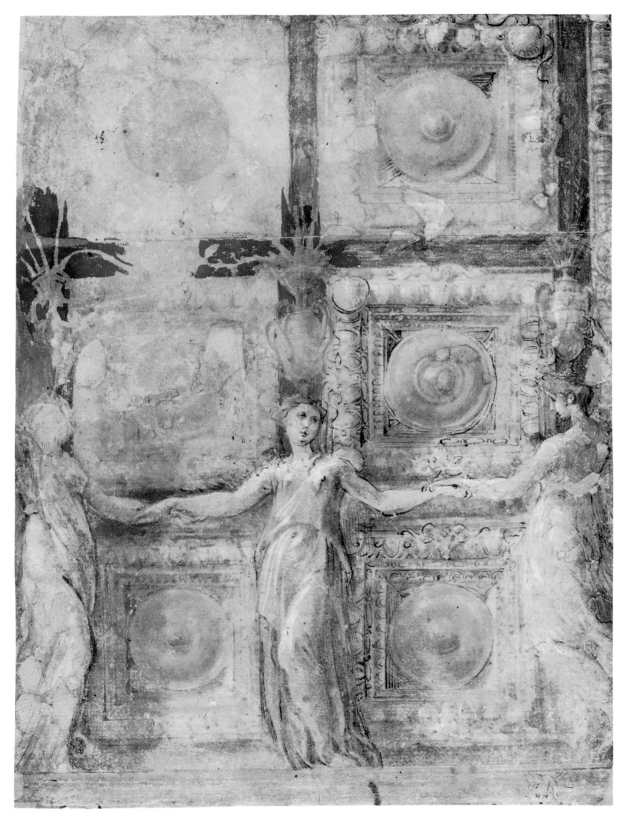

105

106 *Studies of the Wise Virgins* c. 1534–7

Red chalk. 272 × 202 mm (10 ¼ × 7 ¹⁵/₁₆ in)

Private collection, USA

Provenance: J. Richardson Jr (L. 2170);
private collection, London

Literature: Ekserdjian 1999, no. 61

This important sheet was recently
published for the first time, although its
attribution had been established by its
former owner. It was made as a preparatory
study for the fresco of the *Wise Virgins* in
the vault of Santa Maria della Steccata. It is
exceptional among the many surviving
drawings for this project in the large scale
of the figures, in the profile pose of the
central figure's head and in the placement
of the two figures close to one another.
Since the main figure in the drawing was
made first, it is impossible to know if the
placement of the other represents a rejected
experiment by the artist or whether he was
simply sketching the second figure within
the space left on this sheet of paper. One
might at first suppose this to be very early
amongst studies for the Steccata vault, but,
as Ekserdjian points out, it was made after
the iconography of the vault was already
well established. In its elegance of form and
economy of means, it is among the most
impressive drawings for the Steccata. GG

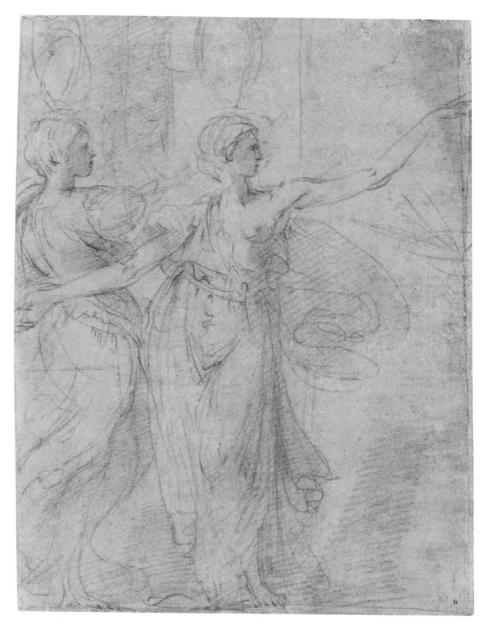

106

107

108

109

107 *A study for figures in the Steccata* c. 1531–5

Pen and brown ink, brown, green and yellow washes, white heightening. 111 × 29 mm (4 ⅛ × 1 ⅛ in)

Christ Church, Oxford (0412)

Provenance: N. Lanier (L. 2886); Sir P. Lely (L. 2092); General J. Guise

Literature: Popham, *Parm.*, no. 347; Byam Shaw 1976, no. 1084

In the upper compartment is a seated winged figure, perhaps holding a shield; in the lower a standing draped female with a shield on the ground by her side. Pen lines indicate that rectangular frames were also considered for the compartments before the octagons were settled upon. Cats 107–9 all show the compartments separated by decorative, acanthus-like elements rather than by the figures of cats 103–4 and 110–13, and presumably date from a relatively early stage of Parmigianino's planning of the Steccata. The three fragments were probably all cut from the same sheet, and the placing of Lanier's star stamps indicates that this was done by the mid-seventeenth century. MC

108 *Saint John the Evangelist for the Steccata* c. 1531–5

Pen and brown ink, brown wash, white heightening. 102 × 43 mm (4 × 1 ¹¹⁄₁₆ in)

Christ Church, Oxford (0413)

Provenance: N. Lanier (L. 2886); Sir P. Lely (L. 2092); General J. Guise

Literature: Popham, *Parm.*, no. 348; Byam Shaw 1976, no. 1085

Saint John the Evangelist holds the chalice that alludes to his drinking from a poisoned cup given to him by the priest of the temple of Diana at Ephesus as a test of his faith. Parmigianino gave little thought to the appropriateness of the pose for the oval frame and, although the chalice and some drapery overlap the frame, the figure seems inconsequential and dominated by the surrounding architecture. MC

109 *A study for a figure in the Steccata* c. 1531–5

Pen and brown ink, brown, green and yellow washes. 97 × 29 mm (3 ¹³⁄₁₆ × 1 ⅛ in)

Christ Church, Oxford (0414)

Provenance: N. Lanier (L. 2886); Sir P. Lely (L. 2092); General J. Guise

Literature: Popham, *Parm.*, no. 349; Byam Shaw 1976, no. 1086

The figure is too tall and narrow for the octagonal compartments envisaged by Parmigianino at this stage of his planning of the *sottarchi* (soffits); his head overlaps the frame above, and the frame is not completed below. The pose of the figure, with the right arm clasped to the side and the head looking over the right shoulder, seems to be based on some version of Michelangelo's *Saint Matthew*: not the unfinished sculpture (Accademia, Florence) or any surviving drawing, but perhaps the same model that Raphael had in mind when he made a drawing in connection with the Borghese *Entombment* (British Museum; Pouncey and Gere 1962, no. 12 verso). MC

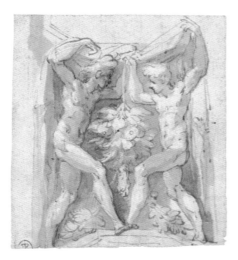

110

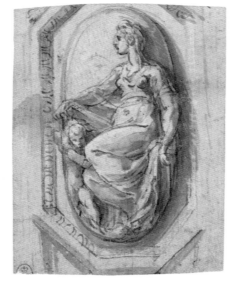

111

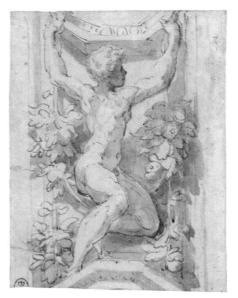

112

110 *Two nude youths with drapery and garlands for the Steccata* c.1531–5

Pen and ink, brown and yellow washes, white heightening. 78 × 66 mm (3 ¹/₁₆ × 2 ⅝ in)

Royal Library, Windsor Castle (0547)

Literature: Popham and Wilde 1949, no. 588; Popham, *Parm.*, no. 656

Cats 110–13 are all studies for a version of the decoration of the Steccata that was subsequently abandoned. Their uniformity of size and style, and the fact that cats 111–13 are all elaborations of motifs seen on cat. 103, suggest that they are contemporary and may even have been cut from the same sheet by an early collector. Putti (rather than youths) similarly paired to support octagonal compartments are seen along the left edge of cat. 104 recto. MC

111 *A sibyl seated in left profile for the Steccata* c.1531–5

Black chalk underdrawing, pen and ink, brown wash, white heightening. 83 × 62 mm (3 ¼ × 2 ⁷/₁₆ in)

Royal Library, Windsor Castle (0548)

Literature: Popham and Wilde 1949, no. 589; Popham, *Parm.*, no. 657

A figure in roughly this position is seen towards the centre of cat. 103 recto. She has before her a winged putto, and rests her right arm on a tablet held against her lap. MC

112 *A nude youth with garlands for the Steccata* c.1531–5

Pen and ink, brown wash, a little white heightening. 93 × 69 mm (3 ¹¹/₁₆ × 2 ¹¹/₁₆ in)

Royal Library, Windsor Castle (0549)

Literature: Popham and Wilde 1949, no. 590; Popham, *Parm.*, no. 658; Quintavalle 1971, no. LXXII

The figure is seen at the centre right of cat. 107, with an alteration to the position of the left leg. Like the woman in cat. 113, he seems to be seated as if on a swing suspended from the octagonal frame above, although this is obscured by the beautiful twist of the body. MC

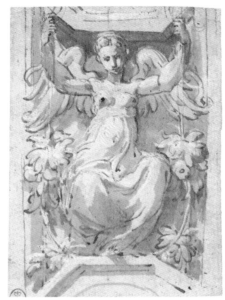

 113

113 *A winged woman seated as on a swing for the Steccata*
c. 1531–5

Pen and ink, brown wash, white heightening. 94 × 64 mm (3 ¹¹/₁₆ × 2 ½ in)

Royal Library, Windsor Castle (0550)

Literature: Popham and Wilde 1949, no. 591; Popham, *Parm.*, no. 659

The figure is seen to the lower left of cat. 103 verso. She appears to be seated on a garlanded swing, her raised hands holding the supporting rope; a male figure in the same posture is found in another fragmentary study for the Steccata, in Sacramento (Popham, *Parm.*, no. 570, pl. 325). This is an unusual conceit: the function of figures interspersed among architectural elements was usually to appear as if they were supporting the architecture, as in cat. 110, and not vice versa. Although the figure is winged her specific identity has not been established.

MC

114 *Nine studies for the figure of Moses in the Steccata* (recto); *Nine studies for the figure of Eve in the Steccata over an architectural elevation drawing* (verso)
c. 1531–5

Pen and brown ink, brown wash, over traces of leadpoint and stylus ruling. 211 × 153 mm (8 ⁵/₁₆ × 6 ¹/₁₆ in)

Inscribed, verso: *48*

The Metropolitan Museum of Art, New York (62.135; Pfeiffer Fund, 1962)

Provenance: Cavaliere F. Baiardo; 2nd Earl of Arundel; A.M. Zanetti (both according to Woodburn); Baron D. Vivant-Denon (L. 780); Sir T. Lawrence (L. 2445); R. Ford (sale, Sotheby's, London, 25 April 1934, lot 29); Sir B. Ingram; purchased in London, 1962

Literature: New York 1965, no. 94; Popham, *Parm.*, no. 301; Quintavalle 1971, no. LXIX; Bean 1982, no. 153; Pugliatti 1984, no. 142; Shearman 1986, pp. 47, 193; Di Giampaolo 1989, pp. 138–9, under nos 63–4; Gould 1994, pp. 135, 153–5; Ekserdjian 1996, pp. 199–200; Paris 1999–2000, no. 557

The stunning sketches for the figures of Moses and Eve on this famous double-sided sheet are preparatory for two of the four large fictive statues (frescoed in monochrome) within the oval niches that are at the base of the two narrow soffits (undersides of the supporting arches) on either side of the barrel vault (see fig. 41). In the frescoes, Moses is paired with Aaron on the underside of the arch toward the crossing, and Eve with Adam on that toward the apse. Cat. 114 offers an amazing glimpse into Parmigianino's sketching process, for each idea unfolds with the kind of spell-binding facility that instantly speaks of genius. He explored at least nine poses for each figure, and also fluently moved about the figure from various angles of view. The viewing angles for the fictive marble sculptures in monochrome, with respect to the larger figures of the *canephori*, were crucially important in the overall illusionism of the frescoes. The enormity of the actual architectural space toward the crossing in the church offers multiple vantage points for Parmigianino's frescoes. In each of the sketches on the sheet, the figure is always seen carefully integrated within its corresponding oval niche (the artist faintly indicated the borders of the soffit with parallel lines drawn in leadpoint). On the recto, the Moses figure in the bottom row, second from the left border – showing the irate patriarch with raised arms, about to shatter the tablets of the Ten Commandments – comes closest to the final form of the fresco (fig. 41). A softly drawn study in the Louvre (Popham, *Parm.*, no. 355, pl. 332) develops this active pose for Moses on a larger scale. Studies in the Louvre and in Parma showing Moses in a seated static pose, although more detailed and finished than the present sketches, must belong to an earlier and discarded phase of planning (Popham, *Parm.*, nos 357, 530, pl. 331). Intriguingly, a detailed copy of one of the figures of Moses in cat. 114 turns up on a page of Girolamo da Carpi's sketchbook from 1549–53, complete with the original's oval framework and *pentimenti* (illustrated and discussed in Canedy 1976, pp. 7, 82, pl. T 26). Although the verso is not mentioned, cat. 114 is probably the item listed in the 1561 inventory of Cavaliere Francesco Baiardo's possessions as '115. Un' disegno di noue figurine di Moysè diferenti l'uno dall'altra di chiaro, et scuro finite in parte dil Parmesanino alte o 2 l'uno' ('a drawing of nine little figures of Moses, each different from the other, partly finished in *chiaroscuro* by Parmigianino'; Popham 1967, pp. 26–7, and Popham, *Parm.*, p. 267, no. 115).

On the verso, the top five sketches of Eve along the upper right closely convey her pose as finally frescoed in the Steccata: she is seen almost frontally, at the moment of picking the apple from the tree of knowledge with her right hand. The various extant preliminary drawings for this figure all seem to represent a stage of planning prior to cat. 114 (Popham, *Parm.*, pls 328–9)

CCB

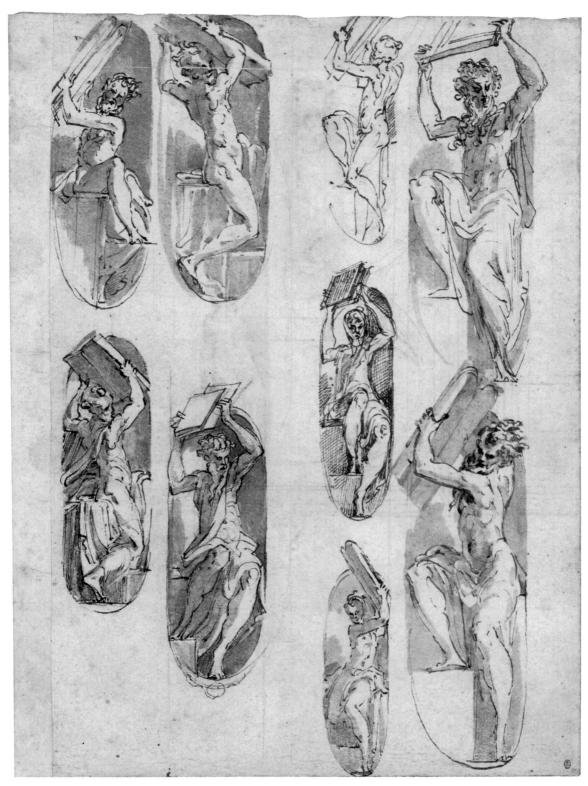

114r

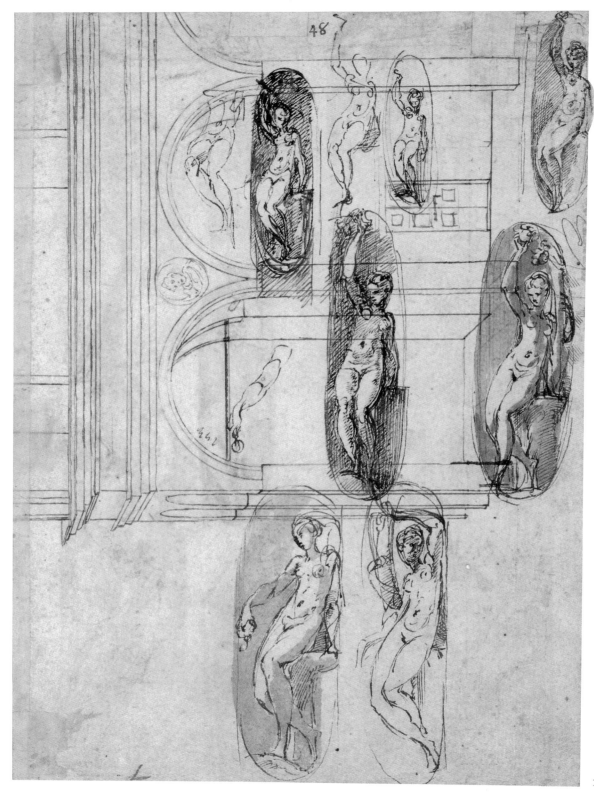

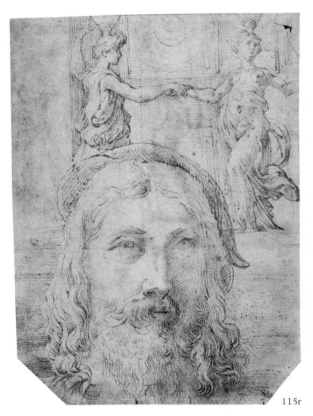

115r

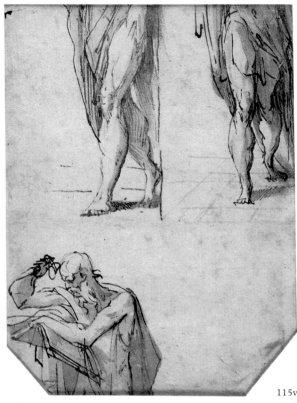

115v

115 *A self-portrait with two* canephori (recto); *Saint Jerome* (verso) *c. 1534*

Pen and brown ink. 107 × 75 mm (4 ³/₁₆ × 2 ¹⁵/₁₆ in), the bottom corners cut

Chatsworth, Devonshire Collections (790)

Provenance: 2nd Earl of Arundel; Viscountess Stafford; 2nd Duke of Devonshire (L. 718)

Literature: Popham, *Parm.*, no. 719; Quintavalle 1971, no. LXXVII; Jaffé 1994, no. 711

The features of the man are consistent with a profile portrait (Albertina, Vienna; Popham, *Parm.*, no. 600, pl. 430) that was used, probably on good authority, for the woodcut portrait of Parmigianino in Vasari's *Lives* (1568); only the hair length is different. A resemblance to Dürer's painted self-portrait of 1500 (Munich) has often been noted, but this is probably a mere coincidence – a frontal pose for a self-portrait is natural and common (cf. cat. 49), and the beard is irrelevant. A more substantial connection with Dürer is the treatment of the hair and beard, drawn with an extremely fine pen and allowing some of the highlit coils to emerge from the mass in a manner highly reminiscent of Dürer's engravings.

The self-portrait was drawn first and the *canephori* added behind, not as a creative sketch, but appended to the portrait as a kind of visual signature. They have not reached their final form, holding each others' wrists, whereas in the fresco they suspend lamps between their outstretched hands. On the verso of the sheet are three fragmentary sketches for Saint Jerome in the background of the *Madonna of the Long Neck* (cats 119–22). This may date the sheet to around 1534, when that painting was commissioned, providing a rare reference point for our knowledge of the progress of the Steccata decorations.

The head alone was etched by Hendrick van der Borcht as the title-page to the series of reproductions of Parmigianino drawings then in the Arundel collection. As the size of the sheet corresponds closely to that of many of the ex-Arundel drawings now at Windsor, it is possible that cat. 115 was once the frontispiece of the album that contained them. The unusual trimming of the sheet's lower corners (chamfering of the upper corners was common in English seventeenth-century drawings collections) might then be explained as removing signs of the thumbing that would have been a consequence of this placing. MC

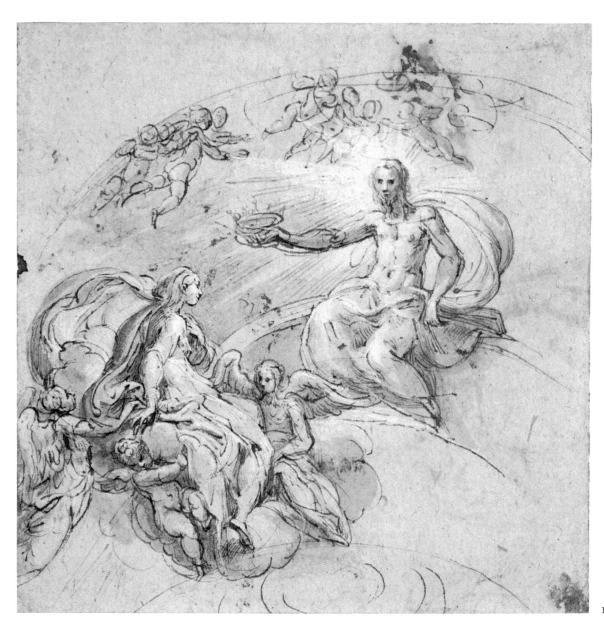

116

116 *The Assumption and Coronation of the Virgin*
c.1531–5

Pen and grey ink, grey wash, white heightening, on faded blue paper. 187 × 183 mm (7 ⅛ × 7 ³/₁₆ in)

Royal Library, Windsor Castle (2185)

Provenance: King George III

Literature: Popham and Wilde 1949, no. 597; Popham, *Parm.*, no. 665; Quintavalle 1971, no. LXXV; Battisti 1982, p.133

117 *The Assumption and Coronation of the Virgin*
c.1531–5

Pen and brown ink on rough paper. 129 × 141 mm (5 ¹/₁₆ × 5 ⁹/₁₆ in)

Inscribed on mount: *Parmesan*

Courtauld Institute, London (D.1972.PG.367)

Provenance: J. Dupan; C.R. Rudolf; Count A. Seilern

Literature: Popham, *Parm.*, no. 770

Exhibited in London only

Parmigianino's commission of 10 May 1531 to decorate Santa Maria della Steccata in Parma included the painting of the eastern apse with the *Coronation of the Virgin*. The revised contract of 27 September 1535 stated that this was to be completed by September 1537, but when the Confraternity finally lost patience with Parmigianino in December 1539 it appears that the apse fresco had not even been begun. The commission was passed to Giulio Romano, and the fresco was finally painted by Michelangelo Anselmi in the 1540s.

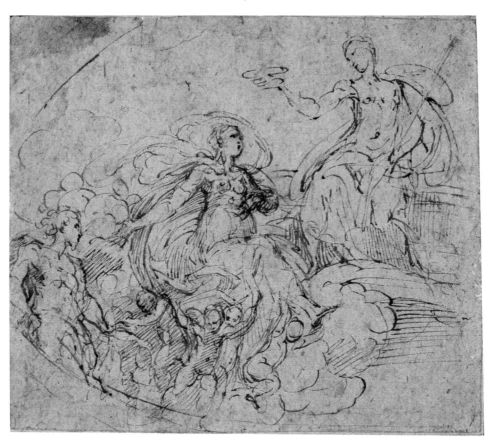

117

By the signing of the first contract in 1531 Parmigianino had already submitted a drawing of the subject to the Confraternity, mentioned in an earlier but undated document. This drawing was quite possibly that now in the Galleria Nazionale, Parma (Popham, *Parm.*, no. 559, pl. 309), which shows a symmetrical composition with Christ and the Madonna seated on the same level at the centre, surrounded by a host of musical angels. The natural symmetry and the pose of Christ relate the design to Correggio's fresco of the previous decade in the apse of San Giovanni Evangelista (see fig. 8 on p. 40), although the larger fresco field of the Steccata (the apse of San Giovanni was nine metres wide, that of the Steccata twelve) and Parmigianino's preference for slender figures over Correggio's more blocky staffage led in the Parma drawing to an overabundance of angels around the central couple.

The other drawings connected with the project, including cats 116–17, appear to be subsequent attempts to overcome this problem rather than preliminary sketches leading up to the symmetry of the Parma drawing; they are later in style than that drawing, possibly even towards the middle of the decade when the contract was revised. Parmigianino's strategy was to activate the composition by showing the Virgin borne up by angels towards the figure of Christ, seated centrally on a rainbow-like arc and holding out the crown towards her, and the subject thus becomes the *Assumption and Coronation of the Virgin*. The Windsor sheet, cat. 116, is the earlier of the two exhibited here, and the outline of the pictorial field is much narrower than the semicircle necessary for an apse. This is resolved to some degree in the Courtauld drawing, cat. 117, but only by virtue of neglecting the half of the field to the right of Christ (the composition is as Parmigianino drew it and has not been cut down).

In cat. 116 the Virgin touches her left hand to her breast in humility. This gesture is reconsidered in cat. 117, where she turns towards the spectator and gestures down to a standing bearded man, nude or almost so and lacking any attributes. He does not appear to be Saint Thomas, to whom the Virgin handed her girdle at her Assumption, for neither appears to hold anything and the male figure stands with his arms by his side. The physical type suggests that he may instead be Saint John the Baptist, to whom was dedicated the oratory that preceded the Steccata on the site and who was also one of Parma's patron saints. The Virgin's action in cat. 117 would then be one of intercession with Christ on behalf of the city. Parmigianino seems soon to have reconsidered the motif, for in two records of subsequent ideas this male figure disappears (although the Virgin's gesture is retained and is thus without context). These are a seventeenth-century copy at Windsor (Popham, *Parm.*, no. o.c. 48, pl. 311) and a sheet in Turin (ibid., no. 594, pl. 311) that has always been considered autograph but that may also be an old copy. These two drawings are very close in their details and precedence is impossible to establish, but the Turin study shows the whole of the pictorial field and is thus our last glimpse of Parmigianino's thoughts on the doomed project. MC

118 *Allegory of the artist at work in his studio* *c.1530–40*

Pen and brown ink, over some traces of leadpoint or soft black chalk. 141 × 125 mm (5 ⁹/₁₆ × 4 ¹⁵/₁₆ in)

Inscribed in a sixteenth-century hand: *parmésan*

The Pierpont Morgan Library, New York (IV, 46)

Provenance: Sir T. Lawrence (L. 2445); C. Fairfax Murray; purchased by J.P. Morgan in London, 1910

Literature: New York 1965, no. 95; Popham, *Parm.*, no. 321; Olszewski 1981, p. 9; Washington and Parma 1984, no. 54

As is typical of many initial sketches (*primi pensieri*) of the Italian Renaissance, most of the figures in this small, enigmatic drawing are portrayed in the nude. The scene represents painters and draughtsmen working from posed live models, as well as casts, mannequins and other props, within a monumental barrel-vaulted architectural interior that resembles the setting of an ideal art academy in the Platonic sense, rather than an actual Renaissance artist's studio or workshop. There are also various onlookers. The kneeling figure on the right (probably meant to represent a *garzone*, or artist's assistant) holds a gauging stick to draw a series of orthogonal lines in a complex perspectival projection. The composition may have been intended as an allegory of the arts, and the commanding princely seated figure in the centre who appears clothed may well represent the patron around whom all the arts of design revolve (New York 1965). His pose is not unlike that of Alexander the Great in representations of him visiting his court painter Apelles. It has also been supposed, less convincingly, that this seated male figure in the centre represents the artist who contemplates his own work (Washington and Parma 1984). More probably, the figure of the artist (portrayed here in an allegorical sense) is to be identified with the nude man

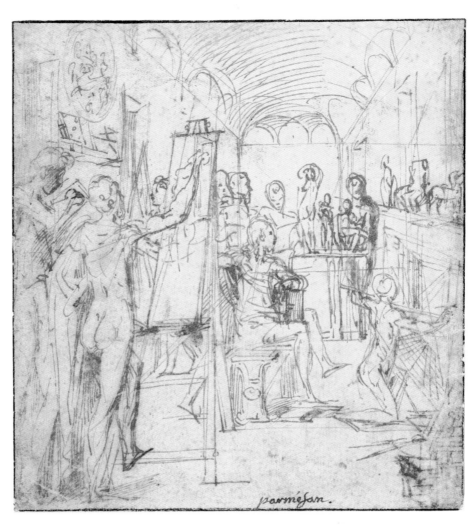

118

standing before his easel in the left foreground, with outstretched arm and brush in hand, in the *ad locutio* pose of classical orators and emperors (Olszweski 1981). He leads the viewer into the space of the picture. At the upper left of the composition, the design within an oval seems to depict the coat-of-arms of an intended patron, but the heraldic elements are too sketchy for identification.

Although less peopled and still more schematically drawn, a closely related sketch in Besançon, of roughly comparable size, also shows artists and onlookers in a similarly monumental interior (Popham, *Parm.*, no. 22, pl. 439). There, however, the conceit of a painting of the artist working on a painting is clearly intended, for the canvas on the painter's easel seen in frontal view partly mirrors elements of the actual architecture of the room; the seated princely

patron figure is omitted. Both sheets date from the last decade of Parmigianino's life, to judge from the elongated figures with rather spare, scratchy, angular outlines and little internal modelling. A much smaller, stylistically related pen and ink sketch of a single figure, holding a cornucopia and drawing at an easel, was recently published (Ekserdjian 1999, no. 54, fig. 71), further enriching the general allegorical reading of this mysterious group of drawings. CCB

The Madonna of the Long Neck *(cats 119–22)*

Parmigianino's most celebrated altarpiece, the *Madonna of the Long Neck* (Uffizi, Florence; fig. 42), was commissioned in December 1534 by Elena Tagliaferri, the sister of the artist's friend and patron Francesco Baiardo. The painting, abandoned by Parmigianino when he fled to Casalmaggiore in 1539, was for the funerary chapel of the patron's deceased husband, also Francesco, in the church of Santa Maria dei Servi in Parma and was placed there in 1542 with an inscription added on the step in the background stating that it had been left unfinished. The funerary context explains the explicit references to Christ's sacrifice in the painting, most evidently in the Pietà-like pose of the Infant Christ on his mother's lap, and the inclusion of a cross which was once visible inside one of the crystal urns held by the angels (it is described by Vasari in 1568 biography of the artist, and also features in old engravings after the work). The sequence of drawings shows that the altarpiece started out as a conventional Virgin and Child enthroned between saints Jerome and Francis (cats 119–22), but these figures were eventually relegated to the background and their place taken by angels bearing vases.

HC

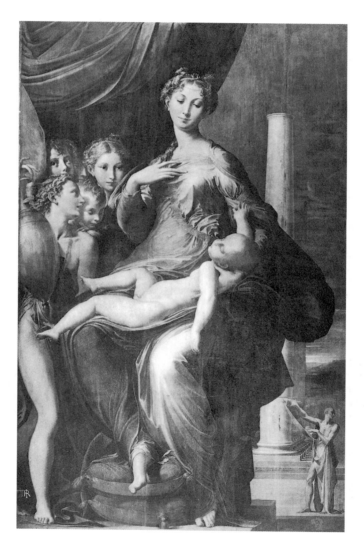

Fig. 42. Parmigianino, *Madonna of the Long Neck*, oil on panel, 214 × 133 cm. Galleria degli Uffizi, Florence.

119 *The Virgin and Child with Saints Jerome and Francis* *c.* 1534–5

Black chalk, pen and brown ink, grey wash, white heightening, on light brown paper. 182 × 104 mm (7 ³/₁₆ × 4 ¹/₁₆)

British Museum, London (1978-3-4-6)

Provenance: Cavaliere F. Baiardo (?); 2nd Earl of Arundel (?); A.M. Zanetti; Du Roveray (?); T. Dimsdale; Sir. T. Lawrence (L. 2445); an unidentified armorial drystamp; anon. sale, Christie's, London, 29 November 1977, lot 35

Literature: Di Giampaolo 1983–4, p. 181, fig. 5; Ekserdjian, 1984, pp. 424–9, fig. 53

This was acquired by the British Museum as a drawing by Girolamo Mazzola Bedoli, but it was independently identified by Mario Di Giampaolo and David Ekserdjian as an early study by Parmigianino for the *Madonna of the Long Neck* (fig. 42). The symmetrical arrangement of the saints below the enthroned Virgin and Child shown in this sheet is repeated in a red chalk drawing in the Louvre, and in a pen and ink study in the Albertina which is an old copy after a lost design by Parmigianino (Popham, *Parm.*, nos 363 and o.c. 33, pls 345–6). Ekserdjian's suggestion that the British Museum study is the earliest of the three is persuasive, as the drawing includes details, such as the three attributes for the figure of Saint Jerome (crucifix, skull and lion), not found in either the Paris or Vienna versions. The meticulously finished nature of the drawing is unusual for a compositional study by the artist, and may possibly show that it was intended to be shown to the patron as a guide to the form of the finished work. The fact that the painting differs so greatly from this study does not necessarily invalidate this suggestion, as it is clear from Parmigianino's preparatory drawings that he had considerable latitude in the composition of the altarpiece. HC

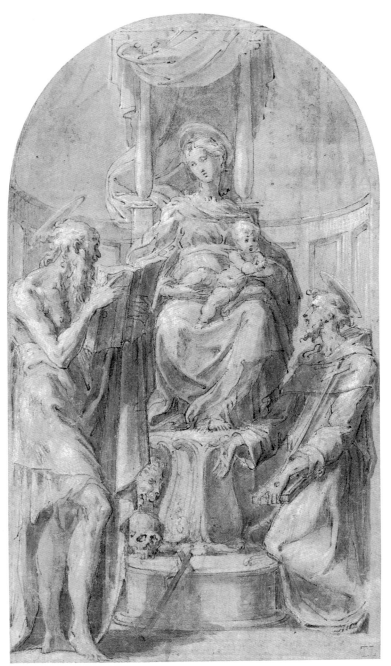

119

120r

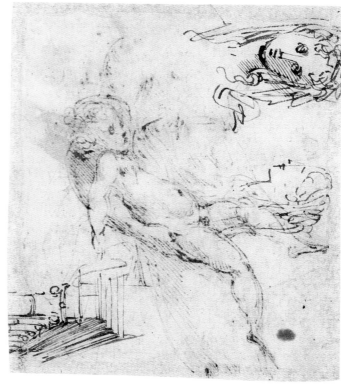

120v

120 *Madonna of the Long Neck* (recto and verso)

c. 1535–7

Pen and brown ink. 102 × 86 mm
(4 × 3 ⅛ in)

The J. Paul Getty Museum, Los Angeles
(83.GA.265)

Provenance: Earl Spencer (L. 1532; sale,
T. Philipe, London, 14 June 1811, part of lot
515, bt Sir H. Englefield); S. Abate

Literature: Goldner 1988, no. 28

This delicate study was made in order to develop the pose of the Christ Child and establish his position on the Virgin's lap. It is stylistically close in handling to two studies of the Virgin in the British Museum (Popham, *Parm.*, nos 243–4, pl. 355). The pose of the Christ Child appears to be based on a sculpture, known in several copies in various media, of a sleeping Cupid which is thought to reflect a lost original by Michelangelo (see cats 84–5). A further study of the Infant Christ from a different angle is in the Louvre (Popham, *Parm.*, no. 432, pl. 354). The pose of the Christ Child in cat. 120 is repeated in a lost full-length study of the Virgin and Child recorded in a print (Popham, *Parm.*, no. O.R.17, pl. 354). In the painting the figure is much altered, an evolution that can be followed in later drawings.

The verso has a study for the Virgin's head at the upper left. She is shown with her head tilted downward and to her left, as in the painting, but she wears a veil that is only seen in early stages of the evolution of the composition (cat. 119). The female head studied in profile and the small architectural detail recur in various other early drawings for the painting, but were discarded in the final version. For these reasons, this would appear to be a relatively early study. GG

121 *The Infant Christ asleep on the lap of the Virgin (recto); Nude man standing by a tree (Hercules?), the torso of the Virgin (verso)*

c.1535–9

Red chalk over stylus (recto); pen and brown ink, brown wash (verso). 191 × 145 mm (7 ½ × 5 ¹¹/₁₆ in)

The Pierpont Morgan Library, New York (IV, 42)

Provenance: 2nd Earl of Arundel (?); A.M. Zanetti (?); Count Gini; G.A. Armano; Sir J. Knowles (according to Fairfax Murray); C. Fairfax Murray; purchased by J.P. Morgan in London, 1910

Literature: New York 1965, no. 93; Popham, *Parm.*, no. 317; Harprath 1971, p. 69; Denison, Mules and Shoaf 1981, no. 22

The exquisitely rendered red chalk study on the recto and the small ink drapery study on the verso relate to the last stages of planning of the *Madonna of the Long Neck* (fig. 42). The red chalk technique of the recto, with smoothly blended strokes and sharp inflections of shadow over stylus underdrawing, is typical of Parmigianino's final years. The study on the recto concentrates on the pose of the Infant Christ as he rests on the Madonna's lap. In comparison to the final painting, the Madonna's entire supporting left hand reaches under the infant's arm, while his body still lies in a relatively upright position across her lap. The child's right arm is not evident, and his right leg still dangles downward rather than resting horizontally. In the drawing, he also has a full head of hair. The altarpiece was still unfinished in parts at the time of Parmigianino's death in 1540, and as many of the drawings – and cat. 121 in particular – seem to suggest, the bald cranium of the Christ Child in the altarpiece would have most probably been softened with at least some pleasing ringlets of hair. In both recto and verso, the

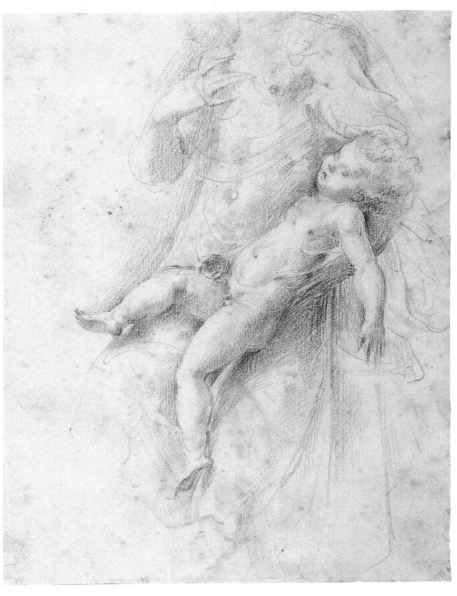

121r

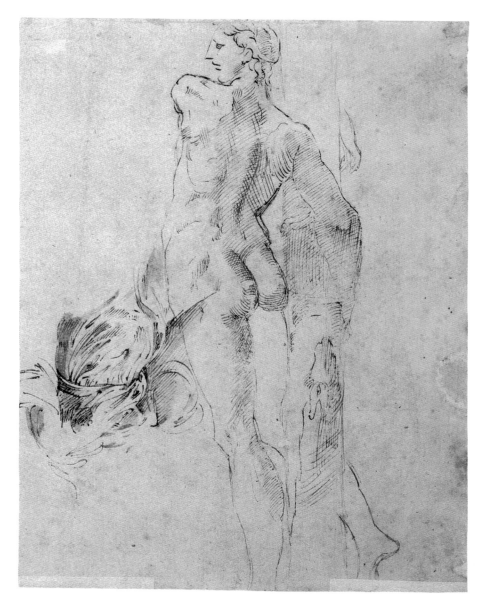

draperies and sash on the Madonna's torso differ substantially with respect to the panel as finally painted.

On the verso, the elegant, thinly draped female torso with a sash bound tightly below the breasts is based on an antique marble, most likely the seated muse Erato unearthed in *c.* 1492–1503, and later owned by Pope Clement VII, Parmigianino's supposed patron in Rome (illustrated in Bober and Rubinstein 1986, pls 40, 40a). The dry drawing of an awkwardly proportioned tall nude youth on the verso appears also to be after a sculpture, to judge particularly from the schematic facial profile. The curious pose may be derived from a sculptural source, as it recalls a faun in a stucco relief roundel by Giovanni da Udine in the Raphael *Logge* at the Vatican Palace, finished in 1519 (illustrated in Dacos 1977, pl. LXXXIa). Like other artists of his time, Parmigianino probably recorded many sculptural motifs in his sketchbooks during his Roman sojourn. The use of an extremely fine-tipped pen and orderly hatching of varying density in the verso studies are, however, typical of drawings from Parmigianino's maturity. CCB

121v

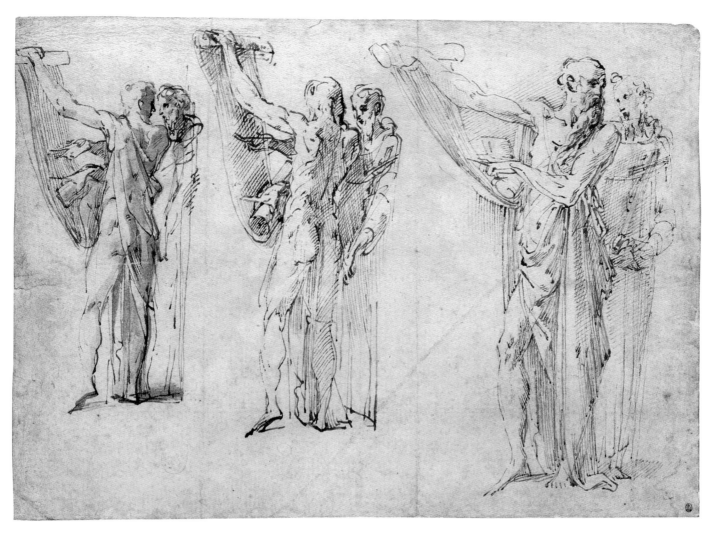

122 *Three studies of Saints Jerome and Francis* c. 1535–9

Pen and brown ink, the left-hand study with brown-grey wash. 141 × 186 mm (5 9/16 × 7 5/16 in)

Ashmolean Museum, Oxford (P. II 440)

Provenance: 2nd Earl of Arundel; A.M. Zanetti; Baron D. Vivant-Denon (L. 780); Sir T. Lawrence (L. 2445); Count N. Barck (L. 1959); A.W. Thibaudeau (L. 2473); E. Galichon (L. 856); J. Isaacs

Literature: Parker 1956, no. 440; Popham, *Parm.*, no. 334

Parmigianino's initial conception of the altarpiece as a traditional *sacra conversazione*, with the enthroned Madonna flanked on either side by standing saints, was abandoned in favour of a strikingly original arrangement with Jerome and Francis (the latter figure left unfinished except for one foot) appearing as diminutive figures relegated to the background of the composition. The distortion of scale and proportion, which are so vital to the painting's unsettling effect, would have been even more marked if Parmigianino had completed the work, as it is clear from the preparatory drawings that he intended

there to be a gigantic colonnade in the background (only the columns of which he completed), which would have towered over the figures, further emphasizing their miniature scale. The pose of Saint Jerome in the painting is close to that of the figure on the right-hand side of the drawing, with the figure holding a scroll, presumably the biblical text which he had translated (as he does in Correggio's *Madonna of Saint Jerome*; fig. 16 on p. 60). In the drawing Parmigianino experimented with three different poses for the saints, and Jerome is also moved slightly further to the left in each of the studies in order to allow more space for his companion. HC

123 *Saturn and Philyra* c. 1534

Pen and brown ink, brown wash, white heightening, over black chalk. 110 × 81 mm (4 5/16 × 3 3/16 in)

Royal Library, Windsor Castle (0563)

Provenance: 2nd Earl of Arundel; King George III

Literature: Popham and Wilde 1949, no. 586; Popham, *Parm.*, no. 654

This is one of several surviving studies for a painting now in the Stanley Moss collection (fig. 43; see Athens 1995, pp. 252–9, 484–6). The painting was recorded in the posthumous inventory of the Cavaliere Francesco Baiardo, Parmigianino's protector, as 'a picture of a nude woman who crowns a horse, with a putto beside them, sketched in colour and finished, 20 *oncie* high by 12 *oncie* wide, by the hand of Parmigianino'. The identification of the subject as the seduction of Philyra, one of the Oceanides, by Saturn in the guise of a horse (which resulted in the birth of the centaur Chiron) cannot be shown to be contemporary with the painting and was first given in an engraving of the painting by Bernard Lépicié (1698–1755). In all other sixteenth-century representations of the subject and in the most prominent literary source, Hyginus's *Fables* (no. 138), the horse is not winged. However, Saturn is often shown winged when in human form, and Popham's consequent explanation of the wings here as an attribute of Saturn may be correct (cf. Bernardino Campi's drawing of the subject at Chatsworth, no. 347c, in which a scythe is drawn next to the nymph and horse). In the absence of other episodes of classical maidens falling in love with horses, Lépicié's identification will have to stand.

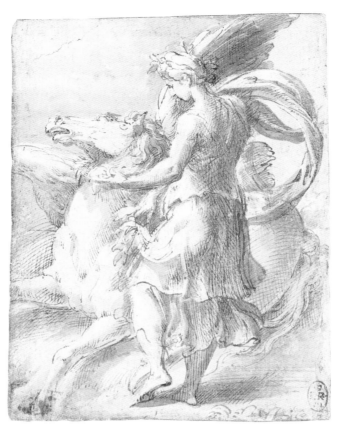

123

Despite the careful finish of cat. 123, the composition is still some way from the final design, lacking most notably the beautiful twist of Philyra's body and the figure of Cupid, who is present in only one of the studies for the project (cat. 105 verso) and there flying above the couple to fire his arrow. The final, and somewhat unsatisfactory, introduction of Cupid may have been a precaution to prevent misidentification of the subject as a Muse crowning Pegasus on Parnassus. Sketches for the same composition on the verso of cat. 105 might place the *Saturn and Philyra* around 1534; that date is dependent upon a comparison within the group of studies for the Steccata and so cannot be relied upon, but is broadly consistent with the style of the painting and related drawings. MC

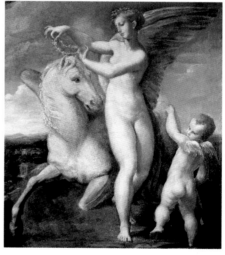

Fig. 43. Parmigianino, *Saturn and Philyra*, oil on panel, 75.6 × 64.1 cm. Stanley Moss, Riverdale-on-Hudson (New York).

124

124 *Head of a bearded man in profile, faint study of a skull-like head also in profile*

c. 1530–5

Red chalk, the head at the left over stylus.
139 × 231 mm (5 ½ × 9 ⅛ in)

Inscribed by the artist: *GIORGIVS ANSELMUS • M • D • XXX • ADI • XXI/D.-SETENBRIS*

The Metropolitan Museum of Art, New York (1973.321; The Elisha Whittelsey Collection, The Elisha Whittelsey Fund, 1954)

Provenance: Sir P. Lely (L. 2092); J. Richardson Sr (L. 2184; and his mount with the inscription: *Parmeggiano.*); Dr L. Pollak (L. 788b); purchased in New York, 1954

Literature: Popham, *Parm.*, no. 298; Bean 1982, no. 160; Bloomington-Pittsburgh-Oberlin 1984, no. 6

Portrait drawings by Parmigianino (other than self-portraits) are quite rare. The left half of this delicately drawn sheet is apparently a portrait of the Parmese statesman and humanist Giorgio Anselmi 'nephew' (he called himself *nepos* or *nipote* to distinguish himself from his older, more famous namesake). Although Anselmi was celebrated in his day as a writer of odes and love poetry in the classical Latin tradition, he has all but been forgotten today. The inscription on cat. 124, which is certainly in Parmigianino's hand as the hue of the red chalk is exactly the same as in the drawings, may establish the poet's precise death date, 21 September 1530. The slight sketch of the skull on the right half of the sheet undoubtedly constitutes a *memento mori*, and the inscription below may well refer to the poet's date of death, although this contradicts Ireneo Affò's late eighteenth-century account of Anselmi's demise in the great plague that swept

through Parma in 1528 (*Memorie di scrittori e letterari parmigiani*, Parma, 1791; Quattrucci 1961). Anselmi is thought to have been born before 1459, although this is not documented. Parmigianino's drawing belongs stylistically to around 1530–5, and it may well have been preparatory for an engraved illustration accompanying a posthumous printing of one of Anselmi's literary works during that decade. CCB

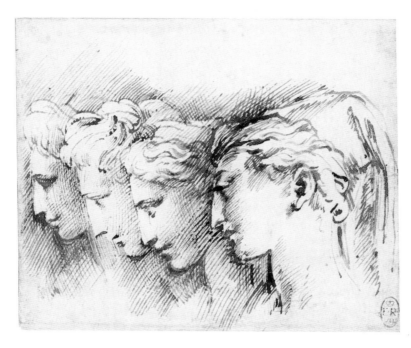

125

125 *Four female heads in profile* c. 1537–8

Pen and brown ink. 87 × 103 mm
(3 ⁷⁄₁₆ × 4 ¹⁄₁₆ in)

Inscribed by the artist, verso: *1537 . a 22 di
decenb io dete duj schudj dor / a Ms damjano*

Royal Library, Windsor Castle (0526)

Provenance: King George III

Literature: Popham and Wilde 1949, no. 601;
Popham, *Parm.*, no. 668

The character of the pen lines as they
approach the edge of the sheet, and the
placing of the inscription on the verso,
suggest that the sheet of paper was very
close to this size when Parmigianino drew
on it, and was thus probably a page in a
sketchbook. The head on the right was
drawn first and the other three added later
in a different pen and ink, apparently as an
exercise in drawing this type of artificially
smooth profile. Such sheets of comparative
physiognomy seem to have fascinated
Parmigianino during the 1530s (Popham,
Parm., pls 422–6); as with Leonardo da
Vinci, this interest may have been a
displacement activity, a substitute for real
work on their commissioned projects (in
Parmigianino's case, the Steccata).

Inscribed on the verso of the sheet is a
note by Parmigianino that on 22 December
1537 he gave two gold *scudi* to 'Messer
Damiano', the architect Damiano de Pleta
who along with the Cavaliere Baiardo stood
surety for Parmigianino's revised contract
for the Steccata in 1535. The drawing on the
recto is presumably close in date to the
recorded transaction. MC

126

127

126 *The head of a boy in profile* c. 1535–40

Pen and brown ink. 116 × 94 mm
(4 9/16 × 3 11/16 in)

Inscribed: *Parmesano*.

Chatsworth, Devonshire Collections (778)

Provenance: Cavaliere F. Baiardo (?); 2nd Earl
of Arundel; Viscountess Stafford; 2nd Duke of
Devonshire (L. 718)

Literature: Popham, *Parm.*, no. 704; Jaffé
1994, no. 719

Although the meticulous cross-hatching
and dotting of this portrait conveys
something of the surface relief, the
gathering density of the background
shading around the face concentrates
attention on the beautifully observed profile.
The profile remained in common use for
drawn portraits (and other head studies)
long after it had fallen from fashion in
painting, for its emphasis on outline was
obviously better expressed in a linear
medium. It is likely that the sheet was
intended as an independent drawing, and
not as a study for a painting. A resemblance
between the boy depicted and the sons of
the Countess of San Secondo in the family
portrait by Parmigianino in the Prado has
been noted, but is probably coincidental.

This may be the drawing recorded as no.
239 in the 1561 Baiardo inventory, 'Un'
disegno d'una testa d'un' giouine col'colo,
fatta di penna finito dil Parmesanino alto o
3', although it lacks distinguishing features
that might confirm this. MC

127 *Head of Julius Caesar*
c. 1535–40

Pen and brown ink, over black chalk.
189 × 143 mm (7 7/16 × 5 5/8 in)

Royal Library, Windsor Castle (2279)

Provenance: King George III

Literature: Popham and Wilde 1949, no. 652;
Popham, *Parm.*, no. o.c.52

The drawing was classed by Popham as a
copy after Parmigianino, but it is of high
quality and no more tense than many
other late pen drawings by the artist. The
rendering of light and surface texture is
particularly fine and there seems no reason
to discount it as an original drawing of the
later 1530s. It is the largest of four studies
from different angles of the same head (the
others are Popham, *Parm.*, nos 564, 646,
783, pls 445–6), a portrait of Julius Caesar
available to Parmigianino either as a marble
original or a plaster cast. MC

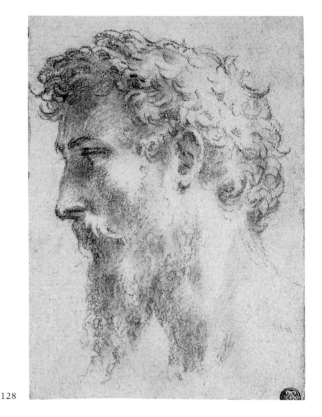

Fig. 44. Parmigianino, *Madonna with Saints Stephen and John the Baptist*, oil on panel, 253 × 161 cm. Gemäldegalerie, Dresden.

128 *Head of a bearded man*
c. 1539–40

Two shades of black chalk, grey wash. 106 × 73 mm (4 3/16 × 2 7/8 in)

Ashmolean Museum, Oxford (P. II 445)

Provenance: J.D. Lempereur (L. 1740)

Literature: Parker 1956, no. 445; Popham, *Parm.*, no. 339

This is probably a study for the head of Saint John the Baptist in the painting of the *Madonna with Saints Stephen and John the Baptist* in Dresden (fig. 44). In the latter the Baptist is shown clean-shaven, but in the preparatory studies for it (Popham, *Parm.*, pl. 449) the saint is shown bearded, as in the present drawing. An argument in favour of this connection is that the lighting and pure profile view of the Baptist's head correspond closely with the study. The meticulous and very detailed observation of light illuminating the figure from the right indicates that this is a life drawing, albeit one in which the features of the model have been refined and idealized. HC

129 *Saint Stephen* c. 1539–40

Black and white chalks on very thin blue paper. 288 × 200 mm (11 5/16 × 7 7/8 in), upper corners trimmed

Royal Library, Windsor Castle (3365)

Provenance: W. Gibson (his price mark *F. Parmigiano. 2.3* on an old backing paper); King George III

Literature: Blunt 1971, no. 333; Popham, *Parm.*, no. 673

Although this drawing was known to be by Parmigianino when in Gibson's hands in the later seventeenth century, it subsequently lost its attribution and was bound in George III's collection as by Guido Reni or his school. Francesco Arcangeli recognized in the 1960s that it is a study for Parmigianino's altarpiece of the *Madonna with Saints Stephen and John the Baptist*, now in Dresden (fig. 44). According to Vasari this was painted for the church of Santo Stefano in Casalmaggiore, the town on the Po north of Parma where Parmigianino spent the last year of his life after his release from prison in 1539.

Several small sketches survive for the whole composition, and the pose of Saint Stephen is different in each – standing, genuflecting, seated in half length, kneeling on one or both knees. Only in the present drawing is he seen in his final form, seated in full length with the stones of his martyrdom in his raised left hand. There is no sign here of the martyr's palm that in the painting he holds in his right hand, nor of the donor who seems to rest his chin on the saint's right knee. As usual, the saint is shown in the robes of a deacon, although in addition to the commonly depicted dalmatic he also has a stole correctly worn diagonally from shoulder to hip, and a maniple around his left wrist, suggesting that an attention to detail was particularly important to patron or painter.

The sheet has been badly rubbed, and traces of white chalk over most of the drapery indicate that this would have been a much more luminous drawing, with greater contrasts, when executed. Parmigianino's combination of black and white chalks may have been an attempt to capture the effect of the strong lighting sought in the painting. MC

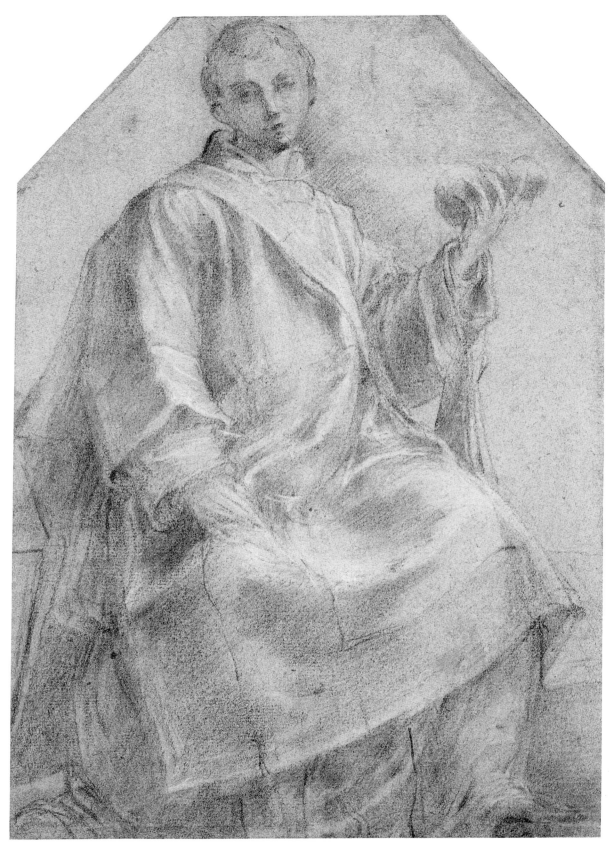

129

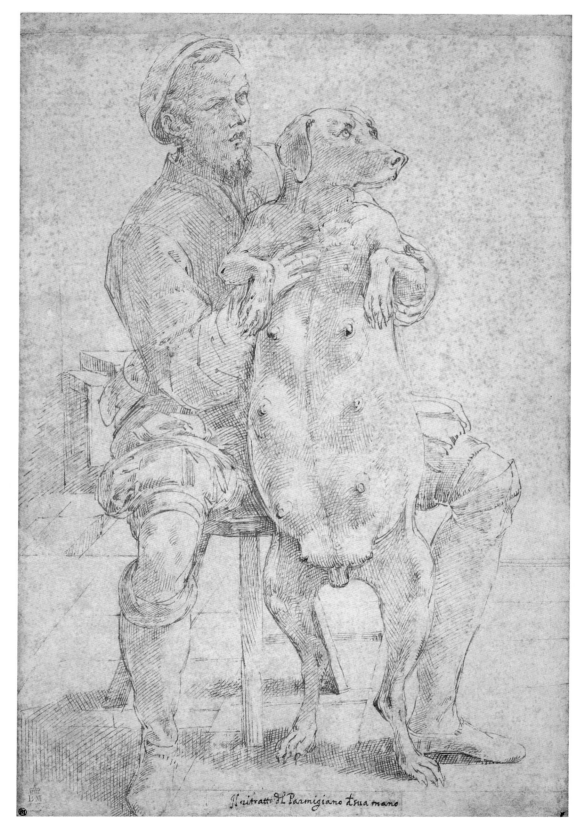

Il ritratto di l Parmigiano di sua mano

130 *A man (Parmigianino ?) holding up a pregnant bitch*

c. 1530–40

Pen and brown ink. 305 × 204 mm
(12 × 8 1/16 in)

Inscribed in a seventeenth-century (?) hand:
Il ritratto del Parmigianino di sua mano

British Museum, London (1858-7-24-6)

Provenance: Moselli of Verona; P.J. Mariette
(L. 2097); Sir. T. Lawrence (L. 2445); Count
N. Barck (L. 1959); W.B. Tiffin

Literature: Popham, *BM*, no. 153; Popham,
Parm., no. 256; Quintavalle 1971, no. LXXVIII

The man holding up the long-suffering dog
is, according to the old inscription, a self-
portrait by the artist. This identification
was supported by Popham, who noted that
the features of the figure generally accord
with those in an anonymous engraving
inscribed with the artist's name, the best-
authenticated portrait of the artist in his
later years. Informal drawings such as this
were probably drawn for the artist's own
pleasure or as gifts to his intimate circle.
Parmigianino's fond interest in man's best
friend is shown in his sympathetic portrayal
of dogs in the frescoes at Fontanellato (see
cat. 92 verso), and by drawings such as the
quick pen sketch of a bitch in the Louvre
(perhaps the same animal as that in the
London drawing) and the memorable study
in the same museum of a dog attaching
itself in an amorous fashion to the leg of a
young man (Popham, *Parm.*, nos 429 and
460, pls 443 and 437). HC

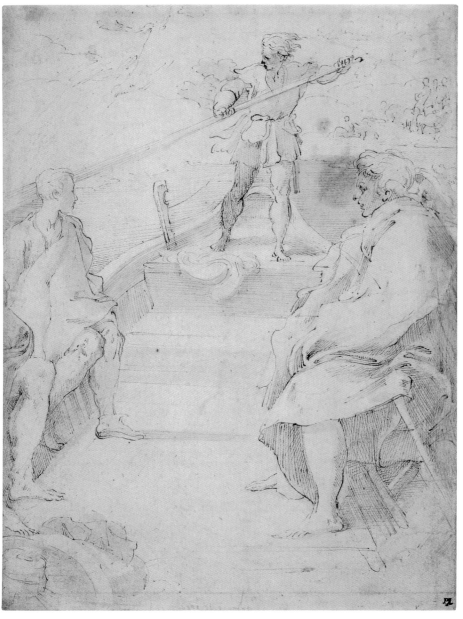

131

131 *Figures in a ferryboat*
c. 1530–40

Pen and two shades of brown ink, brown
wash. 279 × 203 mm (11 × 8 in)

British Museum, London (1895-9-15-753)

Provenance: Sir P. Lely (L. 2092); B. West
(L. 419); Rev. Dr H. Wellesley (sale, Sotheby's,
London, 3 July 1866, lot 1418); Sir J.C.
Robinson; J. Malcolm

Literature: Popham, *BM*, no. 121; Popham,
Parm., no. 224

As Popham observed, the idealized
treatment of the figures suggests that this
is a sketch of a remembered scene rather
than a drawing made from life. The
conspicuously wide-angle viewpoint that
Parmigianino employs here brilliantly
succeeds in creating an impression of
actually being inside the boat. A similar
pen and ink drawing of a man seated on
the gunwale of a boat is in the Louvre
(*Parm.*, no. 406, pl. 437). HC

132 *David with the head of Goliath* *c.1530–40*

Pen and brown ink. 295 × 216 mm (11 ⅝ × 8 ½ in)

The J. Paul Getty Museum, Los Angeles (84.GA.61)

Provenance: Sir T. Lawrence (L. 2445); Count N. Barck (L. 1959); J.-F. Gigoux (L. 1164; sale, Hôtel Drouot, Paris, 20 March 1882, lot 125); art market, Switzerland

Literature: De Grazia 1986, p. 200; Goldner 1988, no. 27

This highly finished composition seems very likely to have been made as a 'presentation drawing' rather than as a study for a painting. It is similar in style of execution and close in size to the *Standard-bearer* in the British Museum (cat. 133). The poses and movements of the figures in the two drawings complement one another, and they may have been made as a pair or part of a series. A third sheet, in the National Gallery of Victoria, Melbourne, of a *Huntsman sounding his horn with a stag hunt in the distance* (Popham, *Parm.*, no. 282, pl. 372) is perhaps part of this group as well, since it is again close in style to the other two and shares with them a common provenance in the Lawrence collection. On the other hand, the Melbourne sheet is also drawn with brush and wash and may simply be a comparable work of the same period, that is, the decade of the 1530s. GG

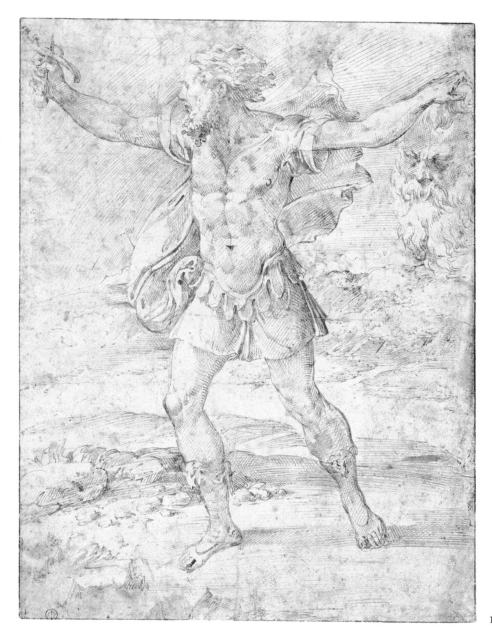

132

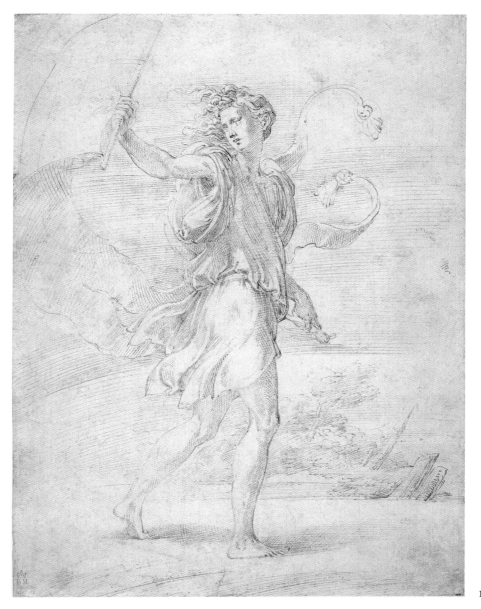

133 *A standard-bearer*
c. 1530–40

Pen and brown ink, over traces of black chalk. 265 × 198 mm (10 ⁷/₁₆ × 7 ¹³/₁₆ in)

British Museum, London (1858-7-24-7)

Provenance: Baron D. Vivant-Denon (?); Sir T. Lawrence (L. 2445); Count N. Barck (L. 1959); W.B. Tiffin

Literature: Popham, *BM*, no. 152; Popham, *Parm.*, no. 255

The subject of the drawing appears not to have a specific source. It is an exercise in virtuoso draughtsmanship, with the billowing flag echoing the sinuous movement of the lithe youth. HC

133

134 *Priapus and Lotis*

c.1530–40

Pen and brown ink, over black chalk,
Priapus's phallus defaced and the area
covered by a brown stain. 321 × 234 mm
(12 ⅝ × 9 ³⁄₁₆ in)

British Museum, London (5210-48)

Provenance: W. Fawkener Bequest, 1769

Literature: Popham, *BM*, no. 154; Popham,
Parm., no. 257

The drawing is inspired by an episode in
Ovid's *Fasti*: Priapus, a fertility god with an
unnaturally large phallus, was on the point
of ravishing the sleeping nymph Lotis, but
was thwarted because his victim was woken
by the braying of Silenus's ass and fled his
advances. This is one of a number of erotic
drawings that Parmigianino made in the
last decade of his life, some of which have
been similarly censored by later owners.
Some of these erotic drawings are rough
sketches and may have been drawn for the
artist's own amusement, while others, such
as the present one, are more finished and
might well have been drawn specifically for
sale or for presentation to patrons such as
Francesco Baiardo, for whom Parmigianino
painted the distinctly homoerotic *Cupid*
now in the Kunsthistorisches Museum,
Vienna. HC

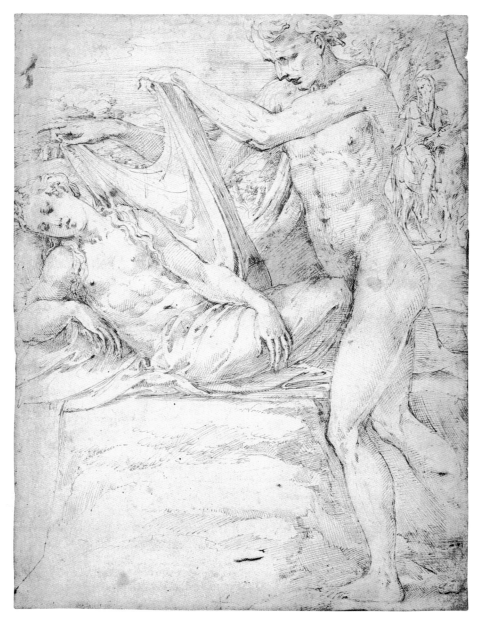

134

Bibliography

ADORNI, B., BATTISTI, E. et al., *Santa Maria della Steccata a Parma*, Parma, 1982

AFFÒ, I., *Ragionamento sopra una stanza dipinta dal celeberrimo Antonio Allegri da Correggio nel Monistero di S. Paolo in Parma*, Parma, 1794

AGGHÁZY, M., *Leonardo's Equestrian Statuette*, Budapest, 1989

ARMENINI, G.B., *De' veri precetti della pittura*, Ravenna, 1587

ATHENS 1995, *El Greco in Italy and Italian Art*, exh. cat., ed. N. Hadjinicolaou, National Gallery, Athens

BAMBACH C.C., *Drawing and Painting in the Italian Renaissance Workshop: Theory and Practice, 1300–1600*, Cambridge and New York, 1999

BAMBACH CAPPEL, C., 'The Uffizi's Sixteenth-Century Drawings in Detroit and Some Tuscan Drawings in Philadelphia', *Master Drawings*, XXVIII (1990), pp. 197–221

BARTSCH, A., *Le Peintre Graveur*, 21 vols, Vienna, 1803–21

BATTISTI, E., '"Ecce Virgo Ecce Habet Lampades": Il Parmigianino alla Steccata', in *Santa Maria della Steccata a Parma*, ed. B. Adorni, Parma, 1982

BEAN, J. with the assistance of L. Turčic, *15th and 16th Century Italian Drawings in the Metropolitan Museum of Art*, New York, 1982

BÉGUIN, S., 'Nosadella et Parmigianino', in *Scritti di storia dell'arte in onore di Jürgen Winkelmann*, Naples, 1999, pp. 35–63

BLOOMINGTON, PITTSBURGH AND OBERLIN 1984, *Italian Portrait Drawings, 1400–1800 from North-American Collections*, exh. cat. by A. Gealt, Indiana University Art Museum, Bloomington (IN); Gallery of Art, University of Pittsburgh (PA); and Allen Memorial Art Museum, Oberlin College (OH)

BLUNT, A., 'Supplements to the Catalogues of Italian and French Drawings', in E. Schilling, *The German Drawings in the Collection of Her Majesty The Queen at Windsor Castle*, London and New York, n.d. [1971], pp. 45–239

BOBER, P.P., AND RUBINSTEIN, R.O., *Renaissance Artists and Antique Sculpture: A Handbook of Sources*, London and Oxford, 1986

BOLOGNA, WASHINGTON AND NEW YORK 1986–7, *The Age of Correggio and the Carracci*, exh. cat. by G. Briganti, et al., Pinacoteca Nazionale di Bologna, National Gallery of Art, Washington and The Metropolitan Museum of Art, New York

BORENIUS, T., *The Picture Gallery of Andrea Vendramin*, London, 1923

BRIQUET, C.M., *Les Filigranes: Dictionnaire historique des marques du papier*, 4 vols, Paris, 1907. Edition with supplementary material edited by A. Stevenson, Amsterdam, 1968

BROOKE, X., *Mantegna to Rubens: The Weld-Blundell Drawings Collection*, London, 1998

BROWN, D.A., 'A Decorative Drawing by Correggio', *Master Drawings*, XIII (1975), pp. 136–41

BYAM SHAW, J., *Drawings by Old Masters at Christ Church, Oxford*, 2 vols, Oxford, 1976

CANEDY, N.W., *The Roman Sketchbook of Girolamo da Carpi*, London and Leyden, 1976

CLAYTON, M., *Raphael and His Circle. Drawings from Windsor Castle*, London, 1999

CLEVELAND AND BLOOMINGTON 1981, *The Draughtsman's Eye: Late Italian Renaissance Schools and Styles*, exh. cat. by E. Olszewski, Cleveland (OH) and Bloomington (IN)

COLLOBI RAGGIANTI, L., 'Disegni del Parmigianino', *Critica d'arte*, XIX (1972), pp. 44–9

DACOS, N., *Le logge di Rafaello: Maestro e bottega di fronte all'antico*, Rome, 1977

DE GRAZIA, D., 'Correggio and His Legacy: Further Observations', *Master Drawings*, XXIII–XXIV (1986), pp. 199–204

DE GRAZIA, D., Review of Muzzi and Di Giampaolo, *Master Drawings*, XXVIII (1990), pp. 83–6

DENISON, C., MULES, H., AND SHOAF, J., *European Drawings: 1375–1825 [of the Pierpont Morgan Library]*, New York, 1981

DI GIAMPAOLO, M., 'Quattro studi del Parmigianino per la "Madonna dal collo lungo"', *Prospettiva*, 33–6 (1983–4), pp. 180–2

DI GIAMPAOLO, M. (ed.), *Disegni emiliani del rinascimento*, Milan, 1989

DI GIAMPAOLO, M., *Parmigianino, catalogo completo*, Florence, 1991

EKSERDJIAN, D., 'Parmigianino's "Madonna of Saint Margaret"', *Burlington Magazine*, CXXV (1983), pp. 542–6

EKSERDJIAN, D., 'Parmigianino's First Idea for the "Madonna of the Long Neck"', *Burlington Magazine*, CXXVI (1984), pp. 424–9

EKSERDJIAN, D., 'Parmigianino in San Giovanni Evangelista', in *Florence and Italy: Renaissance Studies in Honour of Nicolai Rubinstein*, London, 1988

EKSERDJIAN, D., Review of New York 1993, *Burlington Magazine*, CXXXVI (1994), pp. 202–3

EKSERDJIAN, D., 'Parmigianino', *The Dictionary of Art*, ed. J. Turner, London, 1996, XXIV, pp. 197–202

EKSERDJIAN, D., *Correggio*, New Haven and London, 1997

EKSERDJIAN, D., 'Unpublished Drawings by Parmigianino: Towards a Supplement to Popham's *catalogue raisonné*', *Apollo*, CL (1999), pp. 3–41

FINALDI, G., 'The "Conversion of Saint Paul" and Other Works by

Parmigianino in Pompeo Leoni's Collection', *Burlington Magazine*, CXXXVI (1994), pp. 110–12

FREEDBERG, S.J., 'On the Parmigianino Drawing in the Mitchell Bequest', *Fogg Art Museum Newsletter*, VII (1970), p. 3

FRÖHLICH-BUM, L., *Parmigianino und der Manierismus*, Vienna, 1921

FRÖHLICH-BUM, L., 'Some Unpublished Drawings by Parmigianino', *Apollo*, LXXVI (1962), pp. 692–6

GNANN, A., 'Parmigianinos Projekte für die Cesi-Kapelle in S. Maria della Pace in Rom', *Zeitschrift für Kunstgeschichte*, LIX (1996), pp. 360–80

GOLDFARB, H., in *European Master Drawings from the Fogg Art Museum*, exh. cat., National Museum of Western Art, Tokyo, 1979, no. 13

GOLDNER, G.R., AND HENDRIX, L. with the assistance of G. Williams, *European Drawings 1: Catalogue of the Collections*, The J. Paul Getty Museum, Malibu, 1988

GOLDNER, G.R., AND HENDRIX, L. with the assistance of K. Pask, *European Drawings 2: Catalogue of the Collections*, The J. Paul Getty Museum, Malibu, 1992

GOULD, C., *The Paintings of Correggio*, London, 1976

GOULD, C., *Parmigianino*, New York, London and Paris, 1994

HARPRATH, R., 'Zwei unbekannte Zeichnungen Parmigianinos zur Planung der "Madonna dal collo lungo"', *Zeitschrift für Kunstgeschichte*, XXIV (1971), pp. 19–71

HIRST, M., 'Rosso: A Document and a Drawing', *Burlington Magazine*, CVI (1964), pp. 120–6

JAFFÉ, M., *The Devonshire Collection of Italian Drawings: Bolognese and Emilian Schools*, London, 1994

L.: F. Lugt, *Les Marques de Collections de Dessins et d'Estampes*, Amsterdam, 1921 and *Supplément*, The Hague, 1956

LANDAU, D., AND PARSHALL, P., *The Renaissance Print, 1470–1550*, New Haven and London, 1994

LONDON 1981–2, *Splendours of the Gonzaga*, exh. cat. by D. Chambers, J. Martineau, et al., Victoria and Albert Museum, London

LONDON 1983, *Drawings by Raphael*, exh. cat. by J.A. Gere and N. Turner, British Museum, London

LONDON 1987, *Parmigianino: Paintings, Drawings, Prints*, exh. cat. by H. Braham, Courtauld Institute Galleries, London

LONDON AND NEW YORK 1991, *Italian Drawings*, exh. cat., Hazlitt, Gooden & Fox, London and New York

LONDON AND OXFORD 1971, *Loan Exhibition of Drawings from the Collection of Mr. Geoffrey Gathorne-Hardy*, exh. cat., P. & D. Colnaghi, London and Ashmolean Museum, Oxford

LOS ANGELES 1997, *Masterpieces of the J. Paul Getty Museum: Drawings*, exh. cat. by N. Turner and L. Hendrix, The J. Paul Getty Museum, Los Angeles, 1997

MCGRATH, T.H., '"Disegno", "Colore" and the "Disegno Colorito": The Use and Significance of Color in Italian Renaissance Drawings', Ph.D. dissertation, Harvard University, Cambridge (MA), 1994

MCGRATH, T.H., 'Colour in Italian Renaissance Drawings', *Apollo*, CXLVI (1997), pp. 2–30

MCTAVISH, D., 'Pellegrino Tibaldi's "Fall of Phaethon" in the Palazzo Poggi, Bologna', *Burlington Magazine*, CXXII (1980), pp. 186–8

MALIBU, FORT WORTH AND WASHINGTON 1983, *Master Drawings from the Woodner Collection*, exh. cat. by G. R. Goldner, The J. Paul Getty Museum, Malibu (CA), Kimbell Art Museum, Fort Worth (TX), and The National Gallery of Art, Washington D.C.

MANTUA AND VIENNA 1999, *Roma e lo stile classico di Raffaello*, exh. cat. by K. Oberhuber and A. Gnann, Palazzo Te, Mantua and Graphische Sammlung Albertina, Vienna

MARINELLI, S., AND MAZZA, A., *La pittura emiliana nel Veneto*, Modena, 1999

MONGAN, A., OBERHUBER, K., AND BOBER, J., *I grandi disegni del Fogg Art Museum di Cambridge*, Milan, 1988

MUZZI, A., AND DI GIAMPAOLO, M., *Correggio: I disegni*, Turin, 1989

NEW HAVEN 1974, *Sixteenth Century Italian Drawings: Form and Function*, exh. cat. by E. Pillsbury and J. Caldwell, Yale University Art Gallery, New Haven

NEW YORK 1965, *Drawings from New York Collections I: The Italian Renaissance*, exh. cat. by J. Bean and F. Stampfle, The Metropolitan Museum of Art and The Pierpont Morgan Library, New York

NEW YORK 1975, *Graphic Arts of Five Centuries*, exh. cat., William H. Schab Gallery, Inc., New York

NEW YORK 1990, *Master Drawings from the Woodner Collection*, exh. cat. by A. Dumas, C. Lloyd, et al., The Metropolitan Museum of Art, New York, no. 27

NEW YORK 1993, *Sixteenth-Century Italian Drawings in New York Collections*, exh. cat. by W. M. Griswold and L. Wolk-Simon, The Metropolitan Museum of Art, New York

PARIS 1984, *Autour de Raphael*, exh. cat. by R. Bacou and S. Béguin, Cabinet des Dessins, Musée du Louvre, Paris

PARIS 1999–2000, *Dominique-Vivant Denon, l'œil de Napoléon*, exh. cat. by P. Rosenberg et al., Musée du Louvre, Paris

PARKER, K.T., 'Some Observations on Oxford Raphaels', *Old Master Drawings*, 54–6 (Sept–March 1939–40), pp. 34–43

PARKER, K.T., *Catalogue of the Collection of Drawings in the Ashmolean Museum II: Italian Schools*, Oxford, 1956

POPHAM, A.E., 'The Baiardo Inventory', in *Studies in Renaissance and Baroque Art Presented to Anthony Blunt*, Oxford and London, 1967, pp. 26–9

POPHAM, *BM*: A.E. Popham, *Italian Drawings in the Department of Prints and Drawings in the British Museum, Artists Working in Parma*, 2 vols, London, 1967

POPHAM, *Corr.*: A.E. Popham, *Correggio's Drawings*, London, 1957

POPHAM, *Parm.*: A.E. Popham, *Catalogue of the Drawings of Parmigianino*, 3 vols, New Haven and London, 1971

POUNCEY P., AND GERE, J.A., *Italian Drawings in the Department of Prints and Drawings in the British Museum. Raphael and his Circle*, 2 vols, London, 1962

PUGLIATTI, T., *Giulio Mazzoni e la decorazione a Roma nella cerchia di Daniele da Volterra*, Rome, 1984

QUATTRUCCI, M., 'Michelangelo Anselmi' in *Dizionario biografico degli italiani*, Rome, 1961, III, pp. 378–9

QUEDNAU, R., *Die Sala di Costantino im Vatikanischen Palast, Zur Dekoration der beiden Medici-Päpste Leo X. und Clemens VII*, Hildesheim and New York, 1979

QUINTAVALLE, A.G., *Affreschi giovanili del Parmigianino*, Parma, 1968

QUINTAVALLE, A.G., *Parmigianino: Disegni*, Florence, 1971

QUINTAVALLE, A.O., *Il Parmigianino*, Milan, 1948

RAGGIO, O., 'The Myth of Prometheus', *Journal of the Warburg and Courtauld Institutes*, XXI (1958), pp. 44–62

RICCI, C., *Correggio*, London and New York, 1930

RICHARDSON, J., *An Account of some of the Statues Bas-reliefs Drawings and Pictures in Italy*, London, 1722

ROMANO, G., 'Correggio in Mantua and San Benedetto Po', in *Dosso's Fate: Painting and Court Culture in Renaissance Italy*, The J. Paul Getty Museum, Los Angeles, 1997

ROSSI, P., *L'opera completa del Parmigianino*, Milan, 1980

SASLOW, J., *Ganymede in the Renaissance: Homosexuality in Art and Society*, New Haven and London, 1986

SHEARMAN, J., 'Correggio and the Connoisseurs', review of Gould 1976, in *The Times Literary Supplement*, 18 March 1977, pp. 302–4

SHEARMAN, J., *Mannerism*, 7th reprint, London and New York, 1986

SHEARMAN, J., *Only Connect...*, Princeton, 1992

TURNER, N., HENDRIX, L., AND PLAZZOTTA, C., *European Drawings 3: Catalogue of the Collections*, The J. Paul Getty Museum, Los Angeles 1997

VACCARO, M., 'Documents for Parmigianino's "Vision of St Jerome"', *Burlington Magazine*, CXXXV (1993) pp. 22–7

VACCARO, M., 'Resplendent Vessels: Parmigianino at Work in the Steccata', in *Concepts of Beauty in Renaissance Art*, ed. F. Ames-Lewis and M. Rogers, Aldershot and Ashgate, 1998

VAN REGTEREN ALTENA, J.Q., 'Aertgen van Leyden', *Oud Holland*, LXVI (1939), pp. 17–22

VASARI, G., *Le vite de' più eccellenti pittori scultori ed architettori scritte da Giorgio Vasari pittore con nuove annotazioni*, ed. G. Milanesi, Florence, 1878–85, 9 vols

WARD-JACKSON, P., *Victoria and Albert Museum Catalogues. Italian Drawings 1: 14th–16th Century*, London, 1979

WARWICK, G., 'The Formation and Early Provenance of Padre Sebastiano Resta's Drawing Collection', *Master Drawings*, XXXIV (1996), pp. 239–78

WARWICK, G., *The Arts of Collecting, Sebastiano Resta and the Market for Drawings in Early Modern Europe*, Cambridge, 2000

WASHINGTON AND PARMA 1984, *Correggio and his Legacy*, exh. cat. by D. De Grazia, National Gallery of Art, Washington D.C. and Galleria Nazionale, Parma

WEIL-GARRIS BRANDT, K., 'Michelangelo's *Pietà* for the "cappella del re di Francia"', in *Michelangelo: Selected Scholarship in English*, New York and London, 1995, I, pp. 217–60

WELSH, S.R., 'Giovanni Benedetto Castiglione's "God Creating Adam": The First Masterpiece of the Monotype Medium', *Museum Studies*, XVII (1991), pp. 67–73

WOLK, L., *Studies in Perino del Vaga's Early Career*, Ph.D. dissertation, University of Michigan, Ann Arbor, 1987, 2 vols

WYSS, E., *The Myth of Apollo and Marsyas in the Art of the Italian Renaissance: An Inquiry into the Meaning of Images*, Newark and London, 1996

YALE 1974, *Sixteenth-Century Italian Drawings: Form and Function*, exh. cat., Yale University Art Gallery, New Haven

Concordances

Concordance between Muzzi and Di Giampaolo 1988 and the present catalogue

M&DG	cat.	M&DG	cat.
1	1	52	19
3	2	53	18
5	3	54	25
8	6	55	26
9	7	61	31
10	4	68	28
11	5	74	27
18	8	81	32
22	14	82	22
30	10	83	33
33	9	84	23
36	11	85	21
39	15	88	24
40	16	91	34
47	17	95	35
51	20	98	36

Concordance between Popham, *Parm.*, and the present catalogue

P	cat.	P	cat.	P	cat.	P	cat.
46	62	255	133	334	122	691	70
49	84	257	134	335	89	692	76
161	42	256	130	336	91	694	57
162	43	265	50	337	65	697	41
165	40	273	86	339	128	704	126
166	39	294	51	347	107	708	61
176	82	295	38	348	108	718	105
181	88	297	81	349	109	719	115
184	94	298	124	635	49	723	96
188	80	301	114	644	79	732	83
190	75	302	64	650	48	734	98
193	63	311	59	654	123	741	90
203	100	312	77	656	110	747	54
214	85	313	46	657	111	748	47
215	66	319	78	658	112	764	72
216	67	320	95	659	113	768	97
217	68	321	118	665	116	770	117
218	87	323	101	666	58	794	60
224	131	330	37	668	125	823	45
228	103	331	56	673	129	OC52	127
229	104	332	71	690	73		

Index of lenders

References are to catalogue numbers

Photographic acknowledgements

Most photographs were provided by the owners of the works and are published by their permission. Additional credits are as follows:

Alinari/Art Resource, New York: figs 7, 10, 14, 16, 18–20, 25–7, 38, 42

Foto Marburg/Art Resource, New York: fig. 36

Giraudon/Art Resource, New York: figs 22–3

Erich Lessing/Art Resource, New York: figs 15, 21, 44

Scala/Art Resource, New York: figs 28, 41, 43

President and Fellows of Harvard College, Harvard University (photos by David Matthews): cats 45, 55

Board of Trustees of the National Museums and Galleries on Merseyside: cat. 11

The Royal Collection © 2000 Her Majesty Queen Elizabeth II: cats 2, 31, 34, 48, 49, 58, 79, 110–13, 116, 123, 125, 127, 129